CLARENDON STUDIES IN THE HISTORY OF ART

General Editor: Dennis Farr

Toulouse-Lautrec

The Formative Years
1878–1891

GALE B. MURRAY

CLARENDON PRESS · OXFORD

1991

Oxford University Press, Walton Street, Oxford OX2 6DP
Oxford New York Toronto
Delhi Bombay Calcutta Madras Karachi
Petaling Jaya Singapore Hong Kong Tokyo
Nairobi Dar es Salaam Cape Town
Melbourne Auckland
and associated companies in
Berlin Ibadan

Oxford is a trade mark of Oxford University Press

Published in the United States
by Oxford University Press, New York

© Gale B. Murray 1991

British Library Cataloguing in Publication Data
Data available

Library of Congress Cataloging in Publication Data
Murray, Gale Barbara, 1945–
Toulouse-Lautrec : the formative years | Gale B. Murray.
p. cm.
ISBN 0–19–817505–1
1. Toulouse-Lautrec, Henri de, 1864–1901—Criticism and
interpretation. I. Title.
N6853.T6M87 1991
760'.092—dc20 91–23077
CIP

Publication of this book has been aided by a grant from the Millard Meiss
Publication Fund of the College Art Association.

Typeset by Latimer Trend & Company Ltd., Plymouth
Printed in Great Britain by Butler & Tanner Ltd., Frome

For Sandy Kinnee

ACKNOWLEDGEMENTS

THIS book evolved out of a doctoral thesis for Columbia University. I am profoundly indebted to Professor Theodore Reff, who first suggested Toulouse-Lautrec to me as a subject for study and whose guidance, teaching, and scholarship were my initial inspiration. Moreover, this book would not have been completed without his continued encouragement over the years.

I am grateful to the Fulbright–Hays Commission, the French Government, and Columbia University for grants which enabled me to pursue my dissertation research in Paris in the 1970s. Later I was able to broaden the scope of my research and writing thanks to grants from Colorado College. In the final stages of the project, the College's Berg Endowment supported the purchase of photographs, and additional college funds subsidized the book's illustrations. I must also express my appreciation to the Millard Meiss Publication Fund of the College Art Association for its subsidy.

Over the two decades that have elapsed since I began work on Toulouse-Lautrec, I have been helped by more individuals and institutions than I can mention by name. I should like all those not specifically cited here to be aware of my gratitude. I particularly wish to thank Toulouse-Lautrec's relatives, Mme du Vignaud and her family and the Countess Attems, for their generosity in showing me artworks, letters, and family memorabilia not available to the general public. I also owe special thanks to Jean Devoisins, former director of the Musée Toulouse-Lautrec at Albi, who made available for my close inspection many works from the museum's unequalled collection and gave me access to the museum's records and library. I am indebted to Jean Adhémar for his encouragement and for numerous invaluable suggestions that led me to fruitful discoveries, and to M. G. Dortu for permitting me to view her remarkable private collection. I regret that many of those mentioned above did not live to witness the publication of my work; their assistance was extraordinary. I am especially grateful to Herbert Schimmel, who kindly opened to me his collection of artworks and unpublished letters and documents as well as his superlative library, helped me in my search for photographs, and shared his own vast knowledge of Lautrec with me. His contribution has been of inestimable value.

A number of other curators, collectors, art-dealers, and librarians were extremely helpful in providing me with opportunities to see paintings out of their frames, to view works in storage, to consult conservation and curatorial records, and to obtain photographs. For facilitating my research I wish to thank the staff of the Bibliothèque Nationale in Paris, the Art Institute of

Chicago, the Philadelphia Museum of Art, the Metropolitan Museum of Art in New York, the Sterling and Francine Clark Art Institute in Williamstown, Massachusetts, the Ny Carlsberg Glyptotek in Copenhagen, the Barber Institute of Fine Arts in Birmingham, the Rijksmuseum Vincent van Gogh in Amsterdam, the Kröller-Müller Museum in Otterlo, the Kunsthalle in Bremen, the Von der Heydt Museum in Wuppertal, the Kunsthalle in Hamburg, the Tate Gallery in London, and the Oscar Reinhart Collection in Winterthur. In Switzerland, during the early phase of my research in the 1970s, M. E. Bührle, Professor Hans Hahnloser, Mr and Mrs Jaggli-Hahnloser, and Baron Robert von Hirsch also went out of their way to help me and permitted me to see works not commonly shown to the public. More recently, Philip Dennis Cate allowed me privileged access to works at the Jane Vorhees Zimmerli Art Museum at Rutgers University.

I also wish to thank the following collectors, curators, and dealers for supplying photographs of works in their collections and granting permission to reproduce them, or for assisting me in my search for photographs: Manuel Schmit, Marcel Lecomte, Georges Beauté, A. H. Bloom, Claude-Gérard Cassan, Clément Altarriba, Joseph H. Hazen, Danièle Devynck, current director of the Musée Toulouse-Lautrec, Faith Pleasanton of Christie's, New York, Beverly Carter of the Paul Mellon Collection, Guy-Patrice Dauberville of Bernheim-Jeune & Cie, Michel Straus and Stéphane Cosman Connery of Sotheby's, London, Maître Joël Millon of Paris Drouot, Elaine Rosenberg of Paul Rosenberg and Co., Annette Santes of Christie's, London, Leslie Spector Birenbaum of the Werner H. Kramarsky Collection, M. de Bazelaine of the Hermès Collection, Thérèse Burollet of the Musée du Petit Palais, Anne Roquebert of the Musée d'Orsay, Dr Antje Birthälmer of the Von der Heydt Museum, P. M. Bardi of the Museu de Arte de São Paulo Assis Chateaubriand, and above all, Philippe Brame.

Especially important in the genesis and refinement of my ideas were innumerable conversations with friends, colleagues, and fellow scholars, most notably Mona B. Hadler, Mary Ball Howkins, Greta Berman, Herving Madruga, and Dennis Showalter. Early in my research, Albert Boime offered helpful suggestions on several important issues relating to Lautrec's academic career. The members of my dissertation defence committee, Theodore Reff, Allen Staley, John Rewald, Gerald Silk, and Naomi Schorr, posed challenging questions, as did Linda Nochlin more recently, that helped me to establish some new directions in my subsequent research. I am grateful to Herving Madruga for checking my French translations, to Barbara Arnest and Dee Fischer for their many useful editorial suggestions, and to Bill Fischer for his assistance with computer programs. Dee Fischer was also a painstakingly careful, tireless, and reliable typist, whose friendship throughout this project I greatly appreciate. My sincere thanks to Fine Arts Editors Frances Whistler and Anne Ashby at Oxford University Press for their confidence in and

sponsorship of this project and to copy editor Pat Lawrence and designers Mick Sharp and Sue Tipping for their excellent work.

The contributions of three people deserve special emphasis. I should like to thank my parents, Albert and Eve Murray, for their support and understanding every step of the way. Above all, however, it was my husband, Sandy Kinnee, who helped make this book a reality. His acute insights, as well as his expert assistance in the editing of the manuscript, proved invaluable. Without his constant loving encouragement and infinite patience this book would never have come to fruition. It is with great pleasure and deepest gratitude, therefore, that I dedicate my book to him.

The Colorado College, Colorado Springs, Colorado
August 1990

CONTENTS

LIST OF ILLUSTRATIONS

Plates marked * appear in both black and white and colour.

LIST OF COLOUR PLATES

AUTHOR'S NOTE TO THE READER

THROUGHOUT the text I have referred to Lautrec's works by their French titles as listed in M. G. Dortu, *Toulouse-Lautrec et son œuvre* (New York, 1971). I have proposed new titles where I have found Dortu's to be incorrect, but in such cases I have also made note of her title.

Appendix A (Checklist of Revised Dates) provides Dortu's catalogue numbers for the works discussed or mentioned in the text. In general, I have omitted from the notes information provided in the appendix. However, in the few cases where works mentioned in the text are not included in the appendix, their catalogue numbers appear in the notes. Dortu's letters are explained as follows:

P — Painting
D — Drawing
A — Watercolour
SP — Supplemental Painting
SD — Supplemental Drawing
Ic — Iconographie

Appendix A summarizes revisions and adjustments of chronology and selected other new information resulting from this study. The discussions in each chapter of the text pertain to key examples of Lautrec's work of the period in question. The appendix lists additional related works (as well as the key examples). I have organized Appendix A to follow more or less the order of the text, which it is intended to complement.

The original French is given only for literary passages and all translations are the author's own (unless a published English translation is cited in the notes).

This book was prepared before the publication of Schimmel's edition of *The Collected Letters of Henri de Toulouse-Lautrec* (Oxford, 1991). For the convenience of the reader it has been added to the bibliography and wherever possible letter numbers and page references have been provided in the notes.

Toulouse-Lautrec

The Formative Years
1878–1891

Introduction

'UN homuncule ridicule, dont la déformation caricaturale semble se refléter dans chacun de ses dessins' ('a ridiculous homunculus whose own caricatural deformity seems to be reflected in each one of his drawings'), Edmond de Goncourt wrote in his journal in 1896.[1] He was characterizing Henri de Toulouse-Lautrec in a manner that both summarized contemporary attitudes towards the artist and presaged those of posterity. The overriding tendency of critics and historians has been to treat Lautrec's art as an isolated phenomenon, and the artist as an eccentric whose physical deformities and psychological pain almost exclusively determined the special qualities of his style and subject-matter. He is presumed to have suffered a bitter compulsion not only to seek out the ugly in life but cruelly to distort it still further. The literature on Lautrec is extensive and covers a range of categories, from monographs to novels, motion pictures, and even medical treatises; and, in general, the authors have found the romantic and lurid aspects of the artist's life so compelling that they have concentrated on his personal history at the expense of his art, or used it as a convenient basis for appraising his art.

Conflicts over Lautrec's personal life and its relation to his work began during his lifetime on the occasions of his major exhibitions in 1893, 1896, and 1898.[2] Some early critics capitalized on the sensational aspects of his life and personality and used them to explain his art; his family, friends, and other admirers sought to defend him by playing down the same sensational and dramatic personal qualities. When Lautrec suffered a mental and physical breakdown in 1899 and entered an asylum, hostile critics seized on the event as confirmation of the 'madness' and 'ugliness' they saw in his work. Their vituperation intensified even further at the time of his death in 1901.

This dissension over Lautrec renewed the nineteenth-century battle of 'Realism' versus 'idealism' in art. Conservative 'idealist' critics attacked Lautrec's art as the grotesquely obscene product of a 'degenerate'. Edmond Lepelletier, who typified them, asserted that Lautrec's art was that of a 'deformed individual who saw everything around him as ugly and who exaggerated the uglinesses of life, calling attention to all of its blemishes, all of its perversities and all of its realities'.[3] By contrast, Lautrec's 'Realist' defenders pointed out his humanity and compassion and praised the frankness of his work. He searched for reality, they said, 'not the shams and illusions which falsify the truth and distort the past'.[4] But, like his unfriendly

[1] E. and J. de Goncourt, *Journal de sa vie littéraire*, 22 vols. (Monaco, 1957), xxi. 230, entry of 20 Apr. 1896. Goncourt comments on an 'Exposition chez Jouault [*sic*] de lithographies de Toulouse-Lautrec . . .', probably a preview held at Joyant's gallery of the exhibition of Lautrec's album *Elles*, which opened at the offices of *La Plume* on 22 Apr. 1896.

[2] See e.g. on the Lautrec/Maurin exhibition of 1893, G. Geffroy, 'A propos de l'exposition chez Boussod Valadon, 19, Boulevard Montmartre', *La Justice* (19 Feb. 1893); on the one-man show at the Manzi–Joyant Galleries in Jan. 1896, 'Henri de Toulouse-Lautrec, exposition rue Forest', *La Justice* (14 Jan. 1896); and the contemporary comments on the one-man show at the Goupil Gallery in London in May 1898, published in G. Mack, *Toulouse-Lautrec* (New York, 1953, orig. 1938), 313–14.

[3] E. Lepelletier, 'Actualités: Henri de Toulouse-Lautrec', *L'Écho de Paris* (11 Sept. 1901). See also E. Julien, 'Toulouse-Lautrec vu par ses contemporains', *Art et style*, no. 19 (1951).

[4] N.N., *Journal de Paris* (10 Sept. 1901).

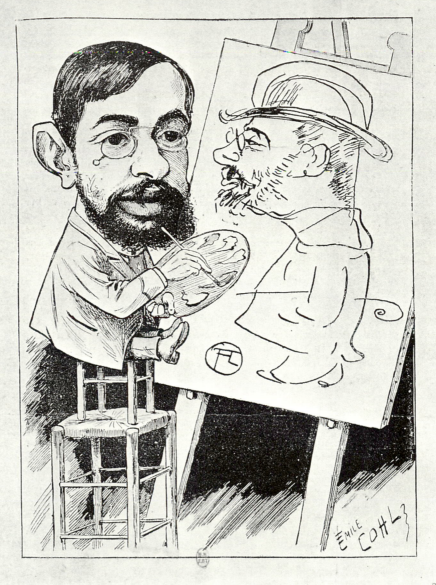

9ᵉ volume. Nº 460. — 10 c. Un an : 5 fr.

LES HOMMES D'AUJOURD'HUI

Texte de CH. DONOS
DESSIN D'ÉMILE COHL
Bureaux : Librairie Vanier, 19, quai Saint-Michel, Paris

DE TOULOUSE-LAUTREC

1. Émile Cohl, after, *de Toulouse-Lautrec*. Zinc engraving from cover of *Les Hommes d'aujourd'hui*, 9, no. 460. Paris, Bibliothèque Nationale. (Photo, Bibliothèque Nationale.)

critics, the artist's friends also dwelt on his character and failed to contest and go beyond the prevailing view of his art as the reflection of his personal idiosyncrasies. Protesting that Lautrec was totally misunderstood, Louis-Numa Baragnon declared, 'In spite of all the adversities he has suffered, he has retained an inner nobility that was truly worthy of his noble birth.' And Arsène Alexandre proclaimed Lautrec's art to be the result of his personal 'thirst for truth'.[5]

From such a climate of controversy, it is unlikely that detached contemporary assessments of Lautrec and his work could emerge. Even the biography by Charles Donos in *Les Hommes d'aujourd'hui* (c.1897–8) was a sarcastic, hostile account, accompanied by a caricature in which the diminutive artist paints a 'life-size' caricature of himself (Fig. 1). While the cartoonist Émile Cohl mocked Lautrec's physical appearance, the biographer belittled the man and his work, insinuating that he continued a family heritage of hedonistic excesses and scornfully pronouncing the art 'incomprehensible' and 'corrupt'. He predicted that its influence would be 'momentary, inevitably transient', and concluded that it was a debauched, false art, 'germinated by bitumen'.[6]

The earliest outright romanticization of Lautrec also appeared during his lifetime. Hugues Rebell obviously drew directly on Lautrec's life and personality for the character of the artist Jacques de Tavannes in his all-but-forgotten novel about *fin de siècle* society, *La Câlineuse*. It was published serially in *La Revue blanche* between 1 November 1898 and 1 May 1899, and as a book late in 1899. Rebell belonged to Lautrec's own circle of *La Revue blanche*; he fully recognized the significance of the artist's work and was seized by its power. Nevertheless he described the work of the fictional Tavannes as that of a 'dwarf' and 'master butcher', 'steeped in malice', who takes 'pleasure in representing the ugly', and spitefully amuses himself with caricature and other distortion in art, and thereby ridicules his models and uglifies life.[7]

Since Lautrec's death, numerous books, including those of Arthur Symons, Émile Schaub-Koch, Lawrence and Elisabeth Hanson, and Henri Perruchot,[8] as well as John Huston's 1953 Hollywood film, *Moulin Rouge* (based on Pierre La Mure's novel of the same name),[9] perpetuated and popularized this sort of romanticization of Lautrec. Meanwhile, friends of Lautrec, such as Paul Leclercq, Tristan Bernard, Thadée Natanson, Édouard Vuillard, and others, continued, in their compilations of anecdotes and fond reminiscences, the early efforts to draw a more 'respectable' picture of Lautrec the man.[10] The artist's family purportedly participated in an attempt to whitewash his reputation and protect its ancient name by destroying works and letters and otherwise suppressing defamatory information.[11] Even

[5] L.-N. Baragnon, 'Nécrologie', *La Dépêche* (9 Sept. 1901), as transl. in G. M. Sugana, *The Complete Paintings of Toulouse-Lautrec* (New York, 1969), 9; A. Alexandre, 'Une guérison', *Figaro* (30 Mar. 1899).

[6] C. Donos, 'de Toulouse-Lautrec', *Les Hommes d'aujourd'hui*, 9, no. 460. This undated issue is situated late in 1897 or early in 1898 by J. M. Place and A. Vasseur, *Bibliographie des revues et journaux littéraires des XIXᵉ et XXᵉ siècles* (Paris, 1974), ii. 134. (NB The drawing on Lautrec's easel in Cohl's caricature reproduces and enlarges one of Lautrec's self-caricatures [D4020].)

[7] G. Grassal [Hugues Rebell], *La Câlineuse* (Paris, 1978, orig. pub. by Les Éditions de La Revue blanche, 1899), 52–3, 427.

[8] A. Symons, *From Toulouse-Lautrec to Rodin* (London, 1929),

see esp. pp. 2–3; É. Schaub-Koch, *Psychanalyse d'un peintre moderne, Henri de Toulouse-Lautrec* (Paris, 1935); L. and E. Hanson, *The Tragic Life of Toulouse-Lautrec* (New York, 1956); H. Perruchot, *La Vie de Toulouse-Lautrec* (Paris, 1958), see esp. pp. 77, 80.

[9] P. La Mure, *Moulin Rouge* (New York, 1950).

[10] P. Leclercq, *Autour de Toulouse-Lautrec* (Geneva, 1954); T. Bernard, 'Toulouse-Lautrec sportsman', *L'Amour de l'art*, 12 (Apr. 1931), 135; T. Natanson, *Un Henri de Toulouse-Lautrec* (Geneva, 1951); G. Bazin, 'Lautrec raconté par Vuillard', *L'Amour de l'art*, 12 (Apr. 1931), 141–2.

[11] Cf. J. Bouret, *Court Painter to the Wicked: The Life and Work of Toulouse-Lautrec*, trans. D. Woodward (New York,

Maurice Joyant, author in 1926–7 of the first authoritative study of Lautrec as an artist, the cornerstone for all future studies, wrote from the point of view of a devoted friend.[12] Joyant had dedicated himself to the task of establishing Lautrec's fame and was instrumental in the founding of the Musée Toulouse-Lautrec at Albi; he, too, carefully built up a positive image to counter the artist's reputation as a decadent. Joyant's stance was continued by M. G. Dortu, the most important of the later defenders of Lautrec.[13]

Naturally a body of literature with such a biographical orientation endeavours to explain Lautrec's art in terms of his personal history. But even the smaller part of the literature that focuses more closely on the artist's work tends to perpetuate the biographical interpretation of his art. However, this over-emphasis on biography did not alone create the inhospitable atmosphere for scholarly investigation of Lautrec's art. Numerous other problems have complicated the situation, not the least of them the artist's own reluctance to speak or write about his art. He also left a large part of his work undated. Until recently such basic research tools as a published body of letters and a complete *œuvre* catalogue have been lacking. The huge production of drawings, essential to understanding Lautrec's artistic evolution, remained largely unpublished and inaccessible, and the total extent and nature of his painted *œuvre* were unknown. Faced with these obstacles to scholarship most writers simply accepted and repeated without serious question the assertions of Joyant's pioneering account and the dates he assigned works in his 'Attempted Catalogue'. Joyant's chronology became canonical, despite its imprecision, gaps, errors, inconsistencies, and confusing placement of works of widely divergent styles to the same date. Many writers simply claimed that Lautrec was one artist whose work was not amenable to chronological study.[14]

This inhibition of scholarship has resulted in great uncertainty over major aspects of Lautrec's work. Particular confusion and contradiction exist over his artistic evolution, stylistic and otherwise, because of the absence of a clear, precisely documented chronology. Although problems exist for his entire career, the period of the 1880s is the most difficult. Since Lautrec exhibited rarely and remained relatively unknown until the end of this period, few contemporary sources of information—specifically exhibition catalogues, reviews, and published graphic works—are available. Moreover, most of the well-known witness accounts, including Joyant's, were the reports of people who knew Lautrec well only in the latter part of his career.[15] In addition, the influences under which his evolution unfolded, save that of Degas, remain too little known. Most scholarship on Lautrec isolates him from the artistic and intellectual mainstreams of his time, in part because of the biographical interpretation of his work, but also because of the persistence of the notion that to set the artist in a context of influences might detract from his reputation for original genius.

1966), 14. The family's defence of Lautrec was continued by Countess Attems, née Mary Tapié de Céleyran, *Notre oncle Lautrec*, 3rd rev. edn. (Geneva, 1963) and G. Beauté, Countess Attems, and R. de Montcabrier, *Il y a cent ans, Henri de Toulouse-Lautrec* (Geneva, 1964), see esp. p. 177.

[12] M. Joyant, *Henri de Toulouse-Lautrec*, 2 vols. (Paris, 1926–7).

[13] See esp. M. G. Dortu and P. Huisman, *Lautrec par Lautrec* (Lausanne, 1964).

[14] See e.g. A. Brook, 'Henri de Toulouse-Lautrec', *The Arts*, 4 (1923), 137; Mack, 77–8; and D. Cooper, *Henri de Toulouse-Lautrec* (New York, 1966), 27.

[15] Joyant and Lautrec had a childhood acquaintance, but did not establish a close personal and professional association until Joyant took over Théo van Gogh's position at the Goupil Gallery late in 1890 and subsequently became Lautrec's dealer. Cf. Joyant, i. 121.

Limited in their means and caught up in old approaches, writers have concentrated on classifying Lautrec's place in a general picture. But, even there, controversy exists over whether he was primarily a Realist or a precursor of abstract art. The early critics and their followers construed the artist as the culminating figure of the nineteenth-century Realist and Impressionist rebellion against academic idealism.[16] As the twentieth century progressed, however, critics in increasing numbers shifted emphasis to his contribution as a stylistic innovator; many redefined him as a Symbolist.[17] In either case, the generalizations have their basis in Joyant's chronology and depend on popular works, especially the graphics of the 1890s—better known than the paintings—rather than on the *œuvre* in its entirety. The literature therefore manifests uncertainty not only about the particularities of Lautrec's development but over the very nature of his accomplishment.

The appearance in 1971 of the long-awaited *œuvre* catalogue of M. G. Dortu,[18] together with the publication of an edition of Lautrec's letters in 1969,[19] marked a turning-point in Lautrec studies. Although Dortu did not revise the original chronology of Joyant, her work brought Joyant's catalogue entries up to date and rendered them more precise and comprehensive; she also introduced a large number of previously unpublished and unknown works, including more than two hundred paintings and some three thousand early drawings, and illustrated for the first time other works mentioned by Joyant. Consequently the way was opened for a systematic re-evaluation of the paintings and drawings in general and the 1880s in particular.[20]

[16] Among the early writers see e.g. A. Alexandre, 'Le Peintre Toulouse-Lautrec', *Le Figaro illustré*, special issue, no. 20 (Apr. 1902), 1–24; J. Meier-Graefe, *Modern Art*, trans. F. Simmonds and G. W. Chrystal, i (London, 1908); G. Geffroy, 'Henri de Toulouse-Lautrec', *Gazette des beaux-arts*, ser. 4, 12 (Aug. 1914), 89–104; T. Duret, *Lautrec* (Paris, 1920); G. Coquiot, *Henri de Toulouse-Lautrec* (Paris, 1913) and *Lautrec ou quinze ans de mœurs parisiennes* (Paris, 1921); Brook; and Joyant. Their followers include Schaub-Koch; Mack; F. Jourdain in F. Jourdain and J. Adhémar, *T-Lautrec* (Paris, 1955); Perruchot; and Dortu and Huisman.

[17] In the 1890s a minority of critics had promoted this view. See e.g. O. Maus, 'H. de Toulouse-Lautrec', *L'Art moderne* (Brussels, 17 Nov. 1901); A. Mellerio, *La Lithographie originale en couleurs* (Paris, 1898) and *Le Mouvement idéaliste en peinture* (Paris, 1896); F. Fénéon, 'Au Pavillon de la ville de Paris', *Le Chat Noir* (2 Apr. 1892), and review of the Lautrec/Maurin exhibition, *L'En dehors* (12 Feb. 1893), which noted that Lautrec did not attempt to reproduce reality, but rather to create 'an ensemble of signs that suggest it', both quoted in F. Fénéon, *Œuvres plus que complètes*, ed. J. U. Halperin (Geneva, 1970), i. 213, 217, respectively. This approach was later reformulated by A. Basler and C. Kunstler, *Modern French Painting: The Post Impressionists from Monet to Bonnard*, trans. A. Basler and C. Kunstler (London, 1931, orig. pub. in French, 1929); R. Huyghe, *Toulouse-Lautrec* (exh. cat., M. Knoedler and Co., New York, 1937); B. Dorival, *Les Étapes de la peinture française contemporaine* (Paris, 1943), i. 194, 199, 210–11. After 1950 it was taken up by such writers on Lautrec as G. Veronesi, 'Toulouse-Lautrec', *Emporium*, 113 (1957), 243–8; L. F. Johnson, Jun., 'Toulouse-Lautrec, the Symbolists and Symbolism', Ph.D. diss. (Harvard University, 1956),

'Time and Motion in Toulouse-Lautrec', *College Art Journal*, 16 (1956–7), 13–22, and 'The Light and Shape of Loie Fuller', *Baltimore Museum of Art News*, 20 (1956), 9–16; and esp. by numerous authors of general textbooks on modern art. Only a few critics took a more eclectic view, discerning in Lautrec's art a tension between the Realist passion for actuality and a tendency toward abstract simplification and/or expressionism. See e.g. H. Focillon, 'Lautrec', *Gazette des beaux-arts*, ser. 6, 5 (June 1931), 366–82; L. Venturi, *Impressionists and Symbolists: Modern Painters*, trans. F. Steegmuller (London, 1950), ii. 200–24; D. Sutton, *Lautrec* (New York, 1962) and 'Some Aspects of Toulouse-Lautrec', *The Connoisseur Yearbook* (1956), 71–8; D. Cooper; F. Novotny, *Toulouse-Lautrec*, trans. M. Glenney (London, 1969); and R. Thomson, *Toulouse-Lautrec* (London, 1977).

[18] M. G. Dortu, *Toulouse-Lautrec et son œuvre*, 6 vols. (New York, 1971). See the review by G. B. Murray in *The Art Bulletin*, 60 (Mar. 1978), 179–82.

[19] L. Goldschmidt and H. Schimmel (eds.), *Unpublished Correspondence of Henri de Toulouse-Lautrec*, with notes and introd. by J. Adhémar and T. Reff (New York, 1969) (a French edn. with additional letters was published in 1972: *Toulouse-Lautrec: lettres 1871–1901* [Paris, 1972]). See also H. D. Schimmel and P. D. Cate (eds.), *The Henri de Toulouse-Lautrec W. H. B. Sands Correspondence* (New York, 1983). [The first complete edition of Lautrec's letters, ed. by H. D. Schimmel, with introd. by G. B. Murray (Oxford, 1991) was published whilst this book was in press; whenever possible references are to this edition.]

[20] Revisionary work on the prints had already begun with J. Adhémar, *Toulouse-Lautrec: His Complete Lithographs and Drypoints* (New York, 1965). It was continued by G. Adriani,

The present work attempts to establish a chronology for Lautrec's paintings, drawings, and graphic works for the period 1878–91, and uses this as a foundation for an analysis of his early evolution.[21] This reassessment of chronology is based on the systematic co-ordination of related works by Lautrec; on clues available in letters, exhibition catalogues, witness accounts, contemporary newspapers and journals, direct sources of inspiration, external events, and the people and places depicted; on investigation of Lautrec's working methods; and finally on a consideration of the stylistic evidence. All this was done in conjunction with the direct examination of a great number of Lautrec's paintings. In addition, this work explores the relationship of Lautrec's art to the broader artistic and intellectual context and calls upon historical sources, contemporary literature, and illustrated journals to illuminate the significance of Lautrec's imagery.

The focus here is on issues that the existing literature leaves unexamined or unresolved. First, what role did Lautrec's earliest animal and sporting subjects have in his overall development? These are usually regarded as the prelude to his maturity—the intuitive beginnings of an avant-garde mentality. But how do they relate to the contemporary sporting art popular in Lautrec's aristocratic family milieu? Second, what were the length and the significance of his periods of academic study under Léon Bonnat and Fernand Cormon? Following the work of the early writers, who as defenders of the late nineteenth-century avant-garde were guided by a strongly anti-academic stance, this is traditionally regarded as a brief and insignificant interlude, but here it is extended in length. What then was the impact of each of his teachers and what do his writings and works of the time (including his hitherto neglected illustrations of Victor Hugo's poetry) tell us about his tastes, attitudes, and artistic aspirations? Third, what were the precise nature, the comparative significance, and the sequence of the progressive influences (including Realism, Impressionism, Neo-Impressionism, Cloisonnism, and Symbolism) on Lautrec's art during the 1880s and exactly when did they commence? This study moves the onset of these influences from the first to the second half of the 1880s and posits a dialogue in Lautrec's early work between his academic training and the influence of the avant-garde. To what extent can Lautrec's choice of and attitude towards such subjects as the circus, dance-hall, and Montmartre low-life be related to a social and intellectual milieu in which popular Parisian life appealed to democratizing instincts at the same time as it could be vicariously savoured for its titillations? What was the

Toulouse-Lautrec, das gesamte graphische Werk (Cologne, 1976), and by W. Wittrock, *Toulouse-Lautrec, the Complete Prints*, trans. C. E. Kuehn, 2 vols. (London, 1985); the latter should be supplemented by W. Wittrock and R. Castleman (eds.), *Henri de Toulouse-Lautrec, Images of the 1890s* (exh. cat., Museum of Modern Art, New York, 1985). Beginnings for revisionary work on the paintings have been made by G. Adriani, *Toulouse-Lautrec, Gemälde und Bildstudien* (exh. cat., Kunsthalle Tübingen, Cologne, 1986); C. F. Stuckey, *Toulouse-Lautrec: Paintings* (exh. cat., Art Institute of Chicago, 1979); R. Heller, 'Rediscovering Henri de Toulouse-Lautrec's "At the Moulin Rouge" ', *Museum Studies*, 12 (1986), 114–35. Recently a few scholars have also begun to view Lautrec's art more closely in terms of its milieu. See e.g. P. D. Cate and P. E. Boyer, *The Circle of Toulouse-Lautrec* (exh. cat., Jane Vorhees Zimmerli Art Museum, Rutgers Uni-

versity, New Brunswick, NJ, 1986); P. D. Cate, 'The Popularization of Lautrec', in Wittrock and Castleman (eds.); R. Thomson, 'The Drinkers of Daumier, Raffaëlli and Toulouse-Lautrec', *Oxford Art Journal*, 2 (Apr. 1979), 29–33, 'Toulouse-Lautrec and Sculpture', *Gazette des beaux-arts*, 102 (Feb. 1984), 80–4, and 'The Imagery of Toulouse-Lautrec's Prints', in Wittrock.

[21] This study grows out of my own earlier work: G. B. Murray, 'Problems in the Chronology and Evolution of Style and Subject Matter in the Art of Henri de Toulouse-Lautrec, 1878–1891', Ph.D. diss. (Columbia University, 1978); 'Henri de Toulouse-Lautrec, A Checklist of Revised Dates, 1878–1891', *Gazette des beaux-arts*, 95 (Feb. 1980), 77–90; 'The Theme of the Naturalist Quadrille in the Art of Toulouse-Lautrec', *Arts Magazine*, 55 (Dec. 1980), 68–75.

role of his early career as a popular illustrator in his formation? Finally, when did Lautrec emerge as a 'mature' artist, and of what did this 'maturity' consist? Writers who viewed him primarily as a Realist placed Lautrec's final attainment of a mature style in the late 1880s when he began to paint modern Parisian subjects on a large scale; most suggested 1888. But those who adhered to the more formalist trend in Lautrec criticism and focused on the decorative and synthetic qualities of his style usually set his attainment of maturity early in the 1890s, when his work seemed most abstract. By contrast, this work views Lautrec's maturity as evolving in a series of phases and as the product of the interaction of a variety of formative influences, ranging from conservative to avant-garde, from Realist to proto-abstract, and from high art to popular art.

This book deals with outstanding and representative examples of Lautrec's work from each of the years under consideration, but not the complete *œuvre* in detail. Hopefully it will serve as a stimulus for future contributions. Moreover, it does not discount those influences on Lautrec which have already been greatly emphasized, for example those of Degas, or of the pathos of his own personal history. Instead, in concentrating elsewhere, it undertakes to add a new perspective to the origins, meaning, and development of Lautrec's distinctive imagery.

I

'The stroke of the rifle, the stroke of the fork and the stroke of the pencil'

Animal and Sporting Subjects, 1878–1883

THE young Lautrec who entered the ateliers of the 'official' painters Léon Bonnat and Fernand Cormon in Paris had already evolved a characteristic subject-matter and a fairly consistent style in his art. He had become a specialist in the painting of animals, especially horses, which he depicted at the hunt, the racetrack, in promenades with modish riders and carriages, and occasionally in military subjects. In style, his painting was generally loose and sketchy. Works of this kind began as Lautrec's juvenilia and continued into the first phase of his academic study.

In style and subject, these earliest works appear almost completely anomalous to Lautrec's later, better-known productions. They show that the young artist had a precocious talent, but technically and aesthetically they fall far short of his mature accomplishment. Their significance lies more in the fact that writers on Lautrec have repeatedly summoned these works as evidence for one interpretation or another of his mature art. Critics, biographers, and art historians have identified selected characteristics of the earliest works with whatever progressive tendencies they perceived in the artist's more mature style, whether the painterly freedom of Impressionism or the schematic, synthetic techniques of proto-abstraction. At the same time they have sought to explain the disparities between the youthful and the adult output with the rationale that the young Lautrec's sketchy way of working represented the instinctual—and possibly untutored—manifestation of his later style. Traditionally, writers on Lautrec have taken the position that these 'instinctual', progressive qualities were temporarily stifled during the period of his academic training and reasserted later when he had 'liberated' himself from the academic influence.

The notion that Lautrec exhibited progressive tendencies so early is untenable and results from an interpretation of these initial works in light of the later works, instead of on their own merits. Study of the earliest paintings in terms of style and subject, and especially considering their sources of inspiration and the artist's letters, reveals Lautrec to have been a conservative, embarking on a quite traditional path, holding to the most conventional of ambitions. Even at this early stage, as young as fourteen, Lautrec was studying the works of other artists and receiving professional instruction, albeit informally. Rather than following instinct, he imitated the *animaliers* and *peintres sportifs* (painters of animals and sporting subjects), practitioners of a minor genre long fashionable with and reflecting the life-style of

the sporting set of French aristocrats to which his family belonged; and he received criticism and teaching from René Princeteau, one of these painters.

This was a phase of learning and of acquiring basic skills; its evolution was toward greater proficiency. Firm dates are difficult to fix for works of the period, but clearly Lautrec moved from laboured, stiff drawing and a muddy palette in the late 1870s to a looser, more luminous, more spontaneous style by the early 1880s; through it he represented movement with enhanced adeptness. His improved facility in drawing, nevertheless, was limited mainly to horses. For the time being he gave less attention to the human figure.

First Endeavours, 1878–1879

The earliest works that Lautrec himself dated are two oil paintings and several watercolours from 1878.[1] These first endeavours, among them *Bruno* (Fig. 2), typify the style in which the young artist worked at this time and the subject-matter that he preferred. All show equestrian scenes, a subject he had already been depicting, at least in drawings, for several years. All reveal a rather halting and uncertain technique. The drawing is awkward, the palette dark and muddied, the application of paint rough and sketchy. In their crudeness, the dated works of 1878, most of those of 1879 (e.g. Fig. 9), and the other drawings and paintings that can be grouped around them, indicate the efforts of a beginner. Precocious though he was, Lautrec at this time was largely unskilled in drawing and inexperienced in the techniques of mixing colours.

Lautrec's early fascination with equestrian subjects undoubtedly originated in his own home and family circle. His father and uncles, amateur artists as well as ardent sportsmen, filled their residences with their own representations of horses and grooms, the hunt, and dead game. Lautrec's paternal grandmother is reported to have stated: 'If my sons kill a woodcock it gives them three distinct pleasures: the stroke of the rifle, the stroke of the fork and the stroke of the pencil.'[2] In their libraries there were also many books containing illustrations of such subjects. Many of these artworks and books still exist and afford evidence that Lautrec copied or imitated them in a number of his first works.[3] Since it was the sort of art his family favoured and to which he was initially exposed, it was natural for him to aspire to be an artist of this sporting genre. The *peintre sportif* Princeteau also reinforced Lautrec's

[1] Unless otherwise noted data regarding inscriptions and dates on Lautrec's works are from Dortu, *Lautrec et son œuvre*. My chronology sets back to 1878 many undated works placed at later dates by Dortu and Joyant. When Joyant wrote his 'Essai de catalogue' of the paintings in 1926 he did not know of any works dated 1878. Therefore he set the works he believed to be the earliest at 1879. Although he added 3 works to 1878 in his supplement of 1927 (ii. 251), he did not revise the original catalogue. Dortu found several additional works dated 1878, but nor did she reconsider Joyant's chronology in the light of them.

[2] Attems, 56. Attems, 55–9, also discusses the family's artistic predilections as does the exhibition catalogue from the Musée de Rennes, *Toulouse-Lautrec et son milieu familial* (Rennes, 1963).

[3] The books include those illustrated by V. Géruzez [Crafty],

a noted specialist in horses, and J. H. Walsh [Stonehenge], who wrote books about sports; Lautrec mentioned these in his letters of the 1870s. See H. Schimmel, letter nos. 17, 14–15, and 23, 18–19. Crafty's illustrations for Fulbert-Dumonteil's *Le Jardin d'acclimatation* (1876), which Lautrec owned, might well have been the inspiration for his early zoological drawings. See e.g. Dortu, D93, D107, D109, D125, D134, D164–73, D175, which consequently may be dated *c*.1876 or after. Also, *Cheval avec valet d'écurie*, a painting by his Uncle Charles, preserved at the family home at Albi, is comparable to Lautrec's *Bruno* (P5); Lautrec's father's pencil drawing of *Alphonse, Charles et Odon de Toulouse-Lautrec* (Bosc, collection Countess K. Attems), is a hunting scene with figures close to those in P7 and A4.

subject preferences. A deaf mute who was a friend of the family, Princeteau gave Lautrec his first art instruction and became a role model for the youth. Lautrec mentioned him in letters as early as 1876; the young artist frequently imitated the elder one.

Lautrec attended the Paris Salons throughout the later 1870s and the Exposition Universelle Internationale in Paris in 1878. There he was naturally attracted to the work of the popular *animaliers* and *peintres sportifs*.[4] Artists such as Princeteau (1844–1914), Édmond-Georges Grandjean (1844–1908), John-Lewis Brown (1829–90), Georges du Busson (1859–1933), Clermont-Gallerande (d. 1895), Jean-Richard Goubie (1842–99), and others like them specialized in pictures of the equestrian hobbies of an elegant, anglophile society. In the country there were the hunts, the most noble and exclusive of sports. In Paris there were the races and the daily promenades by carriage or horseback in the bois de Boulogne,[5] which Lautrec's father frequented during his *séjours* in Paris. Aristocrats were attracted to these activities as potent social symbols which served to display their status and prestige and to maintain a sense of a distinctive noble life-style and identity at a time when they had lost the political and feudal power that had once differentiated them.[6]

In the late 1870s Lautrec began to emulate the sporting scenes at which this group of artists excelled. A practice he followed for a number of years, it therefore provides important clues to his youthful artistic interests and aspirations. His models, Princeteau and the others, constituted a veritable school of painting, a specialized branch of mid-nineteenth-century Realism. This is true because the artists concerned themselves with contemporary life, even though their preoccupation with the leisure activities of a worldly and élite social set afforded only a limited, idealized view of daily existence. Coincidentally, numerous paintings by Manet and Degas fit into the same category, but there is no indication that Lautrec was looking at their art at this time. He was observing, rather, the work of the more fashionable 'gentlemen painters' of his own circle, who were considerably less adventurous stylistically and belonged more to the artistic *juste milieu* than to the avant-garde. Style, if it concerned him, was not his overriding consideration. Despite their underlying conservatism, the artists he admired did display a variety of styles that ranged from the tightly polished to the more painterly. Lautrec's earliest works do not show any preference on his part; the paintings he chose to copy or imitate have no particular stylistic qualities in common. What motivated the young artist was their subject-matter. No sign had yet appeared of his acute formal awareness of the 1890s.

La Calèche (Fig. 3) appears to be Lautrec's earliest emulation of the *peintres sportifs*. It represents one of their typical subjects, fashionable riders on the Avenue of the bois de Boulogne, and is comparable to paintings such as Grandjean's *L'Avenue du bois de Boulogne*, a work Lautrec might well have seen at the Paris Salon in March 1877 and paraphrased shortly thereafter; he also made several drawings after individual figures in Grandjean's painting. The clumsiness and uncertainty of the drawing in *La Calèche*, even more pronounced than in the

[4] Lautrec probably visited the Exposition Universelle Internationale in Apr. 1878, since his letters show he spent that month in Paris. See H. Schimmel, nos. 25, 20; 26, 21.

[5] Described by J. Grand-Carteret, *XIX* ͤ *siècle, classes, moeurs, usages, costumes, inventions* (Paris, 1893), 507–8.

[6] R. Holt, *Sport and Society in Modern France* (Hamden, Conn., 1981), 18, 33–6, 38, 172 ff. See also T. Zeldin, *France 1845–1945*, i. *Ambition, Love and Politics* (Oxford, 1973), 406.

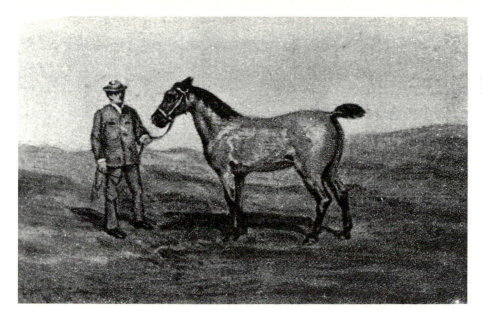

2. Henri de Toulouse-Lautrec, *Bruno*.
Private collection.

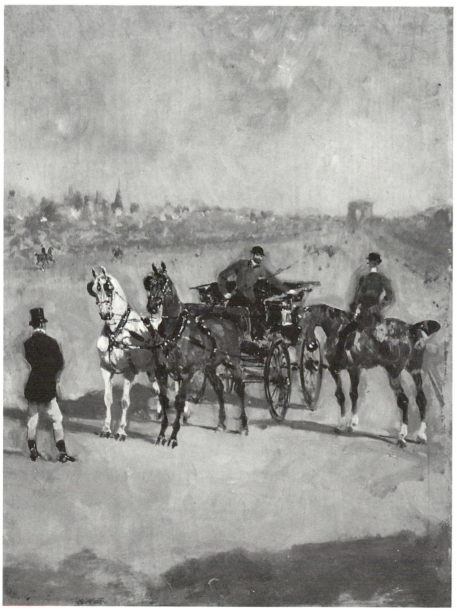

3. Henri de Toulouse-Lautrec.
La Calèche. Present location unknown.
(Photo, Drouot.)

paintings dated 1878, make 1877 a plausible date for this work and serve to identify it probably as Lautrec's earliest known oil painting.

Direct copies that Lautrec made during this period provide more concrete evidence of his dependence on the sporting painters. Three of his paintings, although undated, are traceable to a single work by Jean-Richard Goubie, the *Retour d'une chasse aux oiseaux de mer* (Fig. 4). It was exhibited at the Salon of 1875, but Lautrec probably saw it later, perhaps in 1878 when he copied another Goubie painting. In any case, the awkward and hesitant manner of these three copies places them stylistically with the dated works of 1878. The source is unmistakable for two of the copies, which are signed 'H.T.L. after Goubie'. One of these, *Attelage en tandem* (Fig. 5), represents Goubie's carriage, but the passengers are different and Lautrec has taken only the two right-hand horses of Goubie's team. He copied the darker of two horses in the far left background of his painting from one of the horses in the right foreground of the Goubie. In *Monsieur* (Fig. 6), the second of the inscribed copies, Lautrec borrowed Goubie's carriage and two forward horses, and retained only one passenger, a gentleman.

The third copy, *Deux chevaux et groom*, bears no inscription, but its central element is the white horse from the right foreground of the Goubie; its style as well as its source show that it, too, should be dated in the late 1870s along with drawings that Lautrec also made after the Goubie. Lautrec's copies are loosely painted, in marked contrast to the original with its polished surfaces and meticulous detail. They show Lautrec to have been, as yet, rather inept at plastic modelling, using instead sharply faceted planes of light and dark and emphatic reflections, which tend to segment his forms into separate areas. The same laboured style, lack of overall unity, and pastiche-like effects characterize all the paintings from this stage of Lautrec's development.

In his undated painting, *Cavalier du XVIII^{ème} siècle* (Fig. 7), Lautrec again adapted from Goubie a sporting subject that particularly attracted him, falconry. It was one of his father's favourite pursuits, exclusively a sport of the nobility and apparently a childhood passion of his own, as attested to in his letters.[7] Goubie's original was *Le Vol de la corneille* (Fig. 8), dated 1877, a scene of a group of mounted falconers in eighteenth-century costume, their birds in flight. It was exhibited at the Exposition Universelle of 1878 in Paris, where Lautrec would have seen it and would have read in the official catalogue a dramatic passage in old French from D'Arcussia's early seventeenth-century tract, *La Fauconnerie*, describing the events in falconry that Goubie had pictured.[8] Aristocrats of Lautrec's day prided themselves on the ancient pedigree and traditional aspects of the hunt, particularly falconry, and its element of continuity with the noble life of the past or of geographically remote regions. Hence contemporary accounts of the hunt often cited the classic early texts,[9] and visual depictions also featured falconers in romanticized settings and attire.

Lautrec's copy is a sketchy abridgement of Goubie's painting. It borrows only the single figure of the foremost central falconer astride his horse and isolates him against a more indistinct and simplified background. In style Lautrec's painting is compatible with works

[7] H. Schimmel, nos. 5, 6 and 17, 14–15; Joyant, i. 53. See also Dortu and Huisman, 14. H. Schimmel, no. 69, 60.

[8] *Exposition Universelle Internationale de 1878 à Paris, catalogue officiel*, 1, group 1, *Œuvres d'art, classes 1–5* (Paris, 1878).
[9] Holt, 32–3.

already attributed to 1878. Although it was the subject-matter in Goubie's paintings that excited him, Lautrec never duplicated an entire scene but rather focused on individual motifs. In fact, Lautrec's abbreviated adaptation of Goubie's *Le Vol de la corneille* provides no clues to his source's original subject-matter. One preparatory drawing of the figure Lautrec copied still exists as do several drawings after other selected motifs from the Goubie. Such evidence indicates that Lautrec probably did not yet feel competent to represent in its entirety a complex composition that integrated a series of figures and a landscape. Instead he singled out figures or passages, probably as models from which to practice and study drawing and painting. Borrowed figures from Goubie and others also served to establish a repertoire of models which Lautrec could utilize repeatedly in his own work.

Three other interrelated works, two watercolours and an oil-painting, further attest to Lautrec's enthusiasm for falconry. His subject was his father as a falconer, mounted on his horse, holding his falcon in his raised hand, and dressed in the picturesque costume of a Cossack or Circassian. The two watercolours (e.g. Fig. 9), nearly identical, were directly inspired by a photograph still preserved in an album at the family's Albi residence. It is one of many photographs in which the count sports a fanciful costume. He may even have posed in imitation of some work of art, especially since this old motif was enjoying a popular revival in contemporary art, with falconers often garbed in exotic costume. Traditionally, in artistic images the nobleman holds aloft the falcon, which serves as a symbol of his aristocratic status.[10] The third work, the oil-painting (Fig. 10), has the same theme, but the count is viewed from a different angle, the horse is more active, and the background is a fittingly romantic sunset.

One of the watercolours (Fig. 9), only recently discovered, was actually inscribed 1879 by Lautrec. The other two works are customarily placed in 1881. It seems apparent, however, that the second, undated watercolour should be placed at the same time as the dated one, since the two are obviously a pair, and that the undated oil, identical to the watercolours in subject, should also be dated 1879. Visual evidence corroborates the earlier dating of this oil-painting. As Cooper pointed out, 'the ineptness of Lautrec's draughtsmanship at this stage is clearly evident in the clumsy, rigid foreleg of the horse and in the confused placement and anatomy of its hind legs'.[11]

A piece of sculpture rather than a painting or another photograph may have inspired Lautrec to undertake the prancing horse in the oil-painting of his father as a falconer. A number of small bronzes depicting scenes of falconry were exhibited at the Exposition Universelle of 1878 and would certainly have captured Lautrec's attention. And the anatomical and spatial difficulties that he struggled with in the painting are consonant with an attempt to translate a sculpted source into a two-dimensional medium. That Lautrec made a practice of working from such small equestrian bronzes, examples of which his family probably owned, is evident in a series of drawings after bronzes of the steeplechase that he made about 1878 and 1879. Among the sculptures of falconry shown at the Exposition Universelle, E. A. Lanceray's *Le Fauconnier d'Ivan le Terrible* is notable because an engraving from it was reproduced in an exhibition catalogue (Fig. 11), accompanied by a vivid description calling

[10] A. Boime, *Thomas Couture and the Eclectic Vision* (New Haven, Conn., and London, 1980), 111.
[11] Cooper, 58.

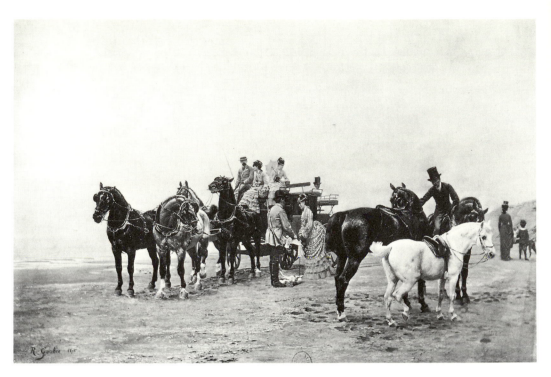

4. Jean-Richard Goubie, *Retour d'une chasse aux oiseaux de mer*. Present location unknown. (Photo, Bibliothèque Nationale.)

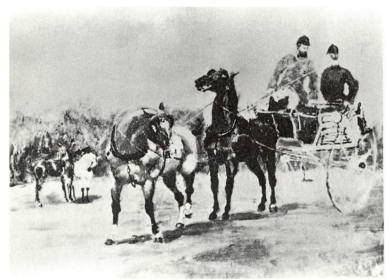

5. Henri de Toulouse-Lautrec, *Attelage en tandem*. Private collection.

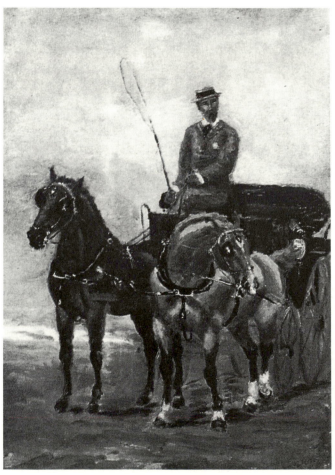

6. Henri de Toulouse-Lautrec, *Monsieur*. Private collection.

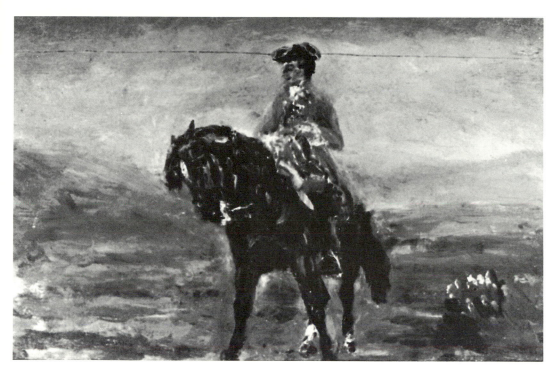

7. Henri de Toulouse-Lautrec, *Cavalier du XVIII^{ème} siècle*. Albi, Musée Toulouse-Lautrec.

8. Below: Jean-Richard Goubie, *Le Vol de la corneille*. Present location unknown. (Photo, Bibliothèque Nationale.)

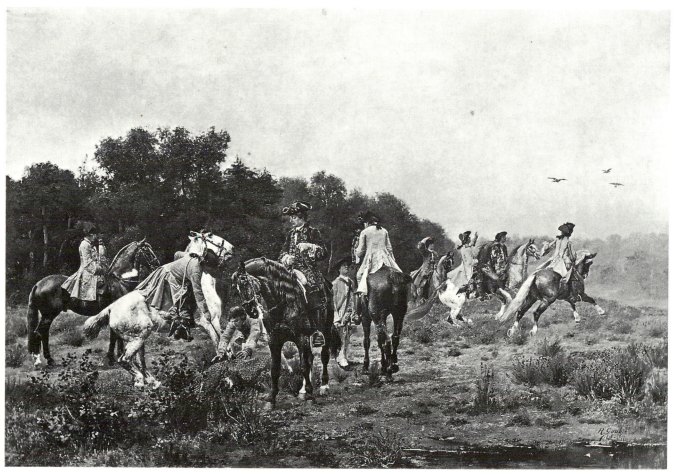

attention to its dramatization of the most crucial moment in falconry. The artist, it said, 'seizes the moment' when the falconer, who has been following his prey with his eye, 'stops his horse brusquely and flings the bird of prey'.[12] In particular, the hind legs of the horse in Lautrec's painting, and the turn of the falconer's head as he regards the bird perched on his outstretched arm, resemble the bronze by Lanceray. Lautrec's painting also closely recalls another statuette in the Exposition Universelle, the *Chasse au faucon* by Pierre-Jules Mène (1810–79),[13] an extremely popular sculptor of animal and sporting subjects. The influence of works like these, which Lautrec must have seen in 1878, reinforces the probability that he did his painting earlier than 1881.

René Princeteau was perhaps the strongest single influence on Lautrec's early career. He was a role model, teacher, and close family friend. Lautrec wrote about him in letters at the age of eleven; his drawings mingle with those of Lautrec in the family albums preserved at the Albi residence and museum, and the youth's copies are frequently indistinguishable from Princeteau's originals.[14] Princeteau's own memoirs testify to his closeness to Lautrec, and also to the young artist's diligence and his choice of subject-matter.

Many of Lautrec's drawings and paintings throughout his early period incorporate specific figures and poses found in works by Princeteau. For instance, Lautrec's drawing *Le Saut* (Fig. 12), echoes one of Princeteau's recurrent figures on a jumping horse. Princeteau's painting of c.1879–80, *Deux cavaliers de chasse à courre* (Fig. 13), or one similar, is the probable source of inspiration for two other works by Lautrec; he did an oil, and a watercolour, *Réunion de cavaliers de chasse à courre* (Fig. 14), which he signed 'after Princeteau', both of which paraphrase elements in his teacher's work. Lautrec seems to have borrowed a large number of poses and types from Princeteau, often, perhaps, by means of tracings. It was one of Princeteau's own techniques to maintain a repertoire of drawings that he could trace and transfer to his canvases, a practice confirmed by two letters of 1882 in which Lautrec requested his uncle to make a tracing from one of Princeteau's drawings in an album at the family's residence and send it to him at Céleyran, because Princeteau wanted it for a painting in progress.[15] Lautrec learned the same technique and may have utilized Princeteau's drawings as well as his own; the use of tracings would account for the fact that his paintings and drawings often repeat the same figures or contain mirror reversals of figures that also appear in Princeteau's paintings.

Moreover, Lautrec frequently worked alongside Princeteau, imitating his master's approach to entire compositions. In one example, Lautrec did a watercolour (Fig. 15) and Princeteau an oil-painting, both entitled *Deux chevaux effrayés par une locomotive*. Princeteau's biographer, Martrinchard, drawing on the artist's unpublished memoirs, related that while Princeteau and Lautrec were taking a carriage ride, they saw a train frighten two horses grazing near a railroad crossing. 'Toulouse made a charming sketch of the incident', wrote Martrinchard, 'and Princeteau the painting . . . transforming the plough horses into saddle horses.'[16] Princeteau did his painting in the later 1870s; Lautrec's must date from the same time.

[12] M. E. Bergerat, *Chefs d'œuvre d'art à l'Exposition Universelle* (Paris, 1878), 155–6. This work is the one referred to as 'A St. Petersbourg, Chasse à l'Heron', by E. A. Lanceray, no. 27 in the *catalogue officiel*.

[13] *Catalogue officiel*, no. 1347.

[14] H. Schimmel, no. 17, 14–15; Joyant, ii. 181.

[15] Joyant, i. 53–4, letters dated 2 Jan. 1882, 17 Jan. 1882. H. Schimmel, no. 69, 60 and no. 70, 61.

[16] R. Martrinchard, *Princeteau, 1843–1914* (Bordeaux, 1956), 32 ff.

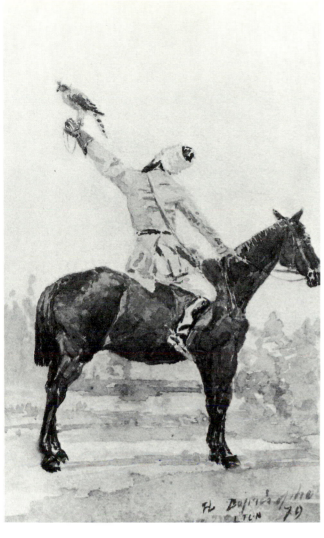

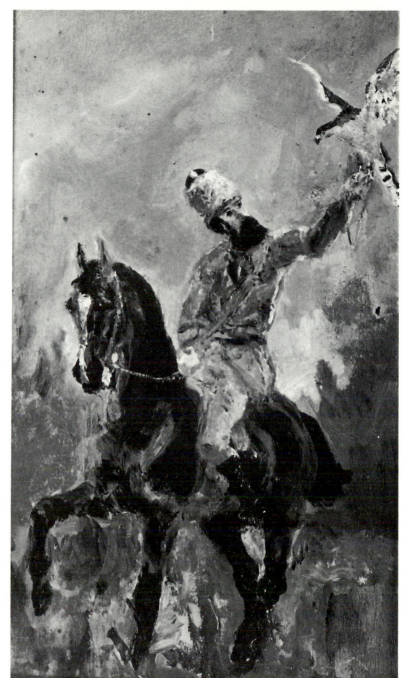

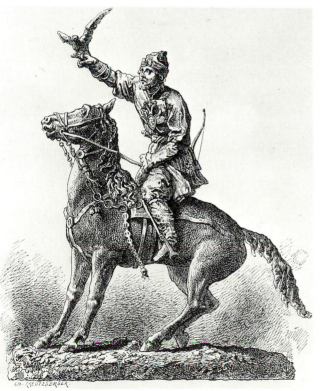

9. Above, left: Henri de Toulouse-Lautrec, *Le Fauconnier*. Watercolour. Richmond, Virginia, Virginia Museum of Fine Arts, collection of Mr and Mrs Paul Mellon.

10. Above, right: Henri de Toulouse-Lautrec, *Comte Alphonse de Toulouse-Lautrec en fauconnier*. Albi, Musée Toulouse-Lautrec.

11. Left: E. A. Lanceray, after, *Le Fauconnier d'Ivan le Terrible*. Engraving by C. Kreutzberger after the original bronze (from M. E. Bergerat, *Chefs d'œuvre d'art à l'Exposition Universelle* [Paris, 1878]). Paris, Bibliothèque Nationale. (Photo, Bibliothèque Nationale.)

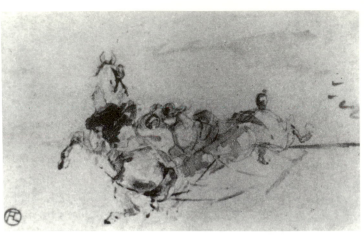

12. Henri de Toulouse-Lautrec, *Le Saut*. Pencil drawing. Private collection.

15. Henri de Toulouse-Lautrec, *Deux chevaux effrayés par une locomotive*. Watercolour. Private collection.

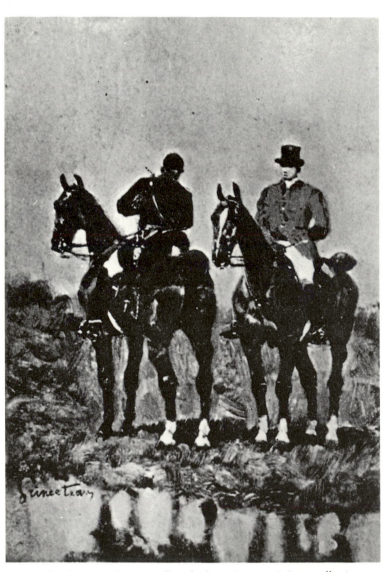

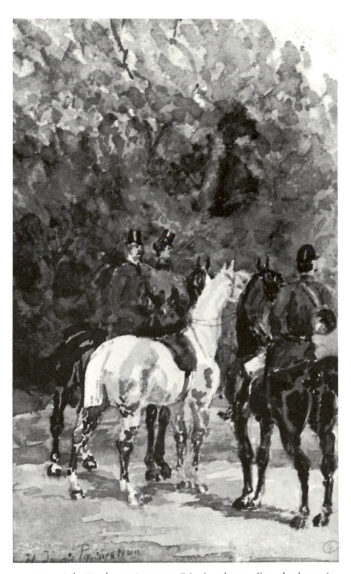

13. René Princeteau, *Deux cavaliers de chasse à courre*. Private collection.

14. Henri de Toulouse-Lautrec, *Réunion de cavaliers de chasse à courre*. Watercolour. Albi, Musée Toulouse-Lautrec.

The practically unknown reminiscences of Princeteau not only attest to the bond between himself and his pupil, but also shed valuable light on the chronology of a variety of Lautrec's early works. For example, Lautrec did a large series of early paintings and drawings, mostly undated, of military manœuvres near Bosc, the site of another family château. Joyant and Dortu place most of them in 1879–80, but Princeteau's account of events from 1878, Lautrec's fourteenth year, and early 1879 indicates that Lautrec made paintings and drawings of artillery soldiers on manœuvre at Bosc when he was on holiday there with his family during the summer of 1878.[17] The military gazette *L'Avenir militaire* confirms that extensive military manœuvres took place throughout the region of Bosc in August and September 1878, whereas none occurred near Bosc or Albi for at least three years thereafter.[18] Moreover, Lautrec's only dated painting of the series, *Les Hussards*, is inscribed 1878. Stylistically also, 1878 is indicated for the works of this series. On the basis of so much evidence, a considerable number of works heretofore attributed to a later time can be redated 1878.

Lautrec's placement of a prominent, relatively smoothly painted figure against a more freely brushed, abbreviated background in *Artilleur sellant son cheval* (Fig. 16), and other paintings of the series, further links his work to Princeteau. This technique, which Princeteau frequently and characteristically used, is evident in a number of Lautrec's earliest paintings.[19] Incidentally, Lautrec based the figure of the *artilleur* (one of the more proficiently drawn of the series) on a tracing, utilizing the method he had learned from Princeteau. On another occasion he used the same tracing for the figure of a hunter. In this series and elsewhere, Lautrec clearly combined direct observation with this more contrived approach.

Lautrec painted other military subjects as well in these early years, including a mounted *Cuirassier* copied from Princeteau. Military subject-matter was another genre popular in contemporary 'official' circles. It had become prevalent in the 1870s, following the Franco-Prussian War. This was a period of intense military reform aimed at increasing French preparedness in response to the losses of 1870. The manœuvres Lautrec depicted were part of the stepped-up field exercises and war games instituted in imitation of the German army in the mid- to late 1870s.[20] Lautrec also painted an early, undated equestrian portrait of his relative and fellow Albigensian General Raymond Séré de Rivières (Fig. 17), the most influential military planner of the era and the key figure in the restructuring of the French defensive fortifications system.[21] Here he may have imitated a painting of a mounted artilleryman exhibited at the Salon of 1877 by Édouard Detaille, one of the foremost practitioners of the military genre. Like the sporting painters, the specialists in military subjects dealt with events from modern life in a realistic style and in their nostalgia for a bygone heroism they too avoided dealing with contemporary social realities.[22] Like the sporting life, the military

[17] R. Martrinchard, *Princeteau*, 63–4. Princeteau mistakenly gave 1879 as the date for the entire period he described in this passage, but he actually recounts events from winter 1879, which Lautrec spent in Nice (see e.g. H. Schimmel, nos. 36, 27–8; 38, 29–30; 40, 31) and the previous summer, i.e. that of 1878.

[18] *L'Avenir militaire*, 1878–81. See esp. 'Programme officiel des manœuvres de 1878' (26 Aug. 1878), 2, which notes that the 16th Army Corps (i.e., that usually stationed in Aveyron and the Tarn, near Bosc) took part in the manœuvres that year and that the 31st Division was stationed around Albi.

[19] This tendency is also noted by Thomson, *Lautrec*, 7, and by N. E. Maurer in Stuckey, 53.

[20] A. Mitchell, *Victors and Vanquished: The German Influences on Army and Church in France after 1870* (Chapel Hill, N.C., 1984), 74, 79, 93.

[21] Ibid. 53–60 and *passim*.

[22] K. Varnedoe, 'Realism's Second String', *Art in America*, 69 (Sept. 1981), 141 n. 12.

remained attractive to Lautrec's class. The officer corps and particularly the cavalry, now on the verge of becoming obsolete, were among the last vestiges of aristocratic tradition and power.

A New Animation, Late 1879–1881

The changes which characterized Lautrec's style of 1880 and 1881 probably first appeared late in 1879. They signalled the definitive formation of his pre-academic style and ushered in a more confident and competent phase in his approach to his basic themes, which continued to be animal and sporting subjects. With his growing proficiency in drawing, a new degree of liveliness and movement began to replace the stiffness and uncertainty of his earlier efforts. His horses now were more likely to move than to stand still. In addition, he developed a more animated method of applying paint: short, staccato hatchings produced greater dash and a bravura sketchiness that activated the painted surfaces and reinforced the enlivened drawing. He abandoned his murky browns, greys, and greens, and lightened and brightened his palette. None the less, Lautrec remained uncertain in his attempts at modelling forms to achieve a convincing three-dimensionality.[23] The works that Lautrec himself dated during 1880 and 1881 present a homogeneous picture stylistically and thematically. Numerous paintings and an enormous number of related drawings correspond stylistically to the many known works of this period and can be dated 1880–1.[24]

The new animation appeared in only a few of Lautrec's works of 1879, probably only those done late in the year since most of his paintings of 1879 do not exhibit this quality. It is evident in the oil-painting of his father as a falconer, with its lively horse and the pastel pinks and blues of the sunset, and in the *Deux chevaux effrayés par une locomotive*, both of which may be tentatively attributed to later 1879. With *Charrette attelée*, which he inscribed 'November 79', Lautrec began a series of paintings of carriages drawn by galloping or trotting horses in which his style more effectively conveys the motion of the horses. This manner of working appears more fully developed in *Aux Courses de Chantilly* (Fig. 18), the only other oil-painting that Lautrec signed and dated in 1879. In a spontaneous manner, he was now applying paint in rapid dashes of colour from a somewhat lightened palette; and he continued to work principally in the same style throughout 1880 and 1881. It characterizes *Nice, sur la Promenade des Anglais*, the only significant oil-painting that he signed and dated in 1880; and it is especially easy to establish as his style of 1881 because he signed and dated twenty paintings and watercolours that year. They include *Mail-Coach, a Four-in-Hand* (Fig. 19), an early masterpiece with several related drawings.

Mail-Coach, and numerous early watercolours and drawings, take up coaching, a subject typical of the English sporting print (e.g. Fig. 20). Both Lautrec's and Princeteau's

23 R. Thomson, 'Henri de Toulouse-Lautrec, Drawings from 7 to 18 Years', in S. Paine (ed.), *Six Children Draw* (London, 1981), 46–7.

24 Many such undated paintings are already correctly placed by Joyant and Dortu. I have not dealt systematically with the drawings, because their number requires the attention of a *cata-*

logue raisonné. Other works that Joyant and Dortu have placed in these years and that do not fit into the same general picture, including academic drawings, landscape sketches, and peasant subjects, can be reattributed to later dates (see Ch. 2 and Appendix A).

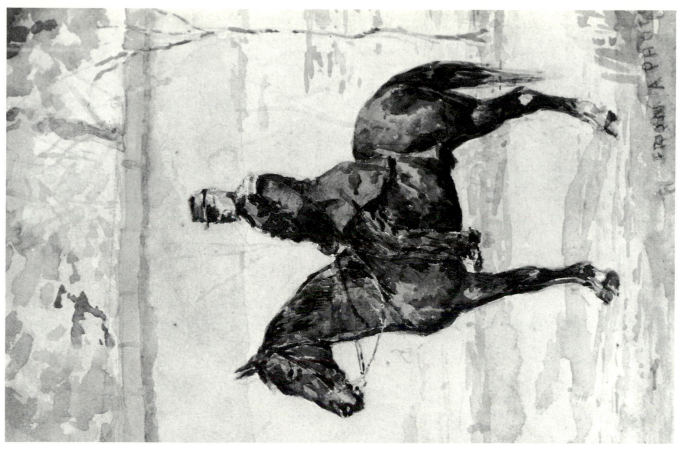

16. Henri de Toulouse-Lautrec, *Artilleur sellant son cheval*. Albi, Musée Toulouse-Lautrec.

17. Henri de Toulouse-Lautrec, *Le Général Séré de Rivières*. Watercolour. Private collection. (Photo, Phillips London.)

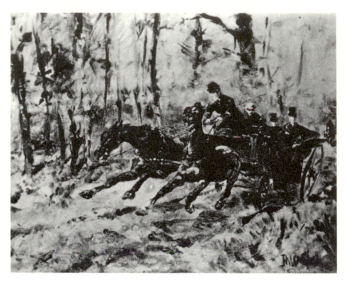

18. Henri de Toulouse-Lautrec, *Aux Courses de Chantilly*. Belgium, private collection.

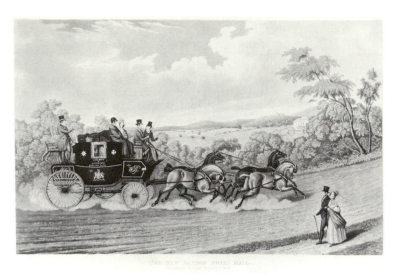

20. Charles Hunt, *The New London Royal Mail*. Coloured aquatint. New Haven, Connecticut, Yale Center for British Art, Paul Mellon Collection.

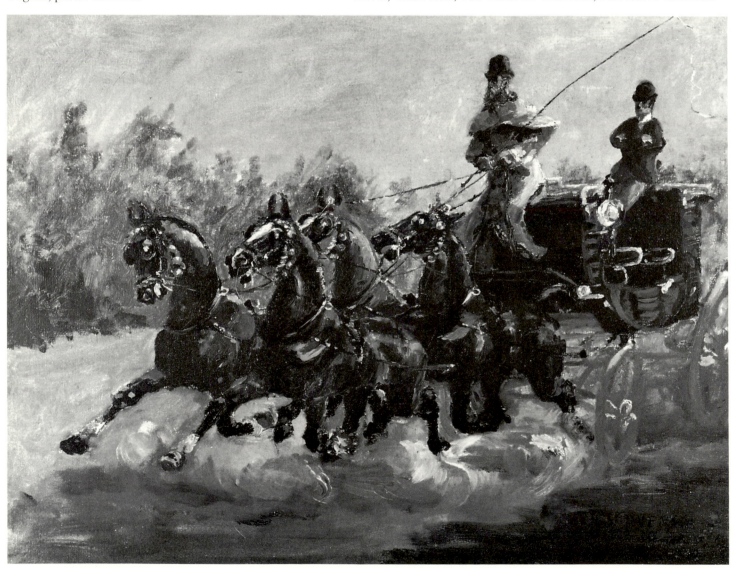

19. Henri de Toulouse-Lautrec, *Mail-Coach, a Four-in-Hand*. Paris, Musée du Petit Palais. (Cliché: Musées de la Ville de Paris © 1990 ARS New York/SPADEM.) *See also colour plate.*

representations of racing horses also recall English sporting prints. The popularity of these prints among the aristocratic French sporting set was a manifestation of their penchant for the English way of life, which amounted to almost a cult in nineteenth-century France.[25] These prints seem to have been adopted frequently by the French sporting painters as inspirations and models for their own work. It would be difficult to establish that English sporting prints directly influenced Lautrec at this time, but they were inherent in the general milieu in which he lived and studied, and the possibility is strong that his family owned such prints. Similarly, the work of Alfred Dedreux (1810–60), who was France's foremost painter of sporting subjects *à l'anglaise* from about 1830 until his death, must be considered a related influence. The circle of younger painters whom Lautrec admired were, in effect, Dedreux's lesser followers. The numerous lithographs made after his work would have been readily available to Lautrec. Many of Lautrec's depictions of *équipages* (carriages) and *amazones* (horsewomen) do in fact bear a close similarity to lithographs after Dedreux.[26]

Lautrec's letters from 1880 to 1882 document that he turned increasingly to Princeteau as his unofficial master. He had suffered his second leg fracture during the summer of 1879, and it was becoming apparent that he would be permanently disabled. Obliged to lead a sedentary life at the various health spas to which his family optimistically brought him, he experienced a growing commitment to painting as a career, not merely as a leisure-time avocation.[27] He studied with Princeteau in Paris during the spring of 1881, and his mother reported in her letters that Princeteau approved of Lautrec's work and that the young artist continued to copy his master's paintings.[28] It was at this time and perhaps in response to Princeteau's approval that he made formal his decision to undertake a career as a professional artist. In a letter to his Uncle Charles, in which Lautrec included a caricature of himself and Princeteau in the latter's studio, he jubilantly announced his plans:

When I think of the compliments that have been paid me I am as inflated as Gambetta in his balloon. Joking aside, I was really astonished. Princeteau raved, du Passage wept, and Papa understood nothing at all. We thought of everything, we even dreamed of Carolus-Duran. Finally, here is the plan that I think has the best chance. École des Beaux-Arts, Cabanel's atelier, and frequent visits to René's [Princeteau's] studio.

This letter, which Lautrec wrote in May 1881, reveals his delight at his prospects.[29] The unusually large number of works that he signed and dated in 1881 probably is attributable to his new self-consciousness as an aspiring artist—his new resolution to make painting his profession.

[25] J. Adhémar and D. Sutton, Musée Galleria, *Huit siècles de vie britannique à Paris* (Paris, 1948); and Adhémar and Reff, introd. to Goldschmidt and Schimmel, 11–12.

[26] Several such drawings by Lautrec are in the same album, now in the Chicago Art Institute. See C. O. Schniewind, *A Sketchbook by Toulouse-Lautrec* (New York, 1952) and Dortu, D1820–D1905.

[27] See e.g. a letter of Dec. 1880, in which Lautrec makes one of his earliest references to his painting, calling his palette his patron saint, in H. Schimmel, no. 54, 42–3.

[28] Attems, 181–4.

[29] Unpublished letter, Albi, collection of the Maison Natale de Toulouse-Lautrec; Dortu and Huisman, 31, publish a fragment of this letter, written from Paris and datable to spring 1881 because of the relation of the drawing on it to P130, dated 1881 by Lautrec, and because it mentions Princeteau's showing at the Salon that year. (NB Lautrec refers to the notorious departure in a balloon of the statesman Gambetta [1838–82] from the Butte Montmartre to join the provisional government in Bordeaux during the siege of Paris in 1870–1. He was also a man of large stature so a pun may be intended.) [H. Schimmel, no. 59, 49.]

Princeteau's intensified influence on Lautrec not only promoted his adeptness but must have enhanced his interest in depicting movement and orientated him towards the more abbreviated, sketchy style. Princeteau himself specialized in the horse in motion,[30] often executed in the rapidly brushed style that he undoubtedly taught to Lautrec. Many of Lautrec's works of *c.*1880–2 contain swiftly moving horses and riders that closely parallel those in works by Princeteau. For example, several drawings and a watercolour (Fig. 21) echo the far left-hand horse and rider in Princeteau's painting, *Le Saut de la rivière* (Fig. 22). Undoubtedly he was still borrowing from Princeteau's equestrian repertoire, but now seeking out the more animated examples. As his skills developed, however, Lautrec was able to emulate both his master's style and subject-matter effectively without copying. In most examples of the period, Princeteau's influence shows indirectly, simply in Lautrec's energetic depictions of movement and his rapid brush work.

A Minor Current, 1882–1883

Lautrec passed the baccalaureate in late November 1881, when he was just seventeen, and was free thereafter to pursue his chosen career as a professional artist and to embark on academic training.[31] During the winter of 1882 he was again studying with Princeteau in Paris, and, as his letter makes explicit, he wished to maintain his attachment to his first teacher even after embarking on his academic studies. One of the paintings of this period is *Deux chevaux menés en main*, which Lautrec inscribed 'January 1882'.[32] It attests to Princeteau's continuing influence on his work and to his own persistent interest in animal and sporting subjects. He dated at least two more paintings of such subjects 1882, and a number of others can be attributed to that year with some certainty. Lautrec pursued this interest at the same time that he was developing new ones during the first year or so of his early academic career, which began in April of 1882.[33]

Lautrec's letters from Paris in 1882 document his acquaintance with Princeteau's fashionable circle of artists, who both participated in and portrayed equestrian pleasures of the prestigious élite in the bois de Boulogne and at the racetrack. The most celebrated and successful painter among them was John-Lewis Brown, whose depictions of animal subjects in military, hunting, and sporting scenes were regularly shown at the Salon, and whom Lautrec notes in one letter that he 'finally met'.[34] Brown's themes and style would have reinforced the influence of Princeteau; by the mid-1870s he often practised a similar luminous, freely brushed, painterly technique.[35] Lautrec was continuing to explore such a sketchy, improvisatory style at the time he met Brown and to test new variations of it, if only in his paintings of sporting

[30] Martrinchard, 32.

[31] For the date of Lautrec's baccalaureate see H. Schimmel, no. 66, 55, and a letter written by Lautrec to Devismes and dated 22 Nov. 1881 in Joyant, i. 51–2. [H. Schimmel, no. 67, 55–6.]

[32] This inscription is reported by Joyant, i. 256, but not by Dortu.

[33] H. Schimmel, no. 73, 64, dated 17 Apr. 1882.

[34] Ibid., no. 72, 63–4. Brown, Princeteau, and du Passage, a sculptor member of this group, all had their studios in the same Paris building. On du Passage see no. 73, 64. Du Passage is also mentioned in the unpublished letter of spring 1881 in the collection of the Maison Natale de Toulouse-Lautrec. [H. Schimmel, no. 59, 49.]

[35] P. Schlommer, 'John-Lewis Brown', *Gazette des beaux-arts*, 3 (1930), 194–202.

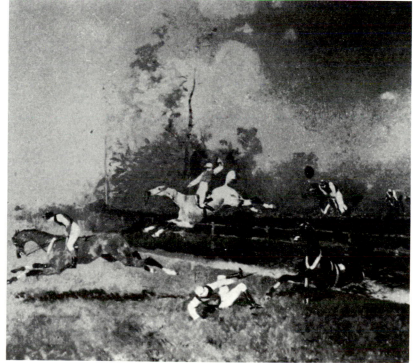

21. Above: Henri de Toulouse-Lautrec, *Chevaux au galop*. Watercolour. Albi, private collection.

22. Left: René Princeteau, *Le Saut de la rivière*. Libourne, Musée.

subjects. By 1883 animal subjects appeared much less frequently among Lautrec's works, although they remained a minor current within his total production. In the equestrian paintings dated or datable to this year Brown's influence seems quite pronounced. None of them is a direct copy but several are reminiscent of scenes of the hunt by Brown (e.g. Fig. 23). *Piqueur et bûcheron* (Fig. 24), exemplifies their style, still sketch-like with energetic brush work and abbreviated detail, but showing nevertheless the artist's increased interest in the forest landscape setting for his figures. All these works demonstrate Lautrec's greatly improved drawing and a new proficiency at integrating figures with their environments.

Lautrec's *Piqueur et bûcheron* provides an ironic, though perhaps unwitting, reminder of the pronounced social hierarchy of rural France and of the fact that the hunt itself reinforced the separateness and social supremacy of his own proprietary class. Here a woodcutter pauses at his travail to gaze up at a mounted hunter whose leisure pastime, horse, whip, and elegant attire are all signs of his wealth and power. Richard Holt has pointed out that hunting was 'a stately aristocratic progress through "their" forests, a visible reminder to the peasants of the superior status that even the detested democracy of the Republic could not expunge'.[36] Thus, the local peasantry often resented the intrusion of the hunt and radical Republican elements were hostile to it.[37] None the less, Lautrec approached his subject uncritically, without particular awareness of the contemporary social issues it provoked. His early paintings remain evocations of the pleasures of a fading, privileged way of life, with whose values Lautrec as yet identified.

Virtually all the evidence pertinent to Lautrec's work of this period points to an essential conservatism in terms of the fashionable, élitist genre of subject-matter that he chose, the sources that he imitated, and the manner in which he worked. Despite the impulse of critics to link Lautrec with Impressionism, it is clear that his real affinities lay with the more conservative and stylish contemporary painters of aristocratic sporting pursuits. Although these painters were quickly forgotten when their subjects lost favour and are little known today, nevertheless they enjoyed great professional success and the admiration and friendship of the upper classes in Lautrec's time. His early paintings most closely resembled those shown by such artists at the prestigious 'official' exhibitions. Moreover his early letters confirm his admiration for Princeteau, Brown, Carolus-Duran, and even for a strict academician such as Cabanel, the director of the annual Salon and a professor at the École des Beaux-Arts; on the other hand, the letters give no evidence that he went to the exhibitions of the Impressionists or had any interest in them.

Lautrec's style of this period—abbreviated in detail, sketch-like and unfinished in appearance, sometimes with a lightened palette—derived from the relatively conservative *juste milieu* trends toward which the aspiring young artist unmistakably gravitated. During the later 1870s and early 1880s Princeteau and Brown were producing and exhibiting luminous, freely brushed paintings characterized by lively crosshatchings; undoubtedly Lautrec picked up the technique from them. Conceivably Impressionism had influenced Princeteau and Brown to develop this style.[38] In fact many artists of the conservative middle ground were at the time

[36] Holt, 173. [37] Ibid. 36–7. [38] See Martrinchard, 80–1, on Princeteau's 'Impressionism'.

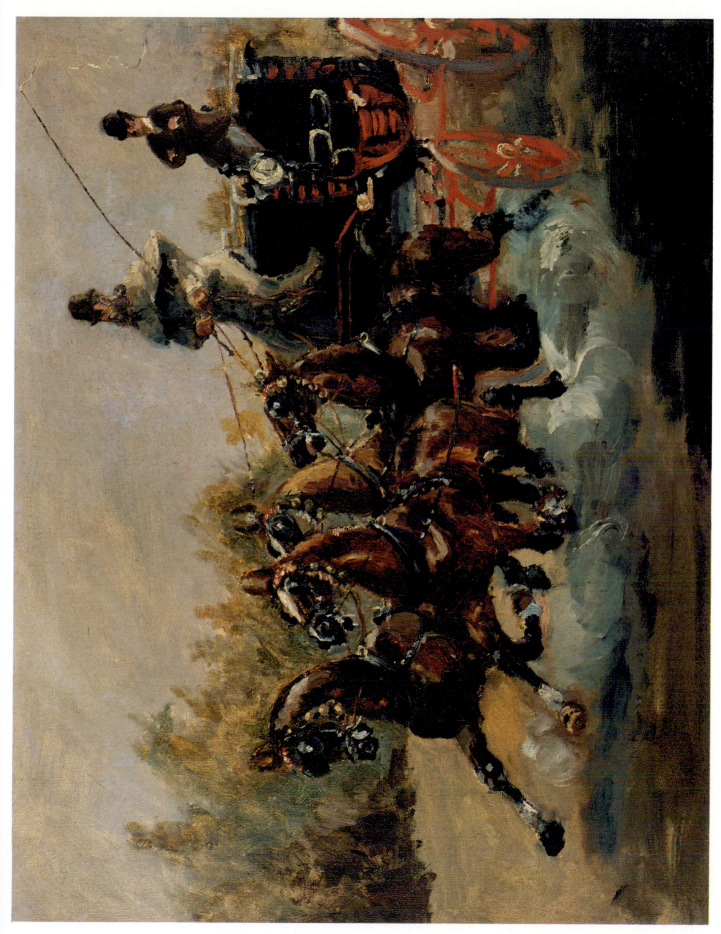

19. Henri de Toulouse-Lautrec, *Mail-Coach, a Four-in-Hand*. Paris, Musée du Petit Palais. (Cliché: Musées de la Ville de Paris © 1990 ARS/New York SPADEM).

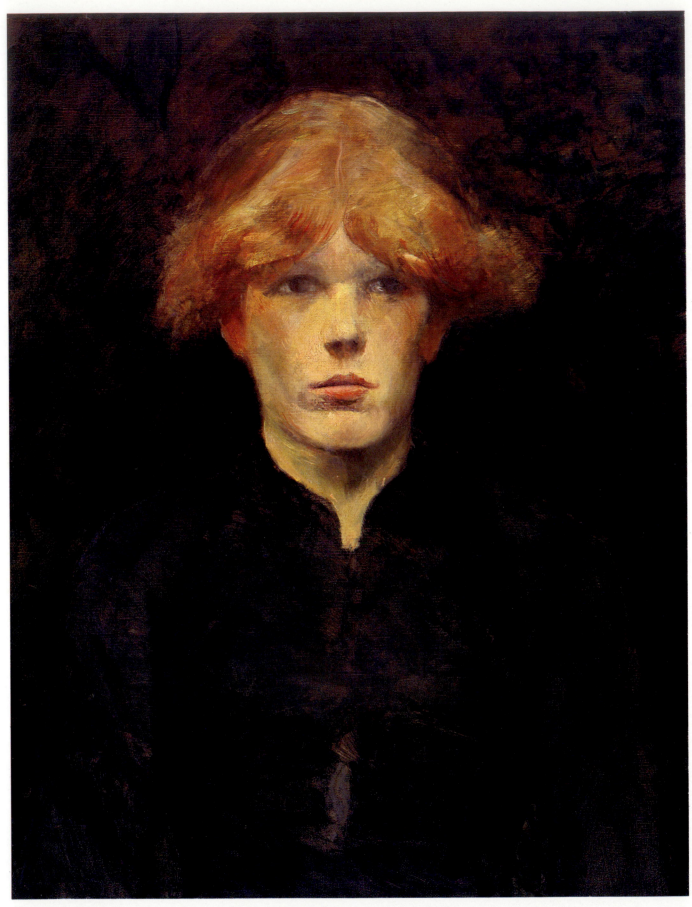

48. Henri de Toulouse-Lautrec, *Carmen*. Williamstown, Massachusetts, Sterling and Francine Clark Art Institute.

practising a diluted form of Impressionism, capturing some of its surface look, the brush stroke, and lighter palette, but rarely testing its more radical implications of compositional innovation, analysis of colour, and the rejection of conventional drawing and modelling in favour of a more extreme dissolution of form. By the end of the 1870s and early 1880s such paintings were acceptable in some official circles, notwithstanding a sketch-like, unfinished appearance. To the extent that Impressionism may have influenced Princeteau, Brown, and others like them, it can be said to have influenced Lautrec, but only indirectly, through them. Years later, according to François Gauzi, Lautrec repudiated these early works, stating disdainfully, 'In those days I was a "pompier", my work lacked colour.'[39]

Moreover, freer and more spontaneous works—initial transcriptions of experience that were commonly referred to as *esquisses* (sketches), *ébauches* (rough sketches), or *pochades* (hasty sketches)—constituted a preliminary step in conventional procedure.[40] The diluted Impressionism of Princeteau and Brown was, in effect, the adaptation of the freer style of their sketches to their formal, finished works. Both also worked in relatively more polished, highly detailed styles. It would be extremely difficult to determine whether or not Lautrec himself regarded some or all of his early paintings as studies rather than finished works, and which might have been which. Much later, speaking to Gauzi, Lautrec referred to his initial works as *traités en pochade* (executed in the manner of hasty sketches).[41] Princeteau also noted in his memoirs that Lautrec was copying his *ébauches* in the 1870s.[42] Possibly the youthful Lautrec had the desire but lacked the skills to emulate the meticulously detailed and tightly painted works of some of the artists he admired. Not having progressed beyond the *pochade*, he contented himself with imitating his masters' more freely painted works. Likewise, his simplification of detail and abbreviation of form, and his notation of rapid movement in the sporting paintings, as we have already seen, may be attributed to the influence of Princeteau rather than to an intuitive talent for the formal synthesis, decorative simplification, and abstract economy of means that Lautrec was to perfect much later in his career.

Certainly many of Lautrec's first paintings were the halting, unsophisticated efforts of a beginner. He was focused on a particular range of subject-matter and on learning how to represent it in a correctly realistic way. These early works do not yet convey a strong sense of self-consciousness on the artist's part about what formal means he should employ; nor do they indicate any large measure of control. In their awkwardness and roughness they reveal the struggles of a novice. Their imitative nature, both in subject-matter and style, demonstrates that the young Lautrec was keenly aware of one branch of contemporary art and sought to emulate it.

Having decided to become a professional artist, he wanted to overcome his limitations, to improve his skills. Especially, he wanted to master drawing, which Princeteau did not emphasize. Much later in the 1880s, in a conversation about his early sporting paintings, Lautrec told his friend Gauzi, 'It was quite easy for me to paint these little panels . . . but I was incapable of making a portrait. Princeteau advised me to learn to draw and to enter the

[39] F. Gauzi, *Lautrec et son temps* (Paris, 1954), 13. Gauzi (1861–1933) was Lautrec's friend and a fellow student at Cormon's atelier. He wrote his memoirs in 1933, although they were not published until later.

[40] A. Boime, *The Academy and French Painting in the Nineteenth Century* (New York, 1971), 9, 37–8.

[41] Gauzi, 12.

[42] Martrinchard, 63.

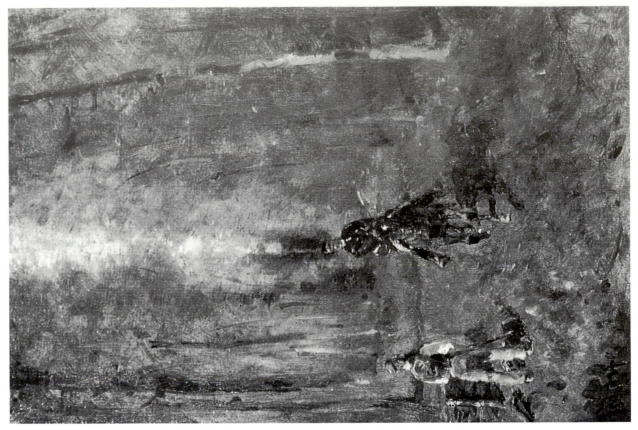

24. Henri de Toulouse-Lautrec, *Piqueur et bûcheron*. Private collection.

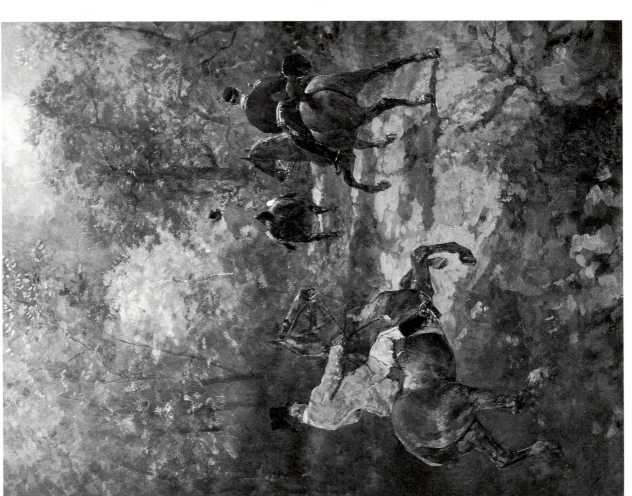

23. John-Lewis Brown, *A la chasse*. Gouache. Paris, S. A. Hermès Collection.

atelier of Bonnat.'[43] Lautrec did so enthusiastically. He wished to begin the appropriate training that would prepare him for the sort of successful career enjoyed by artists like Princeteau and Brown. The academic period did not represent the suppression of early tendencies towards originality in the young artist, but the prolongation and further development of quite conventional ones. It was not an aberrant interlude in Lautrec's evolution, but a continuation of his career along the same lines in which he had begun it.

[43] Gauzi, 14.

2

'It was necessary first to learn to draw'

Lautrec's Academic Career, Spring 1882–Early 1887

LAUTREC did not study, as he had planned, in the rigid environment of the École des Beaux-Arts. Instead he took the greater part of his training in the studio of Fernand Cormon, who ran an independent atelier with a slightly less structured but essentially conservative programme of instruction. The young artist went through the customary stages of academic training, which he took seriously, and did not yet have an anti-conservative point of view. Nor were the conservative influences that he accepted unyieldingly anti-progressive. Cormon himself was a moderate, receptive to the artistic currents of the fashionable *juste milieu* of the Third Republic; Lautrec continued to gravitate toward such trends, which reconciled the innovative with the conservative tendencies of the period. *Juste milieu* liberalism paved the way for his gradual entry into progressive circles in the later 1880s.

This hypothesis calls into question the long-standing consensus that Lautrec's study in the ateliers of Cormon and, earlier, Léon Bonnat was a period of minimal significance in his development, and of little interest. Critics have been practically unanimous in believing that Lautrec submitted reluctantly to academic instruction, rebelled against it from the start, abandoned academic tenets as soon as possible, and proceeded along his own route. Such interpretation characteristically holds that Lautrec's academic career perverted his natural tendencies, but, fortunately, temporarily and briefly. Standard literature has narrowed the period that he spent in academic study in the ateliers of Bonnat and Cormon to 1881–4, and compressed the majority of the works that clearly relate to it into the years 1881–3.[1] Critics have also, correspondingly, advanced the time of his first direct assimilation of Impressionism (as opposed to his 'instinctual' Impressionism) to dates ranging from 1881 to 1884. Lautrec's experience at Cormon's has mostly received critical attention in so far as it served to acquaint him early in his career with other future avant-garde artists, among them Émile Bernard, Louis Anquetin, and Vincent van Gogh, who in turn introduced him to Impressionism, the Japanese print, and the art of Degas.[2] One result of the de-emphasis of his academic training is that no full account of it exists so far.

Meagre documentation and the sparsity of dated works have also hindered investigation of Lautrec's academic period. Furthermore, his academically orientated art was only partially published until the appearance of Dortu's *œuvre* catalogue in 1971. A number of other informative sources were previously unpublished or unused, and these, along with the

[1] Joyant, ii. 6; ii. 183, 185; i. 258–9; and Dortu, *Lautrec et son œuvre*, i. 18, D2427–D2619 and *passim*.

[2] See e.g. Cooper, 23; Mack, 55–7; M. C. Visani, *Toulouse-Lautrec*, trans. D. Fort (Paris, 1970), 6–7; Sugana, 83; Perruchot, 78, 81–2; *Toulouse-Lautrec* (exh. cat., Museum of Modern Art, New York, 1956); and Jourdain in Jourdain and Adhémar, 107.

works themselves, are re-examined here. Lautrec's own letters contain valuable clues to his whereabouts, his friends, and his interests. This was also the only time in his life when he produced a body of writings specifically about art: his commentaries on the 'official' exhibitions.[3] Complementing these writings is one of the rare Lautrec works that can be construed as a critical commentary on other art, his *Parodie du 'Bois sacré' de Puvis de Chavannes* (Fig. 54). Finally, some little-known reminiscences by Lautrec's fellow students, François Gauzi, Henri Rachou, A. S. Hartrick, and Émile Bernard, shed light on the period, and they confirm one another.[4] Accounts of the academic teaching methods and curricula of the late nineteenth century serve as further guides for distributing Lautrec's works chronologically through his academic career and constructing a logical order among them.

The preponderance of evidence indicates first the persistence of conservative tendencies in Lautrec's work throughout the first half of the 1880s. Nor did he pass through an Impressionist phase as early as 1881–4. His direct exposure to Impressionism and his practice of it came at a later date. Second, his commitment to and involvement with his studies were far greater than has previously been believed, and his academic career continued much longer than is generally thought. Documentation shows that Lautrec began his academic studies in 1882 and pursued them into 1887. Not only did he continue to attend Cormon's atelier with great regularity in 1884 and beyond but he applied himself diligently to academic study, had a role as a student leader, took part in competitions, and, significantly, was Cormon's choice to collaborate with him in preparing illustrations for a de luxe edition of the work of Victor Hugo. Finally, as late as the second half of the 1880s, when he was gravitating toward new interests and the number of his academic works showed a relative decline, Lautrec pursued his academic lessons. He did not reject academic instruction so much as he simply graduated from it into other artistic preoccupations. His academic career therefore merits serious consideration as a formative influence. The interest and skill in draughtsmanship that he acquired during these years, and his knowledge of academic preparatory methods as well, ultimately had utmost importance in his mature orientation.

'Your drawing is simply atrocious': Bonnat's Atelier, Spring and Summer 1882

Lautrec himself, in correspondence with members of his family, established when he first met Léon Bonnat, late March 1882,[5] and the date of his entry into Bonnat's atelier less than a month later, 17 April. In a letter to his father on Monday, 17 April 1882, he described the mild hazing that he and another newcomer received on their first day:

I was taken in this morning by the students of the Bonnat studio. Thanks to the recommendation of Rachou, a friend of Ferréol, I had a good reception. By chance a young American from the hotel

[3] Published in Joyant, i. 62–74.

[4] Gauzi; H. Rachou as quoted in Dortu and Huisman, 44–5; A. S. Hartrick, *A Painter's Pilgrimage through Fifty Years* (Cambridge, 1939); and É. Bernard, 'Des relations d'Émile Bernard avec Toulouse-Lautrec', *Cahiers d'art documents*, 18 (Mar.

1952), 13–14 (unedited materials from Bernard's archives, collected by his son). See also É. Bernard, *Cahiers d'art documents*, vols. 16, 17, 21.

[5] Joyant, i. 56, letter dated 22 Mar. 1882. [H. Schimmel, no. 71, 61.] See also a letter by Lautrec's mother in Attems, 200.

went in with me. They had us talk and pay for a toddy. That's all there was to it. Not so terrible. They made enough racket, but not too much actual fighting. There are a lot of English and Americans.

So, there I am, one of the boys, absolutely.[6]

Lautrec's correspondence in the following months reveals that he spent perhaps two or three months with Bonnat during the spring and early summer of 1882, but no more than that. Later that summer he was at Bosc with his family,[7] and from there, in September, he wrote to his father that Bonnat was closing his studio (to accept a professorship at the École des Beaux-Arts) and had 'let all his pupils go'.[8]

When he entered the atelier of Bonnat, Lautrec relinquished painting as an aristocratic leisure pastime and embarked willingly and optimistically on the long, arduous preparation that nineteenth-century convention demanded of anyone seriously interested in a career as a professional artist. He also began to withdraw from the sporting and animal subjects of his mid-teens and, in the milieu of the atelier, to acquire the skills he would need in order to portray the human figure. Initially, perhaps, he intended to return to sporting subjects as a professional painter, but his academic training directed him to the figure and the portrait, and this was to become his permanent orientation.

From the evidence of his letters, Lautrec strongly preferred the conservative Realism of the acclaimed 'official' artists at the time he entered Bonnat's. After he had attended the current exhibitions in Paris in the spring of 1882, he wrote to his Uncle Charles not about the seventh Impressionist showing but the Salon, not about Manet's *Bar at the Folies Bergère* in the Salon, but the '*Portrait de Puvis de Chavannes*', by Bonnat, the *Fête du 14 juillet*, by Roll, the *Derniers moments de Maximilien*, by J.-P. Laurens'.[9] In another letter he enthusiastically described the official Salon des Aquarellistes as 'an exquisite exhibition', and singled out 'above all a head, with a natural grandeur, by Jacquet, of a woman from Béarn, and episodes from Tunisia, by Detaille, done from nature'.[10]

In Bonnat, Lautrec chose a basically conservative academician, who had reached the peak of his reputation as a portrait and history painter, and who would have appealed to these tastes. He painted with a dark palette in a Realist style under the strong influence of the seventeenth-century Spanish masters. According to one of his students of 1882, Bonnat's atelier was devoted to the 'purpose of studying nature as closely as possible',[11] and the artist had become notorious in 1876 for doing his *Crucifixion* (exhibited at the Salon) 'from a cadaver nailed to a cross and painted in bright sunshine on the roof of the École'.[12] By the 1880s, Realism no longer belonged exclusively to the artistic vanguard. The academics also followed many of its precepts, and the work of Bonnat exemplified the extent to which it had been incorporated into the conservative mode of the period.

Lautrec went to Bonnat's to learn to draw. Acceptance at the École des Beaux-Arts, to which he then aspired, presumed a knowledge of the principles of drawing, and students were admitted on the basis of entrance examinations, the *concours des places*, that tested their skills in drawing. Only advanced students could pass; therefore preparatory study, usually at a

[6] H. Schimmel, no. 73, 64. On the hazing at Cormon's, see Gauzi, 16–20, and Hartrick, 49.

[7] H. Schimmel, nos. 75, 76, 65–6, both postmarked 'Le Bosc' and datable with certainty to the summer of 1882.

[8] Ibid., no. 76, 66.

[9] Joyant, i. 58, letter dated 7 May 1882. [H. Schimmel, no. 74, 65.]

[10] Ibid. i. 57, letter dated 22 Mar. 1882. Lautrec refers here to Gustave Jean Jacquet (1846–1909), famous for his portraits of women in a rococo manner. [H. Schimmel, no. 71, 61.]

[11] B. Day, 'The Atelier Bonnat', *Magazine of Art*, 5 (1882), 138.

[12] G. M. Ackerman, 'Thomas Eakins and His Parisian Masters Gérôme and Bonnat', *Gazette des beaux-arts*, 73 (1968), 247–9.

private atelier, was virtually prerequisite to winning a place at the École. Once enrolled, the student became eligible to compete in the semestrial competitions (for which he might continue to prepare at the private atelier), and success in these was preliminary to competing for the coveted Prix-de-Rome, a scholarship awarded only to a few for study at the French Academy at Rome. It practically guaranteed a young artist's professional success and commanded such prestige that the entire academic course of study revolved around it.[13] This was Lautrec's chosen route; he intended to follow the standard academic curriculum: 'Again, my plans', he wrote in a letter of 22 March 1882. 'I'll probably get myself admitted as a student at the École des Beaux-Arts in order to participate in the competitions [there]; all the while remaining at Bonnat's.'[14]

Lautrec's letter to his father on 17 April 1882, his first day as a formal art student, attested to the emphasis on drawing at Bonnat's atelier: 'Draw, draw, that's the rub.'[15] On 7 May he wrote to his Uncle Charles that the master found his drawing poor, and that he had to begin again from scratch: 'You will perhaps be curious to know what sort of encouragement Bonnat gives me? He said, "Your painting isn't bad; it's chic, but after all that's not so awful, but your drawing is simply atrocious." And so one must summon up one's courage and begin again.'[16]

Art students traditionally began their training with drawing, whose most elementary stage consisted of making painstaking copies of *modèles de dessin*, engravings, or (less commonly) lithographs rendered with sharp lines especially for teaching purposes. In these early stages, students copied engravings of individual parts of the human body—eyes, ears, noses, hands, feet, limbs, torsos, which eventually they learned to compose into complete heads and figures—and probably in time they moved on to two-dimensional reproductions of older works of art, notably of the Renaissance masters. From this scrupulous copying of engravings, students progressed to drawing from plaster casts, and finally to drawn *académies*, studies of live models in standardized, 'academic' poses. Only with considerable mastery of drawing did they arrive at painting.[17]

Apparently Bonnat was a rigorous academic master (eventually the director of the École des Beaux-Arts) who almost certainly adhered to the usual sequence of teaching drawing and then painting, but, as a student advanced, the different aspects of studio training must have overlapped in his day-by-day practice. This pattern affords an important key to clarifying the nature of the works Lautrec did in the atelier of Bonnat. Undoubtedly he started with copying *modèles de dessin*, even though no examples survive in his presently known *œuvre*, and went through the customary early stages of drawing instruction. His first attempts must have been awkward—as he suggested in his letters—and he did not remain with Bonnat long enough to have learned anatomical structure very well. He is also unlikely to have progressed far in painting. Yet a few of his paintings datable to 1882 are undoubtedly products of his

[13] Boime, *The Academy and French Painting*, 23. At this time students could also take preliminary training at workshops at the École, which were 'run along the same lines as the private ateliers' by individual masters like Cabanel. The students could attend these workshops with the master's permission prior to official admission to the École. Cf. A. Boime, 'The Teaching Reforms of 1863 and the Origins of Modernism in France', *Art Quarterly*, NS 1 (Autumn 1977), 11–13. Evidently, Lautrec had originally hoped to get into Cabanel's workshop, but either had changed his mind or been rejected. And cf. E. Müntz, *Guide de l'École*

Nationale des Beaux-Arts (Paris, 1889), 8–9; a decree of 30 Sept. 1883 newly restricted the workshops to students officially admitted to the École.

[14] Joyant, i. 57. [H. Schimmel, no. 71, 61.]

[15] H. Schimmel, no. 73, 64.

[16] Joyant, i. 58. [H. Schimmel, no. 74, 65.]

[17] Boime, *The Academy and French Painting*, 24–41, 48; see also H. O. Avery, 'The Paris School of Fine Arts', *Scribner's Magazine*, 2 (Oct. 1887), 402, and N. Pevsner, *Academies of Art, Past and Present* (London, 1940), 92, 202.

25. Above: Henri de Toulouse-Lautrec, *Tête de femme*, copy of Leonardo's drawing of Leda at Windsor Castle. Pencil drawing. Albi, private collection.

26. Right: Henri de Toulouse-Lautrec, *Académie d'homme nu*, drawing of Michelangelo's *David*. Pencil. Paris, private collection.

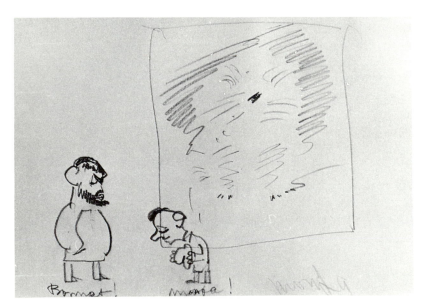

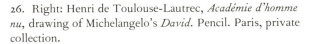

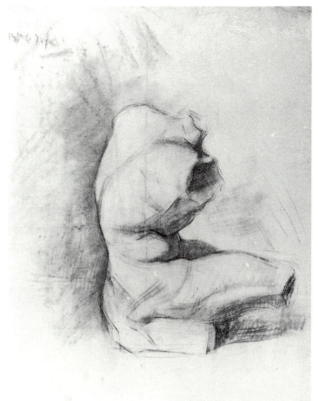

27. Above: Henri de Toulouse-Lautrec, *Bonnat! Monfa!* Pencil drawing. Albi, Musée Toulouse-Lautrec.

28. Right: Henri de Toulouse-Lautrec, *Académie: torse antique d'après un plâtre*, copy after a cast of the *Belvedere Torso*. Charcoal drawing. Albi, Musée Toulouse-Lautrec.

study in Bonnat's atelier; others that he may have done on his own nevertheless conform to atelier procedure. Although Lautrec's surviving *œuvre* from this period is fragmentary, a number of works classically reflect his progress through various stages of the typical academic curriculum.

A few examples survive of Lautrec's early copies after engravings and plaster casts of works by old masters, and they indicate a wide separation between the romantic stereotype of an artist independent of the past and the reality of an artist who learned his skills in the conventional steps. For example, Lautrec used two drawings by Leonardo da Vinci as models for a set of copies, and although they are undated they are entirely characteristic of what he would have done as a beginning pupil in 1882. One of them, a simple pencil drawing (Fig. 25), closely reproduces a drawing in the Windsor Castle collection that Leonardo is believed to have made as a preparatory study for the head of Leda in his *Leda and the Swan*. The Windsor drawing was, in fact, published in the *Gazette des beaux-arts* of March 1881 to illustrate an article about Leonardo. The article, which called attention to his studies of perspective, motion, geometry, and proportion, would have appealed to Lautrec's new academic interests. Another illustration accompanying the article bore the caption, 'Study of the proportions of the horse's head',[18] and it inspired Lautrec to make several drawings in which he applied his new studies to his favourite boyhood subject, the horse.

During the same period Lautrec made a slightly maladroit rendering of Michelangelo's *David* (Fig. 26). This pencil drawing has the appearance and feel of having been copied from a two-dimensional reproduction rather than a plaster cast. It lacks plasticity, and is set against a background of crosshatching, of the sort unusual in drawings from casts. The *David* belongs to a 'lot' of undated drawings, all apparently of the same period. Among them are several of the artist's early nude and anatomical studies which seem certainly connected with Lautrec's initial academic studies of 1882. Another drawing from the same 'lot' also supports this date. It is a caricature in which a timid, obeisant Lautrec bows before a scowling, intimidating, much larger Bonnat (Fig. 27). The artist's caption identifies the two characters: 'Bonnat! Monfa!' (Monfa was the Lautrec family name.) The drawing realizes in pictorial form Lautrec's description of his master in his letter of 7 May 1882: 'whose majesty prohibits any questioning'.[19]

Copying plaster casts introduced students to the great works of classical antiquity while it also helped teach them the *effet*, a concept of painting as well as drawing.[20] Among Lautrec's earliest renderings from plaster casts are a series of drawings (e.g. Fig. 28) and a painting of the *Belvedere Torso*, which coincidentally illustrate his advancement from drawing to painting in conformity with nineteenth-century academic practice. The drawings are awkward throughout (especially by contrast with the artist's later drawings from casts) and the painting has rather dark, muddied colours. Further evidence that places the *Belvedere Torso* series no later than 1882 is the signature on one of the drawings, 'Monfa', which Lautrec used consistently at this time, but rarely thereafter.

At all phases of drawing instruction students moved from the simple contour drawing, the *dessin au trait*, to the *dessin ombré*, the contour with the addition of modelling to achieve the *effet*, the realistic effect of light and dark values which creates the illusion of three-dimensionality. Shading by means of fine parallel lines, *hachures*, sometimes crosshatched to

[18] C. Ravaisson, 'Les Écrits du Léonard de Vinci', *Gazette des beaux-arts*, 23 (1881), 238, 236.
[19] Joyant, i. 58. [H. Schimmel, no. 74, 65.] [20] Boime, *The Academy and French Painting*, 27.

denote greater depth, was one of two drawing techniques students practised in order to represent the *effet*. The alternative was the use of an *estompe*, a 'stump' of rolled paper, to smudge charcoal or pencil lines into smooth shadows.[21] Lautrec's copies of the *Belvedere Torso* illustrate this advancement from contour to shaded drawings.

Among Lautrec's undated *dessins au trait* are also rudimentary attempts at the nude, frequently drawn with the aid of a plumb line; some can be found in the 'lot' of 1882 discussed above (e.g. Fig. 29). These are inexpert, beginner's attempts, awkward in their rendering of anatomy, and they should be classified as early academic studies. Several *dessins ombrés* shaded with *hachures*, or more often utilizing an *estompe* (e.g. Fig. 30), reprise these line drawings and serve explicitly to illustrate how a pupil beginning his studies advanced through the making of an academic drawing. Lautrec's *dessins ombrés* of the Bonnat period are his earliest true *académies*, and they are his weakest efforts (as might be expected), characterized by stilted and somewhat clumsy anatomy, foreshortening, and shading.

Lautrec obviously went through the conventional stages of training. A number of his surviving drawings from this period are of separate hands and feet. But his most proficient drawings were of heads, sketches no longer but painstaking, detailed studies that reflected his knowledge of the academic techniques of modelling, light and shade, and perspective. Bonnat, a specialist in portraiture, perhaps emphasized this aspect of training above others, because it was in portrait drawing, with crosshatching and often foreshortening, that Lautrec progressed most rapidly during the spring and summer of 1882. He himself dated a series of charcoal portrait drawings, modelled with contrasts of light and deep shadow, that demonstrate his new discipline and improving technical command (e.g. Fig. 31). He made many of them of close relatives, using various stages of academic preparatory drawing as he worked toward his final study, blocking out the heads with vertical and horizontal reference lines according to traditional practice. Since he must have done them while he was at home with his family, he obviously practised the lessons of Bonnat's atelier during his summer vacation.[22]

According to academic pedagogy, learning to paint, like learning to draw, went forward in formal stages. Students first copied heads from existing works of art, often old masters, then advanced to portrait studies of live models, and arrived at last at full-scale figure studies. Boime has explained that the initial paintings of heads were intended as preliminary studies of the type called *ébauches*, which technically might serve as underpaintings but could also stand as completed, 'self-sufficient' works 'charged with specific aims'. The *ébauche* employed a limited palette mostly of earth tones because of the solidity they gave to underpainting. It was a quick way of working that began with 'laying in roughly areas of light and dark' and 'the general compositional movement'. According to Boime, 'This stage of painting received the greatest attention and was continually emphasized during an artist's atelier training.'[23]

Most of Lautrec's dated and datable paintings of 1882 (other than those with sporting subjects) relate to the classic procedure of the *ébauche* and reveal the academic character of the training he received under Bonnat. The majority are head and portrait studies with an unfinished, sketchlike appearance, whose orthodoxy suggests they could have been made in Bonnat's studio (e.g. Fig. 32) or at least under the influence of his instruction. Probably these were his first tentative essays; certainly they lack the strong modelling of similar works that

[21] Boime, *The Academy and French Painting*, 24–36.

[22] He showed these drawings to Cormon when he entered the latter's atelier. See his letter of 1 Dec. 1882 in H. Schimmel, no. 80, 68–9, which specifically mentions D2659 and possibly D2634.

[23] Boime, *The Academy and French Painting*, 36–7.

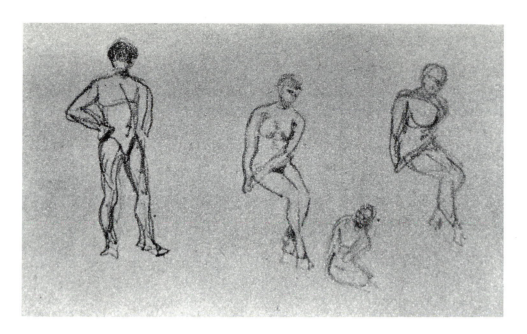

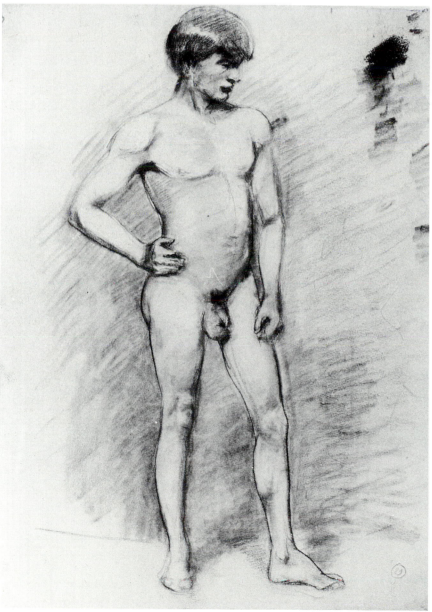

29. Above: Henri de Toulouse-Lautrec, *Personnages*, sheet of studies after nude models. Pencil drawing. Private collection.

30. Left: Henri de Toulouse-Lautrec, *Homme, main sur la hanche*. Pencil and charcoal drawing. Albi, Musée Toulouse-Lautrec.

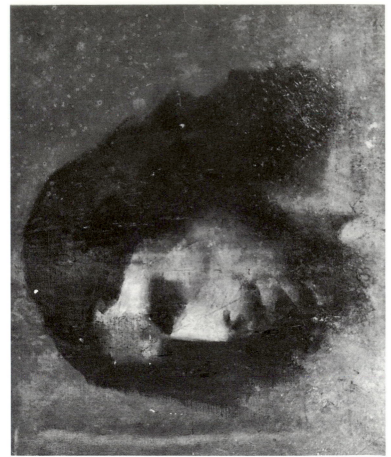

31. Henri de Toulouse-Lautrec, *Comtesse Raymond de Toulouse-Lautrec, née Imbert du Bosc.* Charcoal drawing. Ottawa, National Gallery of Canada, gift of Mrs Samuel Bronfman.

32. Henri de Toulouse-Lautrec, *Étude d'homme, tête.* Albi, Musée Toulouse-Lautrec.

can be attributed to the Cormon period, when the artist had acquired a more proficient technique.

Lautrec had not yet undertaken *ébauches* of full-length figures, but *Jeanne* (Fig. 33) and *Étude de jeune fille nue*, both half-length nudes, painted in subdued tones, with tentative modelling and an unfinished appearance, belong to the early phase of his training. Usually *Jeanne* is attributed to 1884 and, apparently because of their similar subject-matter and format, paired with a better-known work, *La Grosse Maria*, another undated, half-length nude (Fig. 58). The two studies, however, differ markedly in style and mood. The *Jeanne* is a sketch executed in the method of the *ébauche*, in which the artist outlined the figure and denoted the principal shadows with a thin 'sauce' of greenish browns and ochre. *La Grosse Maria* has more powerful drawing and modelling, its pastel-toned shadows reveal the influence of Impressionism, and it projects greater boldness and psychological impact. Whereas 1884 is too late a date for *Jeanne*, it probably is too early for *La Grosse Maria*. Two additional drawings of the 'lot' datable to 1882 relate directly to the *Jeanne* and serve to place it with Lautrec's works of the Bonnat period.

Lautrec did his paintings of this time in a dark palette consisting mainly of earth tones. They have a deep, Rembrandtesque quality, suggestive also of the seventeenth-century Spanish masters whom Bonnat admired, and of much of nineteenth-century Realism as well. *La Vieille des écrevisses* (Fig. 34), a head that can be assigned to 1882 by virtue of dated drawings that relate to it, may indeed have had a Rembrandt as its source. Princeteau owned such a Rembrandt, *Head of an Old Woman*,[24] and though its present whereabouts is unknown, the possibility that it inspired Lautrec seems strong because of the resemblance between his weatherbeaten old woman, portrayed in striking chiaroscuro with dark colours and heavily built-up layers of paint, and known Rembrandts with similar subject-matter. The *Vieille* could be a head study after an old master of the kind that Lautrec did under the tutelage of Bonnat, who would certainly have urged his pupils to study Rembrandt. Other undated portraits, mostly of family members, done in combination with the dated portrait drawings (described above) of Lautrec's summer vacation in 1882 utilize the same palette. In one of these, *Charles de Toulouse-Lautrec*, the pose could have had its inspiration in Bonnat's celebrated portrait of Victor Hugo, shown at the Salon of 1880. Undoubtedly Lautrec at this time was emulating his master's sombre style and in works done on his own was carrying out in more ambitious form the lessons he had learned in Bonnat's studio. He was a dutiful beginning student following the conventional academic procedures for learning to draw and paint.

'More benevolent' Corrections: Cormon's Atelier, Late November 1882–Autumn 1885

In the letter of September 1882 in which Lautrec announced the closing of Bonnat's atelier to his father, he also discussed the choice of a new teacher:

Before making up my mind I wanted to have the consensus of my friends and by unanimous agreement I have just accepted an easel in the atelier of *Cormon*, a young and celebrated painter, the one who

[24] Sugana, 95.

did the famous *Cain Fleeing with His Family* at the Luxembourg. A powerful, austere and original talent. Rachou sent a telegram to ask if I would agree to study there along with some of my friends, and I have accepted. Princeteau praised my choice. I would very much have liked to try Carolus, but this prince of colour produces only mediocre draughtsmen, which would be fatal for me.[25]

His letters of the autumn of 1882 indicate that Lautrec did not begin working at Cormon's until late November or early December.[26] And on 10 February 1883, in a letter to his Uncle Charles, he said he was 'just getting to know Cormon'.[27] At this atelier the atmosphere was less strict and the teaching possibly less forceful than at Bonnat's, but a conventional ambience prevailed nevertheless. Like Bonnat, Cormon groomed his pupils for the *concours des places* at the École and official acceptance at the Salons, and his programme of instruction stressed draughtsmanship, as Lautrec, Gauzi, Bernard, and van Gogh all attested. Van Gogh made it clear that this was his expectation in letters from Antwerp in which he stated his plan to spend a year at Cormon's drawing from plaster casts and the nude model.[28] Hartrick commented, 'No doubt he [Cormon] was particular about drawing, and especially construction, as a true Frenchman.' And his students regarded him highly for this trait.[29] He taught that the model should be represented exactly, and often limited his criticisms of student painting to comments on the draughtsmanship alone. 'In his corrections', Gauzi related, 'Cormon demanded that his students restrict themselves to the study of the model, that is to say that they ought to strictly copy that which they had before their eyes, without changing anything; and the students strictly followed the advice of the "boss".'[30] For teaching purposes his atelier held an eclectic array of props, which Bernard described: walls covered with copies after museum old masters and a variety of sketches, a corner crowded with armour, embroideries, rich fabrics, and a gold Buddha.[31] Here Cormon appeared once or twice a week to sit before each pupil and make corrections on his canvas, retouching the drawing and exclaiming: 'See it this way', or 'You ought to see such and such'. Some pupils he advised to become colourists and copy Veronese, others to draw by 'planes'. The most advanced he urged to 'brush, to envelop with shadow, to blend', but the less adept, to look attentively at drawings in the Louvre.[32]

In choosing his new master, Lautrec placed himself in the hands of a middle-of-the-road practitioner rather than a rigid academician. Cormon's own work was in the realm of history painting, but often of untraditional prehistoric subjects, and a contemporary observer, Stranahan, declared him to be in his day 'the most eminent illustrator of pre-historic man as figured by scientific investigation'.[33] This he combined with a relatively polished, mid-century style of Realism. But while he enjoyed great official success and was enormously popular with the Salon-going public, he had not experienced academic success: he had not won the Prix-de-Rome, nor did he at this time have any association with the Institut de France or teach at the École des Beaux-Arts.

[25] H. Schimmel, no. 76, 66–7.

[26] Ibid., no. 77, 67, which is dated, indicates that Lautrec was in Paris on 9 Oct. In no. 79, 68, of Nov. 1882, Lautrec states he had not yet 'talked to Cormon'. Letter no. 80, 68, 1 Dec. 1882, reveals that Lautrec had just begun to work at Cormon's. Finally, in no. 81, 69–70, of 28 Dec. 1882, Lautrec mentions being hard at work at Cormon's.

[27] Joyant, i. 60. [H. Schimmel, no. 82, 70.]

[28] V. van Gogh, *The Complete Letters of Vincent van Gogh*, 2nd edn., 3 vols. (Boston, 1978), ii. 486, letter no. 449; 480, no.

448. See also J. Rewald, *Post-Impressionism from van Gogh to Gauguin*, 3rd rev. edn. (New York, 1978), 20.

[29] Hartrick, 48.

[30] Gauzi, 28–30, 31.

[31] É. Bernard, 'Des relations avec Lautrec', 14.

[32] Id., 'Les Ateliers', *Mercure de France*, 13 (Feb. 1895), 201–2.

[33] C. H. Stranahan, *A History of French Painting from Its Earliest to Its Latest Practice* (New York, 1902), 327–8.

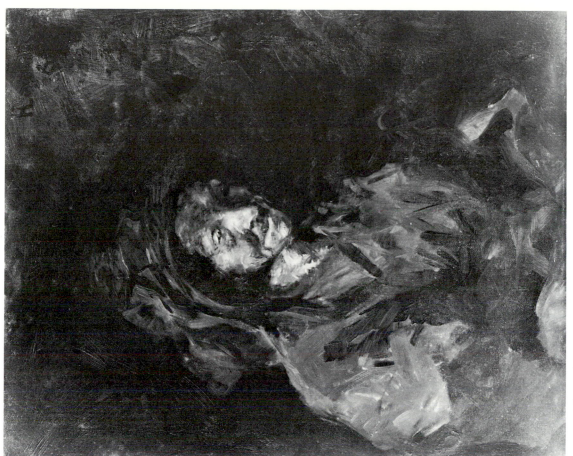

34. Henri de Toulouse-Lautrec, *La Vieille des écrevisses*. Albi, Musée Toulouse-Lautrec.

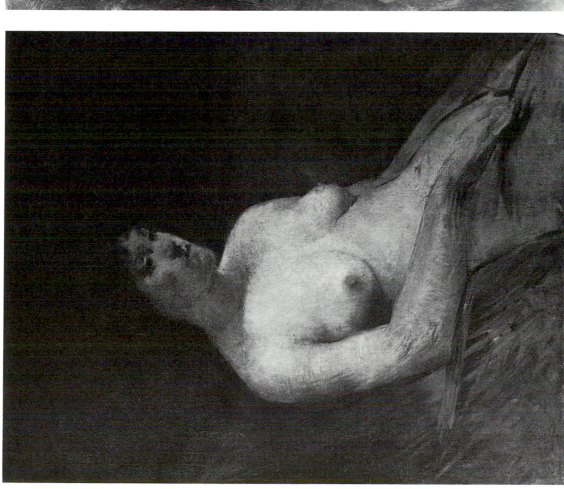

33. Henri de Toulouse-Lautrec, *Jeanne*. Otterlo, Rijksmuseum Kröller-Müller.

Cormon has often been classified as a reactionary, the polar opposite of his students. This is certainly a distortion, since he stood outside the normal academic framework, and at least tolerated innovation although he did not advocate it. A statement of his own seems to bear out his liberalism and receptiveness to change:

Nothing can remain stationary in this world. Everything changes and must change. A school [of art], therefore, cannot stand still. It must be subject to transformation if it is to endure; and, having regard to this fact, I consider it an excellent thing that each of us watches his neighbour, profits by his progress, seeks to correct his own weaknesses, and to assimilate what may advantageously be absorbed . . .[34]

Hartrick said of Cormon that despite his adherence to traditional pedagogy, 'He was an admirable teacher, more sympathetic to novelties than most of his kind', and also a constantly available one, willing to consult with his students even at home, 'where he would look at and criticize any work, even a sketchbook, that might be brought to him'.[35] Observing him once at the Salon along with other pupils of the atelier, Hartrick saw that Cormon was 'looking at everything with a solicitude that surprised us who, student-like, were dismissing most things there with a glance'.[36] He was 'nothing of a fossil', Hartrick added, 'but one of the most liberal minded teachers I have known'.[37] Another student of the 1880s, in his account, emphasized that Cormon did not seek 'to impose his particular views on art, his private way of seeing things, on his pupils'.[38]

In the beginning, Lautrec apparently regretted the separation from Bonnat and the strictness of his teaching. He wrote to his grandmother on 28 December 1822, wondering if he had lost ground by transferring to Cormon's.[39] In his letter of 10 February, several weeks later, he complained to his Uncle Charles:

Cormon's corrections are much more benevolent than those of Bonnat. He looks at everything one shows him and strongly encourages you. You'll be quite astonished, but I like that less! In effect the 'floggings' of my former boss got me going and I wasn't so self-indulgent. Here I am a little enervated and I lack the grit to conscientiously make a drawing that will impress Cormon no more than any other. For the past two weeks he has, however, reacted and reprimanded several students, including myself. Therefore, I have started to work again with enthusiasm.[40]

Cormon's more liberal and encouraging attitude probably contributed in part to the radical tendencies that eventually sprang up among a number of his students, including Lautrec, Anquetin, Bernard, and van Gogh. They do not appear to have crystallized, however, until at least three years after Lautrec entered the atelier, perhaps late in 1885, after the arrival of Bernard.[41]

From December 1882 until the autumn of 1885, Lautrec immersed himself in the conservative milieu, and he produced more and more proficient works of academic character. In this early stage of his study with Cormon, he laboured to gain technical skills that he anticipated using in the traditional ways: to excel in the École competitions, perhaps to win

[34] F. Cormon, 'A Word to Young English Painters', *Magazine of Art*, 16 (1893), 11.

[35] Hartrick, 48. See also Gauzi, 16–20.

[36] Hartrick, 49.

[37] Ibid. 92. See also Rewald, *Post-Impressionism*, 20, 22.

[38] R. H. Sherard, 'Louis Anquetin, Painter', *The Art Journal* (1899), 85–90.

[39] See H. Schimmel, no. 81, 69–70 n. 1, which refers to the unpublished letter in the collection of Mme Privat, Paris.

[40] Joyant, i. 60.

[41] Rewald, *Post-Impressionism*, 30. See also Hartrick, 42, and L. Anquetin, *De l'art*, annotated by C. Versini (Paris, 1970), 11–12.

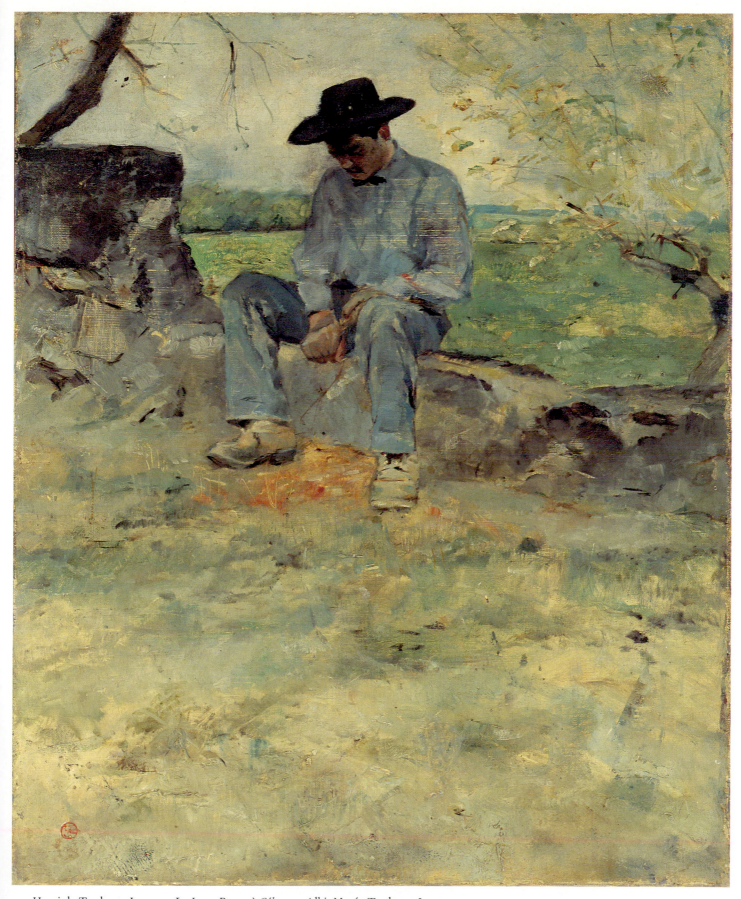

50. Henri de Toulouse-Lautrec, *Le Jeune Routy à Céleyran*. Albi, Musée Toulouse-Lautrec.

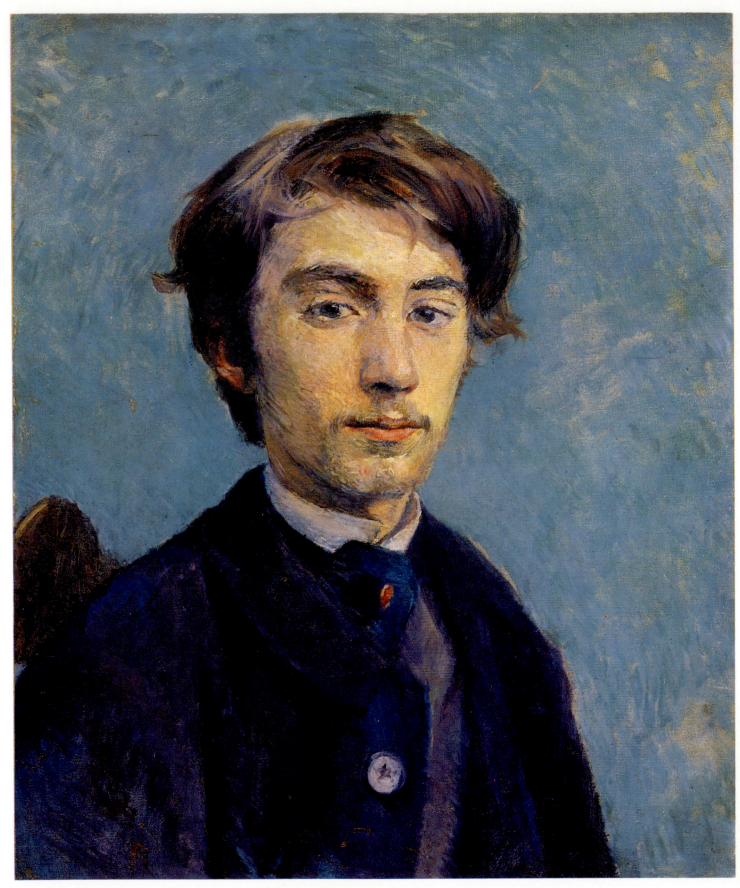

57. Henri de Toulouse-Lautrec, *Émile Bernard*. London, Tate Gallery. (Photo, Art Resource, New York.)

the Prix-de-Rome, and to find conventional success as a professional artist. In 1884, the year a disenchanted Lautrec supposedly left Cormon, his mother said in a letter, 'Henri works like a dog in Cormon's atelier.'[42] Like most French art students of the later nineteenth century, Lautrec customarily worked at the atelier of his master in the morning and independently in the afternoon. And sometime during 1884 he wrote to his mother: 'I keep jogging per usual. Studio in the morning with Rachou correcting, . . . Afternoons outdoors at Rachou's [in the little garden of Rachou's studio].'[43] In the spring of that year the atelier was endangered by a financial crisis. Lautrec, according to another letter of his mother, was designated 'one of the delegates to settle this serious question which puts his entire artistic future in suspense and he has good reason to take that seriously'.[44]

Lautrec did express some discouragement about this time. In a letter of June 1884, he referred to art that 'shunned' him, and announced that he would not enter the competition at the École des Beaux-Arts.[45] This must have been the *concours des places*, the examinations for admission; since Lautrec never matriculated at the École he could have entered no other competition there.[46] But in the autumn he wrote to his mother: 'We're in the competition up to our necks—there are so many people it's a nuisance.'[47] This might once again have been the *concours des places*, which occurred several times a year, and with his spirits buoyed, Lautrec may have decided to participate after all at a later date, though nowhere in his known correspondence did he mention explicitly that he had competed for a place at the École. Whether he chose not to take the entrance examinations or failed them remains conjecture.[48] In any case, he clearly continued to involve himself in academic study at Cormon's far into 1884.

Moreover, Lautrec's letters as well as those of his mother, and the first-hand accounts of his fellow students, also place him at the atelier well past 1884. In 1885 his artistic aspirations,

[42] Attems, 210. This undated letter can be dated 1884 with reference to no. 106 in H. Schimmel, 87–8, dated 'December 24' and recently redated 1884 by him. Both letters mention that Lautrec's mother is attending the lectures of Elme Caro at the Académie Française. In no. 106 Lautrec mentions his plan to move from his 'makeshift studio' to a larger place which he intended to furnish and, presumably, live in. This event took place in late 1884 or early 1885 and hence the letter should be redated to 1884. Lautrec lived in Paris with his friend Grenier from the spring to the autumn of 1884 since his mother was spending less time in Paris and more at her estate of Malromé (see nos. 91, 92, 93, 100, and 102), purchased in May 1883 (cf. H. Schimmel, no. 84, 73, n. 7, and Attems, 211–13). He was obliged to find his own place at the end of 1884 when Grenier moved (cf. a letter published by Attems, 206, which follows letter no. 93 and should be dated summer 1884). Two other letters of 1884 published in H. Schimmel show Lautrec's involvement in Cormon's atelier: see nos. 92, 78; 93, 78–9.

[43] H. Schimmel, no. 104, 86–7 (ed.'s clarification on 86 n. 1). (NB Often, in the absence of the master, correction was the job of an advanced student.) See also no. 80, 68–9, and Rachou as quoted by Dortu and Huisman, 44. Boime, *The Academy and French Painting*, 42 and *passim*, indicates that it was standard atelier practice for students to work on their own. None the less, Joyant, i. 75–6, misinterpreted a letter, which he attributed to July of 1884, in which Lautrec mentioned that he was working

'chez moi' as an indication that Lautrec had ceased to attend sessions at Cormon's atelier. Using this letter in conjunction with Lautrec's move away from home to Grenier's, Joyant developed the idea that Lautrec was rebelling against academic teaching and his family alike by the summer of 1884. (NB Joyant also erred in his dating of the letter. H. Schimmel, no. 110, 91, has since placed it more accurately in the winter of 1885.)

[44] Attems, 210. This undated letter can be dated spring 1884, with reference to nos. 92 and 93 in H. Schimmel, 78–9, which mention the same events.

[45] See H. Schimmel, no. 627, 376, which refers to this unpublished, dated letter in the collection of Mme Privat, Paris.

[46] Lautrec's name does not appear on any of the lists of students registered at the École in the 1880s. Archives Nationales, École Nationale des Beaux-Arts, *Registre d'inscription 1871–1894* (AJ52236); *Registre d'inscription dans les ateliers de peintre* (AJ52248); and *Inscriptions* (listes annuelles des élèves), 1863–87 (AJ52464). On the competitions held at the École des Beaux-Arts and at the private ateliers, see Boime, *The Academy and French Painting*, 22, 23, and *passim*; and Avery, 402–3.

[47] H. Schimmel, no. 103, 85–6.

[48] The only record of the exams for this period describes them, but does not list those who took them. Archives Nationales, École Nationale des Beaux-Arts, *Concours d'admissions, 1875–90* (AJ5259). Possibly Lautrec took the exams in the autumn of 1884 and failed them.

as he disclosed them in letters to his mother, remained quite conventional. 'I've been advised to start something for the Salon', he wrote in January. 'I am waiting for Cormon to speak to me about it himself, but I'm not going to start anything for fear of getting slapped down.'[49] From Paris in March, he reported: 'Just about everybody is making an energetic effort for the Salon.'[50] The period of later 1885–6 and probably the early months of 1887, however, constitute a somewhat separate phase; though he remained at the atelier, his strictly academic works became fewer in number and his more radical, experimental ones increasingly numerous.

Académies *and Painted Sketches*

A master like Cormon, who emphasized draughtsmanship as the essential basis of painting, undoubtedly adhered to the practice of requiring students to master drawing 'before taking up a brush'. In all likelihood, Lautrec devoted a large part of 1883, his first full year at Cormon's, to meticulous drawing. That he felt he lost ground in changing masters possibly indicates that for a time Cormon restricted him to drawing. This might be inferred from the postscript to his letter of 10 February 1883, in which he admonished his Uncle Charles, an amateur artist: 'Don't you give up painting at least!'[51] Of the few drawings dated or definitely datable to 1883, the majority are *académies* such as Lautrec would have done at the atelier. These, however, are exceptional examples; he dated no *académies* thereafter and no drawings at all in 1884 or 1885. Lautrec continued to draw from plaster casts and the nude model throughout his academic career, and produced nearly two hundred drawn *académies* to which dates cannot be assigned. Such works, conforming to set principles in their purpose and execution, are virtually impossible to place in successive stylistic phases. Having achieved a relative mastery of drawing the figure in his first phase at Cormon's, Lautrec did not develop or change significantly enough thereafter to make his earlier *académies* clearly distinguishable from the later ones.

In the context of the present study, therefore, the drawn *académies* of the Cormon period have been categorically regarded as the work of the entire period and simply dated 1883–7. On the other hand, this study distinguishes between the drawn *académies* from the long period of study with Cormon and those Lautrec did as a beginner during his few months under Bonnat. The Cormon *académies* form a stylistically coherent body of work displaying a proficiency in drawing far superior to the young artist's earlier clumsy attempts at Bonnat's. Scores of drawings of nude models, often in poses imitated from antique statuary, amply demonstrate Lautrec's improved mastery of anatomical construction and modelling, and of perspective and foreshortening.

Linear clarity and minimal shading characterize most of the drawn *académies* that Lautrec did at Cormon's. He emphasized contour at the expense of modelling. What concerned him most immediately, perhaps, was capturing the figure's 'line of action', the basic, continuous flow of movement, around which the artist conventionally organized and harmonized the abstract patterns of the human form. An *académie* of a man walking (Fig. 35), affords an example. Lautrec established the primary line of action in an elongated, diagonal 'S' from the head to the left heel of the figure, and counterbalanced it with an opposing diagonal from the

49 H. Schimmel, no. 105, 87. 50 Ibid., no. 111, 91–2. 51 Joyant, i. 62. [H. Schimmel, no. 82, 71.]

left shoulder to the right foot. Around these dominant movements, he composed the forms of the body in a series of intersecting, approximately cylindrical shapes whose curvilinear rhythms reinforce the thrust of the main line of action. Throughout his drawn *académies*, Lautrec's dominant interest was the design of the figure as a whole, but perfecting and idealizing the features and form of the model were outside his concern. The absence of idealization reflected not only the teaching of Cormon (and of Bonnat), but the direction that academic instruction in life drawing had taken in general during the course of the nineteenth century: it favoured actuality, that is, strict copying of the model, while stressing the total design of the figure and the singular character of model and pose through the simplification of line and mass. Its thrust, in effect, was to reconcile the real with the abstract; and in Lautrec's case it may well have contributed to the exaggerated, even caricatural style of his maturity, in which he was to abstract and simplify faces and figures (though to a much greater degree) in order to convey their essential reality more acutely.[52]

Lautrec demonstrated the technical mastery that he gained under Cormon not only in his drawings from live models but also in those he made from casts of antique and Renaissance sculpture. Some of these drawings can be dated to the Cormon period with particular assurance because van Gogh copied the same casts repeatedly while he studied at Cormon's; probably they belonged to the motley collection of props at the atelier, several of which are recognizable in a photograph of Cormon's pupils taken there about 1886 (Fig. 56). Lautrec's drawings from two fragmentary antique female torsos of Aphrodite (e.g. Fig. 36) have counterparts in works, painted as well as drawn, that van Gogh did at the atelier in 1886.[53] Lautrec made numerous drawings from a cast of Pollaiuolo's *Bust of a Warrior* (e.g. Fig. 37) and van Gogh copied it at least once.[54] Lautrec did other drawings of comparable subjects, among them one of a cast of the reclining figure of Ilyssos from the west pediment of the Parthenon and one of a fragment of an antique head.

During the years 1883–5, Lautrec dated only two paintings, both 1883, both equestrian subjects that had no relation to his academic study. By 1884, at least, he must have advanced to making painted *ébauches* of the full figure although his most accomplished painted *académies* must belong to a slightly later date. Five studies of live models (e.g. Fig. 38), one of a plaster cast, and one of a head, all of them freely executed, are attributable to late 1883 or 1884 and exemplify the execution of the *ébauche*. This early stage of instruction in painting was technically the initial, underlying phase of putting a finished work on canvas. Its purpose in the atelier was to teach students how to capture the *effet* in colours before they went on to

[52] A. Boime, 'Curriculum Vitae: The Course of Life in the Nineteenth Century', in *Strictly Academic, Life Drawing in the Nineteenth Century* (exh. cat., University Art Gallery, State University of New York, Binghamton, 1974), 9–13, has described the importance of the 'line of action' and suggested the possibility of the influence of 'the academic emphasis on abstraction in the life drawing process' on the evolution of modernism. See also Boime, 'American Culture and the Revival of the French Academic Tradition', *Arts Magazine*, 56 (May 1982), 99, and Day, 139, who notes that Bonnat stressed the unidealized copying of the model combined with getting the study of 'form right as a whole'.

[53] J.-B. de la Faille, *The Works of Vincent van Gogh*, rev. and annotated by A. M. Hammacher (Amsterdam, 1970), F1363g, F1363f recto, F1363e, F1366 verso, SD1709 verso all reproduce a cast of Aphrodite removing her sandal; F216a, F216b, F216g, F216h, F216i, F216j, F1363a verso, F1363b, F1693h, F1693i, SD1707, SD1708 recto and verso, SD1709 recto, SD1711 verso, SD1713 recto reproduce the cast of a torso of Aphrodite or a Venus Anadyomene type. De la Faille places SD1693h and SD1693i in Antwerp, 1886. They more probably belong in van Gogh's Paris period, together with the other drawings of this cast.

[54] De la Faille, SD1701 recto.

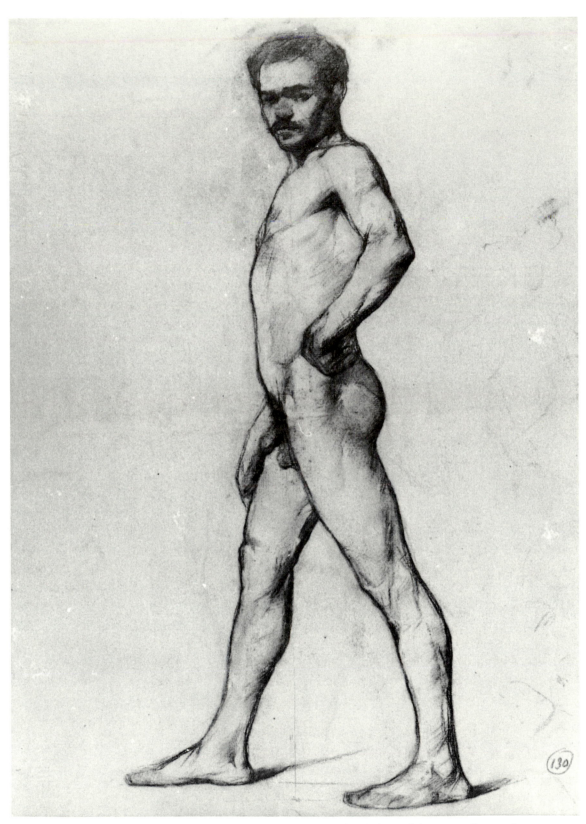

35. Henri de Toulouse-Lautrec, *Académie d'homme marchant*. Pencil and charcoal drawing. Albi, Musée Toulouse-Lautrec.

produce more polished studies. The artist began the *ébauche* from a faint charcoal sketch that he traced over with diluted red ochre, the 'sauce'. He then roughed in the darkest areas of his picture with thin, transparent pigments and followed this with the lightest tones in opaque colours. These he applied thickly with free, spontaneous strokes, minimizing detail and at the same time indicating the tone of the background. In the next step he connected the areas of extreme dark and light with a series of *demi-teintes*, or middle tones, laying them down from lightest to darkest in a patchwork or mosaic of colours juxtaposed to preserve their purity. To finish the *ébauche*, he blended the edges of these discrete patches with light touches of paint of the same tones. Students in the ateliers 'rarely went beyond the *ébauche* stage', according to Boime. Models changed from week to week, and students did not have time to refine their painted *académies*. Preparation had more importance than finished painting, and 'For this reason the nude studies that we associate with the ateliers are often unfinished and show many rapidly executed areas.'[55] This procedure accounts for the partially brushed-in backgrounds and the spontaneity of Lautrec's painted *académies* of the period. Often he worked directly on tracing paper (e.g. Fig. 38), which he must have placed over his preparatory charcoal drawings (Fig. 39)—a method that Gauzi was to observe him using as late as autumn 1885 to 1887. Lautrec's conventional training in the atelier, not the influence of Impressionism, explains the free style of these early, painted, full-figure *académies*. Together with their preparatory drawings, they show how closely the artist adhered to orthodox academic methods.

From study of the nude figure, students progressed to the study of composition in the form of the painted sketch, the *esquisse peinte*, which belonged in the intermediate period of training in the atelier. The sketch was distinct from the *ébauche* in its intent. It was a complete though freely executed work, almost always small, which might serve as a preliminary study for a larger painting. The *esquisse peinte* projected a more fleeting, transitory view than did a conventional finished painting. It was to convey the impression of a picture still developing in the mind and imagination of the artist and to 'foreshadow its composition, effect and colouring'.[56] The painter concerned himself not with details, which might actually be 'injurious to the general effect', but with 'simple dispositions of light and dark areas', with 'dominant movements and directions', and with 'the ensemble' as a whole. It was a crucial part of the instructional programme. At both the École des Beaux-Arts and the private ateliers, all students took part in regular competitions in compositional sketching.[57]

Lautrec probably reached the level of the *esquisse peinte* in late 1884 or early 1885 and continued to produce such work throughout most of 1885. A number of his works, undated and loosely and summarily painted, fit this category. In style and appearance they conform with the practice of the *esquisse peinte* and its feeling of 'the work in process of gestation in the artist's mind'.[58] The subject-matter of these works also helps to place them. They are very much in the spirit of Cormon, romantic treatments of early human history, though not exclusively classical history. Cormon was renowned for scenes from primitive history such as *Retour d'un chasse à l'ours à l'Age de la Pierre*, *Funérailles d'une chef à l'Age du Fer*, and,

[55] Boime, *The Academy and French Painting*, 37–41.

[56] Ibid. 46, quoting from *Dictionnaire de l'Académie des Beaux-Arts* (Paris, 1858 *et seq.*), article on 'Esquisse', v. 305–6.

[57] Ibid. 45–6.

[58] Ibid. 46. See n. 56.

most famous of all, *Cain fuyant avec sa famille*, a painting inspired by verses from Victor Hugo's poem, 'La Conscience', part of *La Légende des siècles*. Lautrec embraced similar themes in his compositional sketches: *Peuplade primitive* (Fig. 40), for which a full-scale preparatory drawing is preserved, *Scène mérovingienne*, and *Le Printemps de la vie*, the last a mythological subject representing Bacchus and Ariadne in their tiger-drawn chariot, accompanied by satyrs. In *La Légende des siècles*, Hugo undertook an epic history of humanity, and Lautrec's paintings of this group, in their dramatic and violent subjects, carry out the spirit if not the letter of the ambitious *Légende*. It may indeed have inspired them, since they generally coincide with Cormon's project to illustrate portions of the Hugo.

One painting in particular, usually entitled *Esquisse allégorique* (Fig. 41), clearly illustrates the climax of the poem, 'L'Aigle du casque', from the segment of *La Légende* called *Avertissements et châtiments*. In the painting, an enormous bird is attacking two apparently struggling figures. The poem relates a medieval tragedy that begins when Jacques, an adolescent boy, challenges Tiphaine, a ferocious knight. But at the moment of encounter, Jacques flees in terror. Tiphaine pursues him relentlessly and kills him despite his pleas for mercy and his disadvantage in strength and experience. At the moment of his victory, however, Tiphaine suffers the punishment of divine justice. The eagle on his helmet comes to life and deals him a gruesome fate:

> Il se mit à frapper à coups de bec Tiphaine;
> Il lui creva les yeux; il lui broya les dents;
> Il lui pétrit le crâne en ses ongles ardents
> Sous l'armet d'où le sang sortait comme d'un crible,
> Le jeta mort à terre, et s'envola terrible.

> [He began to strike Tiphaine with his beak;
> He put out his eyes; he smashed his teeth;
> He kneaded his skull in his fiery talons
> Under the helmet from which the blood flowed as from a sieve.
> He threw him dead to the ground, and took terrible flight.[59]

Joyant concluded that Lautrec left these works in a state of sketchiness because he was 'discontinuing' such subjects.[60] In reality their appearance was entirely in keeping with the technique of the *esquisse peinte* as the ateliers taught it. The sketches and *ébauches* show that along with his concentration on drawing under Cormon, Lautrec also received conventional instruction in painting.

The Victor Hugo Project

In the spring of 1884 something occurred that not only refutes the conception of Lautrec as a rebellious student about to break away from his master's atelier, but also establishes that he must have been a favourite there. Cormon selected Lautrec and Rachou to join him in the

[59] V. Hugo, Édition Nationale, *Poésie*, viii (Book 2 of *La Légende des siècles*) (Paris, É. Testard, 1886), 201.
[60] Joyant, ii. 6.

36. Henri de Toulouse-Lautrec, *Torse*, copy of a cast of a torso of Aphrodite. Pencil and charcoal drawing. Albi, Musée Toulouse-Lautrec.

37. Henri de Toulouse-Lautrec, *Buste d'après un plâtre*, copy of a cast of Pollaiuolo's *Bust of a Warrior* in the Bargello. Pencil and charcoal drawing. Albi, Musée Toulouse-Lautrec.

preparation of illustrations for a luxurious commemorative edition of the works of Victor Hugo. Lautrec's mother made it explicit that the choice was indeed an honour in a letter of 14 June 1884:

Henri has definitely been chosen from all of Cormon's atelier to work alongside of the best and the most grand, on a prime edition of the works of Victor Hugo. . . . The first 500 francs (!!!) earned by your grandson seem to me to be particularly glorious, proving to me that he is not the smallest in all the atelier 'in every respect'. . . . They are predicting now for Henri an unbelievably glorious future.[61]

It was exceptional for Lautrec to spend the summer in Paris, but apparently he did so in 1884 in order to complete his illustrations for the Victor Hugo edition. In late summer, or early autumn, while he was visiting his mother at her newly acquired château of Malromé in the Gironde, he received word that despite Cormon's approval his drawings had been rejected by the publisher. His mother reported the disappointing news in a letter that also revealed the esteem in which Lautrec held his teacher: 'I had a very bad moment when the letter came and I believe that Henri does not regret having left Paris. Happily he has been much more philosophical than I, declaring that the approval of Cormon was sufficient for him and that he scoffs at the rest [of them].'[62]

The Hugo publication for which Cormon, Rachou, and Lautrec submitted illustrations was the Édition Nationale, which the publisher J. Lemonnyer initiated and Émile Testard completed. The first volumes appeared in 1885. The *Poésie*, volumes vii–x, containing the four-book cycle of poems *La Légende des siècles*, was published in the autumn of 1886 by Testard. *Le Satyre* by Cormon appeared as a full-page illustration on the frontispiece of volume ix, book 3 of *La Légende*, and *La Paternité* by Rachou in volume viii, book 2. Many luminaries of the Parisian art scene also contributed full-page illustrations, among them Cabanel, J.-P. Laurens, Gérôme, and Henner. Small vignettes on the title pages of the poems were by lesser artists. The full-page illustrations were printed as steel plate engravings after the original art and the vignettes were simpler line drawings photomechanically reproduced.

The precise nature of Lautrec's collaboration with Cormon on the Hugo project has not previously been ascertained. Even Joyant apparently was entirely unaware of the incident, and later writers have mentioned it only in passing. Dortu and Huisman discussed it briefly in 1964, but they did not know of the letter in which Lautrec's mother revealed that his drawings had been rejected. They concluded that since none of the art in the Édition Nationale bears Lautrec's signature he must have assisted Cormon with the illustration for the poem, 'Le Satyre', from *La Légende*. Dortu and Huisman conjectured that Lautrec 'identified himself with the satyr, ugly in appearance, but beautiful in his creative abilities', and must therefore be credited with the conception of the satyr figure in Cormon's engraving.[63]

The disclosure in the letter from Lautrec's mother that the publisher rejected the drawings her son had submitted not only explains the absence of his name in the Édition Nationale, but also implies that he did his own illustrations independently of Cormon and was not just an assistant collaborating behind the scenes with his teacher. Moreover, Cormon's other

[61] Dortu and Huisman, 54. See also p. 54 for an excerpt from another letter of June in which Lautrec's mother first mentioned the project.

[62] Attems, 206–7, an undated letter, postmarked 'Malromé'.

[63] Dortu and Huisman, 54. See also Stuckey, 85, and J. Polášek, *Toulouse-Lautrec Drawings* (New York, 1976), 21.

40. Above: Henri de Toulouse-Lautrec, *Peuplade primitive*. Albi, Musée Toulouse-Lautrec.

41. Right: Henri de Toulouse-Lautrec, *Esquisse allégorique*. Albi, Musée Toulouse-Lautrec.

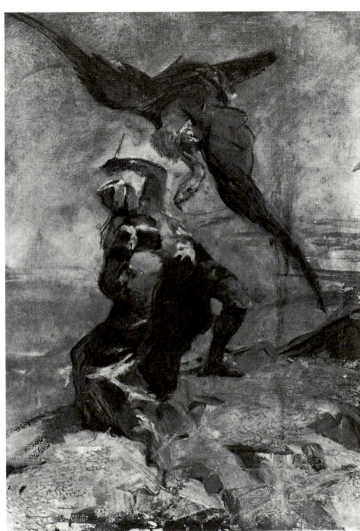

student, Rachou, signed his own work, and it seems probable that Lautrec would have done the same had his been accepted. This evidence, both documentary and circumstantial, pointed to an essential need to search Lautrec's *œuvre* for the rejected drawings in order to identify the work he did on the Hugo project.

Three such finished drawings, all pen and ink, along with one variant and several preparatory sketches may be identified with certainty. Two, because they have titles, and the third, because it so closely matches the others, are attributable without question to the Hugo project of 1884. They can also be related to one another because Lautrec's mother, their original owner, displayed all three (no doubt proudly) in the same frame. Lautrec did not do them for full-page illustrations, but in the somewhat narrow, horizontal format of the smaller vignettes that ornament the opening pages of most of the poems in the Édition Nationale.

Lautrec himself inscribed the first of the drawings, 'Rayons et ombres—Océano nox' (Fig. 42), and it unmistakably illustrates 'Oceano nox' from Hugo's suite of poems, *Les Rayons et les ombres*, published in the third volume of the *Poésie* in July 1885.[64] Two preparatory sketches also exist for *Oceano nox*, but the drawing that Lautrec's mother framed presumably is the final version ready for reproduction, with clear hatchings and stark contrasts of dark and light. The second drawing (Fig. 43) is known by the title Joyant gave it, *Laboureur menant deux bœufs*, and has no inscription other than Lautrec's note at the lower right, 'for the values', a probable instruction to the printer. There is a variant of the drawing, however, which differs from it only in that its values are lighter, and it bears Lautrec's label, 'Rayons et ombres—A M. le Duc de ***'. Again the source is unmistakable. Hugo's poem, 'A M. le Duc de ***', is also part of the suite, *Les Rayons et les ombres*.[65] Several preparatory studies also survive for this drawing. The third drawing in the group (Fig. 44) has no inscription at all, nor can its subject, a galloping Arab or oriental horseman with drawn scimitar, be identified with any of the poems of *Les Rayons et les ombres*. Yet its size, medium, format, and the way that Lautrec's mother displayed it serve to connect it to the Hugo works. There is, moreover, a Hugo poem with which the drawing's narrative coincides, 'Sultan Mourad', from the segment of Book 2 of *La Légende des siècles* entitled *Les Trônes d'orient*.[66]

The drawing inscribed 'Rayons et ombres—Oceano nox' is a view of the sea with a skull and an anchor aground in shallow water. The title of the poem, which Hugo borrowed from the *Aeneid*, means 'obscure' or 'perilous' sea. In mood the poem is a lament, a fatalistic meditation on the sea as a force hostile to humans. Lautrec did not make a literal illustration from a specific verse of the poem, but attempted to convey its dominant mournfulness by adapting several of its key images to a single composition. He took his gloomy horizon from the poem's beginning:

> Oh! combien de marins, combien de capitaines
> Qui sont partis joyeux pour des courses lointaines,
> Dans ce morne horizon se sont évanouis!

[64] Hugo, Édition Nationale, *Poésie*, iii. *Les Chants du crépuscule, Les Voix intérieures, Les Rayons et les ombres* (Paris. J. Lemonnyer, 1885), 599–601.

[65] Ibid. 453–5. Lautrec signed only one of these two drawings (D2005); the artists who made the vignettes generally signed their first illustrations in a given volume and only initialled those following.

[66] Ibid. viii. 151–63.

[Oh! how many sailors, how many captains
Who parted joyously for distant journeys,
Vanished on that gloomy horizon!]

The skull came from the image in the third stanza of the heads of dead men rolling on the waves:

Nul ne sait votre sort, pauvres têtes perdues!
Vous roulez à travers les sombres étendues,
Heurtant de vos fronts morts des écueils inconnus.

[No one knows your destiny, poor lost heads!
You roll across the sombre expanses,
Your dead countenances banging against unknown reefs.]

The anchor came from the fourth stanza, in which Hugo refers to the living who, seated on rusty anchors by the shore, reminisce about those whom the ocean has claimed.

In Lautrec's drawing for 'A M. le Duc de ***', a ploughman guides two oxen as in a normal, peaceful agricultural scene. But there is one reminder of human mortality in the picture, a skull barely visible in a furrow beneath the plough. In the poem, Hugo addresses his friend, Jules, 'M. le Duc de ***', the lord of a magnificent château in the Loire valley. He warns Jules not to desecrate the ancient Roman battleground lying beneath his fields, but to respect it, to meditate on it and its glories, and to read the great lesson-giver, Virgil, who reminds men of their mortality and the vanity of earthly triumphs. Hugo went to Virgil's *Georgics* for his ironic central image, the eternal ploughman toiling in the earth and uncovering the bones and rusted weapons of dead, forgotten heroes.[67] He introduces this figure in the second stanza of the poem. Addressing the duke, he says:

Vos paysans, piquant les boeufs de l'aiguillon,
Ont ouvert un sépulcre en creusant un sillon.

[Your peasants, goading on their oxen with the prod,
Have opened a sepulchre while ploughing a furrow.]

These verses along with Hugo's amplification of them in his closing stanza were the source for Lautrec's illustration. There Hugo further develops the image of 'le laboureur, sur le sillon courbé' ('the tiller, bent over his furrow') who:

. . . rouvrant des tombeaux pleins de débris humains,
Pâlit de la grandeur des ossements romains!

[. . . reopening tombs full of human debris,
Grows pale at the grandeur of the Roman bones!]

The third drawing of the group, so close to the others in rendition, fits Hugo's poem about the Sultan Mourad, a bloodthirsty oriental tyrant who ravaged the East. In this

[67] Noted by P. Albouy (ed.), Victor Hugo, *Œuvres poétiques* (Paris, 1964), i. 1555 n. 1.

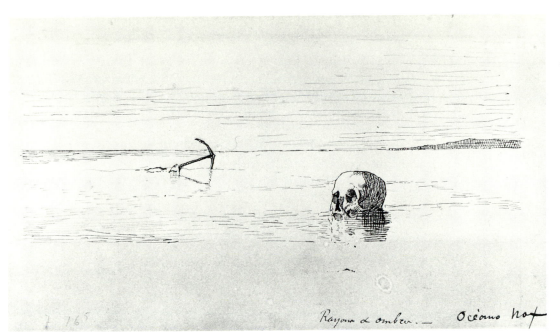

42. Henri de Toulouse-Lautrec, *Océano nox*. Pen drawing. Paris, Claude-Gerard Cassan Collection.

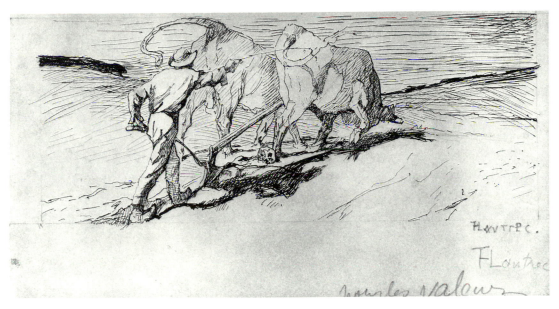

43. Henri de Toulouse-Lautrec, *Laboureur menant deux bœufs* ('A M. le Duc de ***'). Pen drawing. London, private collection.

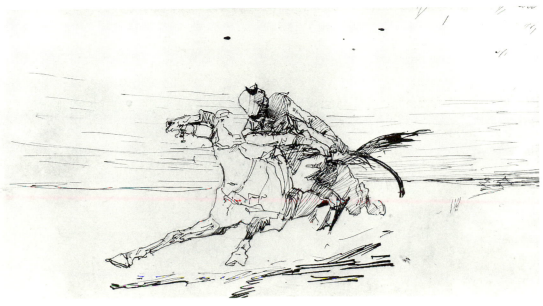

44. Henri de Toulouse-Lautrec, *Cavalier arabe au grand galop* ('Sultan Mourad'). Pen drawing. London, private collection.

illustration Lautrec found reason to return to one of his own favourite subjects, the horse. His drawing of the swiftly galloping horseman, with curved sword drawn, corresponds to Hugo's introductory description of the deadly sultan rampaging across the land:

> Il fit un tel carnage avec son cimeterre
> Que son cheval semblait au monde une panthère.
>
> Mourad, parmi la foule invitée à ses fêtes,
> Passait, le cangiar à la main, et les têtes
> S'envolaient de son sabre ainsi que des oiseaux;
>
> [He wrought such a carnage with his scimitar
> That his horse seemed to the world a panther.
>
> Mourad passed among the crowd invited to his feasts,
> Sword in hand, and the heads
> Flew off his sabre like birds.]

Lautrec's illustrations for the Hugo poems were spare, concise, and generalized. The drawings that the editors selected in their stead contained more tangible imagery, full almost to the point of going beyond the picturesque qualities of the poems themselves in order to make their meaning more explicit and comprehensible to the reader. For instance, De Bréville, whose vignette illustrations accompany 'Oceano nox' and 'A M. le Duc de ***'[68] in the Édition Nationale, used pure pictorial invention to enhance the action of both poems. He created a pseudo-classical, nude youth, gesturing and grimacing in despair, to serve as the reader's co-witness of the scene of 'Oceano nox', and made the peasant in 'A M. le D. de ***' hold the skull contemplatively in his hands, Hamlet like.

Comparisons of Lautrec's drawings with the published illustrations indicate that the editors may have found the content of his work somehow deficient. Perhaps it was too succinct, too lean and abbreviated, even too straightforward in its representation of Hugo's poetic imagery to satisfy their taste for more floridly romantic visual interpretations, which clarified the poems' meanings by making literal what was figurative or merely implied in Hugo. The drawings may also have displeased the publisher, because the figures and objects depicted in all three are small in relation to the space they occupy. In every case, the published illustration has images larger in proportion and therefore more legible than Lautrec's. The artist's mother, writing to her mother from Paris during the summer of 1884, revealed the problems her son was encountering:

Henri is astonishing, always running and working hard. But, in spite of his efforts the work scarcely advances. He has produced drawings already approved by other artists and his masters, but they still must be accepted by the most disagreeable of publishers and nothing has yet been engraved. Henri has even tried to have his pen and ink drawings redone by specialists (laying aside his profit—that's not the question), but either the maladroits distort the work and Henri is furious or something else is wrong! In sum, we are not getting anywhere and the work was to have been finished in September. I can't tell you how much we both long for, how much we need the country.[69]

[68] Hugo, *Poésie*, iii. 599 and 453, respectively. The vignette of Sultan Mourad in viii. 151 is by E. Matthis.
[69] Dortu and Huisman, 54.

Whether or not Lautrec made additional preparations for illustrations for the Édition Nationale so far remains conjecture. He may well have created his *Esquisse allégorique* (above) in 1884 as a preparatory sketch for a full-page illustration in the Hugo. Aside from its subject-matter, the painting's proportions and vertical format would have been suitable for a full-page illustration. Coincidentally, the poem, 'L'Aigle du casque', appears without full-page illustration,[70] whereas Rachou's illustration for 'La Paternité' appears in the same volume, volume viii of the *Poésie*.[71] Two further works, both drawings in a vertical format, also might be preparatory studies for full-page illustrations of poems from *La Légende des siècles*, but Lautrec might simply have been inspired by his experience with Hugo's poetry in 1884 to do them independently. Their content cannot be ascertained, but both have strong literary overtones and depict subject-matter that could well refer to particular poems. However, both poems in question are accompanied by full-page illustrations in the Édition Nationale. The first is *Chevalier* (Fig. 45), a charcoal drawing on canvas. The second, *Composition: chevalier avec trois nymphes sortant des eaux*, is a charcoal drawing on blue paper (Fig. 46).

Chevalier pictures a knight on horseback, accompanied by a more faintly drawn riderless horse (perhaps a pentimento) and facing three-quarters away from the viewer into a misty, nocturnal landscape. Horse and rider present a dark silhouette, spectral in mood, against the mysteriously lit sky. The drawing could relate to one of a number of poems in the segment of *La Légende* entitled *Les Chevaliers errants*, but in particular the image corresponds to the poem that is the prelude to the segment and bears the same title, 'Les Chevaliers errants'.[72] The poem does not tell the story of just one knight, but evokes the 'soul, the allure and the prestige' of all the medieval knights errant,[73] whom Hugo portrays as solitary, heroic, and moral figures, impelled by righteousness and justice, surrounded by mystery, wandering phantom like and appearing suddenly as lights in the darkness and chaos of the Middle Ages:

> La terre a vu jadis errer des paladins;
> Ils flamboyaient ainsi que des éclairs soudains;
> Puis s'évanouissaient, laissant sur les visages
> La crainte, et la lueur de leurs brusques passages . . .
> Ils erraient dans la nuit ainsi que des lumières.

> [In days gone by the land has seen paladins wander;
> They glowed like sudden flashes of lightning;
> Then they vanished, leaving awe on peoples' faces,
> And the glimmer of their brief passage . . .
> They wandered in the night like lights.]

The second of these drawings, which Joyant interpreted as a knight discovering a group of bathing nymphs, could be a quite literal depiction of the central event of 'Moschus', a poem from the *Groupe des idylles* in book 3 of *La Légende*.[74] (Cormon's *Le Satyre* appears in

[70] Hugo, *Poésie*, viii. 183–201.

[71] Ibid. opp. p. 373.

[72] Ibid. 39–42. A full-page illustration by Rochegrosse appears opp. p. 39.

[73] V. Hugo, *La Légende des siècles*, ed. P. van Tieghem, 2 vols. (Paris, 1950), i. 98, ed.'s note.

[74] Hugo, *Poésie*, ix. 186–7. A full-page illustration by Henner appears opp. p. 187.

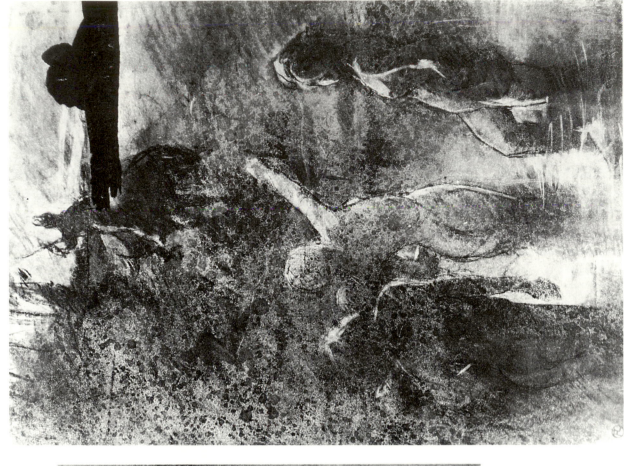

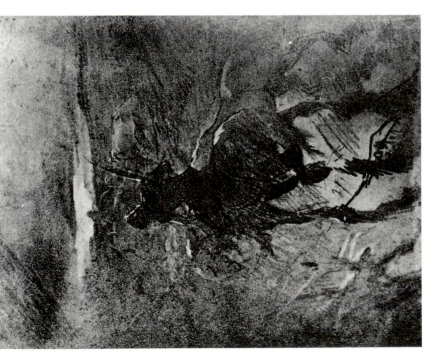

45. Henri de Toulouse-Lautrec, *Chevalier*. Charcoal drawing on canvas. Private collection.

46. Right: Henri de Toulouse-Lautrec, *Composition: chevalier avec trois nymphes sortant des eaux*. Charcoal drawing. Albi, Musée Toulouse-Lautrec.

the same volume.) In the poem, the ancient bucolic poet, Moschus, comes suddenly upon nymphs bathing in a pool deep in a forest. Néère is the nymph whose beauty the poem mainly glorifies, but it opens with an invocation to all:

> O nymphes, baignez-vous à la source des bois.
> Le hallier, bien qu'il soit rempli de sombres voix,
> Quoiqu'il ait des rochers où l'aigle fait son aire,
> N'est jamais envahi par l'ombre qui s'accroît
> Au point d'être sinistre et de n'avoir plus droit
> A la nudité de Néère.

> [Oh nymphs, bathe in the forest spring.
> The thicket while it's filled with sombre whispers,
> While it has crags where the eagle makes his home,
> Is never invaded by the shadow that grows
> To the point of being sinister and of no longer having the right
> To the nudity of the nymph Néère.]

Lautrec's heavily shadowed drawing has three female figures, one of whom, possibly Néère, seems to display her body to the watching mounted horseman.

Lautrec did not bring these two preparatory works, or the comparable *Esquisse allégorique*, to a more finished state, and whatever intentions he originally had for them remain unknown. One possibility is that Cormon assigned his students themes from Hugo's poetry for their competition pieces. On the other hand, if Lautrec created these works specifically as preparations for full-page illustrations in the Édition Nationale, the rejection of his vignettes, in all likelihood, signalled the end of his collaboration on the project and removed his reason to complete them.

Portraits

Compositional sketches and *académies* occupied Lautrec in the atelier, presumably in the mornings. In the afternoons he worked in his own studio or the studios of his friends, and there, outside the atelier, he produced works of a somewhat different character. Instead of romantic themes from history and mythology, inspired by literature or the imagination, he was likely to paint portraits, in which he inclined towards a straightforward, relatively conservative style with gloomy tonalities of the kind he had used under the teaching of Bonnat. Certainly his portraits of this time do not reflect any experimentation with Impressionism, but strongly echo the conventional mid-century Realism. Nevertheless such 'Realist' portraiture (along with his *plein-air* paintings, which come under consideration below) constituted the young artist's most progressive work during the early part of his study at Cormon's.

A portrait of one of his fellow students, Gustave Dennery (Fig. 47), is a notable example. Though he left it undated, Lautrec signed it, and in a letter to his mother in the spring of 1883 mentioned that 'I'm finishing the portrait of d'Ennery, who very obligingly posed for me.'[75] Two drawings of Dennery dated 1883 confirm the time of the portrait. Lautrec himself

[75] H. Schimmel, no. 83, 71–2.

took a similar casual pose on the same divan for his friend, Henri Rachou, in 1883. In their informality, such works seem perhaps related to the portraiture of avant-garde artists such as Courbet, Manet, and Degas. Yet this did not represent artistic radicalism either. By 1880, informality in portraiture was no longer the practice of advanced artists exclusively, but also of fashionable artists of the *juste milieu* such as Roll, Besnard, Boldini, and others, all of whom Lautrec admired. None the less Lautrec's portrait was rejected by the jury of the 1883 Salon by a vote of 38 to 2.[76]

The first portraits in a series of the red-headed model named Carmen probably also belong to this same phase of Lautrec's academic career. 'I'm painting a woman whose hair is all gold', he wrote to his mother in the spring of 1884,[77] and he could have referred to the Carmen paintings. These portraits have an overall dark and gloomy colour scheme with strong modelling in lights and darks and shadows tinged with brown and green (e.g. Fig. 48). The Carmen paintings and a number of others of comparable style predate 1886 because Lautrec departed permanently from such dark shadowing after 1885. Probably they are most suitably placed *c*.1884–5. They all exhibit the cautious Realism that Cormon students generally practised at that time.[78]

Outdoor Subjects

The subjects that Lautrec painted *en plein air* during his early years at Cormon's, landscapes, portraits, and figures of peasant labourers, have a special bearing on the analysis of his evolution as an artist. Their lighter palette, relatively loose style, and airier qualities of atmosphere have led to their widespread acceptance as Lautrec's first essays into genuine Impressionism. On the other hand, their connections to the *juste milieu* and the artist's training under Cormon, which were their real sources of inspiration, have received little recognition. Lautrec assuredly did them while on holiday with his family in the summers, but he did not date them. Writers subsequently have assigned them premature dates, from 1880 to 1882, with the effect of advancing Lautrec's interest in Impressionism—supposedly stimulated by his viewing of Impressionist works in Paris. But the evidence argues otherwise.

The work is too accomplished technically for Lautrec to have done it before he studied in the atelier of Cormon, and it is consistent with the programme of instruction there. The peasant paintings in particular exhibit a mastery of drawing the foreshortened human figure that Lautrec did not achieve in his brief period of study with Bonnat. Moreover, in the summer of 1882, the date Joyant assigned to them, Lautrec used his vacation to draw and to paint portraits with the dark palette he had acquired in his brief study with Bonnat. Gauzi has corroborated that under Bonnat, Lautrec did mostly head studies in sombre colours, and only began to lighten his palette at Cormon's.[79] In addition, correspondence shows that Lautrec spent his summer vacation of 1882 not at the family estate at Céleyran, where indisputably he did many of his early works *en plein air*, but at Bosc. A year later, however, after he had spent an extended time as Cormon's student, he went to Céleyran for his vacation

[76] Cf. an unpublished letter, cited courtesy of H. Schimmel. [H. Schimmel, no. 84, 72.]

[77] H. Schimmel, no. 92, 78.

[78] See e.g. John Russell's portrait of van Gogh, Rijksmuseum

Vincent van Gogh, Amsterdam, reproduced in Rewald, *Post-Impressionism*, 36.

[79] Gauzi, 2, 146.

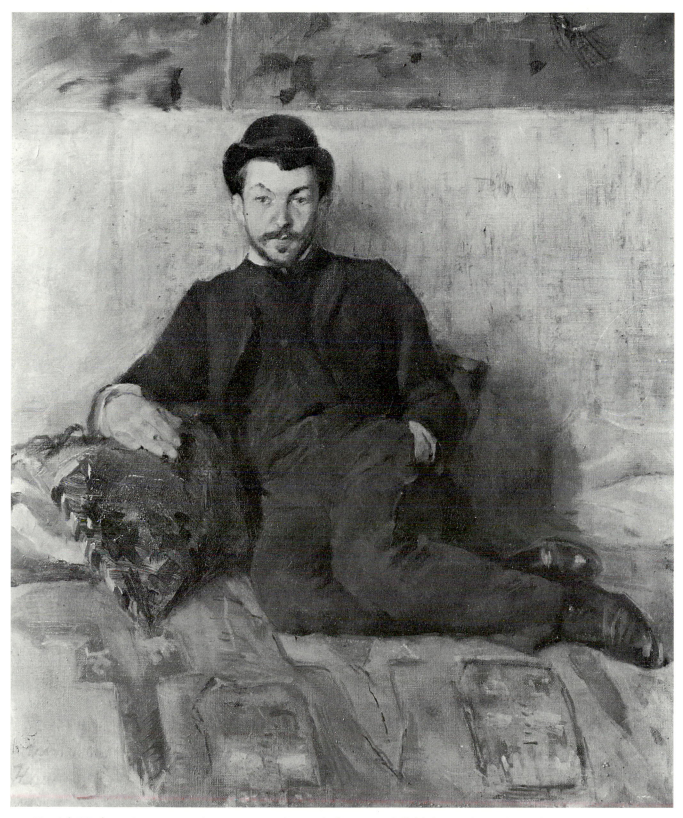

47. Henri de Toulouse-Lautrec, *Monsieur Dennery*. Paris, Musée du Louvre. (Cliché des Musées Nationaux.)

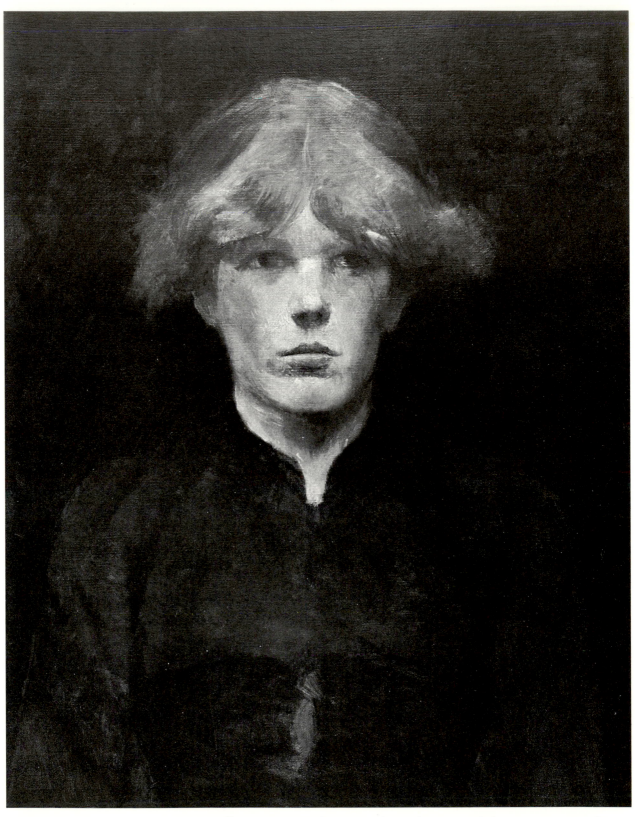

48. Henri de Toulouse-Lautrec, *Carmen*. Williamstown, Massachusetts, Sterling and Francine Clark Art Institute. *See also colour plate.*

and there, according to his own testimony, worked out of doors. In a letter postmarked Céleyran, 2 September 1883, he told his fellow student, Eugène Boch: 'I'll spare you the recital of my ruminations in the sun with a brush in hand and spots of a more or less spinachy green, pistachio, olive or shit colour on my canvas. We'll talk about that later.'[80] In this ebullient commentary, Lautrec described a palette of the exact kind he used in the peasant paintings and landscapes at Céleyran, which must date from the summer of 1883. He spent most of the summer of 1884 in Paris, working on the Victor Hugo illustrations, but letters show that during his brief vacation at Malromé late that summer he continued to paint landscapes and that in the summer of 1884 or 1885 he also made a portrait of his mother out of doors at Malromé.[81]

These works differed from what Lautrec was doing in the studio, but their style and subject-matter remained well within the limits of the conservative ambience of Cormon's atelier. Lautrec was not yet practising true, avant-garde Impressionism. Working out of doors, at the scene, was an Impressionist practice, but painting *en plein air* was also an important part of the tradition of the nineteenth-century atelier even though it was an informal practice outside the regular curriculum. By mid-century, the usual atelier programme had been modified to place greater emphasis on working out of doors, and, according to Boime, the master and his students periodically did landscape painting from direct observation, and studies of the model *en plein air*. Masters also encouraged their students to work independently out of doors in the urban environment in their free time, and to organize group painting excursions to the country on their own. 'At the end of the spring semester', wrote Boime, 'the pupils took a summer holiday, which they spent in the field painting landscapes.'[82] Lautrec's fellow student Rachou made it evident in his account that Cormon observed this tradition and Lautrec's letters testify to it also.[83]

Lautrec's landscape studies (e.g. Fig. 49) of his early phase at Cormon's undoubtedly relate to the traditional academic practice of making rapidly brushed and freely executed painted sketches directly from nature, totally lacking in detail and finish, as spontaneous records of immediate impressions.[84] Their style, although sketchier, is also reminiscent of the Barbizon school of painting, with striking parallels to the landscapes of Daubigny in their preoccupation with sky, water, and reflected light, and their loose brush stroke. The Barbizon painters, in their focus on the natural site, had, in effect, adopted the unfinished appearance of the academic landscape study for their finished works.[85] Coincidentally, a major exhibition of paintings by the Barbizon school artists, 'Cent chefs-d'œuvre des collections parisiennes', was held at the Georges Petit Gallery in 1883. The possibility that Lautrec's landscapes had their inspiration in part in this exhibition, which according to Joyant made the public aware of the magnitude of the contribution of the Barbizon artists,[86] lends support to dating them 1883–4.

[80] H. Schimmel, no. 86, 73–4.

[81] Ibid., no. 102, 84–5, mentions landscapes and cattle painted during the summer or autumn of 1884. In a letter in Attems, 199, datable to summer 1884 or 1885, Lautrec's mother reports his painting her portrait outdoors at Malromé. Lautrec did not stay at Malromé until the late summer of 1884, after working on the Victor Hugo project. Letter no. 87, 74–5, of 8 Sept. 1883, indicates that the château had not yet been set up for residence. He visited again briefly in the summer of 1885 (cf. no. 114, 93–4).

[82] Boime, *The Academy and French Painting*, 34–5, 47.

[83] H. Schimmel, no. 86, 73–4, Sept. 1883; no. 102, 84–5, Nov. 1884; no. 103, 85–6, autumn 1884; no. 111, 91–2, Mar. 1885.

[84] On this practice see Boime, *The Academy and French Painting*, 134, 139.

[85] Ibid. 133.

[86] Joyant, i. 113.

The peasant paintings of 1883 and their related sketches, like the landscapes, were an extension of Lautrec's atelier studies. But these were more formal, finished works that directly reflected the modified Impressionism of the fashionable *juste milieu* of the Third Republic, to which Lautrec had first been attracted under the influence of Princeteau and Brown. The contemporary painters of peasant subjects, like Jules Bastien-Lepage and Léon Lhermitte, whose art Lautrec was now imitating, had also adopted the surface mannerisms of Impressionism without its underlying philosophy. Their deliberately chosen formula was to impose the modernity and informality of the lighter palette and looser brush stroke of Impressionism on a solid structure of traditional draughtsmanship. This was a 'compromise' form of modernism, Boime tells us, that was acceptable in official and academic circles and to the public,[87] and it must have been sanctioned by Lautrec's comparatively open-minded master Cormon.

It was just such painting that Lautrec emulated in the summer of 1883 when he made outdoor studies like *Le Jeune Routy à Céleyran* (Fig. 50), with a relatively loose execution, abandonment of dark chiaroscuro effects, light palette, and luminous surfaces. Despite these superficially impressionistic traits, Lautrec did not use the divided touch of avant-garde Impressionism to break up local colour into its components, nor did he employ its wide spectrum of intense hues. He restricted his palette to a rather limited range of blue-grey, grey-green, and yellow tonalities and painted his shadows in tones of grey. Nor did his free execution threaten the coherence of the surface and the structure of the figure, as he set off many of his forms with sharp, linear edges, often highlighted in white.[88] These techniques characterize the other paintings in the same series and serve to define them as essentially conservative. Clearly Lautrec did not yet follow the optical theories of Impressionism or exploit light and atmospheric effects to dematerialize forms and merge them with their surroundings. In fact, he painstakingly relied on traditional methods of construction to create a firm, underlying structure of drawing, making charcoal preparatory drawings (Fig. 51), which he transferred to canvas by means of tracings; then he worked up the values on his canvas and proceeded to painted *ébauches*. Although we now know that the Impressionists did not work with complete spontaneity either, their preparation did not have this kind of thorough academic exactitude. Among Cormon's other pupils, at least Bernard and Anquetin apparently travelled the same route stylistically as Lautrec did. Their ambition, Bernard wrote, was 'to paint with the palette of the Impressionists and to draw like the old masters in the Louvre'.[89]

The muted grey tonalities of Lautrec's peasant paintings and the white flecks with which he highlighted the foliage especially resemble the style of Jules Bastien-Lepage. Much like the older artist too, Lautrec contrasted figures drawn with academic correctness with more loosely painted background landscapes, and in the composition of these works often placed a central figure against a high horizon. Bastien-Lepage was a leader of the *juste milieu* in synthesizing Impressionism's freer facture with academic draughtsmanship, and had won

[87] Boime, *The Academy and French Painting*, 17. Boime, ibid. 15–18, discusses the Third Republic *juste milieu*.

[88] Cf. Cooper, 60.

[89] É. Bernard, 'Louis Anquetin, artiste peintre', *Mercure de France*, 239 (1 Nov. 1932), 591.

great acclaim at the Salons of the late 1870s and early 1880s for his scenes of rustic life in this manner. The younger generation of painters who aspired to modernism in the 1880s adopted him as their artistic hero. They considered him the foremost exponent of the contemporary Realist movement in painting, and, according to Hartrick, they 'frankly' imitated his style 'with its ideals of exact representation of nature as seen out of doors, everything being painted on the spot in a grey light in order that there might be as little change in the effect as possible while the artist was at work'.[90] The Impressionists disdained Bastien-Lepage, and their fame eventually eclipsed his; nevertheless he was one of the most important painters of the 1880s. That Lautrec was among his younger emulators is probable. That he admired him is certain. In his reviews of exhibitions of contemporary art, he singled out Bastien-Lepage as a creator of 'works of real value', who 'by virtue of his simplicity, surpasses all the others'. In fact, the Salon of 1883, which stimulated these remarks of Lautrec's and probably his peasant paintings as well, was dominated by the work of Bastien-Lepage and his followers.[91]

In terms of subject as well as style Lautrec's peasant paintings must be seen in the context of the *juste milieu*. By the 1880s rural themes made up a substantial proportion of the Salon exhibitions. Genre painting in general gained in official and public acceptance, and increasingly challenged the academic hierarchy's reigning preference for historical, classical, and religious themes. Although rural themes seemed modern they were also rife with nostalgia. In the face of social and economic changes which threatened to displace the traditional French way of life, artists and public alike could idealize rustic life as unchanging, simple, wholesome, and untroubled. The taste for peasant subjects had first crystallized in mid-century, with the generation of Millet and Jules Breton, but it reached its height in the 1880s and 1890s, as urban and industrial growth intensified.[92] Moreover, the image of peasant labour was one which reinforced the bourgeois work ethic and this heightened its appeal. Even Millet, once considered dangerously radical for his uniquely harsh vision of the burdens of peasant life, was reassessed in a more positive light at this time. Sensier's biography of 1881 heroized and romanticized him as a 'painter who has given a place to the humblest, a poet who has raised to honor those whom the world ignores, and a good man whose work encourages and consoles'.[93] The popular, *juste milieu* painters of rural themes of the new generation of the 1880s, among them Bastien-Lepage, Lhermitte, Julien Dupré, Roll, and Dagnan-Bouveret, capitalized on the public taste for this pure and moral representation of the peasant. They reaffirmed bourgeois values with easily intelligible imagery; their portrayals of humble, timeless figures, either industriously at work or idyllically at a well-deserved rest, were nostalgic and reassuring. They were seen by the public and younger artists as Millet's successors, endowing peasant life with nobility.

Lautrec wrote about a number of these artists with admiration in his reviews of this time

[90] Hartrick, 28; also 29–35.

[91] W. S. Feldman, 'His Work and Influence', *Jules Bastien-Lepage* (exh. cat., Musées de la Meuse, Verdun and Montmedy, 1984), 116.

[92] H. Sturges, *Jules Breton and the French Rural Tradition* (exh. cat., Joslyn Art Museum, Omaha, Neb., 1982), 9–10, 19, 27 n. 99, and *passim*.

[93] A. Sensier, *Jean-François Millet, Peasant and Painter*, trans. H. de Kay (Boston, 1896, orig. pub. as *La Vie et l'œuvre de J.-F. Millet*, Paris, 1881), p. xi. See also R. Herbert, 'Peasant Naturalism and Millet's Reputation', in *Jean-François Millet* (exh. cat., Arts Council of Great Britain, London, 1976), 14.

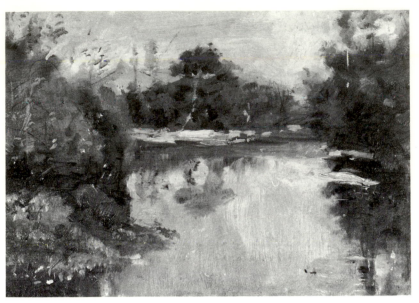

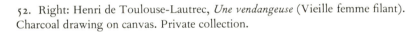

49. Above: Henri de Toulouse-Lautrec, *Céleyran, au bord de la rivière*. Albi, Musée Toulouse-Lautrec.

52. Right: Henri de Toulouse-Lautrec, *Une vendangeuse* (Vieille femme filant). Charcoal drawing on canvas. Private collection.

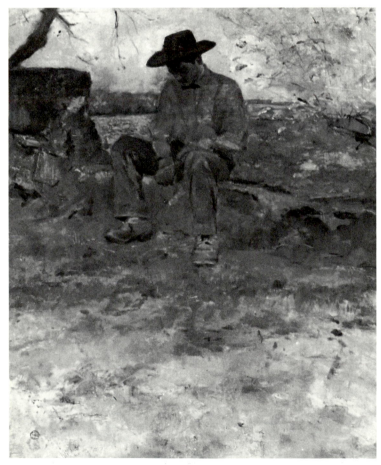

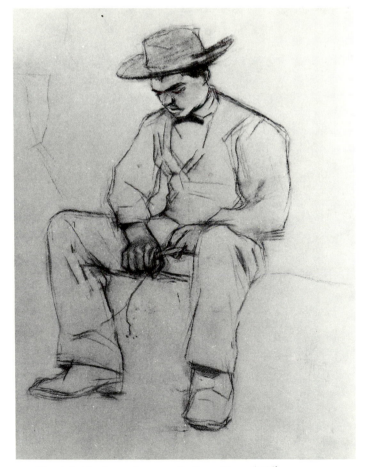

50. Henri de Toulouse-Lautrec, *Le Jeune Routy à Céleyran*. Albi, Musée Toulouse-Lautrec. *See also colour plate.*

51. Henri de Toulouse-Lautrec, *Le Jeune Routy à Céleyran*, preparatory drawing. Charcoal. Albi, Musée Toulouse-Lautrec.

and his approach to rural subjects echoed theirs. For instance, in several of his drawings and paintings of Routy and his *Travailleur à Celéyran*, he took up one of their favourite themes, farm workers at moments of relaxation.[94] And in at least one work he overtly followed the contemporary taste for idealizing the morality and timelessness of peasant labour. This is a large, detailed charcoal drawing on canvas, which Joyant entitled *Une vendangeuse* (Fig. 52); together with a contour drawing on tracing paper (*Vieille femme filant*) of the identical figure it must have been a preparation for a painting. Lautrec's charcoal drawing particularly recalls Millet's work in its sculptural definition of form and its centralized solitary, industrious figure looming against the expanse of a field. His old peasant woman, turning yarn on her spindle like some tragic fate, her simple task infused with an elevated significance, emanates the iconic quality and heroic dignity of numerous figures by Millet whose work, incidentally, was featured at the Barbizon School exhibition of 1883.[95] Moreover, the subject of the shepherdess spinning while she guarded her flock was very much within the tradition of nineteenth-century French peasant painting. Not only did Millet treat it several times; Breton painted it in 1872, and it was also adopted by the *juste milieu* painter Lhermitte in his *Fileuse*, shown at the Salon of 1883.[96] Like his elders, Lautrec chose a motif that was frankly nostalgic. Hand-spinning had long since given way to the machine, but such anachronistic depictions of rural life had become comforting evocations of an unspoiled, simpler, and less frenetic existence.[97]

This interest in rural and peasant subjects perhaps heralded Lautrec's evolving social orientation. These themes largely supplanted the aristocratic sporting scenes that had been his favourite subjects; now he was gravitating towards humble, common activities and people. Following the same pattern that Robert Herbert has commented on in the work of Seurat, van Gogh, and others,[98] Lautrec at this youthful stage represented rural types; later he turned to the urban scene as he developed a new notion of what was modern. But significantly, he was still imitating fashionable conservative Salon artists who idealized rural life to satisfy popular tastes rather than presenting its harsher social realities. Like the consumers of this sort of art, Lautrec remained distanced from these realities. The peasants on his family estates who obligingly posed for him were representatives of a social category and a life-style separated from his own in the hierarchy of rural France by an unbridgeable gap.

Finally, of particular significance to any evaluation of Lautrec's early academic work at Cormon's is his simultaneous use of two distinct approaches: a dark palette and typical academic subject-matter for indoor, studio work, and a lighter palette and freer technique for outdoor painting. In this he remained not only within the conventional practice of his own time, but well within the long-established, nineteenth-century French tradition to which artists such as Corot, Couture, Ingres, and Valenciennes had adhered.

[94] See e.g. Lhermitte's *La Moisson*, Washington University Gallery of Art, St Louis, which had been shown at the 1883 Salon, cf. M. M. Hamel, *Léon Lhermitte* (exh. cat., Paine Art Center and Aboretum, Oshkosh, Wis., 1974), 28, and J. Thompson, *The Peasant in French 19th Century Art* (exh. cat., Douglas Hyde Gallery, Trinity College, Dublin, 1980), 144; also Bastien-Lepage's *Les Foins*, Musée d'Orsay, Paris; and Julien Dupré's *Le Temps de Moisson*, Galleries Maurice Sternberg, Chicago. Herbert, *Millet*, 165, has suggested that Millet's pastel *Le Vigneron* of 1869–

70 provided the model for some of these worn figures of peasants pausing at their work, even though his followers softened his 'brutalized' figure and made it more palatable to popular taste.

[95] Herbert, *Millet*, 229.

[96] Ibid. 191, 193; Sturges, 90; Hamel, *Lhermitte*, 28.

[97] Herbert, *Millet*, 100.

[98] R. Herbert, 'City vs. Country: The Rural Image in French Painting from Millet to Gauguin', *Artforum*, 8 (Feb. 1970), 52.

Lautrec's Early Art Criticism

Early in his academic career, Lautrec wrote a series of reviews of art exhibitions. Youthfully affecting the style of journalistic art criticism of the day, he commented on the annual Salon, Petit's Exposition Internationale, the Salon of Watercolourists, the show of the Society of Women Painters and Sculptors, an exhibition of the work of Eugène Boudin, and shows of the fashionable *cercles*, or clubs. (See Appendix B for an annotated translation.) Lautrec pretended to have visited one show 'as a journalist', but in fact did not write for publication. If he composed his critical essays for the interest and diversion of anyone but himself, it was perhaps for his Uncle Charles. In particular, the tone of the writing, in which heavy irony and humour often obscure the author's intention, hampers analysis. Abrupt alternation of criticisms and compliments also adds to the enigma of his attitude towards individual artists and works. Nevertheless, Lautrec's art criticism of the early 1880s, the only writing of its kind that he ever did, provides an indication of what types of contemporary art he chose to look at in this period and the qualities he liked or disliked in the work he saw.

Joyant published these writings and interpreted them as diatribes against academic art. He associated them with the artist's departure from Cormon's, an episode that he mistakenly believed took place in 1884 as an act of rebelliousness, and so he concluded that Lautrec composed his frequently acerbic little reviews the same year.[99] But a number of significant facts indicate that they date from the winter and spring of 1883, shortly after Lautrec entered Cormon's. First, in his review of the annual Salon, he referred to certain democratizing reforms: 'Democracy is at the Salon. Equality, congestion.' In 1883, but not 1884, a dramatic liberalization of the Salon went into effect as a result of the founding of the Société des Artistes Français. This association had some twenty-five hundred artist members whose work had been accepted in at least one Salon or Universal Exposition. Under the liberalization, the choice of jurors and award winners and the organization of the Salon reverted to them.[100] Second, Lautrec reviewed a major Boudin exhibition, held at the Durand-Ruel Gallery in February 1883,[101] and the Première Exposition de la Société Internationale de Peintres et Sculpteurs, which the Georges Petit Gallery offered in 1883.[102] Finally, he referred to the death of Gustave Doré as a recent event: 'I bow down before the coffin.' Doré died on 23 January 1883. The reviews also coincide with Lautrec's letter of 10 February 1883 to his Uncle Charles, to whom he briefly commented on the same shows: 'Many exhibitions: the watercolourists, pitiful; the Volney, mediocre, and the Mirlitons, bearable.'[103]

[99] Joyant, i. 74–5.

[100] See A. Boime, *Art Pompier: Anti-Impressionism* (exh. cat., Emily Lowe Gallery, Hofstra University, New York, 1974); and Stranahan, 278, 474. The government withdrawal from the management of the Salon had actually begun in 1881, when the first Salon managed entirely by the artists was held. The Salon had formerly been sponsored by the Ministère de l'Instruction Publique et des Beaux-Arts. The establishment of the new democratic system for the election of the jury and the formalization of the transfer of power on a basis of perpetuity did not occur until 1883, however, 'when the Society of French Artists, Painters and Sculptors was formally constituted by the government and empowered to regulate the annual Salons' (Stranahan, 277–8).

[101] G. Jean-Aubrey, *Eugène Boudin* (Greenwich, Conn., 1969), 184–5, notes that this was a showing of 150 paintings and numerous studies, including *Port du Havre during a Storm*, which Lautrec mentioned in his review; see also J. Rewald, *The History of Impressionism*, 4th rev. edn. (New York, 1973), 481.

[102] See a review by A. Baignères, 'Première exposition de la Société Internationale de Peintres et Sculpteurs', *Gazette des beaux-arts*, 27 (1883), 187–92. Not to be confused with Petit's 1st Exposition Internationale de la Peinture held in 1882 and his 2nd Exposition Internationale de la Peinture held later in the spring of 1883. Baignères's review mentions many of the works discussed by Lautrec (see Appendix B for details).

[103] Joyant, i. 60. [H. Schimmel, no. 82, 70–1.]

In his writings Lautrec affected a tone that was often supercilious and crudely ironic. It was, however, the same tone that characterized a great deal of the writing of the contemporary conservative critics, who frequently railed against the poor quality of much of the official art of the period. Lautrec's mixture of criticism and praise therefore was not unusual in the context of the early 1880s. It lends no support for the conclusion that he was anti-academic, nor does it, judging from internal evidence, indicate that he was a new convert to progressivism in art. In particular, Lautrec seemed to imitate *Le Figaro's* critic, Albert Wolff, an extraordinarily powerful figure who could make artists' reputations or, by means of his witty and caustic reviews, ruin them. Rewald pointed out that Wolff 'distinguished himself by particularly ambiguous comments in which he recognized the artist's talent and simultaneously condemned his work'. He was a major opponent of the Impressionists, who in turn considered him to be the critic who had done them greatest harm.[104] On the other hand, he was a partisan of Bastien-Lepage, who painted his portrait in 1881. Lautrec addressed Wolff several times in his reviews as his 'sympathetic colleague', and once described him as 'the above-mentioned very Parisian journalist [who] doesn't shun the sharp word in his profound coolly considered, and sweetly philosophical accounts'. He described himself as a 'gallant idler' (*flaneur*), imitating Wolff's pose.

Besides adopting the acid tone of the conservative press, Lautrec indulged in the irreverence and cynicism that typified student attitudes as both Hartrick and Gauzi described them. Mischievous pranks, which Lautrec and his fellow pupils played at Cormon's, were manifestations of the same irreverence, but Gauzi made it clear that they did not signify rebelliousness. On one occasion, he wrote that Lautrec 'didn't take this amusement seriously', being a dedicated student.[105] But student like, Lautrec laced his reviews with disrespectful humour: he was attempting to appear a witty and knowing sophisticate about the Parisian art scene. His tone reflected the impudence, high spirits, and juvenile hauteur of a student advising experienced artists how to paint.

Sarcastic though he could be at times, Lautrec nevertheless did not display the attitudes of a radical. What he excluded from his reviews is as interesting and nearly as informative in this respect as what he included. Although he appears to have visited the current exhibitions avidly, he never discussed those of the progressive artists, not even the one-man shows of Monet, Renoir, Pissarro, and Sisley at Durand-Ruel's in the winter and spring of 1883, or Seurat's large portrait drawing, *Aman Jean*, in the Salon of 1883. Nor did he mention Petit's major exhibition of Japanese art in 1883. He directed his statements of preference as well as his criticisms towards fashionable, popularly approved, and official artists only. After the manner of Wolff, perhaps, he would praise the work of an artist, then find fault in some different context. Sargent affords an example: Lautrec deprecated him for work he considered too painterly but several paragraphs later paid him a compliment. Among the other artists whom he praised were Bastien-Lepage, Boldini, Dagnan-Bouveret, Edelfeldt (the latter two painters of peasant subjects), Jacquet, Cormon, Duez, Butin, Cabanel, Carolus-Duran,

[104] Rewald, *Impressionism*, 218, 237 n. 46, 351. For an example of Wolff's critical tone, see pp. 368–70. Lautrec's attitude is also reminiscent of that of Albert Baignères, the reviewer for the *Gazette des beaux-arts*.

[105] Gauzi, 24.

Gervex, and Detaille, along with a series of popular sculptors whose names have since faded into oblivion. His favourites ranged from someone as strictly academic as Cabanel, through a variety of less academic but none the less *juste milieu* Realists and Naturalists, to Boudin, who was associated with the Impressionists though far from being one of them. That he singled out Boudin's show for a favourable review does not support the contention that he was leaning towards Impressionism; rather it reinforces the point of view that the artists he most admired were the more moderate practitioners of official painting. Boudin, hardly a radical despite his association with the Impressionists, enjoyed great official success, and the professional critics (as well as Lautrec) received his one-man show favourably. If Lautrec's commentary shows a dominant preference, it was for the fashionable Realism (as opposed to history painting) that was proliferating at official exhibitions in the form of portraits and genre scenes. Within this general category, his preferences seemed to divide between artists who focused on modish high society, such as Sargent, Boldini, Duez, Gustave-Jean Jacquet, and Carolus-Duran, and those who depicted the lower classes, for example, Bastien-Lepage, Dagnan-Bouveret, and Edelfeldt. His preference for Realist subjects, whether of high or low life, may have prefigured Lautrec's future inclinations, but little else in his reviews gave any clues to his artistic future.

His stylistic taste proves even more difficult to pinpoint than the subject-matter he liked best: for instance, he felt an attraction for the more painterly talents, but chided those like Sargent who he felt had gone too far. Again, he seemed to gravitate toward the more 'modern' fringe of conservative painting, but it was the chic, *juste milieu* rather than the avant-garde modernism that appealed to him, that is, modernism as he knew it at a point in his youthful career when he was not yet acquainted with the bona fide avant-garde painters of the day. The paintings that Lautrec did the following summer at Céleyran of landscapes and rural life reflected the influence of the exhibitions he reviewed and his responsiveness to the restrained modernism of the *juste milieu*. In his letters of the previous year, 1882, Lautrec had stated his admiration for such painters as Jacquet, Detaille, Bonnat, Roll, and J.-P. Laurens. His writings of 1883 indicated no significant change in his taste, although his tone shifted from the awe of a youthful newcomer to the student flippancy of a would-be sophisticate.

It is most significant that when Lautrec composed his reviews he had barely begun his study with Cormon, and so far remained thoroughly receptive to conventional practice in art. Rebelliousness had not infected him. To the contrary, he apparently took the attitude that the general quality of the Salon and its audience were unworthy of the men whom he considered to be the best artists exhibiting there. 'But, good God', he wrote, 'Monsieurs Dagnan, Edelfeld [*sic*], Sargent and Bastien-Lepage have yet to expect more from the Salon than mere feminine approval, which the chilly ladies stifle behind their sumptuous catalogues.' It was not the official art that he railed against, but particular examples on exhibition that year and the pretensions of the stylishly elegant viewers. He referred to the clubs with the same sarcasm: 'many pretty things, but only pretty; the average note is seductive, but then, how could one bear a grudge against people who simply want to make one pass an afternoon?' And he extended his tone of mockery to the new liberalization of the Salon, thereby tending to label himself more a snobbish young aristocrat than an aspiring radical: 'Universal suffrage has even invaded the sublunary spheres where Cabanel reigns, and the medal of honour

reverts to the choice of the majority.'[106] While Lautrec indulged in fun at the expense of the official art world, he treated Impressionism no differently in the rare instances, two in number, when he mentioned it at all. Chiding Montenard for a 'very slipshod' seascape, he added, 'go right ahead—but don't wait for the Impressionists'. At the exhibition of works by women artists, Pillaut-Reisener, 'who is inspired by Manet', gave 'the strange note' with her pastels, in one of which 'A violet cat permits itself to be caressed by a bile yellow young girl.'

The tone of Lautrec's reviews, its abrupt reversals, its sarcasm and irony, does not serve to identify him with any one point of view or approach to art. The only consistent ingredient in his writing was a youthful irreverence that held nothing sacred and showed off an artistic expertise that the author was only then acquiring. His taste was eclectic, but still within a conservative mould, with, perhaps, a preference for a restrained, *juste milieu* Realism over both a fashionable prettifying and sweetening and radical Impressionism.

The Parody of Le Bois sacré *of Puvis de Chavannes*

In his monumental painting, *Le Bois sacré* (Fig. 53), Puvis de Chavannes created an idyllic scene on a classical theme in a woodland clearing. The painting's subjects are the muses and female personifications of the plastic arts, all draped in robes of pastel tones with one exception; Melpomene, the muse of tragedy, wears black, and sits apart from the others beneath a tree in the left foreground. Most of the other figures are grouped in their park-like setting in postures of meditation or conversation, though Erato and Euterpe, the muses of poetry and music, fly overhead, bearing a lyre. An Ionic portal rises out of the woods in the middle distance. Puvis won the medal of honour at the Salon of 1884 for *Le Bois sacré*, and the painting was a popular sensation.[107]

Le Bois sacré, in turn, became the subject of the humorous work usually attributed to Lautrec alone, the *Parodie du 'Bois sacré' de Puvis de Chavannes* (Fig. 54), a re-creation that satirized the famous original. The *Parodie* represents a hectic disruption of Puvis's chaste and tranquil atmosphere. A roistering crowd of young men in contemporary attire intrudes upon the quiet glade from the forest, under the watchful gaze of a restraining gendarme. The destination of their procession might be the personification of painting seated at the foot of the Ionic portal, but unlike the child paying homage to painting by strewing flowers on her robe, most of the young men apparently ignore her, and Lautrec, near the procession's head, turns his back on the classical figures and appears to be relieving himself.[108] The *Parodie* also contains other distortions of *Le Bois sacré*. The procession of revellers has replaced the figures of Polymnia and Clio, the muses of eloquence and history, in the original painting. A large clock beneath the cornice of the portal disrupts the timelessness of classicism in the scene. It reads 9.05. Erato or Euterpe carries a large tube of paint instead of a lyre.[109] And the pensive Melpomene has become an unkempt male figure sitting before an easel and canvas with several

[106] C. Bigot, 'Le Salon de 1883', *Gazette des beaux- arts*, 27 (1883), 459–60, criticizes the reforms in similar sarcastic terms.

[107] Gauzi, 116–17; L. d'Argencourt *et al.*, *Puvis de Chavannes, 1824–1898* (exh. cat., National Gallery of Canada, Ottawa, 1977), 192.

[108] R. J. Wattenmaker, *Puvis de Chavannes and the Modern Tradition* (exh. cat., rev. edn., Art Gallery of Ontario, Toronto, 1976), 98.

[109] On the iconography of Puvis's painting, see the artist's own explanatory text as quoted by d'Argencourt *et al.*, 192.

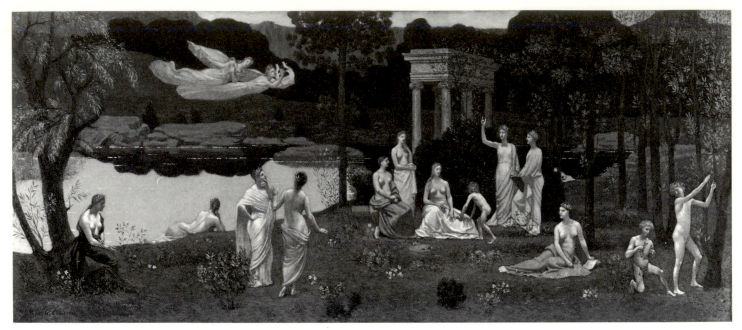

53. Puvis de Chavannes, *Le Bois sacré*. Chicago, Art Institute, Potter Palmer Collection. (Photo, courtesy of The Art Institute of Chicago, © 1988. All rights reserved.)

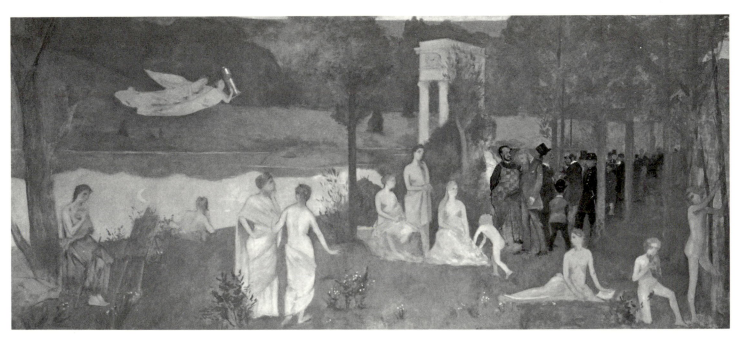

54. Henri de Toulouse-Lautrec and the students of Cormon's atelier, *Parodie du 'Bois sacré' de Puvis de Chavannes*. New York, Henry and Rose Pearlman Foundation, Inc.

pigs beside him. Wattenmaker and Joyant recognized that the source for this last figure was Puvis's *The Prodigal Son*, which critics had received sourly at the Salon of 1879, and Wattenmaker added the second important observation that the inscriptions on the prodigal's canvas, 'Mackay' and 'Meissonier', referred to a recent incident in which Mackay rejected a portrait he had commissioned from Meissonier.[110] The *Parodie* seems to say, in essence, that at this stage of his career Lautrec held nothing sacred in art, not even the greatest triumph of the Salon, and in this it is the visual counterpart of his critical writings of 1883.

The traditional interpretation of the *Parodie du 'Bois sacré'* echoes the traditional interpretation of the writings, that Lautrec was making an anti-academic declaration—that the painting constituted yet another rejection of academic idealism and a further manifesto in support of avant-garde Realism. In this view, the *Parodie* brought to a climax the young Lautrec's supposed break with Cormon in 1884, and afforded additional evidence of the precociousness of his revolutionary stance.[111] The usual assumption is that the rowdies in contemporary dress are a band of Lautrec's new Montmartre friends.

This standard interpretation, however, is compatible neither with Lautrec's own conservative orientation at this time nor the attitude of most of the contemporary progressive artists toward Puvis.[112] They admired his reductive, abstracted style, and did not regard him as the epitome of reactionary art. Because progressive painters of the 1880s generally esteemed Puvis, a few modern writers have taken exception to the usual interpretation of the *Parodie* so far as to argue that Lautrec intended it as a homage to Puvis as a hero of the Symbolist generation, and not a pure satirization.[113] This interpretation, nevertheless, was based on the same assumption that underlies the traditional interpretations—that is, that, by 1884, Lautrec had attained his mature, progressive artistic stance, and the *Parodie* reflected it. Where it departed sharply from the traditional position was in treating Lautrec as, essentially, a Symbolist who liked Puvis's flat, simplified style and perhaps also his literary subject. In the more usual interpretation, he was a Realist expressing his disdain for Puvis's mythological subject-matter and idealizing style. In reality, Lautrec was far from formulating a consistent anti-academic position in 1884. He strove for realism in his style, but still depicted literary and idealistic subjects. Whether or not he admired Puvis as early as 1884, and, if he did, for what reasons, can only be conjecture.[114] The target of his irony in the *Parodie*, as in his 'reviews' of the previous year, remains ambiguous.

Gauzi did not arrive at Cormon's until a year or more after the creation of the *Parodie*, but his account is more nearly a witness report of how the painting came about than any other. It seems to prove that the parody was a prank rather than a protest, and may not have been the work of Lautrec alone. According to Gauzi, *Le Bois sacré* stimulated great student interest at the atelier because of the heated commentary it had generated not only in the world

[110] Wattenmaker, 98; Joyant, i. 74.

[111] See esp. Perruchot, 87; Cooper, 23; and M. Schapiro, 'New Light on Seurat', *Art News*, 57 (Apr. 1958), 45.

[112] Rewald, *Post-Impressionism*, 151, notes this contradiction. On the general admiration of Puvis by progressive artists at this time, see R. Goldwater, 'Puvis de Chavannes: Some Reasons for a Reputation', *The Art Bulletin*, 28 (Mar. 1946), 33–43; and Wattenmaker.

[113] Dorival, i. 210–11, and Boime, *Couture*, 493.

[114] Gauzi, 39, noted Lautrec's admiration for Puvis at the Salon of 1887 and Lautrec's acquaintance of the 1890s, W. Rothenstein, *Men and Memories* (New York, 1935), 66, said that Lautrec 'looked upon Puvis de Chavannes as the greatest living artist'.

of art but among the public. The parody became, as Lautrec related the circumstances to Gauzi in 1886, a group project of the students at Cormon's: 'We did it . . . at Cormon's, to amuse ourselves; part of the atelier worked on it.' Gauzi wrote:

The medal of honour, awarded to Puvis de Chavannes, two years earlier, in 1884, had provoked impassioned discussions amongst Cormon's pupils. Some wanted to see in that decoration the dream of a poet, the calm serenity of art surpassing the material; others made fun of the flat tones, the contours that isolated the figures from the landscape and the simplified drawing.

It's too facile, they said. And to prove it, in two afternoons, they made the parody of the painting! Lautrec signed for all of them. It was he who led Cormon's atelier to the Muses, in the parody. Alongside Maisonneuve, who bows, displaying his blond beard, he represented himself, turning his back and, in a disobliging manner, showing his derrière to the Muses.

It didn't at all embarrass him to contradict himself, for he is far from having completely disdained them [the Muses]. . . . Moreover, this parody of *Le Bois sacré* had only been an amusement in which one can discover a homage as well as a critique.[115]

If the *Parodie* made a critical statement about Puvis, therefore, it would have pertained to style. The flat, simplified, abstract quality of the original *Bois sacré* could have aroused the disdain of an academic Realist: it was much at variance with what Cormon taught, and it seemed to lack *métier*. In this sense the *Parodie* might have represented an espousal of Realism. In terms of subject, on the other hand, Lautrec at this time was painting realistically out of doors and, simultaneously, doing idealized work in the atelier—so he did not have a negative attitude towards idealistic subject-matter and may simply have felt ambivalent, as Gauzi implies.

In all probability, the art and profession of painting itself—not *Le Bois sacré* or Puvis's style or subject-matter—was the principal butt of the humorous commentary in the *Parodie*. Puvis had painted *Le Bois sacré* as an allegorical tribute to the varieties of creative inspiration. Lautrec and his fellow students did the *Parodie* with alterations that redirected the focus of Puvis's subject-matter to the art of painting and its attributes. The references to the earlier Puvis painting of the *Prodigal Son* and the Meissonier portrait (paintings that had unfavourable receptions); the transformation of the ragged prodigal into an artist and the equation of his isolated figure with the muse of tragedy; and, finally, the prodigal gang of art students clamouring for admission to the sacred grove, yet without doing homage to the deity of painting: all these appear to be complementary images. Lautrec and his fellows at Cormon's perhaps intended to comment on painting in their day as the prodigal among the arts, an outcast, subject to assaults by critics and connoisseurs alike. Whereas Puvis's scene is one of harmony, the *Parodie* vividly contrasts the bedraggled painter, his pigs at his side, and the rowdy art students—i.e. the 'real' artists—with the serene, idealized muses and deities existing on some higher plane. It is significant that the young men invading Puvis's tranquil setting represent the students of Cormon, and not the Montmartre crowd of Lautrec's later associations.[116] His world at this time remained largely that of the atelier. Mere youthful

[115] Gauzi, 116–17.

[116] Cate and Boyer, 11, identify two figures near the head of the procession as the poet Maurice Barrès (wearing a top hat) and the writer Dujardin (with blond beard). Cate's identifications are based on portraits of the 1890s of these two men by Lautrec and Steinlen. It seems to me that the figures in question can much more plausibly be identified with individuals in photographs of Cormon's atelier. Gauzi proves to have been a generally reliable

irreverence, much like that in his written reviews, most plausibly explains the motivation behind the *Parodie*. Joyant probably came closest to the truth when he described the painting as evidence of 'the disrespect . . . that indicates the preoccupations of the youthful who have not yet completely understood things'.[117] Artists, critics, and the Salon-going public were poring over *Le Bois sacré* with deadly seriousness. Wittily, and perhaps somewhat cynically, Lautrec and the other students prankishly directed their humour at a work that their elders, both conservative and progressive, seemed to take too seriously. The *Parodie* did not represent a doctrinaire statement of Lautrec's artistic position or portend his mature artistic stance— Realist or Symbolist.

'The direct and prolonged observation of the model': Cormon's Atelier, Late 1885—Early 1887

The memoirs of Lautrec's fellow students and his own letters confirm his continued attendance at Cormon's from late 1885, through 1886, and even into the early months of 1887. Lautrec wrote to his mother in the spring of 1886 that 'Cormon was satisfied with my work on Sunday. The competition will be judged on Wednesday.'[118] Even if he composed his letters in ways calculated to please his mother, as Joyant contended, other evidence corroborates that he none the less remained a serious academic student. François Gauzi, the day he entered the atelier in October 1885, found Lautrec there not only working assiduously at art, but also as student leader, or *massier*, in charge of posing the model, collecting tuition fees, and keeping the other students in line.[119] According to Gauzi, Lautrec began at Cormon's early in 1883 and remained there four years at least, 'au moins', that is, through 1886 and possibly into 1887.[120]

Émile Bernard met Lautrec when he entered the atelier for the 1885–6 academic year; he was ejected by Cormon for insubordination in the spring of 1886, but apparently returned that same autumn, either as a student or a visitor.[121] Lautrec's friendship with Vincent van Gogh must have begun about this same time. Van Gogh arrived in Paris in March 1886 and entered Cormon's studio in late spring; probably he and Lautrec first became acquainted there.[122] Bernard, in his little-known reminiscence of Lautrec, recalled that when he returned to Cormon's in the autumn of 1886, he practised with Toulouse-Lautrec and van Gogh. Van Gogh, he said, 'worked without slackening in the morning after the nude model, with the students', but in the afternoon he worked from plaster casts of antique gods in the nearly

(cont.) reporter. None the less, his statement about the *Parodie* (and my interpretation) does not preclude the possibility of the presence of friends of the students in their procession.

[117] Joyant, i. 74.

[118] H. Schimmel, no. 125, 100. Another letter of the spring of 1886 mentioned Cormon; see no. 126, 100–1.

[119] Gauzi, 16–20. On the role of the *massier*, see Hartrick, 49, and Boime, *The Academy and French Painting*, 49. Lautrec had

previously been offered this job, during the summer of 1884, but had refused it. See H. Schimmel, no. 93, 78–9.

[120] Gauzi, 16 and *passim*.

[121] W. Jaworska, *Gauguin and the Pont Aven School*, trans. P. Evans (New York, 1972), 13. See also Bernard's own archives in *Cahiers d'art documents*.

[122] Rewald, *Post-Impressionism*, 20–3, 26–30. See also Gauzi, 28–32, and van Gogh, ii. 515, for the date of van Gogh's entry into Cormon's.

empty studio, 'where there was no one but him, Toulouse-Lautrec, Anquetin and me'.[123] Gauzi emphasized how steadily and seriously Lautrec worked in this period to master the conventional exercises at the atelier. He 'arrived at Cormon's every morning, regularly, a little after nine', and 'always seated in the first row . . . he seemed to apply himself, scrupulously, to copying the model'. The 'direct and prolonged observation of the model', continued Gauzi, was to Lautrec, 'as to everybody, indispensable'.[124]

The Englishman A. S. Hartrick also found Lautrec working diligently at Cormon's at the time of his own entry in mid-November 1886, at the start of the new school year. 'In fact', he wrote, 'I had a photograph of him with others in the studio, taken some months later while I was there.'[125] Presumably 1887 was the year of the photograph. Finally, one of Lautrec's own letters datable to spring 1887 unequivocally links him to Cormon. 'We presented Cormon with a ridiculous silver palm which he received with much emotion', Lautrec reported to his mother. Cormon's students gave him the palm to celebrate his winning a silver medal at the Salon that year for his *Vainqueurs de Salamine*.[126] When Lautrec saw the painting at the Salon he reportedly declared, 'If he wins the big medal, we will also offer him a silver gilt palm.' Gauzi, the witness to this scene, wrote in his account that Lautrec kept his word.[127] Circumstances, therefore, strongly seem to place Lautrec in Cormon's circle of students and friends at the late date of 1887.

Gauzi's account provides some insightful descriptions of the interplay of pressures and influences upon aspiring young art students of the time and the bewildering situation with which a rapidly changing art world confronted them. The very 'prudent', said Gauzi, had only the Salon as an immediate goal, 'and by this means to arrive at the professorship, at the well paid portrait, at the painting commissioned by the state, that which promised to "put a little butter on the spinach"'. But he went on to say that others, while not wishing to disavow or repudiate their masters, refused 'to imitate them indefinitely; it was necessary to search for one's own personality, to go ahead, to find new means of expression'. No doubt he was making a personal as well as a general observation when he wrote about how the students at Cormon's were 'tormented, tossed about in every sense' because of the confusion of influences that surrounded them in their 'epoch' and 'milieu'. Manet had recently died, but Degas, Renoir, and Cézanne 'were quite alive'. Even a former winner of the Prix-de-Rome, Besnard, exhibited at the Salon the painting of 'a woman half blue, half yellow . . . that in spite of its excessiveness was repudiated by the Impressionists', who denounced him as 'a false brother'. In the Louvre, Gauzi continued, Manet's Olympia was like a 'pendant' to Ingres's Odalisque, and, 'there was plenty to disquiet the young and to make them hesitate'.[128]

The evidence of participants such as Gauzi, Hartrick, and Bernard suggests that Cormon created an atmosphere in his atelier that was conducive to experimentation, though he did not actually promote it. Hartrick in particular believed that the progressive experiments of students

123　É. Bernard, 'Des relations avec Lautrec', 13–14.

124　Gauzi, 23–4.

125　Hartrick, 48; see also 91. Hartrick reproduced the photograph in a drawing dated 1888 and published it in his book along with a portrait he made of Lautrec around 1886–7.

126　H. Schimmel, no. 141, 112–13, n. 1. Goldschmidt and

Schimmel, no. 72, 92, n. 1 erroneously placed this letter in spring 1885 on the mistaken assumption that Cormon won a medal at the Salon that year. Schimmel has recently redated it to spring 1887.

127　Gauzi, 40.

128　Ibid. 26–7.

like Lautrec, van Gogh, Bernard, and Anquetin evolved naturally out of the ambience of the atelier. Hartrick found all four of them engaged in radical ventures at the time of his arrival at Cormon's, but still in faithful attendance; Anquetin, one of the most adventurous, remained with Cormon until 1888.[129] Both Gauzi and Hartrick projected a scene in which a group of remarkable young talents searched for their own 'means of expression', as Gauzi said, but at the same time freely acknowledged the value of the academic training they were receiving, particularly in drawing. Gauzi explained:

At Cormon's atelier, the influence of the Impressionists remained discreet; the students who underwent this influence, contented themselves to draw in the atelier, reserving their new researches, for their studies done on their own, unknown to the 'boss'. Under the direction of the master, accepted quite willingly, everyone worked without worrying about anything else other than learning how to manage with plumbs, proportions, foreshortening and values.

It was necessary first to learn to draw, upon that everyone was in agreement, then each one would choose his route . . .[130]

Gauzi noted in his account that in painting as well as drawing Lautrec adhered to academic practice, at least when he was under Cormon's eye, well past 1885. 'Almost always', wrote Gauzi, 'Lautrec contented himself to draw. When he desired to paint, he fixed, after the boss's correction, a sheet of tracing paper over his charcoal study and he painted utilizing the transparency.'[131] As late as the spring of 1887, though he claimed to disdain the annual Salon, Lautrec was not yet ready to spurn it. He submitted a sedate still life in 'black and ochre' to prove that he could easily work in a manner acceptable to the jury (which nevertheless rejected his entry).[132]

Lautrec's atelier work began to become increasingly distinct from his more experimental work by late in 1885, but nevertheless remained interwoven with it chronologically. As the reports of his fellow students have shown, he continued in his later years at Cormon's to work conscientiously at the atelier even while independently, outside it, he was exploring some of the progressive trends in the art world of Paris. By this time he had become disenchanted with conventional, academic subject-matter. His new friend Gauzi related: 'He disdained the subjects of the sketch, borrowed from the Bible, Mythology and History, which were recommended by the "boss": according to Lautrec one ought to leave the Greeks to the Panthéon and the firemen's helmets to David.'[133] All such sketches therefore belong to the previous period of his academic study. But he had entered a time of transition when he still felt the value of the traditional academic exercises of drawing and painting from casts and the living model.[134]

Undoubtedly Lautrec did a portion of his drawn and painted *académies* in the period 1885–7 as the product of his sessions at Cormon's even as he moved into the avant-garde on his own. The traditional placement of a disproportionately small number of drawings in these years, were it correct, would indicate that Lautrec nearly abandoned drawing as he embraced

[129] Sherard, 85–90. See also Centre Régionale de Documentation Pédagogique, *Exposition Anquetin* (exh. cat., Bordeaux, 1965). [130] Gauzi, 22.
[131] Ibid. 24–5. [132] Ibid. 33–7.
[133] Ibid. 25–6. [134] Ibid. 24.

Impressionism.[135] The witness accounts, however, show that Lautrec's preoccupation at the atelier was drawing; moreover, even while he and his fellows experimented with radical art in their free time, they attached no less significance to Cormon's academic lessons. His drawn *académies*, done under Cormon, however, cannot be fitted into successive time periods with any precision because no conspicuous development differentiates them stylistically. It is tempting, however, to speculate that he made at least some of his studies of the plaster casts also drawn by van Gogh, while the two artists worked together in the atelier during the autumn of 1886, as Bernard suggested in his reminiscences. And at least one of Lautrec's *académies* of a nude couple can be attributed with certainty to the later years at Cormon's, because Bernard drew the same two figures, identically posed, but viewed from a different angle. Presumably the two young artists worked on these drawings on the same day in late 1885 or 1886.

It has been claimed that Lautrec eventually burned a number of paintings from his latter period at Cormon's, leaving scant evidence of his academic work of this time. Among the small number of surviving painted *académies* are two half-length male nudes (e.g. Fig. 55) of the kind he might have entered in the competitions mentioned in his letters. They are more finished than his *ébauches* of *c.*1883–4, and would have been appropriate for the *demi-figure peinte* category of judging.[136] The predominantly sombre palette of grey-brown tones and the poses of the models were typical of conventional painted *académies* of the period, but these torsos also demonstrate the advancement that Lautrec had made in his studies by *c.*1886. His strong modelling of the dramatically lighted figures shows especially his mastery of chiaroscuro. This obvious technical progress alone serves to date the two *demi-figure* paintings among Lautrec's later academic works, but, in addition, the model for one of them (Fig. 55) held the same pose in which Lautrec painted him for a class photograph taken at Cormon's *c.*1886 (Fig. 56).[137]

By late 1885–7, many of his paintings showed the effects of his exposure to more progressive stylistic trends, but two portraits still manifested an essentially cautious tonal range and conservative style that stemmed from the atelier and Cormon's influence. One is *Émile Bernard* (Fig. 57), which Bernard's own writings date in 1885–6.[138] The other is *Jeanne Wenz*, a painting of the sister of a fellow pupil, which is datable to late 1885 through a letter in which the artist referred to 'the portrait of one of my friends' beautiful sister'.[139] In these pictures, Lautrec created sensitive, sober likenesses suggestive of the academic *tête d'expression*

135 Dortu attributed a total of 924 drawings to the years 1881–3 and scores of others to 'about' 1880–2, but only 186 to the entire period 1884–7: 4 to 1884, 82 to 1885, 4 to 'about' 1885–6, 68 to 1886, and 28 to 1887. See Appendix A for redistribution of these drawings over the period 1882–7.

136 On the *demi-figure peinte* see Boime, *The Academy and French Painting*, 41.

137 Rewald, *Post-Impressionism*, 21, correctly sets the photograph *c.*1886. Dortu's date of 1883, Ic137, is impossible since both Gauzi and Bernard appear in the photograph. The photo is dated 1885 by Perruchot, but his date probably is also incorrect, because Lautrec has a beard, which he evidently did not grow until very late in 1885 or 1886. He refers to it proudly in a letter of the spring of 1886 in H. Schimmel, no. 124, 99–100 and in his

New Year's greetings of Dec. 1885 or Jan. 1886, nos. 122, 98; 123, 98–9. See also no. 122, 98 which Schimmel has recently redated to Dec. 1885. Hartrick's representations of Lautrec, made in late 1886 or 1887, show him with a beard. Atelier photos of Lautrec made *c.*1885 (Bernard's presence precludes an earlier date) show Lautrec beardless. See Goldschmidt and Schimmel, illus. no. 24, no. 26.

138 É. Bernard, 'Des relations avec Lautrec', 13–14. NB Bernard recalls sitting for the portrait in the studio on the rue Tourlaque. If this is the same as the studio at 27 rue Caulaincourt (corner of rue Tourlaque), which Lautrec did not rent until late 1886, the portrait could not have been done before that date. Cf. Adriani (Tübingen), 62.

139 H. Schimmel, no. 117, 95.

55. Henri de Toulouse-Lautrec, *Académie d'homme nu*.
Paris, private collection.

56. Below: *The Atelier Cormon in 1886 or 1887*.
Photograph. Albi, Musée Toulouse-Lautrec.

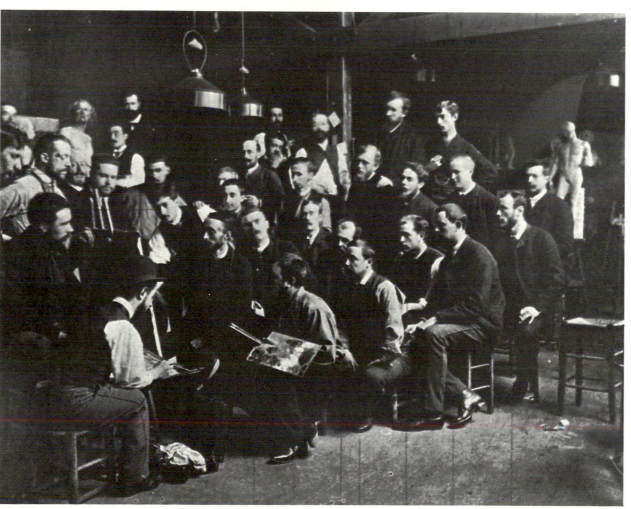

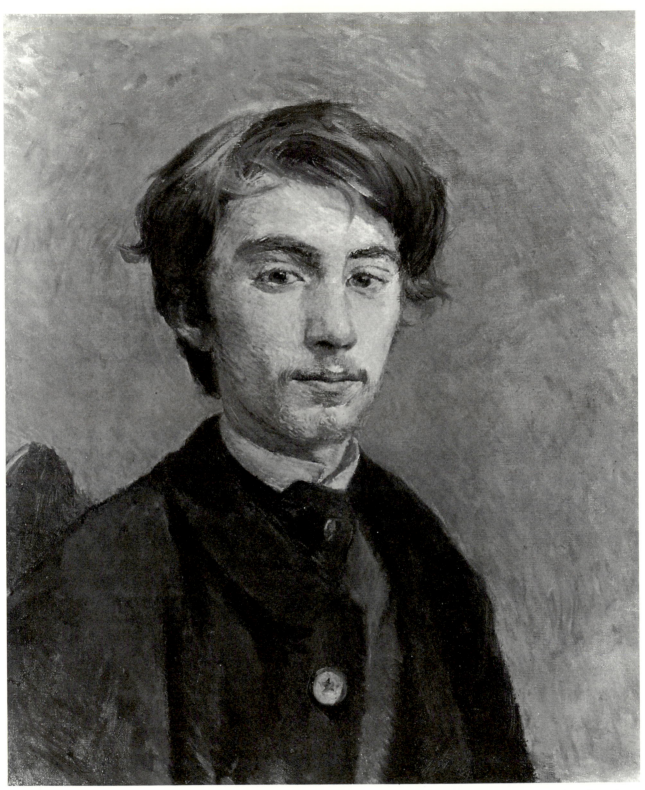

57. Henri de Toulouse-Lautrec, *Émile Bernard*. London, Tate Gallery. (Photo, Art Resource, New York). *See also colour plate.*

competitions for which students did portraits with emphasis on character depiction and facial expression. Both works display the dark-toned palette and greenish brown shadows of academic Realism, but not its polish and surface smoothness. Their sketchy execution, as well as their lighter blue highlights, places them more within the realm of *juste milieu* Realism and renders them illustrative of the tolerance that Lautrec experienced under the tutelage of Cormon. During this latter part of the time he studied at the atelier, he was making a gradual commitment to the more advanced kind of Realism in both style and subject-matter that prepared him to turn at last to progressive trends in art.

Whatever his other interests, Lautrec did not entirely abandon his interest in academic success in conventional terms during his last years at Cormon's. He continued to visit the Salon, as Gauzi recalled. He also participated in student competitions as late as the spring of 1886—but apparently with little success, which invites speculation that his disappointments over these contests helped lead him away from official art. In any case, in the course of his prolonged academic study he had mastered what Cormon had to offer him, i.e. conventional drawing techniques, and he was now prepared to absorb lessons of a rather different kind from those offered in his master's atelier.

The long period that Lautrec spent at Cormon's is undoubtedly attributable to the importance that he himself placed on technical perfection in drawing. Like van Gogh and others of his post-Impressionist generation, he evidently felt that it was crucial to draw well, and the intensive training in draughtsmanship and the human figure that he received from Cormon was to prove decisive to his mature development and a determining factor in his lifelong stress on line. Lautrec had not yet developed an original graphic style when he left Cormon's, but his meticulous and competent drawings show his thorough command of his academic lessons. Eventually he put the technical skills of foreshortening and manipulating line that he learned at the atelier to different uses in other contexts than Cormon intended, but the original lessons never lost their validity for him. His mature art was to wed the traditional drawing and preparatory techniques of his atelier training to a contemporary vision and style and a modern subject-matter.

3

Escaping the Atelier 'while he was still working there'

First Forays into the Avant-Garde, Late 1885–1886

DURING the mid- to late 1880s, Lautrec had his first experiences with the progressive trends that eventually proved critical to his formation of a distinctive personal style and thematic content. It was a period of experimentation, during which he probably shared the disquiet of his friend Gauzi over the perplexing variety of choices available to a young artist. Rapidly he embraced a series of the emerging new styles in painting, assimilating some elements and discarding others. The effect from the historian's standpoint was to confuse the picture of how his artistic style evolved, and to complicate the problem of arranging a chronology of his works of the period. Adding to the difficulty, he dated few of his canvases: none in 1886 or 1887, one in 1888, three in 1889.[1] But the apparent disorder belies the actuality. Lautrec's progressive experiments followed a logical sequence, which analysis of his stylistic development helps to establish and documentation relevant to his milieu greatly clarifies.

Lautrec shifted toward the avant-garde only gradually, in a step-by-step transition that is traceable from his increasingly bold essays with impressionistic devices in 1886 through a series of experiments with more advanced approaches in 1887 and 1888. There was no abrupt break with his formal training. He maintained his attachment to Cormon's atelier and the academic practice there throughout 1886 and probably into the spring of 1887. When he first turned toward progressive art, it occurred quite naturally within the setting of the atelier while he continued to produce conventional portraits and *académies*. This coincidence of contrasting modes makes plotting the chronology of his works of this transitional period still more complex. So does a third aspect of his activity. During this same period, he was establishing a career as an illustrator, publishing in 1886 his first drawings in the popular journals. Popular illustration was instrumental in his choice of new themes and the way that he treated them. He now created his first representations of what was to become his preferred subject-matter: first, modern urban entertainments—the ballet, circus, dance-hall, and *café-concert*; and second, marginal types from the depths of society—the prostitutes, alcoholics, and impoverished workers. In singling out such themes, he announced his embrace of urban

[1] There is an imbalance in the standard chronology for these years. Joyant, i. 261–8, placed 67 paintings in the years 1886 to 1889, but fewer than one-third of them in 1886 and 1887. Dortu assigned over 90 paintings (P260–P354) to this period, but only 31 of these to 1886 and 1887. Also, both set works similar in style years apart and grouped together works of varied styles, and neither attributed any *plein-air* works to the period 1886 to 1888, despite witness accounts to the contrary.

Realism and Naturalism. These developments, along with his growing personal alliance with the world from which his subjects came, contributed to his approaching break with the establishment.

No evidence exists that Lautrec took an interest in avant-garde art before late 1885 or early 1886, when Gauzi and Rachou observed his early progressive essays. Beyond that time, he still moved slowly in the new direction. During the latter part of 1885 and at least during 1886, while he remained at the atelier, progressive trends appeared in his work, but ran parallel to the conservative ones. And some of the conservative elements persisted throughout 1887 and 1888. One consistent thrust did characterize this period: his interest in realism. In style he maintained his desire to represent external reality accurately, but experimented with new, more radical means to attain visual realism. In subject he added the egalitarian perspective of the progressive intellectual and artistic circles of the day, and adopted their unsentimental, even pessimistic, view of the poorer classes of society. In effect, he was moving from academic and *juste milieu* Realism to avant-garde Realism.

New Stimuli: 'So "outside the law"'

The stimuli that Lautrec was beginning to be receptive to in late 1885 and 1886 ultimately displaced the more conventional expectations of family, social class, and the art establishment to which he had thus far conformed. These new influences came both from within Cormon's atelier and outside. According to his pupils, Cormon often took an almost indulgent view of their experiments in progressive art, and even Émile Bernard conceded that at Cormon's 'everyone worked as he wanted to' (though he implied that students avoided the master's critiques).[2] The 'spot' painters, or 'intransigeants', of the avant-garde left Cormon 'amused and contemptuous', noted Hartrick, but a relatively tolerant atmosphere prevailed in his atelier.[3] Cormon extended particular freedom to Lautrec, according to Gauzi, perhaps regarding him 'as a pupil apart, gifted at caricature, to whom high art was forbidden, and who must be allowed freedom to follow his fantasy'.[4] In the autumn of 1885, when Gauzi entered Cormon's, Lautrec was drawing caricatures that 'were so far from the technique taught at the École des Beaux-Arts of Toulouse, which I had just left, that I was astonished by the indulgence of the author of *Cain* [Cormon]'.[5] Hartrick also observed that when Lautrec made 'novel' works, Cormon 'was quite interested in what he was doing and left him alone'.[6] In the milieu at Cormon's, where diversity could flourish up to a point, Lautrec had begun to identify with the avant-garde—which ultimately was to lead him to abandon the traditional avenues of success and seek his fortune by exhibiting with the 'intransigeants' and selling through their dealers.

However tolerant Cormon generally was, from late 1885 onwards a revolution was rising at the atelier. More and more, Cormon's most adventurous students felt the attraction of avant-garde art and grew less attentive to the master. Bernard thought that 'a wind of revolt'

[2] É. Bernard, 'Louis Anquetin, artiste peintre', 591.
[3] Hartrick, 33. See also Gauzi, 30–1.
[4] Gauzi, 25.

[5] Ibid. 16–17.
[6] Hartrick, 92.

was already abroad when he entered Cormon's, and that it came from the Durand-Ruel Gallery, where the Impressionists exhibited. Anquetin, Bernard, Lautrec, and Tampier visited Durand-Ruel's frequently during late 1885 and 1886 (though admittedly they admired Velasquez, Michelangelo, and Signorelli at the Louvre with equal enthusiasm),[7] and in 1886 Anquetin transformed his palette in imitation of Monet.[8]

The accounts of his students show that some time in the middle part of 1886 the growing radicalism within Cormon's atelier had become offensive to him. It may have been that a number of his students, now beyond Impressionism and newly influenced by Neo-Impressionism, strayed further than he could accept from the academic techniques that he taught. Perhaps they brought their experiments into the atelier and challenged him with them. The mounting crisis probably led to the eventual estrangement of his more progressive, possibly his most talented students. Hartrick reported on a crucial turn of events during the spring of 1886: 'Anquetin, Cormon's best pupil who had painted and had on the walls some very powerful studies, rather in the manner of Courbet, quite orthodox *académies*, which would have won medals in any school, turned "intransigeant": that is he went over to the advanced section of the "pointillists" led by Signac and Seurat and carried most of the studio with him.' Shortly thereafter, Émile Bernard, 'a young pupil in whom Cormon took an interest', provoked a commotion that moved Cormon to expel 'all the more aggressive students' and temporarily shut down his atelier. In Hartrick's words:

Cormon came around one morning, as usual, to find Bernard painting the old brown sail that served for a background to the model, in alternate streaks of vermilion and vert veronese. On asking the youth what he was doing, Bernard replied, 'that he saw it that way'. Thereupon Cormon announced that if that was the case he had better go and see things that way somewhere else. . . . Bernard was religiously carrying out this experiment on the theory that, put down side by side, in spots or streaks, these colours at a distance would combine and make a grey to the eye. But immediately, 'the fat was in the fire'. Someone, I forget whom, told Cormon he was an old Academician, hidebound with prejudice, and that he was interfering with genius in the bud. In short, there was a great uproar. . . .[9]

The rebellious group included Lautrec and van Gogh, but when the studio reopened in the autumn, 'some of the former pupils had been permitted to return', and Lautrec was among them.[10]

Bernard confirmed that a movement toward radicalism was growing among Cormon's pupils in 1886, although he depicted himself, rather than Anquetin, as leader of the rebellious faction. He recounted that as he formulated his own anti-academic ideas about art, he spread them throughout the atelier, declaring that academic teaching had no foundation, arguing that 'the theory of colour' and 'the verity of observation and of sentiment' of Impressionism were superior, and urging his fellow students to follow theory and nature in order to become 'personal painters'. Bernard gave the following account of the crisis: 'I had just painted for

[7] É. Bernard, 'Louis Anquetin, artiste peintre', 591; and É. Bernard, 'Notes sur l'école dite de "Pont-Aven"', *Mercure de France*, 12 (Dec. 1903), 675.

[8] Bernard, 'Louis Anquetin, artiste peintre', 593–4.

[9] Hartrick, 42–3. Since Hartrick did not begin at Cormon's until autumn 1886, he probably heard about these events from

J. P. Russell, an Australian student at the atelier, who introduced Hartrick there. See Hartrick, 38–9. Hartrick wrote that these events happened in the summer, but spring 1886 is a likelier date since Bernard left Paris in Apr. on a walking tour of several months in Brittany, following his ejection by Cormon.

[10] Hartrick, 48.

the first time at the atelier [previously he had only done drawings] and my study, being too Impressionist, had put him [Cormon], in a fury. I was the first who dared bring colour theory through the doors [of Cormon's atelier]. It was made known to my father that I was sowing disorder and that he should withdraw me.'[11] Both Hartrick and Bernard made it evident that by mid-1886 Cormon's more adventuresome students were deserting his teachings. Hartrick associated Lautrec, van Gogh, and Anquetin with this group. Lautrec himself, in letters he must have written during this period, told his mother enthusiastically: 'Long live the revolution, long live Manet! . . . a wind of Impressionism is blowing through the atelier';[12] and wrote to his grandmother: 'I would like to tell you a little about what I am doing, but it is so special, so "outside the law". Papa, of course, would call me an "outsider".'[13]

At the same time as Lautrec was responding with exhilaration to the stylistic revolution at the atelier, he was also assimilating some of the more up-to-date thematic developments in Realism. The Realist and Naturalist ethos retained its vigour throughout the 1880s regardless of the emergence of Symbolism, the movement more widely identified with the art of the decade. A widespread predilection for naturalistic subjects in the arts of the period reflected the enduring influence of the Realism that had dominated French art and literature from the 1840s until the early 1880s, and of its offshoot, Naturalism. Naturalism, which grew out of Realism in the 1870s and overlapped it, was generally harsher, cruder, less compromising, and more pessimistic, its representations frank and unsparing.[14] It dwelt on modern life in its gloomier and more depressing aspects, commonly at the lowest levels of society, and often at its most sordid and raw. It permeated the contemporary fiction of novelists such as Huysmans and Zola, the popular songs and illustrated journals of the day, and the paintings of a number of followers of Degas. Among the more progressive younger painters, not only Lautrec but the entire group of radical students at Cormon's experimented with its subject-matter at least for a time. Such subjects were part of their evolving concept of modernity in art. Although a distinction is not always made between Realism and Naturalism in the visual arts as it is in literature,[15] in so far as its choice and treatment of subjects paralleled the Naturalist literature of the 1880s, the work of all these artists fulfilled the meaning of 'Naturalism'.

One perceptive historian, Eugenia Herbert, has attributed a renewed vitality in Realism and Naturalism during the late 1880s and 1890s to the surge of social and political awareness which arose, in response to contemporary egalitarian social movements, among writers and artists—hence the less impersonal and more socially conscious and humanistic, more

[11] É. Bernard, 'Des relations avec Lautrec', 13–14. See also Bernard, 'Louis Anquetin, artiste peintre', 593–4; cf. Hartrick, 43–5; and Rewald, *Post-Impressionism*, 20–1 and 71 nn. 20, 21.

[12] Quoted in F. Carco, *Nostalgie de Paris* (Geneva, 1941), and incorrectly attributed by him to 1879.

[13] Dortu and Huisman, 48. Excerpt from an unpublished letter (H. Schimmel collection), datable to Dec. 1886. [H. Schimmel, no. 137, 107.]

[14] On Naturalism, see R. M. Stromberg, *Realism, Naturalism and Symbolism: Modes of Thought and Expression in Europe, 1848–1914* (New York, 1968), pp. xix–xxii; P. Martino, *Le Naturalisme français, 1870–1895* (Paris, 1923); and F. W. J. Hemmings, 'The Origin of the Terms *Naturalisme, Naturaliste*', *French Studies*, 8 (Apr. 1954), 109–21.

[15] Émile Zola identified Impressionism with Naturalism. See e.g. 'Le Naturalisme au salon' of 1880, in F. W. J. Hemmings and R. J. Neiss (eds.), *Émile Zola salons* (Geneva, 1959), 233–54. More recently G. Weisberg has attempted to make a historical division between Realism and Naturalism in art, distinguishing as Naturalist those works done after 1870: G. P. Weisberg, *The Realist Tradition: French Painting and Drawing, 1830–1900* (exh. cat., Cleveland Museum of Art, Cleveland, Ohio, 1980). See also G. Lacambre, 'Toward an Emerging Definition of Naturalism in French Nineteenth-Century Painting', in *The European Realist Tradition*, ed. G. P. Weisberg (Bloomington, Ind., 1982), 229–41.

anti-bourgeois attitudes of this new phase of Realism, as compared to its antecedents. Democratic sentiments led to the new focus on the misery and injustice suffered by the poor, and the treatment of the seamy side of urban living: the *déclassé* types, the workers, the dispossessed, the 'hitherto unrepresented aspects of the modern city'.[16] Some of the adherents of later Realism and Naturalism embraced radicalism in politics;[17] others, like Lautrec, remained independent of political movements even though they developed the same interest in the lower classes as a subject-matter for their art. Possibly Lautrec reacted, indirectly at least, to the influence of his numerous new friends and acquaintances—among them Bruant, Steinlen, Fénéon, and van Rysselberghe—who sympathized with anarchism and socialism. Their point of view could have affected his choice of subjects without involving him politically. On the other hand, political radicalism was only one element in a general climate of 'daring and independence of mind' and Lautrec undoubtedly felt the wider impact of 'the complex pattern of urges toward liberation from social, moral and artistic bonds' in the France of the 1880s.[18]

Epitomizing this urge towards liberation, and possibly acting as the most important factor behind Lautrec's Naturalism, was the whole cultural and intellectual ambience of Montmartre, the Bohemian and working-class district of Paris where Lautrec lived and where Cormon's studio was located. Together with his fellow students he had begun to frequent its cafés and nightspots. In the 1870s Montmartre had been the cradle of the Commune, and in the early 1880s many Communards returned to it after their release from prison. When Lautrec became a *habitué* there, it still functioned as a centre of political ferment and many of the intellectuals who congregated in its cabarets inclined towards radical political ideas. At the same time, it was a rough and sinister area, which the purveyors of vice and the poor inhabited side by side. But Bohemians and radical artists and writers from the opposite end of the social scale also gravitated to Montmartre in search of freedom from society's strictures and its accepted artistic ideals. The district embodied anti-establishment values, independence, spontaneity, and revolt, all in contradiction and contempt of bourgeois conventionality.[19] Lautrec in the mid-1880s, just entering his twenties and in the process of liberating himself from a traditionalist family and art education, must have been highly susceptible, like many others, to the allures of this environment. 'I'm living a bohemian life', he announced to his grandmother in December 1886, but in anticipation of her disapproval protested that he did so 'against my will'. None the less he did express some genuine ambivalence about it at this time, explaining 'the fact that I feel hemmed in by a number of sentimental considerations that I will absolutely have to forget if I want to achieve something makes me all the more ill at ease on the hill of Montmartre'.[20] Its nonconformist atmosphere also promoted the growth of Montmartre as a

[16] E. Herbert, *The Artist and Social Reform: France and Belgium, 1885–1898* (Freeport, NY, 1971, repr. of 1961 Yale University Press edn.), 62–3, 144, 146–55, 155 ff. The existence of several chronological phases of Realism is pointed to by G. M. Ackerman in his review of L. Nochlin, *Realism* (Baltimore, 1971) in *The Art Bulletin*, 55 (Sept. 1973), 466–9.

[17] See R. Herbert and E. Herbert, 'Artists and Anarchism', *Burlington Magazine*, 102 (Nov., Dec. 1960), 472–82, 517–22.

[18] G. Woodcock, *Anarchism, A History of Libertarian Ideas* and *Movements* (New York, 1962), 304–6. See also C. Rearick, *Pleasures of the Belle Époque: Entertainment and Festivity in Turn-of-the-Century France* (New Haven, Conn., 1985), 47.

[19] See esp. R. Shattuck, *The Banquet Years: The Origins of the Avant-Garde in France, 1885 to World War I*, rev. edn. (New York, 1968), 26; also P. Jullian, *Montmartre*, trans. A. Carter (New York, 1977), 33–53 and *passim*, and G. Montorgueil, *Old Montmartre* (Paris, 1924), 47–9.

[20] Unpublished letter (H. Schimmel collection), datable to Dec. 1886; also cited in n. 13 above. [H. Schimmel, no. 137, 107.]

commercial pleasure centre, because, as Charles Rearick has pointed out, it provided 'an antidote to the pomposity and stiff class rules that reigned elsewhere. In its dance halls and cabarets Parisians could temporarily free themselves from inhibitions of everyday respectability and find normal forms of bourgeois behavior mocked or disregarded.'[21] The Montmartre night-life offered members of the middle class and the more daring aristocrats like Lautrec, many of whom also felt the urge for personal liberation from conventional moral and social constraints, the opportunity to participate vicariously in a 'naughty' world of risk, rebellion, and sexuality, normally associated with lower-class and marginal life-styles. They had already been introduced to such a world by the Naturalist novel, and had responded to it with enthusiasm.[22] Clever entrepreneurs and impresarios were quick to recognize and exploit the commercial potential of this phenomenon and by the end of the 1880s the most notorious and profitable night-time enterprises of Paris were concentrated on Montmartre.

In the mid-1880s this commercialization of Montmartre (and of the Naturalist aesthetic along with it) was just in a nascent phase; the transition from and subversion of an indigenous and spontaneous popular culture and Bohemia to a consumer-orientated one, 'packaged for bourgeois consumption',[23] had not yet been completed. Lautrec became involved with the Montmartre phenomenon early on and at the same time as he was attracted by its titillations, many of his naturalistically orientated works of this period also emphasize the district's originally progressive ethos and humanitarian orientation and seem motivated by a genuine, if naïve, social consciousness. By the early 1890s, however, he was creating numerous images with a changed style and tone that were direct products of the commercialization of Montmartre and of Parisian entertainment in general. His posters and lithographs especially were aimed at advertising and publicizing the entertainment industry and marketing it for middle-class male consumption by emphasizing more sharply the fantasy of its sexuality and freedom from respectability.[24] In any case, Montmartre of the 1880s, its journals, cabarets, songs, and artists, its complex and seemingly contradictory mixture of humanitarianism and titillation, provided the original inspiration for Lautrec's particular Naturalism.

Lautrec's new naturalistic subjects of this time and the Montmartre spirit with which he infused them coincided most closely with the tone of the popular periodicals in which many of them were reproduced and allied him to a circle of contemporary Realist illustrators and popular song-writers. Through the influence of this group, he first explored the thematic interests that ultimately became characteristic of his art. Lautrec's Realism has been associated almost exclusively with the example of Degas, whom in fact he greatly admired and deliberately emulated. But Degas affected Lautrec only indirectly at this early stage. Illustrators of the 1880s, including artists such as Jean-Louis Forain and Jean-François Raffaëlli who were direct followers of Degas, had incorporated many of his characteristic subjects and stylistic devices into their own work for the popular journals. Their published illustrations had a more immediate impact on Lautrec than the 'high' art of Degas himself. Lautrec found a large number of sources for his emerging urban themes in popular art and culture, and frequently borrowed them directly.

[21] Rearick, 62. See also J. Seigel, *Bohemian Paris: Culture, Politics and the Boundaries of Bourgeois Life, 1830–1930* (New York, 1986), 239–41.

[22] Rearick, 47, 62.

[23] Seigel, 239.

[24] Thomson, 'Imagery of Lautrec's Prints', in Wittrock i. 13–34.

By the early 1880s, the popular illustrated journal was a commonplace on the urban scene and represented a rapidly expanding industry.[25] It was not a new phenomenon, but it proliferated at this time as a result of two principal developments. First, the liberalized attitudes of the Third Republic led to new legislation permitting freedom of the press. The Law of 29 July 1881 abolished censorship, which had been in effect since 1835, and so extended a renewed right of expression to political and social satire and caricature.[26] Second, Charles Gillot developed new photomechanical techniques in the 1870s that allowed the inexpensive reproduction of drawings within the body of printed text.[27]

Illustration of a characteristic kind and outlook dominated much of the flourishing popular press in Paris, and especially on Montmartre, in the 1880s. Reinvigorated by the removal of censorship, the art of caricature—the term used loosely to designate most categories of popular illustration—found application not only to political commentary but especially to contemporary social life in the city. In essence, a new graphic art form developed. It was cheap and widely available at the popular level, and therefore—unlike the limited edition print—had no upper-class associations and was also innately suitable to social criticism. Hence, many journals ridiculed the aristocracy and the bourgeoisie and celebrated the everyday life and mores of the masses, empathizing with the exploited lower classes, whom they opposed to the predominantly capitalist ruling class of the Third Republic.[28] Many of the popular publications complemented this social consciousness with an assault on traditional French middle-class values, especially prudery and moralistic hypocrisy, and with the promotion in their stead of the hedonistic sensual pleasures of Parisian amusements.[29] This was notably the case with *Le Courrier français*, *Le Chat noir*, and *Le Mirliton*, the journals with which Lautrec was associated.

The journals themselves were of a wide variety, and each one tended to focus on a selected aspect of the contemporary environment. A new wave of young illustrators grew up who specialized in the 'democratic' subject-matter of popular life and *mœurs*. Steinlen, Ibels, Willette, Lunel, Heidbrinck, Raffaëlli, and Caran d'Ache were some of the best known. They were heirs to a tradition of caricature already established by the journalistic satirists of Daumier's time, but they now expanded and renovated it. These illustrators, in their attachment to the commonplace in the modern scene, popularized the interests of the Realist and Naturalist generation of writers and artists. The public, in response, bought the journals more for their numerous lively pictures—often ironically humorous, satirical, or racy—than for their texts, and regarded them with intense enthusiasm.[30]

[25] J. Lethève, *La Caricature et la presse sous la IIIᵉ République* (Paris, 1961), 5. See also. P. Roberts-Jones, *De Daumier à Lautrec: essai sur l'histoire de la caricature française entre 1860 et 1890* (Paris, 1960), p. xvii, and *La Presse satirique illustré entre 1860 et 1890* (Paris, 1956).

[26] Roberts-Jones, *De Daumier à Lautrec*, 9–19, 39–40; and Lethève, 45; also H. Avenel, *Histoire de la presse française depuis 1781 jusqu'à nos jours* (Paris, 1900), 766–8, and I. Collins, *The Government and the Newspaper Press in France, 1814–1881* (Oxford, 1959), 181–4.

[27] On the Gillot process, see Cate in P. D. Cate and S. H. Hitchings, *The Color Revolution, Color Lithography in France,*

1890–1900 (exh. cat., Jane Vorhees Zimmerli Art Museum, Rutgers University, New Brunswick, NJ, 1978), 4–6, 35 n.; A. Gowans, *The Unchanging Arts* (New York, 1971), 252; and P. D. Cate and S. Gill, *Théophile-Alexandre Steinlen* (Salt Lake City, Utah, 1982), 77–81.

[28] P. D. Cate, 'Empathy with the Humanity of the Streets', *Art News*, 76 (Mar. 1977), 56. E. Herbert also discusses the attitudes of the popular illustrators: 192–5, 62–3, 146–55, 160–79, 180–97 and *passim*.

[29] Rearick, 42–3, 97.

[30] Roberts-Jones, *De Daumier à Lautrec*, 10.

Many artists of the 1880s practised caricature while they also pursued careers in high art. It was both a means to earn a living and a way to win public recognition.[31] For Lautrec, caricature was first an acceptable sideline to his academic study, and later an alternate route to fame. Gauzi recalled that when Lautrec was 'almost unknown', he 'tried to place his drawings with the editors of the journals' less for money than to make a name for himself— journals were so widely read that a young artist might quickly gain a reputation through them.[32] The unorthodox works that Gauzi and Hartrick saw him producing at Cormon's *c.* late 1885–7 were probably newspaper illustrations, which he frequently prepared in painted form.

The popular illustration of the 1880s was possibly the single most important and tangible formative influence on the art of Lautrec. His very adoption of a career in illustration confirms its significance in his turn to Naturalist subjects in the mid-1880s and he was to maintain his interest in such subjects throughout his career, regardless of changes in his style. Even though he was later to specialize in just one facet of the typical subject-matter—the entertainment establishments of Paris—and to view it with his own individual attitude, his early illustrations none the less took up the content and the outlook of the illustrations in popular journals. Themes that have been considered Lautrec's in essence, which became hallmarks of his art, did not originate with him, but echoed the most commonplace subject-matter of the contemporary press. His great achievement would be to carry them into the realm of high art in his formal easel paintings, and to transform them both stylistically and emotionally into more expressive and eloquent images. Moreover, his journalistic illustrations of the 1880s were to evolve into his posters and graphic works of the 1890s, and eventually 'popular' and 'high' art were to merge in his work.

Progressive Work, Late 1885 and 1886

It was in late 1885 and 1886 that Lautrec made his first experiments with modern urban subjects and tried out some of the stylistic devices of avant-garde Impressionism. By late 1885, according to Gauzi, he was painting in matt, subdued colours on cardboard.[33] Hartrick, who came to Cormon's in 1886, a year later than Gauzi, reported that Lautrec then 'was painting in turpentine on cardboard, using a very liney method of drawing, showing the influence of Degas and also of Forain'.[34] Rachou added that Lautrec 'already manifested marked preferences for the art of Degas, of Monet and the Impressionists in general, so that he escaped the atelier even while he was still working there'.[35] His initial attempts at a progressive style were circumspect, just a step beyond the cautious modernism of the early peasant paintings. Lautrec made some highly tentative experiments with Impressionist colour during this period, advanced a little further stylistically in a number of *plein-air* works, and, most daring of all, executed two sets of wall decorations and several canvases with multiple figures, bold croppings, and oblique viewpoints.

[31] Ibid. 168–9. [32] Gauzi, 46–8. [33] Ibid. 25–6.
[34] Hartrick, 91–2. [35] Rachou, as quoted by Dortu and Huisman, 44.

He made his most radical departures initially in experiments with progressive, Naturalist subject-matter, which he mainly restricted for the time being to illustrations for the popular press and the paintings connected with them. In the autumn of 1885, Lautrec wrote to his mother that he had been trotting through the streets of a dark and muddy Paris 'after the musicians of the Opéra, whom I'm trying to charm so as to sneak into the temple of the arts and boredom'.[36] The letter is the earliest documentation of his developing interest in a modern subject-matter, the ballet and theatre. Writing later that autumn from Normandy (where he was the guest of Anquetin's parents), he told his mother, 'I hope you've sent my daub to the big newspaper.'[37] But probably not until 1886 did he produce his earliest works with theatrical subjects; and not until late 1886 was one of his illustrations published and his career as an illustrator actually underway. His gradual move away from the atelier began more or less with these developments, which coincided as well with his increasingly bold stylistic experimentation. About 1886 he also became a regular patron of the cabarets and dance-halls of Montmartre, where the personality and work of the song-writer Aristide Bruant epitomized the local Bohemian spirit. Bruant's influence on Lautrec originated towards the end of 1885 or early in 1886.

Lautrec's thematic interests advanced at different paces in the separate arenas of his popular illustration and his easel painting. His illustrations remained somewhat removed from his 'high' art, and many of his new subjects made their initial entrances in the works he made for publication. He was to experiment most freely in his graphic art—the 'lesser' medium—throughout his career, only to translate the results into his easel paintings at some later point. During the present period he introduced his new subjects into his more formal works cautiously, almost timidly. Even as his vision began to grasp the more advanced concepts of his milieu, his academic training persisted in its hold on him.

Cautious Experiments

Lautrec performed his most cautious experiments of this period in a group of undated paintings often described as 'dark Realist', a development in his style that did not depart in any dramatic way from the precepts of later nineteenth-century academic and *juste milieu* painting. His subjects, women of the lower classes, represented the transfer of the more contemporary Realism of his popular illustrations to his easel paintings, but the modified Impressionism with which he treated them was only slightly ahead of that in his earlier peasant paintings, in its use of reflected colours. Previous dating has scattered these paintings from 1884 to 1889, despite the strong stylistic resemblances among them. Grouping them under the same approximate date, *c*.1886, eliminates the historical confusion that has surrounded them and also helps to clarify the nature of Lautrec's evolution toward progressive art while he still remained a pupil of Cormon.

The paintings include *La Grosse Maria* (Fig. 58), heretofore always placed in 1884; *La Blanchisseuse* (Fig. 59), usually attributed to 1889; and related studies of Carmen Gaudin (e.g. Fig. 60), also the model for *La Blanchisseuse*, placed in either 1888 or 1889. The widely

[36] H. Schimmel, no. 117, 95. [37] Ibid., no. 118, 96.

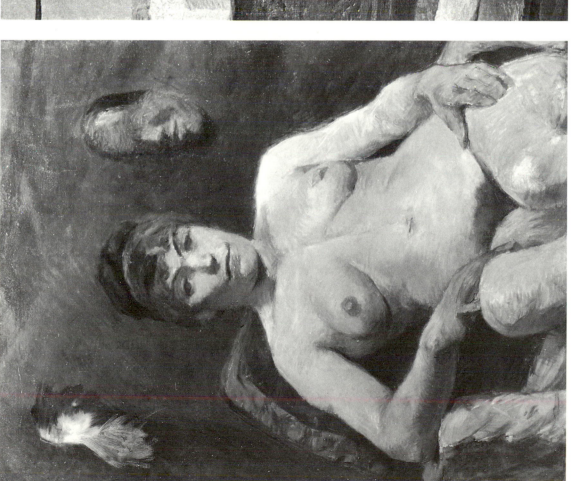

58. Henri de Toulouse-Lautrec, *La Grosse Maria*. Wuppertal, Germany, Von der Heydt-Museum. *See also colour plate.*

59. Henri de Toulouse-Lautrec, *La Blanchisseuse*. France, private collection.

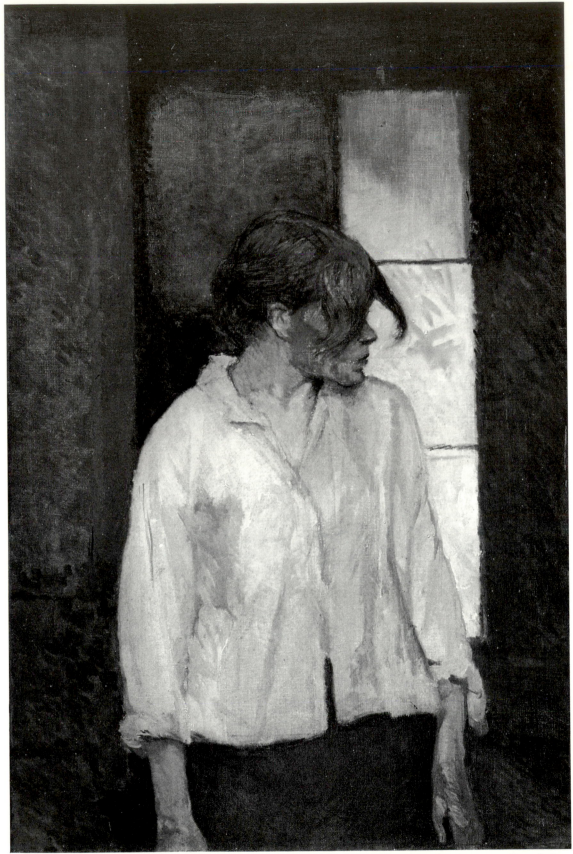

60. Henri de Toulouse-Lautrec, *A Montrouge—Rosa la Rouge*. Merion Station, Pennsylvania, Barnes Foundation. (Photo, © 1991 by The Barnes Foundation.)

dispersed dating of these paintings has led to the general belief that Lautrec alternated them with works of a lighter palette and freer stroke throughout the second half of the 1880s and to the theory that their conservative, sombre palette indicated that Lautrec suffered recurring, temporary 'reversions' to the chiaroscuro of the academic ateliers as a consequence of feelings of youthful uncertainty.[38]

Joyant must have felt it necessary to place *La Grosse Maria* in 1884 because he believed it to be an atelier nude, which, in the framework of his chronology, Lautrec could not have painted any later. Obviously he related it to the painted *académies* which he dated 1884 (e.g. Fig. 33, here redated to 1882) despite its marked similarity in style and palette to the Carmen series that he set in 1888–9. Recognizing that Lautrec worked from the nude model at the atelier at least throughout 1886 substantially alters the context in which such works can be arranged. The 'dark Realist' paintings, all or in part, might literally have been atelier products, or, just as plausibly, the results of Lautrec's independent work, because stylistically they hover between the atelier and progressive art. In either case, Cormon would not have disapproved. *La Grosse Maria* represents a dramatic advance over the earlier *académies*. The bold pose and direct gaze with which the model confronts the spectator, as well as the more accomplished drawing and powerful modelling of the nude figure, show a far greater sophistication than do the academic works of 1882–4. Technically and in its mood, the *Maria* has much more in common with the paintings of Carmen. They share the same dark palette, and in the figures, the tight brush stroke and relatively smooth surfaces, careful draughtsmanship and sturdy construction, and interest in perspective foreshortening—all of them typical stylistic traits of academic training. *La Grosse Maria* and *La Blanchisseuse* in particular have almost identical, loosely brushed, brownish-black backgrounds.

These two 'dark Realist' works also exhibit a number of progressive stylistic features that link them together in the chronology. In both of them, despite his general cautiousness, Lautrec modified the sombre, academic Realism with Impressionist techniques of which he must have been newly aware. Instead of painting shadows in the usual grey, brown, or greenish colours, he painted them and the flesh tones and hair of the two figures and the white shirt of the laundress in myriad, reflected pastel hues of blue, pink, yellow, and violet. A Japanese mask at the upper right of *La Grosse Maria* might be an indication of another of Lautrec's new progressive interests, Japanese art, whose formal devices he was also eventually to assimilate.

In terms of content, both paintings display a subtle subjective quality, a gloomy mood that links them to later Realism and Naturalism. In *La Blanchisseuse* (Fig. 59) in particular, Lautrec adopted one of the established themes of Realist and Naturalist artists and writers and gave his painting a commensurate undertone of social orientation. The laundress, by 1886, was virtually the symbol of all poor, working-class women. Degas had used this theme throughout the 1870s; Zola had treated it in his novel of 1876, *L'Assommoir*. Degas portrayed the laundress at her work, but Lautrec centred his attention on the pathos of her situation in life rather than her work, and on psychological reality rather than the details of her physical surroundings. His compassionate rendering shows the laundress during a melancholy pause,

[38] Joyant, ii. 12–15.

when she turns away, both from her work and her drab surroundings, to gaze wearily out of the window. The sobriety of Lautrec's colours augments the mood. He depicted the laundress as almost a captive in a closed-in domain, but monumentalized this figure from plebeian life by creating her as a large, powerful, densely modelled, pyramidal form. This representation of Carmen as a laundress was indicative of the subtle way in which Lautrec initially introduced Naturalist sentiment and his interest in the subjects of modern urban life into his formal easel paintings. For the most part, however, he seemed to reserve such portrayals for his illustrations and the paintings that he did for Bruant, the latter also illustrative in nature.

Their similarities of style and mood place *La Grosse Maria* and *La Blanchisseuse* together, just between the conventions of the atelier and the freedom of progressive art, yet the latter painting no more belongs to 1889 (where Joyant set it) than the former does to 1884. Joyant was not arbitrary in his dating, however; published illustrations apparently misled him. He recognized the Carmen works as related, and dated all of them with reference to the publication of a drawing after one of them, *A Montrouge—Rosa la Rouge* (Fig. 60). A reproduction of the drawing appeared in *Le Courrier français* of 2 June 1889, and accordingly Joyant attributed these works as a group (but not *La Grosse Maria*) to about this time. But on a number of occasions Jules Roques, publisher of *Le Courrier français*, asked the artist to make drawings of already existing paintings for publication as illustrations.[39] Consequently, the publication of the drawing after *A Montrouge* provides no more than a final possible date for the painting, whereas the stylistic evidence makes earlier dating far more defensible.

A Montrouge may have been Lautrec's first treatment of prostitution, another stock subject of Realism and Naturalism; as such it was a uniquely audacious essay among his 'dark Realist' works. It was probably also his first illustration of Bruant's lyrics. Lautrec based his painting on the song, 'A Montrouge', one of a particular group of Bruant's songs known as *Les Refrains du Mirliton* and first published in his journal, *Le Mirliton*, of 1 February 1886. This song tells the sinister story of a red-headed streetwalker of the Montrouge quarter named Rosa, who lures a prospective client into a dark corner so that her pimp (the song's narrator) can rob him. The following day the victim is found dead in a pool of blood:

> C'est Rosa . . . j'sais pas d'où qu'a'vient
> Alle a l'poil roux, eun'têt' de chien . . .
> Quand a' passe on dit v'là la Rouge,
> A Montrouge.

> Quand a'tient l'michet dan' un coin
> Moi j'suis à coté . . . pas ben loin . . .
> Et l'lend'main l'sergot trouv'du rouge
> A Montrouge.

[39] *Le Courrier français* in 1889 published several drawings (D3089, D3091, D3092) that Lautrec made as reprises of his formal paintings, in addition to the one in question (D3090). All but one of the paintings illustrated had hung for several years in Aristide Bruant's cabaret, Le Mirliton, where Roques probably saw them. Only the remaining illustration, *Au bal du Moulin de la Galette* (D3091), which appeared on 19 May 1889, reprised a painting which had been completed earlier in the same year. See also H. Schimmel, no. 153, 120–1, recently redated by him to mid-Nov. 1887, in which Lautrec discloses that Roques was considering reproducing his 'Mirliton panels' of 1886.

[It's Rosa . . . I don't know where she comes from
She has red hair, a dog's head . . .
When she passes they say, here comes 'Red',
 At Montrouge.

When she gets a 'John' in a corner,
Me, I'm right there . . . not far at all . . .
And the next day the cop finds 'red' all right,
 At Montrouge.][40]

In his painting Lautrec created a night scene in which he posed Carmen as Rosa the streetwalker in a dark doorway, glancing furtively over her shoulder, on the look-out for her prey. In Carmen he had an ideal model: 'What an air of spoiled meat she has!' he had exclaimed when he first saw her.[41] This painting, which Bruant owned, was one of a 'gallery' of portraits of prostitutes by Lautrec that he displayed, in a shocking reversal of bourgeois respectability, at his cabaret, the Mirliton. All of them apparently were related to *Les Refrains du Mirliton*. Two drawings, which are variations on the theme of 'A Montrouge', might originally have been preparations for a published illustration of the song, made around the same time as the painting and possibly for Bruant's journal, but the drawings seem never to have been reproduced.

It is consistent with Lautrec's history as a serious academic student that he would have produced his relatively conservative 'dark Realist' works while he still attended the atelier of Cormon, possibly in connection with his work there. They belong together—*La Grosse Maria* and all the stylistically similar paintings for which the model Carmen posed. Their shared characteristics serve to identify a transitional stage in the young painter's development. The tentative and selective incorporation of Impressionist features into otherwise conservative works was for Lautrec a first step toward a more progressive art. The stylistic advances in these paintings and their thematic relationship to Lautrec's popular illustrations place them towards the end of 1885 or thereafter. Their academic qualities indicate the first half of 1887 as the latest reasonable date for them. But Lautrec's experiments with Impressionist colour were to advance somewhat beyond them by 1887–8. Therefore, *c.*1886 becomes a credible date for these works.

The accounts of Rachou and Gauzi have confirmed that Cormon encouraged his pupils to work independently *en plein air*, and that Lautrec by 1885 often painted the regular model out of doors in the afternoons at the garden of M. Forest and another in the rue Ganneron. Two paintings of the model Carmen out of doors bear a strong stylistic resemblance to the 'dark Realist' works and appear to be among the first he painted in these gardens. They probably belong in late 1885 or early 1886. The portrayals of Carmen that Lautrec painted *en plein air* are more conservative in style than other works of similar subjects that may thus

[40] A. Bruant, *Dans la rue, chansons et monologues*, 2 vols. (Paris, 1895), 'Édition définitive' (reissued by Les Éditions d'aujourd'hui, Paris, 1978), i. 97–100. (NB Vol. i first appeared *c.*1888 and vol. ii in 1895, along with a reissue of vol. i.) [41] Gauzi, 129.

be attributed to later in 1886. Suzanne Valadon, whom the painter Federico Zandomeneghi may have introduced to Lautrec in 1886,[42] was the subject of two *plein-air* portraits (e.g. Fig. 61), both undated, executed with a lighter palette and freer brush stroke than the garden portraits of Carmen. One other undated *plein-air* painting, the *Femme assise de face, et tenant une ombrelle*, exhibits the same sketchiness and simplified or awkward drawing as the portraits of Valadon and seems to belong with them in 1886. These three works, in their palette and brush stroke as well as their pleasant garden subject, are related more closely to avant-garde Impressionism than are the 'dark Realist' paintings. Conceivably the last Impressionist show, held in the spring of 1886, stimulated Lautrec.

These and most of Lautrec's more advanced independent works of 1886 project an awkwardness in drawing, modelling, and perspective that approaches cartooning and that contrasts sharply with Lautrec's more painstaking academic studies and 'dark Realist' paintings. Possibly it was a deliberate *naïveté* that expressed the artist's desire to simplify means in order to show that he spurned convention and the technical complexity of the academic tradition, and to tie his work more closely to the avant-garde Realist position. In this, Lautrec might have been looking to popular caricature as inspiration for an alternative, more personal style. Perhaps he was influenced by his own experiences and new work as a popular illustrator. On the other hand, the simplification and *naïveté* of the *plein-air* portraits and other works of 1886 could have been genuine indications that he was not yet comfortable with these newer, more spontaneous means of painting, and simply did not draw as well without the careful academic preparations which he had been trained to make. In fact, when he carried his new impressionistic stroke and palette into his more formal portraits of 1887, he reverted to preparatory drawing in the familiar manner of the atelier. Clearly, however, in his progressive work of late 1885–6 Lautrec was beginning to practise the lessons of avant-garde Impressionism, as were a number of his fellow students at Cormon's. It is tempting to speculate that he made all his boldest attempts in late 1886, following the insurrection at the atelier that spring.

Bolder Ventures

Lautrec reserved bolder experimentation in style and subject during this period for works that he did apart from the atelier and his continuing academic training. In two sets of wall decorations and several ballet scenes, all with multiple figures, he investigated for the first time the potential of the more radical devices of style and composition associated with advanced art. And in his illustrations and the paintings he did for Bruant he made a number of daring treatments of contemporary Realist and Naturalist themes.

At Père Ancelin's inn at Villiers-sur-Morin, Lautrec executed a series of four murals (e.g. Figs. 62 and 64), scenes from the ballet and theatre, that constituted one of his most venturesome early departures from tradition.[43] He also did several canvases of ballet subjects

[42] Gauzi, 131–2.

[43] Lautrec visited René Grenier several times at Villiers between autumn 1885 and summer 1888, cf. H. Schimmel, no. 117, 95, autumn 1885; no. 132, 105, autumn 1886; no. 130, 104, recently redated by him to autumn 1886; no. 149, 117–18, recently

redated by him to July 1887; no. 164, 126–7, July 1888. In one undated letter, quoted by Dortu and Huisman, 240, written from Villiers, Lautrec mentions 'the inn where I've done some panels'. [H. Schimmel, no. 131, 104.]

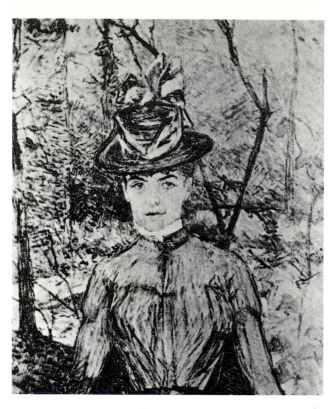

61. Henri de Toulouse-Lautrec, *Madame Suzanne Valadon*. Private collection.

62. Below: Henri de Toulouse-Lautrec, *Scène de ballet* from Ancelin's Inn at Villiers sur Morin. Oil on plaster, transferred to canvas. Chicago, Art Institute, Helen Birch Bartlett Memorial Collection. (Photo, courtesy of The Art Institute of Chicago, © 1988. All rights reserved.)

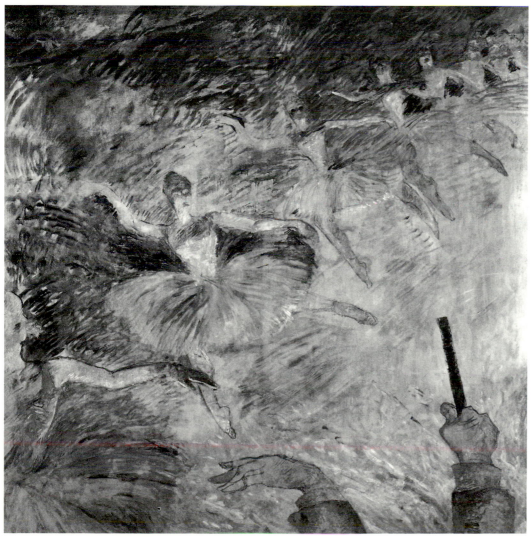

(e.g. Fig. 63) with a close stylistic relationship to the Père Ancelin murals. All these paintings exhibit the same overall awkwardness and simplification and the slightly caricatural quality of the *plein-air* paintings of later 1886 along with the looser brush stroke and lack of *fini* that distinguish them from the more polished and conventional works of the period. They share these qualities, as well as some newly daring and contrived compositional devices, with two panels (Figs. 70 and 71) that Lautrec made for Bruant's Mirliton cabaret. The latter are securely datable between late 1885 and late 1886, but most likely belong in late 1886 (see below). They therefore provide a stylistic guide for dating the other progressive works of the period.

Works such as these, complex in composition and depicting numbers of figures, were still rare among Lautrec's paintings of the mid-1880s. They have particular significance because they represent his first experiments with unconventional compositions. The oblique and unusual viewpoints, the rapid plunges of perspective, the diagonal disposition and radical cropping of figures, and the stress on surface by means of pronounced, repetitive silhouettes, as well as visible, sketchy brush strokes went back in origin to Degas's ballet pictures of the 1880s and before. It is likely, however, that these stylistic devices were transmitted to Lautrec through Degas's followers. In particular, Gauzi singled out Federico Zandomeneghi, who lived in the building where Gauzi had his studio, as 'the first painter who led Lautrec to Impressionism'. Gauzi claimed that Lautrec first learned from Zandomeneghi to attach 'enormous importance to the choice of the visual angle, to the originality of the compositional layout, to the extension of the subject beyond the painting's edges, with the figures cropped by the frame'.[44]

The work of the painter and popular illustrator Forain may likewise have been the immediate inspiration for Lautrec's interest in subjects from the ballet and theatre.[45] Although Degas had explored behind the scenes at the ballet and the theatre much earlier, the influence of Forain's journal illustrations of these subjects may account for the caricatural and even slightly comical manner in which Lautrec treated them. At least one of Lautrec's paintings at Père Ancelin's inn, *Danseuse dans sa loge* (Fig. 64), used an iconographical formula that Forain had popularized specifically in his caricatures: the ballet dancer off-stage, at her dressing table with a male admirer looking on. It could have been one of the first examples of Lautrec's borrowing directly from popular illustration. Thereafter, however, though he continued to emulate the art of the illustrated press, he began to choose his modern themes from lower-class subjects and low-brow forms of entertainment.

His career as a popular illustrator started with the publication of *Gin-cocktail* (Fig. 67) in *Le Courrier français*, no. 39, of 26 September 1886. Established in 1884, *Le Courrier* was the popular journal whose spirit and subject-matter most closely matched Lautrec's maturing vision of the latter 1880s. It took its subjects from daily social life in the streets of Paris and the cabarets, *bals*, brasseries, and prostitutes of Montmartre, and often satirized them. In fact, it contributed greatly to creating the myth of 'the Butte [Montmartre] and its bohemian life'.[46]

[44] Gauzi, 130–2. On Zandomeneghi, see G. Mourey, 'Les œuvres et les hommes: Federico Zandomeneghi (1849–1917)', *Les Arts*, 16 (1920), 22–4; and E. Piceni, *Zandomeneghi, catologo generale dell'opera* (Milan, 1967).

[45] Cooper, 24; Joyant, i. 9–12; Johnson, 'Symbolists and Symbolism', ch. 2, 4. On Lautrec's admiration for Forain see Gauzi, 144–5.
[46] Lethève, 45.

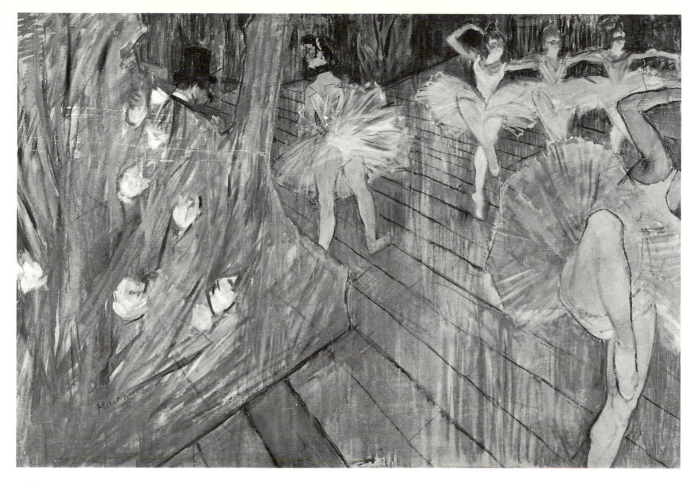

63. Above: Henri de Toulouse-Lautrec, *Danseuses*.
Stockholm, Thielska Galleriet.

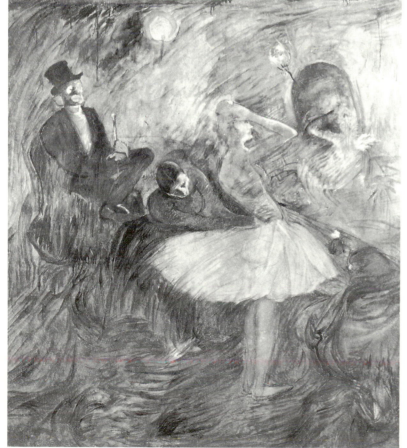

64. Left: Henri de Toulouse-Lautrec, *Danseuse
dans sa loge* from Ancelin's Inn at Villiers sur
Morin. Oil on plaster, transferred to canvas. Japan,
private collection. (Photo, Sotheby's London.) *See
also colour plate.*

Lautrec told his mother in a letter of spring 1886, 'I'm going to make some sketches for the *Courrier français*.'[47] Probably he referred to the series of drawings that he subsequently submitted to Jules Roques, the publisher, in the autumn of 1886. Roques used *Gin-cocktail* but not the others, and evidently refused to pay Lautrec for them. He later sold them at auction (for which the artist retaliated by taking legal action)[48] and (since the drawings were catalogued for sale as a group) it is possible to identify several of them.

Two scenes of the grape harvest, *Les Vendanges* (Fig. 65) and *Sortie du pressoir* are on Gillot paper, the special paper on which finished drawings intended for publication were done. The textured Gillot paper made it possible to reproduce photomechanically a drawing in relief on zinc for printing as a line cut. *Jeune fille tenant une bouteille de vin* (Fig. 66) is a drawing in blue pencil. Possibly a later, final version on Gillot paper has been lost. Wine was the theme of the series: the grape harvest, wine-making, and both the social enjoyment and the abuse of wine. This common theme substantiates the likelihood that Lautrec made the drawings as an ensemble, probably for the special issue that *Le Courrier français* devoted annually to the *vendanges*, or vintage season, in late September or early October.[49] Lautrec's drawings were typical of this annual edition in terms of their visual content, but his series would have been almost a moralistic narrative on the wholesomeness of peasant life in contrast with the corruption of the city, especially in the lives of the poor. The peasants in Lautrec's harvest scenes are energetic and robust; their opposite in the city is a young, alcoholic woman, her shoulders drooping in dejection, who seems heavily burdened with the bottle of wine she carries along a cobbled Paris street. It is a lower-class district, because the figures looking at the meat in a butcher's window in the background of the drawing wear the attire of the working classes. The tone of social consciousness projected by this scene and by the illustrations as a group was analogous to that of Bruant's songs, and of illustrators such as Steinlen. Perhaps it did not appeal to Roques whose *Courrier français* had a more risqué, carefree spirit despite its radical political orientation. The serial nature of the drawings could also have displeased

[47] H. Schimmel, no. 125, 100; in letter no. 124, spring 1886, 99, he also mentioned illustration. Both letters commented on the fact that his father was pressuring him to take a studio near the Champs Élysées. Evidently Lautrec preferred the less fashionable Montmartre quarter where he rented a studio at 27, rue Caulaincourt. This is the earliest evidence of Lautrec's moving away from his family's aristocratic identification. Yet in letter no. 125, he still reported on his work at Cormon's and his participation in an academic competition. In an unpublished letter of spring 1886 to his mother (quoted courtesy of H. Schimmel), Lautrec notes that he has not 'appeared in the newspapers yet, but it is going to happen. Finally!!' and refers to his drawing for the *Courrier français* as 'still in an embryonic state'. In the same letter he speaks apologetically about his 'evenings out on the town', calling himself a 'bad son'. [H. Schimmel, no. 127, 102.]

[48] Ibid., no. 125, 100, n.1. See also no. 192, 144–5 and Gauzi, 48.

[49] Joyant, i. 101, states that Lautrec submitted 6 drawings to Roques. I have been able to identify positively only the 4 listed above, although a 5th might possibly be the *Bataille de fleurs: Mail Coach à Nice* (D2844), an ink drawing on Gillot paper. This drawing, similar in style to the *vendanges* drawings, was originally commissioned for publication, but never used, by the *Guides pratiques Conty*. Cf. an unpublished letter (H. Schimmel collection) written by Lautrec to his mother in Jan. 1885 or Jan. 1886. [H. Schimmel, no. 107, 88.] The 6th is probably *Jeune fille lisant* (D2927), originally owned by *Le Courrier français*. *Gin-cocktail* (D2965) was listed as no. 124 at a Hôtel Drouot sale of 1 June 1891, but was withdrawn from the sale and sold on 20 June 1891 at the Hôtel Drouot as no. 302. The *Jeune fille tenant une bouteille de vin* (D2928) was listed as no. 304 at the same sale. *Les Vendanges* (D2925) was also withdrawn from the sale of 1 June 1891, where it was listed as no. 122; similarly, *Sortie du pressoir* (D2926), no. 123. The works probably were withdrawn from the sale due to Lautrec's legal action, which evidently was unsuccessful since *Le Courrier français* ultimately was able to sell them. Another drawing entitled *Sortie du pressoir* (D2992) is quite close in style to *Gin-cocktail*, especially in its simplification of light–dark patterns and its short staccato lines, and may also have belonged to this group. The other two harvest drawings had complex, almost academic tonal shadowing and detail, which may have rendered them unsuitable for reproduction.

him. He finally used a more compact, lighthearted, single-page illustration of the *vendanges* by Henri Pille in his issue of 5 October 1886. He did, however, publish one of Lautrec's drawings in a different context—the drawing that he captioned *Gin-cocktail* (Fig. 67). It lacked the pointed commentary of the young woman with her bottle of wine, and simply portrayed two gentlemen enjoying a convivial drink at a bar.

Gin-cocktail was a type of visual image that appeared commonly in the popular press. Although it perhaps recalled Manet's paintings of bar scenes, its closest affinities were observable in the transliteration of the Realist idiom of Manet and Degas into popular illustration. One of the artists whose illustrations intervened between the older Realism and its iteration in the work of younger painters and illustrators such as Lautrec was Raffaëlli. His *Un bar* (Fig. 68) coincidentally appeared as a two-page display in *Paris illustré* the week that *Le Courrier français* published Lautrec's modest *Gin-cocktail*. And despite differences in scale and complexity, the two illustrations share not only their subject, but also such compositional devices as the formal juxtaposition of the bar pumps and the barmaid's profile, and the dark, cropped figure of a man in a top hat at the extreme left.

Gin-cocktail probably was an adaptation of a drawing that Lautrec had made of the bar at the Café de la rue de Rome (Fig. 69). Marked differences exist between them, but the artist also made an intermediate charcoal sketch, which clearly shows the transformation of the seated patron's top hat to a bowler, and the additions of a cropped male figure at the left and a second barmaid in the background at the right as well as the substitution of a tumbler for the original wine glasses. Lautrec did the original drawing (Fig. 69) in the academic manner, using the *estompe* in alternation with scraping to create heavy shadows and emphatic modelling.[50] In *Gin-cocktail*, by contrast, he eliminated these complex tonal effects and replaced them with simplified patterns of dots and lines. No doubt the photomechanical process accounted for some of the changes, because it most effectively accommodated linear illustration, with only limited halftone modulation. Conceivably the simplification that photomechanical reproduction required gave Lautrec ideas that later contributed to the abbreviation in his mature style. The original, *estompe* rendering, on the other hand, shows that while he was undergoing the transition from an academic to an avant-garde point of view, he also remained capable of using a traditional drawing as the basis for even his most avant-garde work. Nor was the subject-matter of these works about people and scenes from modern life entirely alien to academic training: sketching events outside the atelier was part of a student's daily practice, and Lautrec's letters confirm that as early as 1884 he devoted evenings to sketching in bars.[51] The drawing from which *Gin-cocktail* evolved could have been such an exercise, and it adds to the evidence that Lautrec gradually, not abruptly, reversed direction from traditional subject-matter and atelier practice to an avant-garde commitment to themes from contemporary life.

By July 1886, Lautrec was frequenting the Chat Noir cabaret on Montmartre, which he reported to his mother in a letter, and by the autumn Roques had nearly completed arrangements for him to draw at the Eden Café-Concert.[52] These meeting-places drew him

[50] B. Welsh-Ovcharov, *Vincent van Gogh and the Birth of Cloisonism* (exh. cat., Art Gallery of Ontario, Toronto, 1981), 324 n. 1, suggests that this drawing was executed in Lautrec's studio on the basis of an on-the-spot preliminary sketch (D2982).

[51] H. Schimmel, nos. 104, 86; 95, 80.

[52] Ibid., nos. 129, 103–4; 132, 105.

65. Henri de Toulouse-Lautrec, *Les Vendanges*. Pencil drawing on Gillot paper, highlighted with blue. Copenhagen, Den Kongelige Kobberstiksamling, Statens Museum for Kunst.

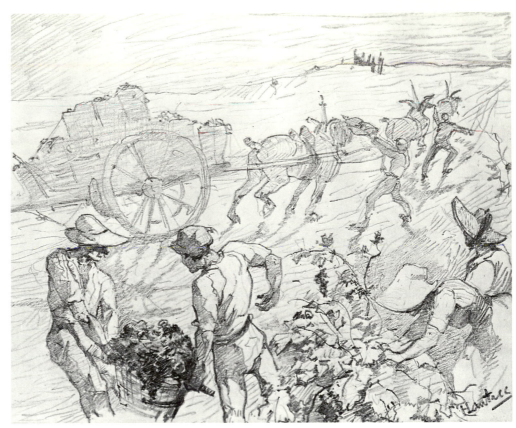

66. Below, left: Henri de Toulouse-Lautrec, *Jeune fille tenant une bouteille de vin*. Blue pencil drawing. England, private collection.

67. Below, right: Henri de Toulouse-Lautrec, after, *Gin-Cocktail*. Photomechanical reproduction of a pen drawing from *Le Courrier français* (26 Sept. 1886). New York, collection of Mr and Mrs Herbert Schimmel.

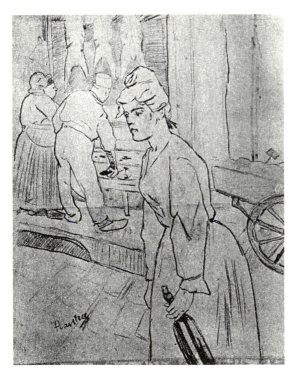

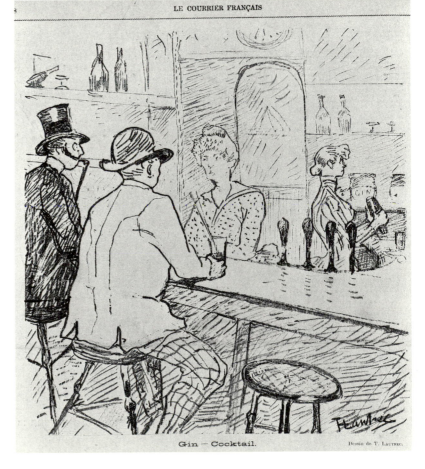

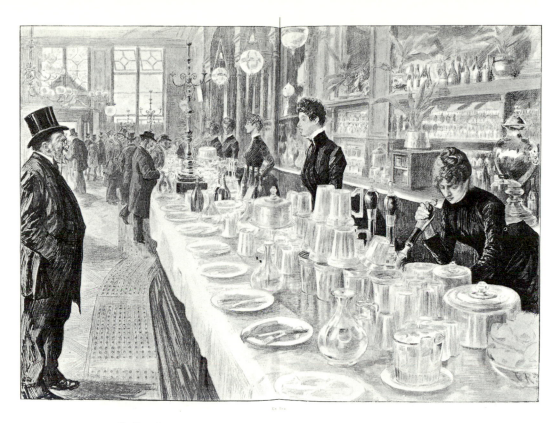

68. Jean-François Raffaëlli, after, *Un bar*. Zinc engraving from *Paris illustré* (Oct. 1886). Paris, Bibliothèque Nationale. (Photo, Bibliothèque Nationale.)

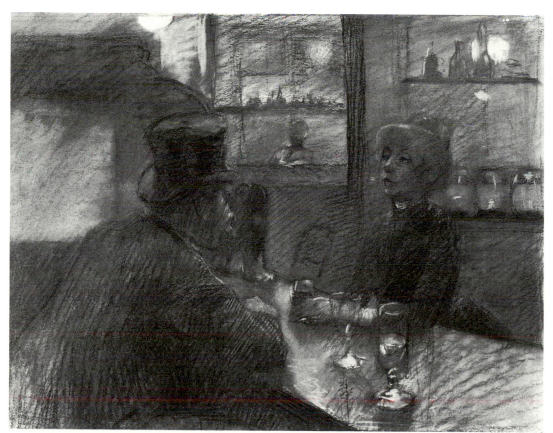

69. Henri de Toulouse-Lautrec, *Bar du café de la rue de Rome*. Charcoal and chalk drawing. Chicago, Art Institute, gift of Mr and Mrs Carter H. Harrison. (Photo, courtesy of The Art Institute of Chicago, © 1988. All rights reserved.)

into the social circle of avant-gardists from all the arts. The Chat Noir, especially, established in 1881 by Rodolphe Salis, attracted young radical and Bohemian poets, song-writers, and artists 'on the fringe of the accepted'.[53] Many of them shared a Naturalist attitude and a focus on the downtrodden, and many contributed to Salis's weekly journal, *Le Chat noir*, which he had begun in 1882.

In July 1885, Aristide Bruant, singer as well as song-writer and a member of this circle, had opened his Mirliton cabaret on premises just vacated by the Chat Noir, and in October he began publishing his own journal, *Le Mirliton*.[54] War between the classes was his dominant theme, and he provided nightly entertainments in which he mingled his *chansons populaires* with a rain of insults upon the bourgeois sophisticates in his audience—who apparently took masochistic delight in the atmosphere of tension and abuse. Bruant's songs, which he sang in the popular argot, celebrated the street people and low-lifes of the city and decried their position in society. In his own time, he was regarded as the Zola of song for his harsh and often fatalistic commentaries on human poverty, degradation, and sordidness. Like Zola, he concerned himself with questions about heredity and environment, and in his songs made frequent allusions to the deprived upbringing and miserable background of his characters.[55] Bruant corresponded to the character Legras in Zola's socially critical novel *Paris* of 1897, and Zola described the singer and his cabaret as follows:

Puis il n'y avait plus que bancs, sans coussin ni tapis, le long desquels s'alignaient des tables de guinguette, où les verres des consommations laissaient des ronds poisseux. Aucun luxe, aucun art. Des becs de gaz sans globe, brûlant à l'air libre, flambaient, chauffaient furieusement l'épaisse buée dormante, faite des haleines et de la fumée des pipes. On apercevait sous ce voile des faces suantes, congestionnées, tandis que l'odeur âcre de tout ce monde entassé accroissait l'ivresse, les cris dont l'auditoire se fouettait à chaque saison nouvelle. . . .

Legras venait de paraître sur l'estrade. . . . Et son répertoire, ses fleurs du pavé, achevait d'expliquer son succès, des chansons où l'ordure et la souffrance d'en-bas, toute l'abominable plaie de l'enfer social, hurlait et crachait son mal en mots immondes, de sang et de feu.

Le piano préluda; Legras chanta 'La Chemise', l'horrible chose qui faisait accourir Paris. A coups de fouet, le dernier linge de la fille pauvre, de la chair à prostitution, y était lacéré, arraché. Toute luxure de la rue s'y étalait dans sa saleté et son âcreté de poison. Et le crime bourgeois clamait, derrière ce corps de la femme traîné dans la boue, jeté à la fosse commune, meurtri, violé, sans un voile. Mais, plus encore que les paroles, la brûlante injure était dans la façon dont Legras jetait ça au visage des riches, des heureux, des belles dames qui venaient s'entasser pour l'entendre. Sous le plafond bas, au milieu de la fumée des pipes, dans l'aveuglante fournaise du gaz, il lançait les vers à coup de gueule comme des crachats, toute une rafale de furieux mépris. Et, quand il eut fini, ce fut le délire; les belles bourgeoises n'essuyaient même pas de tant d'affronts, elles applaudissaient frénétiquement: la salle trépignait, s'enrouait, se vautrait éperdue dans son ignominie.

[Then, there wasn't anything but benches, without cushions or covers, which were aligned length-wise with tavern tables on which the glasses from drinks left sticky circles. No luxury, no art.

[53] M. Frèrebeau, 'What Is Montmartre? Nothing! What Should It Be? Everything!', *Art News*, 76 (Mar. 1977), 61–2; and A. Zévaès, *Aristide Bruant* (Paris, 1943), 29. On the Chat Noir, see also R. Dumesnil, *L'Époque réaliste et naturaliste* (Paris, 1945), 69–70, and Rearick, 58–60 and *passim*.

[54] Zévaès, 33–6.
[55] S. Gill, 'Steinlen's Prints: Social Imagery in Late 19th Century Graphic Art', *The Print Collector's Newsletter*, 10 (Mar.–Apr. 1979), 8.

Gas jets without globes flamed, scalding the open air, furiously heating the thick, stagnant vapour, made by breath and the smoke from pipes. One could see through that blur flushed, sweaty faces, while the acrid odour of all those crammed-in people increased the drunkenness, the cries of which the audience whipped up each new season. . . .

Legras had just appeared on the platform, and his repertoire, his flowers of the street, completed the explanation of his success, songs in which the excrement and the suffering of the lower depths, all of the abominable plague of the social hell, hurled and spit their evil in foul words of blood and fire.

The pianist began the prelude; Legras sang the song 'La Chemise', the horrible thing that made all Paris come running. With whip lashes, the last underwear of the poor girl, of the prostituted flesh, had been lacerated, stripped off. Every lust of the street was displayed there in its obscenity and in its acrimoniousness. And the bourgeois shame cried out, behind this body of the woman dragged in the slime, thrown in the communal grave, without a shroud, murdered, raped. But more than the words the scorching insult was in the manner in which Legras threw it in the face of the rich, the happy, the beautiful ladies who packed in to hear him. On the low platform, in the midst of the smoke of the pipes, in the blinding gas furnace, he hurled out the lyrics with a thrust of his mug, like spit, all a blast of furious scorn. And when he had finished, there was delirium, the pretty bourgeois ladies did not even suffer from so many affronts. They applauded frenetically, the room of people stamped, grew hoarse, wallowed, frantic in its disgrace.][56]

It is of course ironic that in spite of Bruant's expression of sympathy for the downtrodden, ridicule of the privileged, and professed self-identification with the lower classes, his cabaret was not a gathering place for the poor, but for a bourgeois and upper-class clientele. His sensationalistic lyrics about the Parisian 'lower depths' must have stimulated exciting fantasies of risk, sexuality, and rebellion against convention in this audience. Like many others, Bruant traded on the appeal of the Montmartre popular culture to a slumming public in search of a temporary and liberating escape from bourgeois social strictures.[57] He eventually made a fortune out of it, retired to the country, and became a reactionary nationalist and militarist. But in the mid- to late 1880s, before his great commercial success, the initial humanitarian and socially critical impetus behind his songs must still have been strongly felt.

Lautrec and Bruant had formed a close friendship by 1886, and the song-writer exercised a considerable influence over the young artist for several years. Bruant and his ideas were decisive in completing Lautrec's transition from his original aristocratic and traditionalist orientation to his identification with the complexities of the Montmartre spirit: the titillating allure of its radicalism, its Bohemianism and irreverence, its fascination with and sympathy for society's outcasts, and, ultimately, its commercialization. Late in 1886, Lautrec painted two small panels to decorate the Mirliton, recording early events in the history of the cabaret in the caricatural manner of popular illustration. In using them as décor, Bruant was probably imitating Rodolphe Salis, who displayed paintings by Willette and Steinlen in the Chat Noir.[58] Lautrec's paintings for the Mirliton pertained indirectly to the Chat Noir. It had been

[56] É. Zola, *Trois villes: Paris*, 3 vols. (Paris, 1921), i. 275–84. Zévaès points this out on p. 41. For contemporary descriptions of the Mirliton, see also R. Darzens, *Nuits à Paris* (Paris, 1889), 77–84; J. Grand-Carteret, *Raphael et Gambrinus ou l'art dans la brasserie* (Paris, 1886), 139–42; and P. Veber, 'Les Cabarets artistiques et la chanson', *Revue d'art dramatique*, 16 (Dec. 1889), 339–43.

[57] Seigel, 235–41.

[58] On the decor of the Chat Noir see Grand-Carteret, *Raphael et Gambrinus*, 77–98.

appointed in elegant Louis XIII furniture, and when Salis moved it to its new location one of the chairs was left behind. Bruant, who established a more proletarian ambience on the same premises, hung the chair as an object of ridicule upside down above the door and dedicated a song and a *quadrille* to it. In all likelihood he parodied Salis, who 'put on a masquerade of politeness, treating every client as a prince and addressing everyone by a title'.[59]

In one of Lautrec's Mirliton panels, *Le Refrain de la chaise Louis XIII au cabaret d'Aristide Bruant* (Fig. 70), he depicted the song-writer reciting his ironic lyrics:

> Ah! Mesdames, qu'on est à l'aise
> Lorsqu'on est assis sur la chaise Louis XIII.
> Elle est à Rodolphe, et cependant,
> Pour s'asseoir dessus, fault aller chez Bruant.

> [Oh! My ladies, how comfortable one is
> When one is seated on the Louis XIII chair.
> It belongs to Rodolphe [Salis]; nevertheless,
> To sit on it, you must go to Bruant's.][60]

In the left background, the artist portrayed himself and his friend Anquetin. This may have been the first work that he signed 'Tréclau', the pseudonym with which he often disguised himself from late 1886 to 1888 while his identification with avant-garde Bohemianism was relatively new.[61] The other Mirliton panel, *Le Quadrille de la chaise Louis XIII à l'Élysée Montmartre* (Fig. 71), pictures La Goulue, Grille d'Égout, and Valentin le Désossé performing Bruant's *quadrille* at the nearby dance-hall, the Élysée Montmartre, a working-class establishment notorious for its rowdy, disreputable patrons.[62] The spectators include Anquetin and Gauzi in the right background, Bruant in his usual wide-brimmed hat just behind the male dancer, Valentin, and, in the right foreground, Coutelat du Roche with his face averted from the high kick.[63] He had been nicknamed 'Père la Pudeur' ('Father Modesty'), because he was the inspector in charge of maintaining decency at the Élysée Montmartre—but he had a reputation for indulgence. At the upper right, Louis Dufour (the dance-hall's new musical conductor in 1886) leads the orchestra.

Lautrec composed *Le Quadrille* in a horizontal format with the performers in the middle distance between a ring of spectators in the background and a number of large figures cut off by the edges of the panel in the extreme foreground. It was the organizational device that he came to prefer in his representations of the subject. The cropped figures loom disproportionately large in the foreground plane, spectators or bystanders to the central scene.

[59] Zeldin, ii. *Intellect, Taste and Anxiety* (Oxford, 1977), 701.

[60] Zévaès, 35–6.

[61] Since the pseudonym appears most frequently on his illustrations, Lautrec may have used it in imitation of Steinlen, who signed his illustrations for *Le Mirliton* with the pseudonym Jean Caillou. 'Caillou', French for pebble, was a transposition of the Germanic root of his name, 'stein', meaning stone.

[62] Like the Mirliton, the Élysée Montmartre was located on the Boulevard Rochechouart. It is described by Darzens, 71–5; A. Warnod, *Bals, cafés et cabarets*, 5th edn. (Paris, 1913), 60, 82–97; L. Bloch and Sagari, *Paris qui danse* (Paris, n.d.), 69–74; and G. Montorgueil, *Paris dansant* (Paris, 1898), 176–80. All note its sleazy atmosphere and shady clientele. Salis moved the Chat Noir from its vicinity after one of his waiters had been murdered by pimps in the neighbourhood. Bruant, however, seems to have delighted in the proximity of the déclassé dance-hall that Salis disdained. See M. Mouloudji, *Aristide Bruant* (Paris, 1972), 25, and Grand-Carteret, *Raphael et Gambrinus*, 140.

[63] Gauzi, 67–70, describes going to the Élysée Montmartre in 1886 with Lautrec, Bruant, and the Mirliton crowd.

Here, as in the other Mirliton panel, the viewer observes the scene from their position, which makes the realism of the pictures all the more vivid. The influence of Impressionism is apparent both in the cropped figures and in the painting's vibrating surface, which the artist activated with short crosshatchings. The brush stroke was the same that he used in his other impressionistic works of the period, including the *Refrain de la chaise Louis XIII*. Both Mirliton panels also exhibit a simplified and caricatural style, but the still greater simplicity and economy of means of Lautrec's mature graphics were not yet in evidence. Instead of the bold outlines and flattened spaces of his later illustrations, he complicated his compositions with the busy crosshatchings—in a style similar to that of Forain's contemporary illustrations—and still resorted to modelling in light and shadow.

Late 1885 is the earliest possible date for Lautrec's two paintings, since the Mirliton was not established until then. One of them, *Le Quadrille*, was reproduced on the cover of Bruant's journal, *Le Mirliton*, on 29 December 1886; Lautrec rendered it in grisaille, a technique he commonly employed for preparations for illustrations, which suggests that he expressly intended the panel as a preliminary to the reproduction. Therefore, it had to have been painted by December 1886, and late 1886 is its likeliest date. The second panel, *Le Refrain de la chaise Louis XIII*, is attributable to the same date because of its relationship in style and subject-matter to the other.

Le Quadrille was Lautrec's first representation of a theme that was to preoccupy him for years. The *quadrille* (cancan) as a subject often seems, in art history, to have an exclusive association with Lautrec, and his manner of treating it to be unique. But by the late 1870s and early 1880s, the working-class dance-halls of Montmartre had already become favourite subjects of illustrators, a trend enhanced by the growing number and increased patronage of such establishments and also by the popularization of the illustrated press after 1881.[64] The star performers of the *quadrille*, among them La Goulue, Valentin de Désossé, Grille d'Égout, and Môme Fromage, had gained notoriety through such representations long before Lautrec painted them. He simply followed the prevailing spirit, and his well-known paintings of the *quadrille* undoubtedly had their origins in the earlier, well-established, popular imagery. *Le Courrier français* especially, throughout 1885 and 1886, published art of this character by Uzès, Willette, Morel, and others (e.g. Fig. 72).[65]

The most famous and striking contemporary representation of the *quadrille* was Raffaëlli's *Le Quadrille naturaliste aux Ambassadeurs* (Fig. 73), which appeared as a two-page colour illustration in *Paris illustré* of August 1886. It exhibited the caricatural quality of all contemporary illustrations of the *quadrille*, which emphasized the coarseness of the performers'

[64] The dance-halls of Paris had been represented in the illustrated press for at least two decades, but did not reach their height of popularity as pictorial subject-matter until these developments. The original 'cancan', of which the *quadrille* was a revival and vulgarization, dated from the 1830s and 1840s, and it was performed mainly in the Latin quarter at the Closerie des Lilas. Contemporary lithographs (e.g. J. Richardson, *La Vie parisienne, 1852–1870* [New York, 1971], 62) show the *grisettes* and gentlemen patrons of the Closerie to have been people of fashion rather than the déclassé habitués of the Élysée Montmartre (which, though it was established in 1840, only became a true dance-hall when it moved to the Boulevard Rochechouart in the mid-1880s). Before the illustrated press began to portray the dance-halls of Montmartre, Naturalist writers like J. and E. de Goncourt, *Germinie Lacerteux* (Paris, 1921, orig. 1864), described establishments such as La Boule-Noire as sordid places. On the history of the cancan see F. de Mesnil, *Histoire de la danse à travers les ages* (Paris, 1905); E. Rodrigues [Erastène Ramiro], *Cours de danse, fin de siècle* (Paris, 1892); Montorgueil, *Paris dansant*; and Warnod, *Bals, cafés et cabarets*.

[65] e.g. Uzès, *Les Soirées métra*, cover of *Le Courrier français* (29 Nov. 1885); A. Willette, *Le Quadrille naturaliste*, cover of *Le Courrier français* (6 Dec. 1885); see also Steinlen's cover for *Le Mirliton* of 15 Jan. 1886.

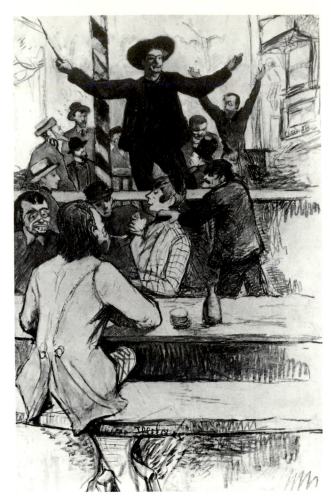

70. Henri de Toulouse-Lautrec, *Le Refrain de la chaise Louis XIII au cabaret d'Aristide Bruant*. Private collection. (Photo, Galerie Schmidt, Paris.)

71. Below: Henri de Toulouse-Lautrec, *Le Quadrille de la chaise Louis XIII à l'Élysée Montmartre*. Grisaille painting. Paris, private collection.

LE CARNAVAL EST MORT Dessin de Pierre Morel

72. Pierre Morel, after, *Le Carnaval est mort*. Zinc engraving from *Le Courrier français* (7 Mar. 1886). Paris, Bibliothèque Nationale. (Photo, Bibliothèque Nationale.)

73. Below: Jean-François Raffaëlli, after, *Le Quadrille naturaliste aux ambassadeurs*. From *Paris illustré* (Aug. 1886). Paris, Bibliothèque Nationale. (Photo, Bibliothèque Nationale.)

Le Quadrille naturaliste aux Ambassadeurs.

features and the vulgarity of the dance. It also had a more realistic and informal composition in horizontal format than the examples previously referred to, and its dancers were more animated. Lautrec adopted the qualities of caricature, realistic composition, and animation in his Mirliton panel, *Le Quadrille*, and since Raffaëlli's illustration was the closest precedent for his own, slightly later work, he may have used *Le Quadrille naturaliste aux Ambassadeurs* as a direct source of ideas. His two female figures are juxtaposed in a manner quite like Raffaëlli's; the figure of the male dancer, Valentin, recalls the Raffaëlli in its contorted pose and has a similar placement in relation to the women; and the audience forms a backdrop as in the Raffaëlli.

Lautrec's borrowing from the older artist was not total. Raffaëlli's dancers occupy and dominate the entire foreground of his composition, whereas Lautrec placed spectators casually (and perhaps distractingly) between the viewer and the central incident of his picture. He also omitted the second male dancer, Guibollard, and reversed the relationship of the principal figures, women to the left, man to the right. Raffaëlli's rendition with its pronounced silhouettes and dominant dancers is the more powerful of the two. Nevertheless, the distortion and caricature in Lautrec's figures certainly derive from the treatment the *quadrille* typically received in the contemporary illustrated press, and in his composition and handling of the principal figures he could well have imitated the Raffaëlli. Certainly others did so. Henri Beraldi, writing in 1891, noted that this Raffaëlli in its time was the prototype for at least ten illustrations by other artists.[66]

Raffaëlli's illustrations accompanied an article entitled 'Les Cafés-concerts', by Maurice Vaucaire, a young poet, playwright, and song-writer, whose references to the dance as the *quadrille réaliste* and *naturaliste* related it to the whole spirit of the popular culture of the 1880s. In fact, these were the titles by which this dance was commonly known. The *quadrille* was naturalistic in its uninhibitedness and raw impropriety, especially in the immodesty of the high kicks and the brazen display of flesh through sheer, lace pantaloons. Its purpose in part (like Bruant's in his cabaret) was *épater le bourgeois* (to shock the conventionally minded). At the popular level, the dance made an audacious declaration of the relaxed morals and heightened permissiveness of the Third Republic. A large part of the audiences in the plebeian dance-halls of the Élysée Montmartre and the Moulin de la Galette were men and women of 'the people', whose crude behaviour, language, and nicknames (La Goulue, 'the glutton'; Grille d'Égout, 'sewer grating'; and Valentin le Désossé, 'Valentin the boneless') matched the *canaille* (vulgar) character of their dance. Vaucaire celebrated this popular culture in his article, and his description of the *quadrille* was a verbal counterpart to the visual imagery of Raffaëlli and incidentally to that of Lautrec:

D'abord le quadrille réaliste. Cette merveille de blague insolente ou deux femmes arrivaient de front en remuant sur le pied gauche, tandis que le droit restait à la hauteur de l'oeil. On leur avait mis de bas de soie et un pantalon de batiste et de dentelles; tout un froufrou de jolis jupons, pour exciter la convoitise des naïfs et des blasés.

66 H. Beraldi, *Les Graveurs du* XIXe siècle (Paris, 1891), xi. 60. This and Raffaëlli's other illustrations in *Paris illustré* of Aug. 1886 were reproductions of a series of drawings heightened with watercolour that he had exhibited in June–July 1886 at Petit's Exposition Internationale. Although they were not listed in Petit's catalogue, J. K. Huysmans noted the showing in his 'Chronique d'art: le Salon de 1887, l'Exposition Internationale de la rue de Sèze', *La Revue indépendante*, NS 3, no. 86 (June 1887), 352, cf. B. S. Fields, 'Jean-François Raffaëlli (1850–1924): The Naturalist Artist', Ph.D. diss. (Columbia University, 1979), 286 n. 33.

Les noms de femmes ne manquaient pas d'une odeur de poésie canaille: La Goulue et Grille d'Égout! L'une mince et nerveuse, riant finement et mystérieusement; l'autre grassouillette et la figure immobile, fière de sa mission à remplir.

Les hommes qui servaient de vis-à-vis à ces filles, mis en calicots de province, pirouettaient avec elles, les enlevaient, comme pour dire au public: 'Voilà nos femmes, elles sont du peuple, nous sommes leurs vrais compagnons, elles nous reviendront toujours.' Et ils leur dédiaient ces exagérations chorégraphiques, ces gestes significatifs, cette mimique qui vaut de l'argot.

[First the *quadrille réaliste*. This marvel of an insolent joke, where two women faced one another, moving about on the left foot while the right was raised to the height of one's eyes. They had been dressed in silk stockings and underdrawers of lace and batiste; a whole rustle of pretty skirts, to excite the lust of the naïve and the blasé.

The names of these women did not lack an odour of vulgar poetry: The Glutton and Sewer Grating! The one thin and nervous, laughing delicately and mysteriously; the other pudgy, with an immobile face, proud of her mission of stuffing herself.

The men who served as partners, facing these girls, dressed in provincial calicos, pirouetted with them, lifted them up, as if to say to the public: 'Here are our women, they are of the people, we are their true mates, they will always return to us.' And they dedicated to them these choreographic exaggerations, these gestures full of innuendoes, this pantomime which is worthy of argot.][67]

The *quadrille* at the Élysée Montmartre and its cast of grossly named performers also appeared in a popular novel of 1885, *Mon petit homme*, by Émile Bonnetain:

On faisait cercle autour d'eux; les jambes émergeant d'un fouillis de dentelles et de jupons blancs, elle se trémoussait avec un brio et une rapidité étonnante qui soulevait les bravos.

Puis l'un et l'autre, se tenant par la main, partaient à un coup d'archet, levant en même temps et à chaque pas, une jambe à une hauteur prodigieuse. Une nouvelle mesure, et ils étaient en face l'un de l'autre; lui, le pied droit à la hauteur de son chapeau; Grille d'Égout, sa fine bottine dans la main, étalant son mollet bien fait, ses grands bas rouges et son pantalon à large dentelle serré au-dessus du genou, tournait lentement sur elle-même aux cris de la foule enthousiasmée.

Leur vis-à-vis homme et femme ne se remuaient pas moins. La Goulue, en laitière, bondissait comme un chevreau avec le bruit de sa boîte au lait tintant à chaque mouvement.

Les pistons détonaient avec des notes stridentes, c'était le galop; les musiciens semblaient s'exciter eux-mêmes à rivaliser de bruit et un vent de saturnales emportait les danseurs bondissant, vibrant aux coups de cymbales, ébranlant le plancher sous leurs talons frénétiques.

[The people made a circle around them: legs emerged from a jumble of lace and white petticoats, she danced about with gusto and an astonishing fleetness which stirred up calls of 'bravo'.

Then one and then the other, taking each other by the hand, setting off at a stroke of music, raising simultaneously and at each step of the dance, a leg to a prodigious height; a new measure and they were one facing another; he—his foot right at the height of his hat; Grille d'Égout, her small buttoned boot in her hand, displaying her well-shaped calf, her long red stockings, and her lace knickers, tight fitting above the knee, slowly pirouetted herself around, to the cries of the wildly enthusiastic crowd.

The couple facing them moved no less. La Goulue, dressed like a dairy maid, bounded about like a little goat with the noise of her milk can clinking at each movement.

[67] M. Vaucaire, 'Les Cafés-concerts', *Paris illustré*, no. 50 (Aug. 1886), 138.

The cornets played out of tune, with strident notes, it was the gallop; the musicians seemed to excite themselves by competing to make the most noise and an air of a saturnalia carried away the leaping dancers, ringing with the blows of the cymbals, shaking the floorboards under their frenetic heels.][68]

The *quadrille naturaliste* no doubt owed its popularity in the Paris of the 1880s to its low-brow character and power to titillate as well as its association with modern mores. Its anti-bourgeois impudence and 'naturalistic' expression of contempt for the respectability and prudishness of traditional morals were essential to the Montmartrois spirit. The increased sexual and social freedom that it epitomized lent it immense appeal for the contemporary popular mentality, and made it an authentically Realist subject for writers and artists of Bonnetain's, Vaucaire's, and Lautrec's naturalistic bent. In the 1880s the lower-class and vulgar associations were apparent in Lautrec's images of the dance. By the end of the decade, as entrepreneurs began to exploit for profit the lascivious aspects of the dance, Lautrec produced consumer-orientated images of it in posters that emphasized even more audaciously its voyeuristic and sexually provocative appeal.

Vaucaire's article and Bonnetain's book illuminate the nature of Lautrec's subject-matter and the spirit in which he portrayed it. Vaucaire did this not only for the *quadrille naturaliste* but also for the *café-concert*, the subject of Lautrec's Mirliton panel, *Le Refrain de la chaise Louis XIII* (Fig. 70). In a prose remindful of the Naturalist novels of Zola and Huysmans, Vaucaire stressed the commonplace, the vulgar, and the ugly in *café-concert* performances, and their attractiveness to audiences seeking release from routine and regimentation; he described a comfortable atmosphere of relaxation and informality in the night-life that Lautrec was beginning to embrace as his own world:

Au café-concert, on ne mange pas d'oranges, on boit de la bière et des grogs, et, comme il est permis de fumer, l'air saturé de relents canailles et irrespirables; de plus, les brouillards qu'occasionnent les cigarettes et les pipes, sont une sorte de collyre agaçant pour les yeux.

On respire et on voit mal.

Ajoutons à cela une musique forcenée, faite de refrains toqués, jouée par un orchestre vulgaire, chantée par des sujets qui se complaisent à pousser des cris d'hystériques, à mimer des gestes d'ivrogne, et vous verrez que le café-concert est la féerie du laid, de l'obscène et du grotesque.

.

On préfère passer sa soirée, moyennant trois, deux ou un franc, consommation comprise, depuis huit heures jusqu'à onze heures, que de dépenser le double et le triple, pour entendre un opéra-comique ou un vaudeville.

Le public veut être à son aise; il veut parler haut, chanter les refrains, rester coiffé, savourer son cigare en serotant des liqueurs.

N'est-ce pas l'idéal du théâtre pour lui?

Ailleurs: à l'Opéra, aux Françaises, au Gymnase, il faut garder un décorum ennuyeux, ne pas bouger, ne pas tousser, ne pas manifester franchement, être plus tranquille dans son fauteuil que dans un salon où l'on fait visite.

[68] É. Bonnetain, *Mon petit homme* (Brussels, 1885), 36–7. For further contemporary descriptions of the naturalist *quadrille*, see Bloch and Sagari, 31–2; Warnod, *Bals, cafés et cabarets*, 57–60; and Montorgueil, *Paris dansant*, 169–96.

[At the *café-concert*, one doesn't eat oranges, one drinks beer and grogs, and, since smoking is permitted, the air is saturated with foul and unbreathable stale smells; moreover, the dense haze caused by the cigarettes and pipes is a sort of irritating wash for the eyes.

One breathes and sees poorly.

Let us add to this a frenzied music, made up of daft refrains, played by a vulgar orchestra, sung by individuals who delight in uttering the shrieks of hysterics, in mimicking the gestures of a drunkard, and you will see that the *café-concert* is the fairyland of the ugly, the obscene and the grotesque.

.

One prefers to spend one's evening at the cost of no more than three francs, drinks included, from 8 p.m. until 11 p.m., rather than spending two or three times as much, to hear a comic opera or a play.

The public wants to relax, they want to speak loudly, to sing along, keep their hats on, savour their cigars while sipping liqueurs.

Is the ideal of the theatre for them?

Elsewhere: at the Opéra, at the Comédie-Française, at the Gymnase theatre, one must maintain a bothersome decorum, not move, not cough, not act candidly, one must be more still in one's seat than in a sitting room during a visit.][69]

Many times, Bruant must have had to shout to make himself heard over the noise of his boisterous patrons. In *Le Refrain*, Lautrec pointed up the vulgarity of the audience by caricaturing their features and facial expressions as they talked and gesticulated, barely aware of the performer. The painting is on paper—later pasted onto canvas—and may have been a preparation for an illustration. Though it was never published, this would account for its caricatural style.

Lautrec had precedents dating back to Daumier's lithographs of the 1850s and Degas's and Manet's *café-concert* scenes of the later 1870s for his interpretation of cabaret atmosphere, not only in the older artists' shrewd psychological analyses and satirical content, but in formal structure as well. Identifying the viewer of the painting with the audience by placing spectators in the extreme foreground; using these figures as *repoussoir* elements looming larger than the central figure of the performer; dividing the surface into two zones, performance above and audience below: these pictorial devices appeared in the work of Daumier, Manet, and Degas before Lautrec used them.[70] More directly, however, he probably borrowed them from Raffaëlli, whose illustrations of Vaucaire's article included two of *café-concerts*, *La Scala* and *Madame Duparc chantant*. Manet's and Degas's depictions of *café-concerts* and cabarets in the late 1870s were exemplars for the popular illustrators of the 1880s. Illustrations similar to Raffaëlli's, borrowing from Degas and Manet, were common in the popular press, which reflected both verbally and pictorially the new, more natural and informal social values that were part of the modern spirit of the decade.

The songs of Bruant expressed some of the same social attitudes. In addition, they conveyed a dual sense of social consciousness about, and romantic fascination with, the depths of Parisian society: the pimps and prostitutes, the vagabonds, the uneducated, the petty criminals, the

[69] Vaucaire, 130.
[70] These qualities of Degas's and Daumier's works are noted by T. Reff, *Degas: The Artist's Mind* (New York, 1976), 77–80, 176.

simple workers, the street types of the city's most depressed quarters. On the one hand, though not overtly political in content, the lyrics expressed compassion and moral outrage at the plight of the poor and the misery and injustice they endured at the hands of the bourgeoisie. On the other, they characterized the poor by a provocative animalistic brutality, coarseness, and lack of inhibition.[71] Bruant's so-called *chansons naturalistes* of the 1880s looked back to the tradition of the fifteenth-century poet of the underworld, François Villon, and also stemmed from the more recent movement in popular song-writing of the period after 1870 that had been accelerated by the development of the *cabaret littéraire* in the early 1880s.[72] Bruant's own songs and those of his circle appeared in each four-page edition of *Le Mirliton*, which the cabaret published irregularly from 1885 to 1894. *Le Mirliton* also featured old popular songs, poetry, jokes, and black-line drawings of plebeian life, the last photo-mechanically reproduced and sometimes coloured by stencil (*pochoir*). Steinlen was the chief contributor of the illustrations, but work by Lautrec also appeared in *Le Mirliton* during the 1880s and many of his paintings of the period bear titles of songs by Bruant. Several of these paintings in addition to the Mirliton panels hung at the cabaret from 1886 onward.

No doubt Bruant educated Lautrec to the new mores, affirming the more 'modern' direction of his art. Bruant's spirit informed Lautrec's Naturalism of the later 1880s, and his songs had particular importance in establishing a thematic territory for the artist. Gauzi stressed Lautrec's relationship with Bruant.[73] Joyant recognized the considerable duration of the song-writer's influence on the much younger artist (five years according to Joyant) even while he referred to it as 'quickly exhausted'. He conceded that both men disguised compassion beneath their harsh Realism and the outward cruelty in their observations of life. But, preferring to emphasize Lautrec's individuality, Joyant discounted the likelihood that certain of Lautrec's works derived immediately from Bruant's songs, despite the fact that the paintings hung in the Mirliton and had the same titles as the songs.[74]

Contrary to Joyant's belief, Lautrec specifically intended many of his works of this period to illustrate Bruant's songs. His new engagement with subjects of *le peuple* was stimulated by the cultural ambience of Montmartre, but more particularly by Bruant, although his treatment was less strident than the song-writer's. In addition to the panels illustrating the refrain and *quadrille* about the *chaise Louis XIII* and his 'dark Realist' painting, *A Montrouge—Rosa la Rouge*, Lautrec did other works during the later 1880s that pertained directly to songs by Bruant or were related to them in concept. *Jeune fille tenant une bouteille de vin* (Fig. 69) is an example of the latter. It does not appear to illustrate a particular song, but it has a general relevance to Bruant's concern about the life of the street people.

A Saint-Lazare, on the other hand, which Lautrec executed as both a drawing and a painting (Fig. 74) explicitly illustrated Bruant's song of the same title. Like *A Montrouge*, the painting hung at the Mirliton as one of the 'gallery' of portraits that Lautrec did of streetwalkers from various poor quarters of Paris. In both versions, *A Saint-Lazare* portrays a woman in prison garb writing, and conforms to the words of the song, which Bruant wrote in the form of a

[71] That Bruant did have leftist political leanings in the 1880s and early 1890s is affirmed by L. de Bercy, *Montmartre et ses chansons* (Paris, 1902), 59, and O. Méténier, 'Aristide Bruant', *La Plume* (1 Feb. 1891), 39–57. On Bruant's romanticism see Seigel, 237.

[72] De Bercy; G. d'Ale, 'La Chanson contemporaine', *La Revue bleue*, 46 (20 Sept. 1890), 362–6; Zévaès, 105 ff.

[73] Gauzi, 23–4, 105–10, and *passim*.

[74] Joyant, i. 96–102. Joyant, i. 98, maintains that Lautrec allowed Bruant to devise his own titles for the paintings.

love letter from a streetwalker, confined in Saint-Lazare jail, to her pimp lover. Ironically and pitiably, she worries about how he will live without her to support him:

> Mais pendant c'temps-là, toi, vieux chien,
> Quéqu'tu vas faire?
> Je n'peux t'envoyer rien de rien,
> C'est la misère,
> Ici, tout l'monde est décavé,
> La braise est rare;
> Faut trois mois pour faire un linvé,
> A Saint-Lazare!
>
>
>
> Vrai, d'te savoir comm'ça, sans l'sou,
> Je m'fais eun'bile!
> T'es capab' de faire un sal' coup,
> J'suis pas tranquille.
> T'as trop d'fierté pour ramasser
> Des bouts d'cigare,
> Pendant tout l'temps que j'vas passer,
> A Saint-Lazare!
>
>
>
> Je finis ma lette en t'embrassant,
> Adieu, mon homme,
> Malgré qu'tu soy'pas caressant,
> Ah! j't'ador' comme
> J'adorais l'bon Dieu comm' papa
> Quand j'étais p'tite,
> Et qu'j'allais communier à
> Saint'-Marguerite.

> [But during that time, you, old dog,
> What will you do?
> I can't send you anything at all,
> It's destitution,
> Here, everyone is stone-broke,
> Cash is rare;
> It would take three months to make twenty sous,
> At Saint-Lazare!
>
>
>
> Truly, to know that you are without a sou,
> Makes me worry!
> You're capable of rotten deeds,
> I'm not untroubled.
> You're too proud to collect
> Cigar butts,

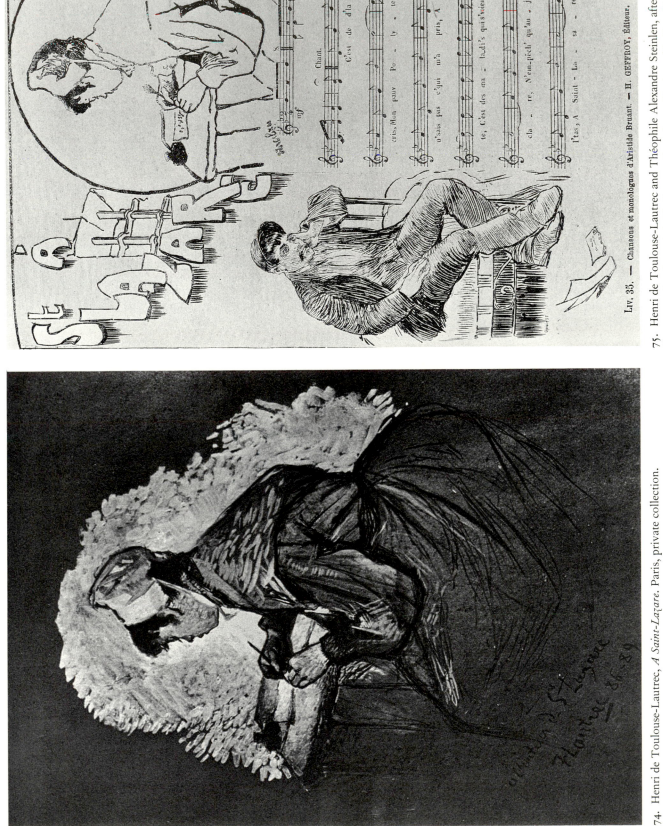

75. Henri de Toulouse-Lautrec and Théophile Alexandre Steinlen, after, *A Saint-Lazare*. Zinc engraving from Aristide Bruant, *Dans la rue* (Paris, n.d.). New York, collection of Mr and Mrs Herbert Schimmel.

74. Henri de Toulouse-Lautrec, *A Saint-Lazare*. Paris, private collection.

During all the time I've got to spend,
At Saint-Lazare!

.

I finish my letter by embracing you,
Good-bye, my man,
Even though you're not affectionate,
Oh, I adore you like
I adored God, like papa
When I was little,
And when I went to Communion at
Saint-Marguerite.][75]

Lautrec probably made both the drawing and the painting with a published illustration in mind. The pen and blue pencil drawing on Gillot paper was the terminal image, ready for photomechanical reproduction. The blue pencil would not have photographed, but would have indicated to the printer the density of the dot patterns (for reproducing tonal gradations) to be etched into the zinc printing plate.[76] The painting is a blue and white oil sketch on cardboard (essentially a grisaille) that could have been a preparatory study for the drawing. Such paintings, sketchy and incomplete in appearance, and created as preparations for graphic works, should be distinguished from Lautrec's more finished formal paintings, of which he occasionally made later graphic reprises, as in the case of *A Montrouge*. The year 1886 is the earliest possible and most likely date for the drawing and painting of *A Saint-Lazare*. The song that Lautrec pictorialized so literally in them must have dated from about mid-1886, since the first printed reference to it occurred in *Le Mirliton* (no. 24) of 1 September 1886, in Bruant's regular listing of *Les Refrains du Mirliton*.[77] The painting, moreover, which may well have preceded the drawing, bears the dates, '86–89', in Lautrec's hand, and his inscription, 'to the author of Saint-Lazare'. Possibly he worked on it over a period of time, but it is more likely that he painted it in 1886 and presented it to Bruant in 1889. The artist also signed the drawing 'Tréclau', which he did not use before 1886 or after 1888. The drawing by itself was reproduced twice by printers, not Lautrec, the first time as a zinc engraving on the cover of *Le Mirliton* of August 1887 (no. 39). In 1888, it was reproduced as the lithographic cover illustration on the sheet music to 'A Saint-Lazare'—incidentally the only time that a work by Lautrec is known to have been published in this format to illustrate a Bruant song.[78]

The drawing was reproduced a third time in a rare, possibly unique collaboration between Lautrec and the older, more famous Steinlen. When the collected songs of Bruant appeared in 1888 in volume i of *Dans la rue*, Lautrec's depiction of the jailed streetwalker at her writing

[75] Bruant, i. 61–3.
[76] Cate in Cate and Gill, 79.
[77] For further discussion of the song's date see F. Lachenal, 'Remarques en marge: à Saint-Lazare', in *Henri de Toulouse-Lautrec* (exh. cat., Ingelheim am Rhein, 1968).
[78] L. Delteil, *Le Peintre-graveur illustré*, x, no. 10 (Paris, 1920), erroneously dated this lithograph 1885 and believed it to be Lautrec's first original graphic work. However, Lachenal has shown that the lithograph bears the name of a printer, specializing in music, who made a variation on Lautrec's drawing by adding feathers to the woman's quill pen. Moreover, this printer, E. Dupré, was not in business until 1888. The sheet music for this song was not deposited at the Société des Auteurs et Compositeurs until Dec. 1888.

table accompanied one by Steinlen of the woman's lover seated on his bed with the letter on the floor at his feet (Fig. 75). Steinlen, who illustrated Bruant's songs in *Dans la rue*, was the song-writer's principal illustrator, and the artist whose works reputedly were the best pictorializations of Bruant's spirit. But Lautrec shared the distinction to some extent during the latter 1880s, and probably emulated Steinlen. Later, however, Lautrec's stylistic advances were to influence Steinlen.

Bruant's song, 'A Grenelle', originally published in *Le Mirliton* (no. 18) of 15 May 1886, was Lautrec's subject for another related drawing and painting (Fig. 76). In the melancholy words of this song, a woman dwells nostalgically on her past, when she was a young prostitute consorting with the soldiers in the Grenelle quarter of Paris (where the École Militaire was located). But she lost her beauty, and with it the admiration of the soldiers, who made her a *pension* of a filled mess-pot:

> J'en ai t'i' connu des lanciers,
> Des dragons et des cuirassiers,
> I's m'montaient à m'tenir en selle,
> A Grenelle.
>
> Fantassins, officiers, colons
> Montaient à l'assaut d'mes mam'lons,
> I's m'prenaient pour eun' citadelle,
> A Grenelle.
>
> Moi j'les prenais tous pour amants,
> J'commandais tous les régiments,
> On m'app'lait mam'la colonelle,
> A Grenelle.
>
> Mais ça m'rapportait que de l'honneur,
> Car si l'amour ça fait l'bonheur,
> On fait pas fortune avec elle,
> A Grenelle.
>
>
>
> Aujord'hui qu'j'ai pus d'position,
> Les régiments m'font eun' pension:
> On m'laiss' manger à la gamelle,
> A Grenelle.
>
> Ça prouv' que quand on est putain,
> Faut s'établir Chaussé-d'Antin,
> Au lieu d'se faire eun' clientèle,
> A Grenelle.
>
> [I've known lancers,
> Dragoons and cuirassiers,

They mounted me and kept me in hand,
 At Grenelle.

Infantrymen, officers, legionnaires
Mounted to the assault of my breasts,
They took me as a citadel,
 At Grenelle.

Me, I took them all as lovers,
I commanded all the regiments,
They called me Mademoiselle the Colonel,
 At Grenelle.

But this brought me nothing but honour,
For if love makes happiness,
It doesn't make one a fortune,
 At Grenelle.

.

Now that I no longer have a position,
The regiments have granted me a pension;
They let me eat from a mess-pot,
 At Grenelle.

This proves that when one is a whore,
One must establish oneself at Chausée-d'Antin,
Instead of making a clientele,
 At Grenelle.][79]

A heavy-set woman sitting pensively at a café table is the subject of both the drawing and the painting. In this instance, the pencil drawing appears to have been a preparatory study for the painting and was not the more finished work as in *A Saint-Lazare*. Lautrec himself labelled it '1886—A Grenelle Mirliton', and its formal title is *A Grenelle: buveuse pour le Mirliton*. In the painting, entitled *A Grenelle, buveuse d'absinthe*, the woman seems to muse dejectedly over the glass on the table in front of her. The colour in this work, predominantly of drab, greenish-grey tones, intensifies the depressing mood. The painting's obvious connection to the dated drawing and its brush stroke, characteristic of the impressionistic technique that Lautrec used in his independent works of 1886, place it at the same time as the drawing. Not only do their titles relate these two works to Bruant's song. The painting belonged to Bruant and hung at the Mirliton, and Gauzi, who described it there, noted specifically that the song, 'A Grenelle', had inspired it.[80]

[79] Bruant, i. 143–7. Another of Bruant's songs deals with the subject of the prostitute and soldier: cf. *La Noire*, Bruant, i. 135–40.

[80] Gauzi, 45. Gauzi, 46, is incorrect, however, in noting that this painting was exhibited in Reims in 1889. He confuses it with P328. See Stuckey, 107, 117.

77. Henri de Toulouse-Lautrec, *Artilleur et femme*. Oil sketch on canvas. Albi, Musée Toulouse-Lautrec.

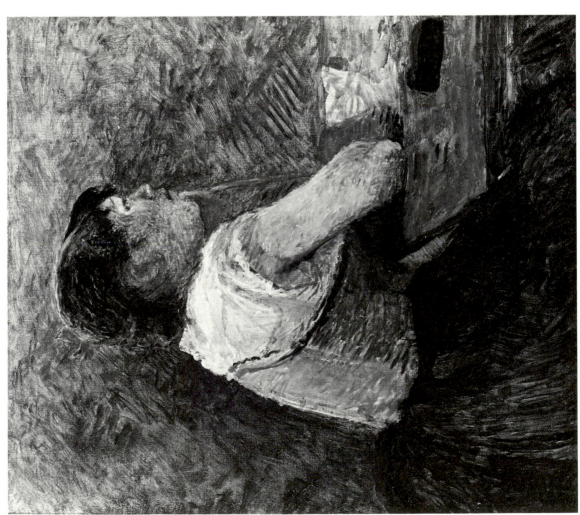

76. Henri de Toulouse-Lautrec, *A Grenelle: buveuse d'absinthe*. New York, Hazen Collection.

A series of six works all entitled *Artilleur et femme* (e.g. Fig. 77) show the subsequent evolution of Lautrec's idea for illustrating 'A Grenelle'. They consist of four drawings heightened with oils on tracing-paper, an oil sketch on canvas, and a charcoal drawing. All of them pertain to the explicitly sexual imagery in Bruant's lyrics and as a group they also have direct links to the drawing and painting of *A Grenelle* as shown. In the first two of these works, Lautrec still represented the prostitute sitting at the table alone, but he then expanded the scene by adding the figure of an *artilleur* (artilleryman), who stands opposite the woman, staring at her lewdly and hitching up his pants. Some aspect of the female figure in every version, whether in pose, hair style, or costume, derives from the figure in *A Grenelle*, though in the most nearly complete of these works Lautrec gowned her with a bold *décolletage* and generally transformed her appearance. The figure of the artilleryman made its first entrance as a sketch on the verso of the drawing *A Grenelle: buveuse pour le Mirliton*, a further indication of the relationship between the two sets of illustrations. But by adding the soldier to his picture of the prostitute, Lautrec made the connection with Bruant's verses more evident.

Lautrec did not illustrate Bruant's lyrics to 'A Grenelle' in specific detail, but reproduced their theme and their mood of sordidness and repressed despair. The song was his inspiration, even though he did not borrow from it literally. Yet Bruant and Lautrec both had precedents for dealing realistically with the theme of the soldier and the prostitute. A brothel near the École Militaire was one of the settings in Edmond de Goncourt's novel *La Fille Elisa*, and Degas had drawn representations of these scenes in a notebook of 1877.[81] (Lautrec knew *La Fille Elisa*, and in the mid-1890s was to make a series of illustrations of it in his personal copy.)[82] In their desire for an uncompromising and provocative vision of modern life, Degas and the Realist and Naturalist novelists had given extensive treatment to the theme of prostitution and its connotations of sexual freedom well in advance of Bruant and Lautrec. Lautrec, however, did not arrive at this theme by way of the detached vision of Degas, but through Bruant's songs of social protest. Bruant himself was probably influenced by Zola's portrayal in *L'Assommoir* of poverty, drunkenness, promiscuity, and general degradation among the poor in the working-class slums of Paris and by his use of their coarse argot for authenticity and as an aesthetically iconoclastic gesture.[83] The song-writer, as well as the circle of modern popular illustrators, was Lautrec's initial, most direct link to the Realist and Naturalist traditions.

The series of studies on 'A Grenelle' demonstrates that Lautrec still used the academic methods of preparation, first careful preliminary drawing and realistic depiction of the model, then sketching in paint on tracing-paper laid directly over a drawing. For studies such as these, he undoubtedly worked from life, sometimes from subjects whom he found on the local scene, sometimes from models who might have been professionals or just his friends, whom he posed to conform to Bruant's lyrics. For example, Gauzi wrote that Wenz, a fellow student, posed for the 'artilleryman in the act of putting his trousers back on'.[84] At the same

[81] See Reff, *Degas*, 172–4, who points out that Constantin Guys had earlier made numerous drawings of soldiers and prostitutes. In a painting entitled *La Forte chanteuse* of the mid-1880s, Raffaëlli showed a café flirtation of a female performer and two soldiers. The theme of the soldier and prostitue was also treated by the Naturalist novelist Robert Caze in his novel *Les Filles:* *femme à soldats* (Brussels, 1884), and later by Lucien Descaves in his novel *Sous-offs, roman militaire* (Paris, 1889).

[82] Édition Charpentier (Paris, 1877) (A237–52).

[83] On the use of argot by Zola and other Realist writers see E. Herbert, 177–9.

[84] Gauzi, 44–5.

time, this method was in keeping with Bruant's Realist aesthetic of working from life rather than imagination. Lautrec himself now scoffed at the prettified eroticism of mythological subjects, and declared his preference for a modern, more raw and explicit representation of sexuality: 'Scorning the banality of the École des Beaux-Arts' type of classicism,' wrote Gauzi, 'Lautrec sought to affirm his independence by choosing vulgar [*canaille*] subjects.' Gauzi noted that at this moment, however, Lautrec still hesitated in this choice.[85]

In 1886 Lautrec still participated in the academic competitions at Cormon's, but at the same time asserted his identification with his alternative career as a popular artist and with the iconoclastic spirit of the Bohemian community of Montmartre by showing in the Salon des Artistes Incohérents, the exhibition of the Montmartre circle of illustrators. The artists of this group referred to themselves in their catalogue as 'The Anarchists of Art', and their credo, though they stated it humorously, emphasized their anti-bourgeois, anti-puritanical point of view. In 1882, at their first exhibition, they had expressed their desire 'to make an exhibition of drawings executed by people who don't know how to draw',[86] and their shows lampooned the official Salon. Lautrec observed the custom of the Salon des Artistes Incohérents of adopting humorous pseudonyms: he was listed as 'a certain Tolau-Segroeg, "Hungarian of Montmartre"'. His work, no. 332, was entitled *Les Batignolles, trois ans et demi avant Jésus-Christ* (The Batignolles District, Three and a Half Years before Jesus Christ), which suggests that it could have been a parody of Cormon's prehistoric scenes. It was described as an 'oil-painting on sandpaper'. Lautrec was to exhibit with these artists once more, in 1889, when he was listed as the pupil of one 'Pubis de Cheval', and his painting as *Portraits d'une malheureuse famille atteinte de la petite grêlure* (Portraits of an Unfortunate Family Stricken by Chicken-pox), an apparent parody of Neo-Impressionism.[87]

[85] Gauzi, 44–5.

[86] Roberts-Jones, *De Daumier à Lautrec*, 82. See also *Le Courrier français* of 3 Dec. 1884, 30, in which Jules Roques states the credo of the group, and a special issue of *Le Courrier français* of 12 Mar. 1884.

[87] Roberts-Jones, 'Les Incohérents et leurs expositions', *Gazette des beaux-arts*, 52 (Oct. 1958), 235–6.

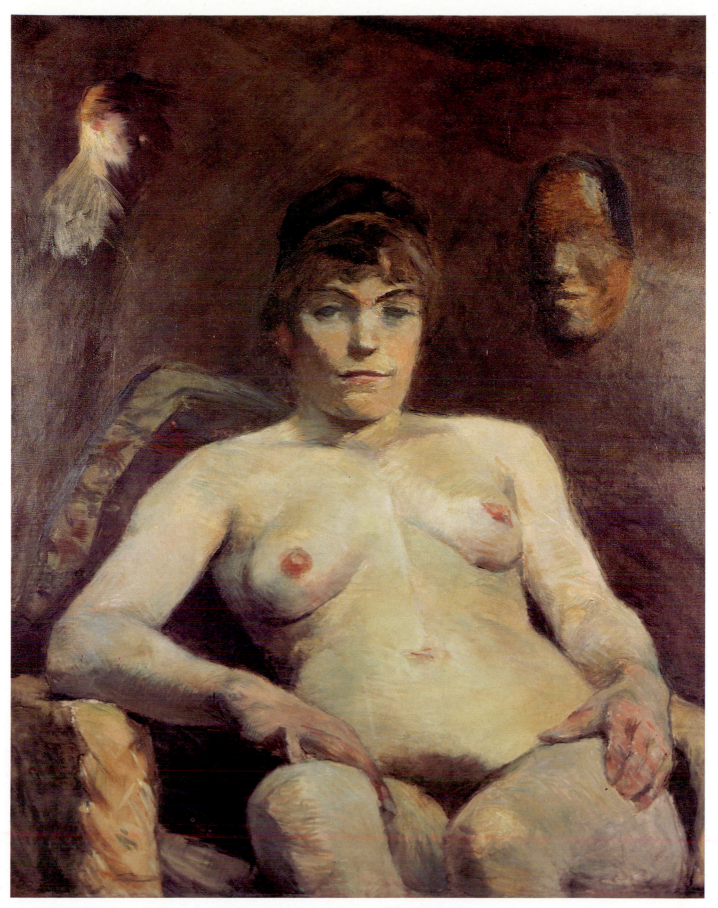

58. Henri de Toulouse-Lautrec, *La Grosse Maria*. Wuppertal, Germany, Von der Heydt-Museum.

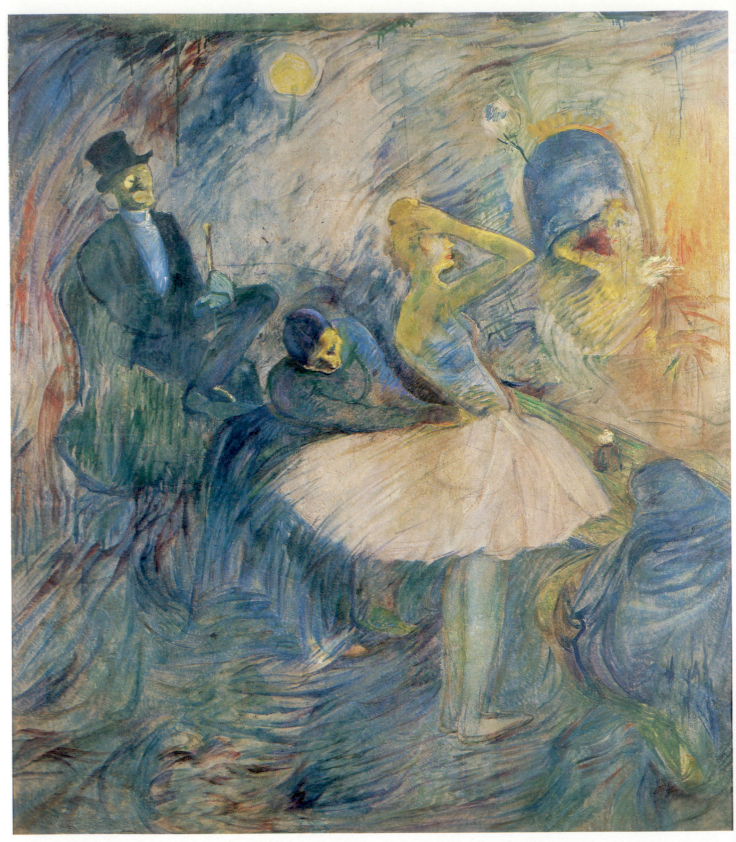

64. Henri de Toulouse-Lautrec, *Danseuse dans sa loge* from Ancelin's Inn at Villiers sur Morin. Oil on plaster, transferred to canvas. Japan, private collection. (Photo, Sotheby's London.)

4

Painter of the 'Petit Boulevard'

Continued Experimentation, 1887–1888

LAUTREC moved towards a resolution of the growing contradictions between his roles of academic student and radical artist and illustrator in 1887 by leaving Cormon's atelier and allying himself more definitively with progressive circles. He was already linked to the avant-garde currents that swept the atelier from late 1885 onward, and no evidence exists to place him there after the winter–spring of 1887. In 1887, not 1884, Lautrec entered the mainstream of advanced art, completed his assimilation of Impressionism, and went on to Neo-Impressionism. And as he became more daring stylistically, he also continued to explore Naturalist subject-matter in his popular illustrations and his paintings. But the period 1887–8 was still one of experimentation; Lautrec did not yet develop a distinctive, original style nor did he fully integrate the subjects of his popular illustrations into his more formal works. Nevertheless, as he had left the atelier, the distinction between his academic and independent works disappeared and his identification with the avant-garde became more firm. No longer a student now, but a professional artist, he expressed this identification by participating in the public exhibitions of the more radical artists of the day. The developments in Lautrec's career at this point should be seen in the context of influences and experiences he shared with the other emergent young artists he had met at Cormon's atelier and to whose circle he still belonged.

The Emergence of Cormon's Avant-Garde Students as the Painters of the 'Petit Boulevard'

Both Hartrick and Bernard made it evident in their accounts that by mid-1886 the rebels at Cormon's atelier were advancing beyond Impressionism. Later in 1886 and into 1887, these young artists shared in particular a powerful attraction to Seurat, Signac, and the theories of Neo-Impressionism, which possibly dated from their exposure to Seurat's work: at the eighth Impressionist exhibition of spring 1886, the second exhibition of the Société des Artistes Indépendants in August–September 1886, and the showing of the Indépendants of spring 1887. The critic Félix Fénéon spelled out the theories of Neo-Impressionism in a manifesto of 1886.[1] Few works of Bernard and Anquetin survive from the period, but the written

[1] F. Fénéon, 'Les Impressionnistes en 1886', as reprinted in Fénéon, *Œuvres plus que complètes*, i. 27–58. Originally appeared as 2 articles in *La Vogue* in June and July 1886 and a 3rd in *L'Art* *moderne* in Sept. 1886 and reissued in Oct. 1886 by *La Vogue* in the form of a pamphlet.

accounts indicate that they, especially, felt the influence of Neo-Impressionist colour theories. They discussed and experimented with them, and Bernard exhibited pointillist works at Asnières in late 1886 or early 1887.[2] Signac, at the same time, strongly impressed van Gogh, and his influence may have been instrumental 'in Vincent van Gogh's "conversion" to painting with bright, clear colours and broken brushstrokes' in 1887.[3]

By 1887, these young progressives were leaving Cormon's orbit altogether, and considered themselves independents. They exhibited as a group just once, in November–December 1887, in a show that van Gogh organized at a proletarian restaurant on the Avenue de Clichy.[4] Van Gogh, in letters from Arles in 1888, was to distinguish them by the title, 'Les Impressionistes du Petit Boulevard', to set them apart from the older, established Impressionists who exhibited in the fashionable galleries on the *grands boulevards*.[5] (Van Gogh and others at this time used the term 'Impressionist' to designate all avant-garde artists.) In addition to van Gogh himself, the group included Lautrec, Anquetin, Bernard, and a Dutch painter, A. Koning, all of whom had studied in Cormon's atelier at 104 Boulevard Clichy. Their exhibition, for which Bernard's much later descriptions are the authority, culminated but did not end their association.[6] Since Lautrec belonged to this informal group the interests and activities of its members are pertinent to his development. They were unknown radicals in search of a viable, innovative style. Though at different paces, they nevertheless followed much the same path from Impressionist and Neo-Impressionist Realism to more abstract, simplified, and decorative styles.

Hartrick made it evident in his account that Lautrec, too, took an interest in avant-garde colour theories and put them into practice. Though he has generally been considered anti-intellectual and uninterested in art theory, at this stage of his career he shared the concerns of his fellows of the Petit Boulevard for principles of colour. In 1887, Hartrick recalled, he thought that Lautrec 'understood Chevreul's theory of colours and the division of tones better than anyone else, as applied to painting'.[7] Van Gogh used the Impressionist theory of the division of tones, Hartrick wrote, but 'I do not think he was ever a scientific painter in the sense that Seurat and Lautrec became in dealing with complementary colours'.[8] Bernard, confirming Hartrick's account, included Lautrec as well as himself and Anquetin in his description of the changes the young vanguardists went through during the period of 1886–7. They began with a strong interest in Naturalism, but 'we all soon fell, by and by, strongly under the influence of the pointillist theories'. Bernard related that he himself eventually rejected Signac's pointillist dot because he felt that it detracted from the true effects

[2] Rewald, *Post-Impressionism*, 504. C. Pissarro, *Lettres à son fils Lucien*, ed. L. Pissarro and J. Rewald (Paris, 1950), 153, noted in a letter of c.20 May 1887 that Anquetin was working in a pointillist style.

[3] L. Nochlin (ed.), *Sources and Documents in the History of Art: Impressionism and Post-Impressionism, 1874–1904* (Englewood Cliffs, NJ, 1966), 117. See also É. Bernard, 'Souvenirs sur van Gogh', *L'Amour de l'art*, 5 (1924), 399–400.

[4] Referred to in van Gogh, ii. 611–12, no. 510 of summer 1888; and iii. 182–3, no. 595 of June 1889. B. Welsh-Ovcharov (ed.), *Van Gogh in Perspective* (Englewood Cliffs, NJ, 1974), 39 n. 8, and *Vincent Van Gogh, His Paris Period, 1886–1888* (Utrecht and The Hague, 1976), 21, 28, 34–40, argues con-

vincingly that the exhibition took place in the Grand Bouillon Restaurant du Châlet on the Avenue de Clichy. For the Nov.–Dec. dating, see p. 60 n. 63 in the latter book.

[5] Van Gogh, ii. 530–2, no. 468, 10 Mar. 1888, and n.; ii. 589–90, no. 500, summer 1888. Bernard also used this term: see A. Vollard (ed.), *Lettres de Vincent van Gogh à Émile Bernard* (Paris, 1911), preface.

[6] É. Bernard, 'Vincent van Gogh', *L'Arte*, Feb. 1901; 'Souvenirs sur van Gogh', 393; 'Notes sur "Pont-Aven" ', 678. See also Rewald, *Post-Impressionism*, 62–4, who quotes from an unpublished manuscript by Bernard, describing the exhibition.

[7] Hartrick, 92.

[8] Ibid. 44.

of colour and light, and made figures too wooden. Therefore he explored other facets of colour theory: 'I set forth my ideas to Toulouse-Lautrec and Anquetin, and consequently each one of us individually and without seeing the others' works, took up experiments with an oversimplification that was very personal and very highly coloured.'[9]

Presumably this idea of 'oversimplification' was to lead to Bernard's and Anquetin's development of Cloisonnism in late 1887. They had maintained their interest in pointillism in 1886 and the spring of 1887, but during the summer of 1887, at his father's house, Anquetin began original experiments with colour theory that were to turn them in the new direction and to affect van Gogh and Lautrec as well. The experiments concerned the effects of dominant colour tones as distinct from the pointillist juxtaposition of small dots of many different colours. In his later account, Bernard described Anquetin's first attempts:

There was at his father's house at Étrepagny, one of those doors fitted with squares of coloured glass, that were very popular in those days. This door looked out on the countryside; he observed that each pane of glass formed, according to its colour, a different harmony; a harmony where all of the tones, far from *opposing* each other, merged one into the other in favour of a *dominant*. It was the opposite of the Impressionist theory. He seized on that to push it to its extreme consequences, and he painted a mower in a summer landscape where everything depended on yellow. This painting was soon followed by another representing a butcher shop at nightfall on the Avenue de Clichy, where Anquetin then lived. The latter was in the blue scale.[10]

What Anquetin saw through the coloured panes of the door, Bernard related, was that yellow gave the impression of sunlight, green of dawn, blue of night, and red of dusk.[11] According to Bernard, van Gogh was enthusiastic about Anquetin's experiments and made direct imitations of them as well as his own variations.[12] Hartrick confirmed Bernard's account and amplified it. Van Gogh 'was particularly pleased with a theory that the eye carried a portion of the last sensation it had enjoyed into the next, so that something of both must be included in every picture made', Hartrick wrote. For example, 'the entering of a lamplit room out of the night increases the orange effect of the light, and in the contrary case, the blue. Hence, to depict it properly, according to theory, it was necessary in the former case to include some blue in the picture and in the latter some orange.'[13] The Petit Boulevardists at this point were primarily interested in using dominant tones to create the sensation of a particular time of day, rather than to evoke emotions, but like other artists and theorists of the nineteenth century they eventually transferred their curiosity about the scientific aspects of colour to its expressive possibilities.[14]

[9] É. Bernard, 'Des relations avec Lautrec', 14.

[10] Id., 'Louis Anquetin', *Gazette des beaux-arts*, 11 (1934), 113. Bernard refers here to Anquetin's 2 paintings *The Mower at Noon, Summer* (Collection Professor and Mme Velluz, Paris) and *Avenue de Clichy: Five O'Clock in the Evening* (Wadsworth Atheneum, Hartford, Conn.), both dated 1887.

[11] Id., 'Notes sur "Pont-Aven"', 676.

[12] Id., 'Louis Anquetin', 114. See also Rewald, *Post-Impressionism*, 30, 32. The direct imitation was van Gogh's *Mower* (Musée Rodin, Paris).

[13] Hartrick, 44.

[14] Earlier comments on the physical and/or emotional effects of dominant tones had been made by Baudelaire, *L'Œuvre et la vie de Eugène Delacroix, variétés critiques*, vol. iii, as quoted by J. Rewald, *Georges Seurat* (New York, 1946), 5; also by C. Blanc, *Grammaire des arts du dessin* (Paris, 1867), and F. Braquemond, *Du dessin et de la couleur* (Paris, 1885). Welsh-Ovcharov, *van Gogh and the Birth of Cloisonism*, 240, notes that Anquetin probably studied the latter two theorists. Seurat had been aware of the effects of dominant colours since the early 1880s, though he did

At the Exposition des Vingt in Brussels early in 1888, the critic Dujardin observed a new tendency in the works of Anquetin towards simplified forms, flattened surfaces, emphatic closed outlines, and a stylized, decorative appearance.[15] This was the style he called Cloisonnism, whose characteristics had appeared in the painting of Anquetin and Bernard (but not strongly in that of van Gogh or Lautrec) by late in 1887. Van Gogh was to confirm Bernard's role as well as Anquetin's in this new stylistic development in a letter of June 1888, but suggested that Bernard was then the more advanced of the two—that he 'has perhaps gone further in the Japanese style than Anquetin'.[16] Probably their new familiarity with Japanese art[17] (in addition to their experiments with coloured glass) was one of the principal sources of inspiration for an innovative style that combined their Realist interest in colour theory with abstraction of form.[18]

Van Gogh's letter of June 1888 probably reflected his own experiences of his last months in Paris, during the early winter of 1887–8. He declared that Seurat was 'the leader of the Petit Boulevard', implying that despite the new tendencies of Bernard and Anquetin, pointillism was still the group's main direction. He seemed also to assume that Lautrec and Anquetin remained committed to a style orientated toward Realism and influenced by Neo-Impressionism. His own new aim, he said, was to move away from Realism toward an expressive exaggeration, and added: 'Anquetin and Lautrec—I think—will not like what I am doing.'[19] In 1887, van Gogh and Lautrec, too, were still comparatively restrained in style. Lautrec's paintings of 1887, which the accounts of witnesses confirm, show that he kept up with the developments in the work of Anquetin and Bernard. Under their influence he seems to have experimented with colour theory and even to have tried—but rejected—the pointillist dot. But he did not go as far in developing a more simplified, abstract style in this period, and so lagged behind his friends. Abstraction and simplification must have seemed to him incompatible with the Naturalist themes he was becoming increasingly committed to, and so he preferred styles that he associated with greater realism—styles inspired by Impressionism and Neo-Impressionism. The works that he exhibited at the Exposition des Vingt in early 1888 demonstrate this.

Like Lautrec the other Petit Boulevardists also responded to the late Realist and Naturalist influences so prominent within the artistic and intellectual milieu.[20] Van Gogh, the principal organizer of the Petit Boulevard exhibition in 1887, originated the concept that the event had a social purpose, and that the Petit Boulevardists were creating an art for the common people: 'Art must be spread to the humble people.' He was pleased, therefore, to hold the exhibition

not explore their emotional possibilities fully in his works until later in the decade. See Rewald, *Seurat*, 5, and *Post-Impressionism*, 125–9. Seurat explored dominants under the influence of Charles Henry's theories, first published in 1888 in the *Revue indépendante*. Henry's ideas may have been discussed in Seurat's circle prior to 1888, however.

[15] E. Dujardin, 'Aux XX et aux indépendants—le cloisonisme', *La Revue indépendante*, 6 (Mar. 1888), 487–92. See also Rewald, *Post-Impressionism*, 176–7.

[16] Van Gogh, ii. 589–90, no. 500, June 1888. In this letter van Gogh must be responding to a complaint by Bernard of Dujardin's failure to mention his role in the development of the new style. Cf. Rewald, *Post-Impressionism*, 177.

[17] Van Gogh, ii. 612, no. 510 of July 1888, wrote, 'The exhibition of [Japanese] prints that I had at the Tambourin [a Paris café] influenced Bernard and Anquetin a good deal.' This showing took place in the spring of 1887.

[18] On this aspect of Cloisonnism see Welsh-Ovcharov, *Van Gogh and the Birth of Cloisonism*, 240.

[19] Van Gogh, ii. 590, no. 500.

[20] Welsh-Ovcharov, *Van Gogh and the Birth of Cloisonism*, has brought to light several previously unpublished and little-known works, facilitating analysis of the influential role of Naturalism upon the Petit Boulevard group.

at a popular restaurant on the Avenue de Clichy instead of at a fashionable gallery.[21] For Lautrec, the idea of directing his art to a humble audience, to which van Gogh introduced him, was new at this time. It must have reinforced the influences of Bruant, the illustrated press, and the Montmartre ambience. Moreover, van Gogh, Bernard, and Anquetin each undertook Naturalist subjects parallel to those of Lautrec, although they did not embark upon careers as popular illustrators. The interest in such subjects must have begun at Cormon's for all of them and it persisted for the next few years along with their stylistic experimentation as another facet of their artistic modernism.

Van Gogh's enthusiasm for literary Naturalism before and during his Paris period is generally acknowledged; he also collected illustrations from Parisian popular journals during the second half of the 1880s, among them Raffaëlli's *café-concert* series from *Paris illustré* of 1886 and Lautrec's *Le Quadrille de la chaise Louis XIII* from *Le Mirliton*.[22] The influence of Realism and Naturalism emerged in his work through his preference for humble, proletarian subjects. It had begun before he went to Paris, and at Arles during 1888 it was reflected in paintings that he made about popular life: notably *The Night Café*, *The Brothel* (dedicated to Émile Bernard), *The Dance-Hall*, and *Interior of a Restaurant*.[23]

Naturalistic subjects interested Émile Bernard, too, though they never became central to his art as they did to Lautrec's. Some time between 1885 and 1887 he made preparatory sketches for a large-scale mural (which he never completed) on Parisian cabaret life, to be entitled *L'Heure de la viande* (e.g. Fig. 78).[24] In his sketches, bourgeois men accost working-class women, probably prostitutes, in the shadowy, gaslit interior of a cabaret, while working men loiter at the periphery of the scene. The sexual overtones indicate that Bernard, a regular patron of the Mirliton with Lautrec and Anquetin,[25] may also have felt the influence of Bruant's songs. In style, the emphatic modelling and heavy shadows are still academic techniques. Bernard also treated stock Realist and Naturalist subjects in *The Saltimbanques* and *The Ragpickers* of 1887. About late 1887 or early 1888, he made a number of ink drawings of Parisian night-life, including a streetwalker and a scene in a Parisian dance-hall,[26] probably the Élysée Montmartre, in which he emphasized the vulgarity of the figures by treating them with caricatural simplification and exaggeration. He subsequently did a group of drawings and watercolours of prostitutes that he sent to van Gogh at Arles during the summer and autumn of 1888; possibly they led van Gogh to undertake his own depictions of similar subjects that autumn.[27] But in these Bernard had advanced into the enhanced stylization and decorative effects of Cloisonnism.

Anquetin and Lautrec were close friends at this time, so close that 'Lautrec scarcely left Anquetin's side', according to Bernard.[28] They chose the same subjects and shared the same

[21] É. Bernard, 'Souvenirs sur van Gogh', 393.

[22] Welsh-Ovcharov, *Van Gogh, Paris Period*, 48, and 59 n. 57. His continued interest in popular illustration while in Arles in 1888 is documented by van Gogh, ii. 555, no. 480; ii. 530, no. 468; ii. 591, no. 591; and ii. 602, no. 505, which records his receipt of Lautrec's illustrations published in *Paris illustré* of July 1888.

[23] De la Faille, F463, F478 (dedication recorded in van Gogh, iii. 72, no. 548), F547, F549, respectively.

[24] Reproduced and discussed in Welsh-Ovcharov, *Van Gogh and the Birth of Cloisonism*, 268–9.

[25] É. Bernard, 'Louis Anquetin, artiste peintre', 593.

[26] See Welsh-Ovcharov, *Van Gogh and the Birth of Cloisonism*, 293, 286–7, 265, and 326, respectively.

[27] M. Roskill, *Van Gogh, Gauguin and the Impressionist Circle* (Greenwich, Conn., 1970), 126–7, and Welsh-Ovcharov, *Van Gogh and the Birth of Cloisonism*, 264–6, 293–4.

[28] Bernard, 'Louis Anquetin, artiste peintre', 592.

models from among the women who frequented the dance-halls and cabarets of Montmartre.[29] Anquetin, the leader of the Petit Boulevardists, planned a mural-sized painting of the interior of the Mirliton during the winter of 1886–7, and made numerous drawings and sketches on cardboard, several of which he exhibited at Les Vingt in 1888.[30] He abandoned this work, to have been entitled *Chez Bruant*, and none of the studies has survived.[31] Lautrec and Bernard may have both posed for the projected *Chez Bruant*, and Bernard wrote about how exciting they had found their friend's work on this project.[32] Despite the failure of his *Chez Bruant*, Anquetin continued to represent naturalistic subjects over the next several years, though by late 1887 he had turned to treating them in a Cloisonnist style. Émile Verhaeren, who wrote a review of the Exposition des Vingt of 1888, concluded from the work of Anquetin and Lautrec that the same researches into 'the special and modern "character" of things' had motivated them. In the work of both young artists, he noted: 'Certain feminine types are profoundly and decisively conveyed. The maliciousness of certain people, the chilly enigma of certain glances, the vice of such an air or such a posture, there they are. And all of this, modern, everyday living, observed, and thoroughly gone into.'[33]

Naturalism was just one of the factors, but an important one, that drew the Petit Boulevard painters together when they emerged from their academic training. Undoubtedly a community of shared interests and the exchange of ideas flourished among these young artists. However, the crucial distinction that set Lautrec apart from the other Petit Boulevardists was the strength and permanence of his commitment to naturalistic content. Realism, not only factual but subjective, was to remain his central preoccupation. Anquetin and Bernard in particular, on the other hand, appear in retrospect to have treated the representation of Naturalist themes secondarily in the later 1880s, while they evidenced much greater interest in the invention of an avant-garde style. Their commitment to Naturalist themes apparently waned as Lautrec's grew more accentuated. In style, the turn toward abstraction and simplification occurred earliest with Anquetin and Bernard and next with van Gogh, all three of whom still retained a naturalistic subject-matter even as they grew more involved in radical stylistic experimentation. In their rejection of strictly naturalistic style, they moved well ahead of Lautrec, though their avant-gardism eventually had its impact on him. The Cloisonnism that Anquetin, Bernard, and van Gogh practised in the late 1880s served as a vital transitional phase between Naturalism and the more abstract Symbolism in avant-garde art. It provided Lautrec with a precedent for treating naturalistic subjects in a simplified abstract style, and manipulating form to magnify subjective mood and meaning in his Naturalist themes. These were to constitute the main thrust of his mature art.

[29] Rothenstein, 64.

[30] Item no. 6 on his personally designed exhibition list reads 'Quelques études pour "Chez Bruant"'. Reproduced in Welsh-Ovcharov, *Van Gogh and the Birth of Cloisonism*, 230.

[31] É. Bernard, 'Louis Anquetin, artiste peintre', 593.

[32] Ibid. 592–3, and 'Louis Anquetin', 114. On Bernard's posing see also M. A. Stevens, 'Innovation and Consolidation in French Painting', *Post-Impressionism: Cross-Currents in European Painting* (exh. cat., Royal Academy of Arts, London, 1979), 21, and Welsh-Ovcharov, *Van Gogh and the Birth of Cloisonism*, 229, fig. 80, a portrait of Bernard by Anquetin, which she tentatively attributes to this project. Anquetin both drew and painted Lautrec's portrait in this period, possibly for *Chez Bruant*, cf. Welsh-Ovcharov, *Van Gogh and the Birth of Cloisonism*, 234–5.

[33] É. Verhaeren, 'L'Exposition des XX à Bruxelles', *La Revue indépendante*, 6 (Mar. 1888), 456–7.

The Year 1887

'Busy enough to exhibit right and left': Paintings

Lautrec's paintings of 1887 project a more consistently independent spirit than do those of 1886. The artist abandoned his 'dark Realist' palette entirely and embraced a more thorough-going Impressionist colour and stroke in all of his paintings. He also experimented more boldly with new theories of colour and light and the point at which he began to do so apparently also marked his final departure from Cormon's sphere. None the less, he treated his new naturalistic subjects in relatively few of his formal easel paintings and, particularly during the first half of 1887, his work combined certain conservative features with others typical of the most advanced experiments of the Petit Boulevard painters.

Lautrec's few extant letters of the period convey his new sense of professionalism, even though he made no direct pronouncements in them about his art. Late 1887 was the time of his first sale.[34] Despite his family's considerable wealth and willingness to support Lautrec in his artistic career,[35] which might have freed him from the pressure of making sales, he always maintained a keen ambition to sell his work, less for the end of financial gain than as a sign of success. And in addition to selling he wanted to show his work in order to have it known to the public. 'My work is getting along pretty well', he wrote on one occasion, 'and I'm busy enough to exhibit right and left, which is the only way to get your work seen.'[36] Beginning in 1886, he had placed a number of paintings on permanent display at the Mirliton; in the spring of 1887 he showed one painting in Toulouse (but he did not participate in the Salon des Indépendants in Paris) and he exhibited, according to Bernard, 'prostitute types' with the Petit Boulevard painters in the restaurant on the Avenue de Clichy in the autumn of 1887.[37] However, the Exposition des Vingt of 1888 in Brussels was the first major avant-garde exhibition in which Lautrec participated. He may not have felt ready until 1888 to announce his identification with the avant-garde in a highly visible exhibition. The official beginning of his association with the avant-garde, therefore, and its formal recognition of him, occurred in February 1888. Les Vingt, the Belgian avant-garde group that sponsored the annual Exposition des Vingt, exhibited work that was representative of new tendencies in art, whether by the established Impressionists or the more youthful avant-garde, and played a vital role in giving exposure to young, progressive painters.

The fifth Exposition des Vingt in 1888 was also the first occasion for which a firm record was made of Lautrec's works on formal exhibition. The catalogue of the exhibition contains a page of his own design with his handwritten list of the eleven works he showed (each

[34] In H. Schimmel, no. 146, 115–16, Lautrec stated, 'I have sales in prospect.' For the redating of this letter from 1888 to summer 1887, see n. 40 below. This letter coincides with van Gogh's report in summer 1887 to the vacationing Théo: 'I saw de Lautrec today; he has sold a picture, I think through Portier.' (Arsène Portier was a small dealer who also handled van Gogh's works.) See van Gogh, ii. 520, no. 461. Three additional unpublished letters (cited courtesy of H. Schimmel) written by Lautrec to Portier in July 1887 and thereafter relate to this sale of Lautrec's work, apparently to the German critic and collector Julias Elias.

[H. Schimmel, no. 145, 115; no. 154, 121; no. 155, 121.] H. Schimmel, no. 148, 117, which he has recently redated to July 1887, also refers to this sale.

[35] On the family wealth see J. Frey, 'Henri de Toulouse-Lautrec: A Biography of the Artist', in Wittrock and Castleman (eds.), 21.

[36] H. Schimmel, no. 147, 116. See also no. 152, redated to summer and autumn 1887 respectively in n. 40 below.

[37] É. Bernard, 'Souvenirs sur van Gogh', 393.

exhibiting artist contributed such a page) and a drawing to illustrate a detail of one of them (Fig. 79). It makes an important guide for dating his work of the period preceding the exhibition and for establishing Lautrec's development in 1887 as a Petit Boulevard Impressionist. The stylistic variety in the works Lautrec showed at Les Vingt suggests that they were the product of a considerable span of time. The year 1888 has previously been treated as the logical date for a number of the works that he is known to have sent to this exhibition, especially the circus scenes. Yet it is improbable that he could have produced so many major oil-paintings in the month of January, given them time to dry, and shipped them to Brussels to be catalogued and installed for the opening of the show at the beginning of February. It is far more reasonable to assume that he sent works he had completed over a rather extended period, principally in 1887.

Furthermore, in the summer of 1887, a representative of Les Vingt, the Belgian artist Théo van Rysselberghe made a trip to Paris to search for new talent and to select works for the exhibition of the following winter. Two letters that he wrote to the secretary of Les Vingt, Octave Maus, document that Lautrec was one of his discoveries.[38] In the first letter he told Maus:

The little 'low ass' [*Bas-du-Cul*] is not at all bad. The chap has talent! In no uncertain terms he fits in with Les XX. *He's never exhibited*—he's making at the moment some very amusing things. Fernando's circus, prostitutes and all that. He knows well a certain corner of the world. He's good, in short; the idea of showing at Les XX with 'those of the rue de Sèze' and 'those of the rue Lafitte', he finds it chic! It would be good to say, I think, that *you have seen his work*, you can rely on me, I assure you. And that will be a weight in the scales of saying that *you* have seen.[39]

The prostitutes to which van Rysselberghe referred in his letter (as well as the 'prostitute types' that Lautrec reportedly showed at the exhibition of the Petit Boulevard in the autumn of 1887) may have included the group of works that comprised Lautrec's 'gallery' of portraits of prostitutes that hung in the Mirliton. He was not to show these at Les Vingt, but he would exhibit a number of his paintings of circus subjects. This letter revealed coincidentally that Lautrec used the same style as van Gogh to refer to artists in terms of the avenues where they exhibited, contrasting himself with painters who showed their work at the Georges Petit Gallery on the rue de Sèze and the Durand-Ruel Gallery on the rue Lafitte. The last group exhibition of the Impressionists in 1886 had also been on the rue Lafitte at the Maison Dorée restaurant. Apparently Lautrec relished the prospect of showing with the established Impressionists and others who exhibited and sold on the fashionable *grands boulevards*. Van Rysselberghe reported in his second letter to Maus that Lautrec had accepted the invitation to participate in Les Vingt, and strongly implied that he had already chosen several works and would have no difficulty selecting as many as might be desired for the exhibition:

Toulouse-Lautrec is enchanted to exhibit with us, and will send us some things that are truly very good. He will surely come to Brussels in February [for the exhibition opening] and couldn't be

[38] M. J. Chartrain-Hebbelinck (ed.), 'Les Lettres de van Rysselberghe à Octave Maus', *Bulletin des Musées Royaux des Beaux-Arts de Belgique*, 15–16 (1966), letters no. 7 and no. 8, 65–7. Note 5, 66, dates these letters to mid-summer 1887. Evidence in the letters supports this, especially van Rysselberghe's complaints of the heat. It is noteworthy that on this visit van Rysselberghe stayed with Eugène Boch, Lautrec's friend and neighbour at 22 rue Ganneron, and it was probably Boch who introduced the two.

[39] Ibid., no. 7.

nicer. . . . From Lautrec, we will have all the work that we want of him and already I've seen three or four things that would make a chic effect at Les XX.

We'll also be able to get Forain, through the little 'low ass'.[40]

The paintings listed in the Les Vingt catalogue of 1888, which therefore must date from 1887, can be tentatively identified as follows:[41]

No. 1 'Rousse (plein-air)' may correspond with P343, *Femme rousse assise dans le jardin de M. Forest* (Fig. 86). It is stylistically similar to no. 4, a portrait of Lautrec's mother securely datable to 1887; the brushwork and strong modelling are close in particular.

No. 2 'Rousse (plein-air)' may correspond with P342, *Femme rousse en mauve*. The model was the same as in no. 1, the setting was also M. Forest's garden, and stylistically it is very close to no. 1.

No. 3 'Rousse étude appartient à M. Leclanché'[42] may correspond with P317, *La Rousse au caraco blanc*. It depicts a seated model with red hair in Lautrec's studio, and in the strong modelling of the figure it is another work comparable with the portrait of the artist's mother.

No. 4 'Portrait de Mme A. d. T. L.' is P277, *Madame la Comtesse A. de Toulouse-Lautrec, mère de l'artiste* (Fig. 81).

No. 5 'Portrait de Mme J. Pascal' is P279, *Madame Juliette Pascal*.

No. 6 'Portrait d'homme' may correspond with P276, *Monsieur François Gauzi*, which is stylistically similar to no. 4 and no. 5.

No. 7 'Étude de face' may correspond with P394, *Femme assise dans le jardin de M. Forest, Justine Dieuhl, de face*. Its stylistic qualities make 1887 a plausible date.

No. 8 'Étude de profil' may be the profile portrait, *Vincent van Gogh*, P278 (Fig. 82), a pastel study on cardboard, close in style to nos. 4, 5, and 6.

No. 9 'Poudre de riz, à M. van Gogh' is P348, also titled *Poudre de riz* (Fig. 87). It belonged to Théo van Gogh.[43]

No. 10 'Écuyère' may correspond with P315, *Au Cirque Fernando* (Fig. 89).[44] Lautrec, however, also did a much larger, more elaborate painting of the same subject, and it is more likely to have been the painting that he exhibited at Les Vingt. This larger painting has been missing for an undetermined length of time and none of the *œuvre* catalogues includes it. Yet it was a painting of extraordinary scale, and a part of it is plainly visible on the wall behind a variety of artist's paraphernalia in three photographs taken of Lautrec in his studio between *c.*1889–90 and *c.*1894–5 (e.g. Fig. 80).

[40] Ibid., no. 8. Information in van Rysselberghe's letters enables the redating of 3 of Lautrec's letters previously attributed to Jan. 1888; in 2 of them, written during the summer of 1887, he told his mother about his invitation to Les Vingt, and in the third, written after van Rysselberghe's return to Brussels, probably in autumn 1887, he thanked van Rysselberghe and mentioned that he had 'made some overtures to Forain' on his behalf. See H. Schimmel, nos. 146, 115–16; 147, 116; 152, 119–20. In Nov. 1887 Lautrec wrote to Maus concerning his and Forain's participation in the exhibition. In Jan. 1888 he wrote again to Maus, sending the illustrated list of his submissions to the exhibition and noting his plan to send some of the works and bring others to Brussels himself. In another letter, he told his grandmother that he was 'preparing to go to Brussels carrying the purple flag of the Impressionist Painters'. See H. Schimmel, nos. 151, 119; 159, 124; 631, 376.

[41] The italicized titles are those given by Dortu and/or Joyant for the paintings I have proposed to correspond with those listed in the Les Vingt catalogue, here in quotation marks. In several cases, to identify the paintings, I have utilized the abbreviated titles in the Les Vingt catalogue which are often close to the more expanded Joyant/Dortu titles, in conjunction with stylistic evidence. Lautrec did not date any of the paintings mentioned here.

[42] Maurice Leclanché, mentioned by G. Coquiot, *Vincent van Gogh*, 4th edn. (Paris, 1923), 132, as the first collector to purchase Impressionist work from Théo van Gogh at the Goupil Gallery. Leclanché owned another of Lautrec's paintings of this period, *A l'Élysée Montmartre* of 1888 (P311).

[43] A receipt marked 12 Jan. 1888, for 150 frs., sent by Lautrec to Théo, is preserved in the Archive of the Rijksmuseum Vincent van Gogh, Amsterdam. Cf. Welsh-Ovcharov, *Van Gogh and the Birth of Cloisonism*, 333. [H. Schimmel no. 160, 124.]

[44] Identified by Dortu as no. 10 of the exhibit.

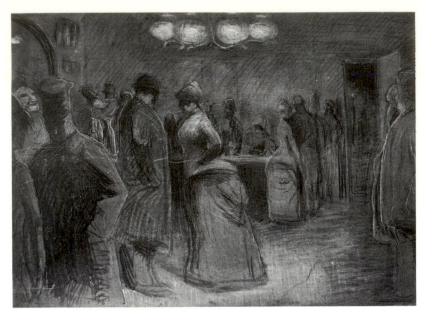

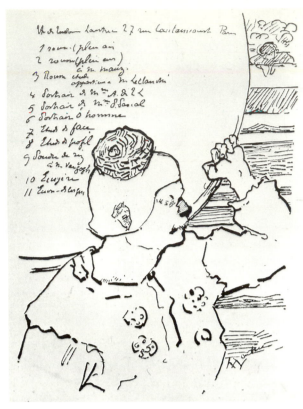

78. Above: Émile Bernard, *L'Heure de la viande*. Pastel and gouache. Paris, Clément Altarriba Collection.

79. Right: Henri de Toulouse-Lautrec, after, illustration and list of works exhibited, from *Catalogue de la Vᵉ Exposition des XX à Bruxelles*. Photomechanical reproduction of a pen drawing. Paris, Bibliothèque Nationale. (Photo, Bibliothèque Nationale.)

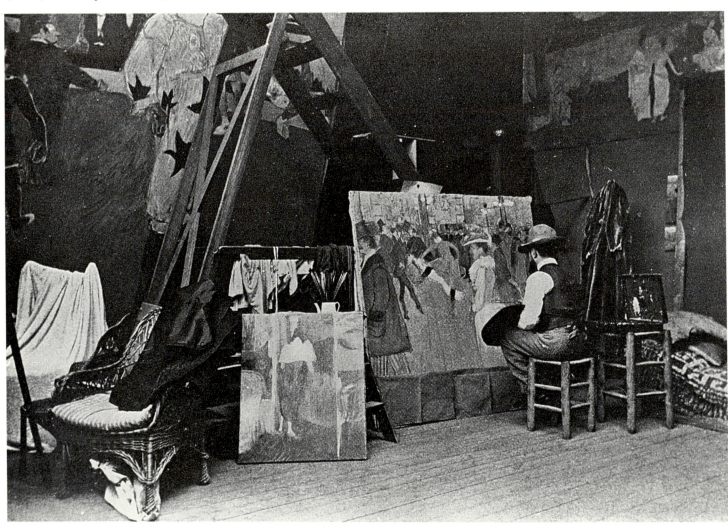

80. Photograph of Lautrec in his studio showing the 'Missing *Écuyère*'. Albi, Musée Toulouse-Lautrec.

Two of the photographs show Lautrec at work on *Au Moulin Rouge, la danse,* which he completed early in 1890. This establishes a *terminus ante quem* for the missing painting. The third photograph is later, *c.*1894–5.[45] The style of the painting is difficult to analyse, because much of it was cut off by the framing of the photographs, and what remains is partly hidden by the objects in front of it. Nevertheless it is evident that in this painting the large figure of a clown dominated a somewhat clumsy composition in which Lautrec also depicted the ringmaster, the audience, and the horse of the *écuyère* in a scene from the circus.

What makes it probable that Lautrec showed this painting in Brussels are the striking resemblances between the central figure of the clown, in so far as it is visible in the photographs, and the drawing of a clown with which Lautrec illustrated his page in the catalogue for Les Vingt. The chin, neck, and the fall of the costume around the neck are similar in the two works. The clown in the painting, like the one in the drawing, probably holds a paper-covered hoop through which the *écuyère* is to jump. Because of its scale, this painting would have been Lautrec's largest and most important example at Les Vingt and the work by which he wanted to be characterized in the exhibition catalogue. Logically he would have illustrated the checklist of his paintings with a drawing from the most prominent figure in his major work. The painting is referred to hereafter as the 'Missing *Écuyère*'.

Joyant mentioned 'circus scenes with clowns three times life size' in his description of Lautrec's studio and its fixtures.[46] Gauzi also wrote about a circus painting of enormous size that Lautrec did over a two-year period beginning in 1886. Around 1886, according to Gauzi, Zandomeneghi introduced Lautrec to the model, Maria (Suzanne Valadon), who was a circus acrobat at the time, so that Lautrec might employ her for a mural-sized painting of a circus subject. The pose he gave her was that of an 'equestrienne dancing on the back of a horse' in a work that showed the influence of Zandomeneghi's style.[47] Gauzi called the painting 'Le Cirque', but it was unmistakably the 'Missing *Écuyère*'. 'On a canvas of immense height', he wrote, 'one saw in the foreground, and larger than life, a clown holding up a paper covered hoop, which an equestrienne [*écuyère*], standing on the platform-saddle of a horse, was preparing to jump through.' He described it as the only painting by Lautrec so large that the artist worked on it from his studio ladder. To begin, he put the figures on canvas and lightly indicated the tones of his composition. Then he left the painting unfinished, apparently for some two years, perhaps because its large size made working on it difficult for him. Eventually he enlisted his friend, Maurice Guibert, to help him fill in the background. From Gauzi's account, Lautrec began the painting *c.*1886; shortly after its completion, he had it rolled up.[48] A likely explanation is that he finished it in time for the Exposition des Vingt and had it rolled for shipping to Brussels. After its return he displayed it in his studio, where the camera caught a corner of it.

What became of the painting remains unknown. In the posthumous retrospective of Lautrec's work at the Manzi-Joyant Galleries in Paris in 1914, painting no. 130, entitled *Au Cirque Fernando: 'clown'*, corresponded in description to the large central figure of the 'Missing *Écuyère*'. Joyant wrote that *Au Cirque Fernando: 'clown'* represented a standing clown turned toward the right, and that it measured 1.50 m. by 0.9 m. in a vertical format.[49] It could have been the central portion of the missing painting, which the artist or somebody else had cut down to excise all but the most successful

[45] See Dortu, I c158, I c159, and I c179.

[46] Joyant, i. 77, 86. Cf. Adriani (Tübingen), 87; these were either left behind or destroyed when Lautrec gave up his rue Caulaincourt studio in May 1897 and moved to smaller quarters.

[47] Gauzi, 131–2.

[48] Ibid. 119–20. Guibert was a champagne salesman and an amateur painter. This may be the painting Lautrec refers to in a letter to his mother of mid-June 1887 (H. Schimmel, no. 142, 113) in which he states: 'I'm busy doing a large panel for the circus. Unfortunately I'm afraid I shan't be able to finish until this winter at the reopening.' Alternatively, he may refer to another work entirely, one he was painting *in situ* at the circus.

[49] Joyant, i. 265.

figure, the clown, sometime after 1894–5. Even so, *Au Cirque Fernando: 'clown'* still would have been one of his larger paintings. Handicapped by his small stature and physical weakness, he made only five or six of comparable dimension. The very scale of *Au Cirque Fernando: 'clown'* in addition to the posture of the clown supports the possibility that it was from the 'Missing *Écuyère*'. Unfortunately, and perhaps ironically, *Au Cirque Fernando: 'clown'* has also disappeared since Joyant exhibited it thirteen years after Lautrec's death.[50]

No. 11 Probably 'Éventail du cirque', although it is not entirely legible, in which case it may correspond with A197, *Scène du cirque* (Fig. 90). It is a watercolour in the form of a fan, with the appearance of a drawing heightened with colour. Its subject is the same as the 'Missing *Écuyère*', and its background is treated in a similar, loosely brushed fashion.[51]

In terms of style, the paintings that Lautrec showed at Les Vingt in February 1888, which must have represented his best work of *c*.1887, manifested his awareness of, and response to, a variety of developments occurring in his artistic milieu: to the experiments of the other painters of the Petit Boulevard, to aspects of Impressionism and Neo-Impressionism, and also to the work of Degas and his followers. He was not yet moving in a single fixed direction of his own and much of his work still maintained conservative features. In terms of subject, the core of Lautrec's painted production and of his exhibition at Les Vingt remained a series of relatively cautious portraits. With just a few exceptions, he still confined his new urban genre subjects to his popular illustrations and their painted preparations.

Several of the portraits shown at Les Vingt can be dated early 1887, and some additional works bear a close stylistic relationship to them. They form a group of essays in Impressionist colour and facture and Neo-Impressionist colour theory, which the artist nevertheless modified with a somewhat conservative concentration on the human figure: it predominates in each painting, a strong, solid volume, detached from the background and undissolved in the play of the light. Lautrec was sacrificing his exploration of the momentary effects of light to this concentration on the figure.

The key to dating this group of works is *Madame la Comtesse A. de Toulouse-Lautrec, mère de l'artiste* (Fig. 81). Although the 1888 Exposition des Vingt has traditionally provided its *terminus ante quem*, it had an earlier exposure to public viewing and critical appraisal in the spring of 1887 in Toulouse, the provincial centre of Lautrec's native region, a fact that establishes a new *terminus ante quem*. This might have been the first formal exhibition in which he ever participated. He signed the work 'Tréclau', the anagrammatic pseudonym he had adopted in 1886 and usually reserved for his more progressive works, most often his popular illustrations. Probably he wished to save his family embarrassment. The portrait is among the very few formal easel paintings that he signed 'Tréclau', and on this occasion he may have used it in anticipation of an adverse reaction to his work in his parents' conservative milieu.

A local review and several letters made references to his portrait of his mother, seated in profile with a red settee in the background. In a letter dated 15 May 1887, Lautrec recommended

[50] Dortu confused the painting shown in 1914 with another painting of a clown (P313). But in the *Clown* painting she identifies as no. 130 at the Manzi–Joyant retrospective exhibition, the figure faces left, and the size, 0.85 m. by 0.47 m., does not conform to Joyant's description.

[51] Dortu incorrectly identifies no. 11 as P312, *Au Cirque Fernando, l'écuyère*. Other identifications by Dortu that differ from mine are: P295 (no. 6), P317 (no. 7), and P289 (no. 8).

some of the fashionable, current art exhibitions to his Uncle Charles—the Salon, the sixth Exposition Internationale at Petit's, and a major show of Millet—then thanked him for praising the painting that he himself was showing in Toulouse: 'You are very kind to speak admiringly of my painting exhibited at Toulouse under the definitive name adopted by me, Tréclau, when I only have the right to a little indulgence and to a "good, young man, continue".'[52] The review appeared in the *Messager de Toulouse* in June 1887. It probably spoke for local response to the painting as well as the reviewer, but in doing so it also gave a fair description of certain of its features:

Here is the strange canvas signed with the transparent pseudonym of 'Tréclau'. Surely similar endeavours ought not to be encouraged . . . and the greatest number of visitors have certainly recoiled in horror from that violet hair and those lemon-yellow marks [brush strokes] that resemble minced vegetables. But, let me move back three or four steps to the distance from which one habitually views a portrait in a salon and one will perceive that this apparent barbarism is calculated, that the profile takes on value and solidity in spite of the vibrations of the touch, that the red silk of the settee plays its role in this far-fetched harmony, and even in that reciprocal exaltation of yellow and violet. M. Tréclau is engaged in the company of which M. Besnard is the captain . . . we strongly urge him to desert.[53]

The review as much as the painting elicited a worried commentary from Lautrec's maternal grandmother that affords the earliest known evidence of how concerned his family was about his turn towards radical work. But public opinion, his parents' discomfiture, and the possibility that unfavourable criticism would discourage her grandson seemed to trouble her as much as the 'slightly strange and still unknown school' of painting to which he had been drawn. In a letter of June 1887, she wrote to her sister, Lautrec's paternal grandmother:

What will father and mother say? I am sad for them. My God, if only there could be a reversal of opinion regarding this slightly strange and still unknown school [of painting]; that would be good and I wish above all that he [Henri] is not upset by discouragement. Isn't Henri going to defend himself after this fulminating article? I would have preferred it if the criticism had not come from our world. Perhaps it would have been better if our dear boy kept to pencil and charcoal [drawings] which one can't dispute and which are thoroughly his sort of medium.[54]

This painting, with its vibrating brush stroke and its predominantly blue-violet palette accented in yellow, must indeed have seemed unconventional in provincial Toulouse. Yet at this date, for the Parisian art milieu, its style was far from radical. Perceptively, the Toulouse critic pointed out the conservative features of the portrait, especially the 'solidity' of the profile; and shrewdly he identified the style with that of the *juste milieu* painter Besnard.

It is probable that Lautrec did preliminary work for a painting such as this portrait, and a drawing does exist that may well be a preparatory study.[55] In the drawing, Lautrec's mother

[52] Joyant, i. 106. [H. Schimmel, no. 140, 112.] (NB A large Millet exhibition was held in Paris at the École des Beaux-Arts during the spring of 1887. Cf. R. Herbert, *Millet*, 229.) Lautrec probably also refers to this painting in an unpublished letter to Paul Durand-Ruel of 18 Jan. 1888 (quoted courtesy of H. Schimmel) in which he states, 'I want to exhibit the drawing [*sic*] that I have on deposit with you, signed Tréclau. I therefore ask

that you give it to my framer, Mr. Cluzel.' [H. Schimmel, no. 161, 125.]

[53] J. de Lahondés, in *Messager de Toulouse*, June 1887, as reprinted in Attems, 213–14.

[54] Attems, 214–15.

[55] Cooper, 26, 66, makes the connection between drawing and painting, but preserves separate dates for them.

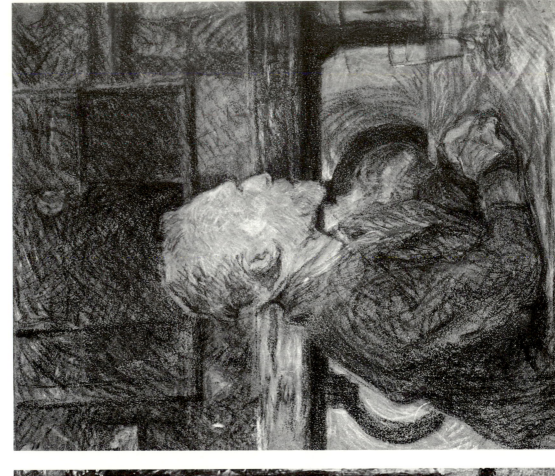

81. Henri de Toulouse-Lautrec, *Madame la Comtesse A. de Toulouse-Lautrec, mère de l'artiste*. Albi, Musée Toulouse-Lautrec. *See also colour plate*.

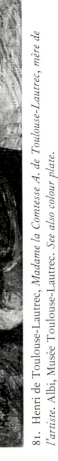

82. Henri de Toulouse-Lautrec, *Vincent van Gogh*. Pastel on cardboard. Amsterdam, Rijksmuseum Vincent van Gogh/Vincent van Gogh Foundation. *See also colour plate*.

has similar attire and sits in the same chair, although the pose is slightly different. In both the drawing and painting, Lautrec had difficulty representing the drape of his mother's gown over her bosom. Lautrec's use of a meticulous preparatory drawing is not surprising at a time when he continued to practise drawing at Cormon's or had only recently left the atelier. He would also have had the example of the Impressionists themselves, most notably Pissarro and Renoir, who reacted against the formlessness of advanced Impressionism in the 1880s and turned to tighter composition and more solidly constructed figures. Lautrec, just leaving his long academic apprenticeship, may have been sympathetic to this seemingly more conservative development in Impressionist practice.

Lautrec's portrait of his mother had stylistic counterparts in *Madame Juliette Pascal*, no. 5 at Les Vingt, and in *Vincent van Gogh* (Fig. 82) and *Monsieur François Gauzi*, probably no. 8 and no. 6 respectively. All have the same comma-like, broken strokes and similar composition and use of colour, which would place them at the same time, along with several other stylistically related works not shown in Brussels. Further evidence corroborates the date for the pastel of van Gogh: Hartrick recalled that Lautrec was working on a portrait of van Gogh early in 1887.[56] Although in this group Lautrec was still creating paintings with a conservative quality, he also gave them an aspect that identified him with the revolutionary avant-garde at Cormon's. Not only did he abandon the muddy palette and smoothed strokes of the studio and 'dark Realist' portraits of 1886, but he demonstrated a lively interest in colour theory. His use of complementary colours, for example the yellow and violet in the portrait of his mother (which the Toulouse reviewer derided), characterizes all these works. Moreover, several of these paintings seem to reflect the influence of the experiments that Anquetin and Bernard had made with a dominant colour tone. Bernard called attention to this influence in his account, and attributed it directly to Anquetin's researches with coloured glass: 'We had noticed by means of coloured panes that the sensations of sun, of night, of dusk, were synthesized by a single tone, undergoing only the modification of values and of its neighbours on the colour wheel. Toulouse-Lautrec approved loudly of our research.'[57] The effect is most striking in the blue and orange colour scheme of the pastel portrait of van Gogh, and comes close to the subject's own experiments of a similar kind as Hartrick described them. The complementary blues and oranges convey the impression of one's entering a lamplit room out of the night. By contrast, the dominant tone of blue-violet touched with yellow in the portrait of the artist's mother projects an evening light.

A comparison of the portrait that Lautrec painted of Bernard in 1885–6 (Fig. 57) and his 1887 pastel of van Gogh discloses how remarkably Lautrec had changed his style. From relatively smooth surfaces, conventional dark shadows, and subdued colour, he had advanced to composing his strongly opposed lights and darks consistently in colour, and to laying down the different tones in separate strokes. In subject, too, he moved from the relatively unemotional neutrality of the Bernard portrait to his more perspicacious, intense characterization of van Gogh. The advanced stylistic qualities of the van Gogh picture have often

[56] Hartrick, 50. This portrait is probably the work referred to in a letter written by Lautrec in early 1887 to Théo van Gogh. Lautrec also discusses its framing in preparation for the Les Vingt showing in another letter to Théo of late 1887 or early 1888. [H. Schimmel, no. 139, 111; no. 156, 122.]

[57] É. Bernard, 'Des relations avec Lautrec', 13–14.

been interpreted as evidence of van Gogh's influence on Lautrec at this time.[58] It is more likely that as students and newcomers to the avant-garde, who had reached, respectively, crucial points in their artistic development, they simply responded in similar ways to the influences of a shared environment. Indeed, close parallels existed between their researches of 1887. But whereas Bernard and Anquetin were soon to use their experiments as the basis for moving from Neo-Impressionism to simplification, Lautrec and van Gogh used theirs for the time being to advance beyond their previous dark palettes. Not until the succeeding months did either try a more truly pointillist stroke.

Most of this group of paintings, and certainly the ones Lautrec sent to Les Vingt, were straightforward portraits of respectable types of people. However, two of those he did not exhibit introduced elements which related to his new Naturalist orientation. *A la Bastille, Jeanne Wenz* (Fig. 83) and *A Grenelle, l'attente* (Fig. 84) share the choppy, impressionistic brush stroke of the other works of the group, but both take up the contemporary urban theme of the solitary woman at a café table. Lautrec based *A la Bastille* on the Bruant song of the same name, first published in *Le Mirliton* (no. 15) of 17 April 1886. In his sad song, Bruant related the story of a barmaid of the Bastille quarter. Working to support her parents, she sank inevitably into prostitution:

> On la rencontrait tous les soirs,
> Parfois l'éclat d'ses grands yeux noirs
> Faisaient pâlir la lun' qui brille,
> A la Bastille.
>
> Maint'nant a sert dan'eun'maison
> Où qu'on boit d'la bière à foison,
> Et du champagne qui pétille.
> A la Bastille.
>
>
>
> Pour eun' thune a'r'tir son chapeau,
> Pour deux thun' a'r'tir son manteau,
> Pour un sique on la déshabille,
> A la Bastille.
>
>
> [One could find her there every evening,
> Sometimes the lustre of her big brown eyes
> Made pale the moon that shines,
> At the Bastille.
>
> Now she serves in a house
> Where one drinks beer a-plenty,
> And champagne that sparkles.
> At the Bastille.

[58] See e.g. Cooper, 68.

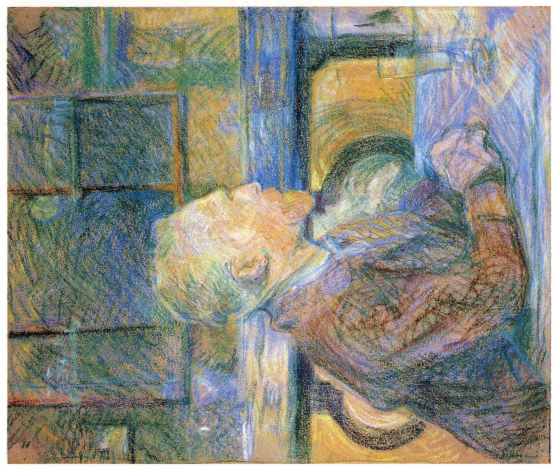

82. Henri de Toulouse-Lautrec, *Vincent van Gogh*. Pastel on cardboard. Amsterdam, Rijksmuseum Vincent van Gogh/Vincent van Gogh Foundation.

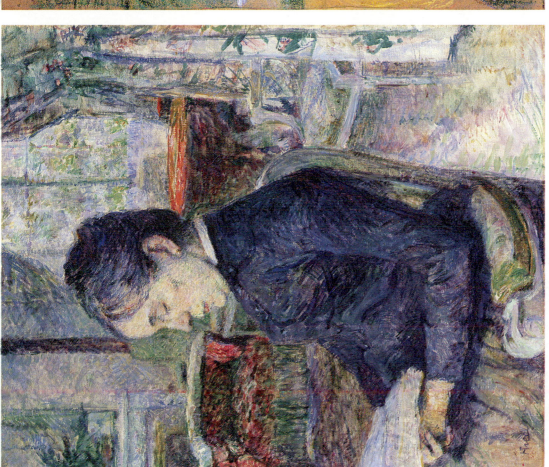

81. Henri de Toulouse-Lautrec, *Madame la Comtesse A. de Toulouse-Lautrec, mère de l'artiste*. Albi, Musée Toulouse-Lautrec.

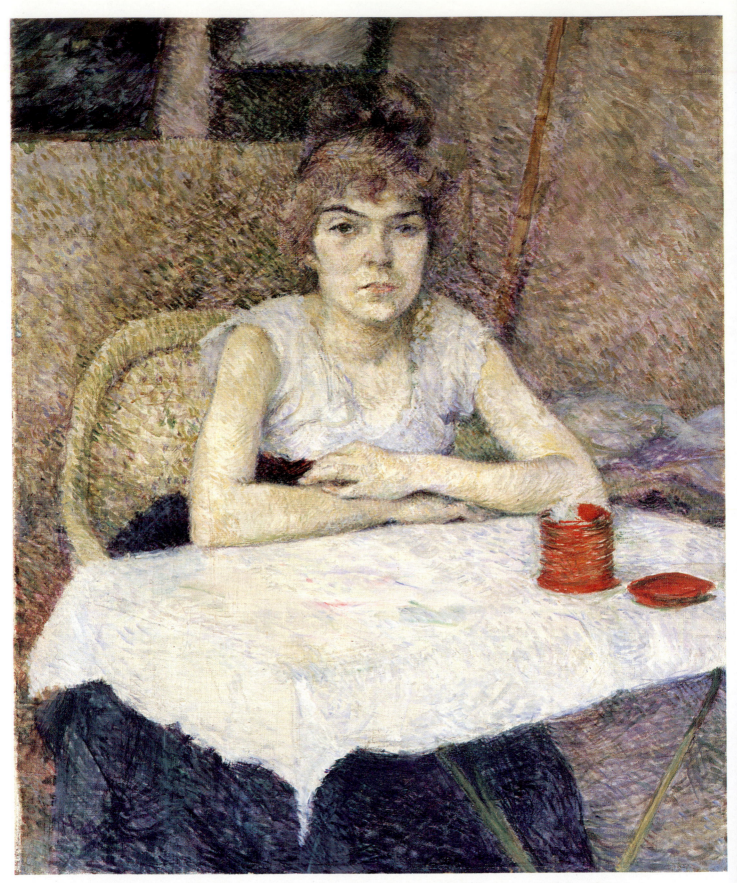

87. Henri de Toulouse-Lautrec, *Poudre de riz*. Amsterdam, Rijksmuseum Vincent van Gogh/Vincent van Gogh Foundation.

.

> For a five franc piece she takes off her hat,
> For two of them she takes off her coat,
> For twenty francs one can undress her,
> At the Bastille.][59]

Customarily, Bruant infused his lyrics richly with sentiment but little visual description. The artist, as a consequence, had freedom to interpret. Lautrec's illustrations of Bruant's songs usually took the form of portraits rather than narratives, but each one embodied some subtle narrative implication that tied it to the verses and their mood. To conform to the story of 'A la Bastille', Lautrec attired his model, the dark-eyed Jeanne Wenz, in a characteristic barmaid's uniform of a dark dress with a white apron and a scarf around her neck and posed her at a café table,[60] but treated his subject more softly and sympathetically than did Bruant. In restrained colours to reinforce the mood, he painted his barmaid with a sad, resigned expression.

The female figure of Lautrec's painting and Bruant's lyrics was undoubtedly a waitress in one of the novel and popular *brasseries à femmes* where women rather than men served the drinks. It was widely acknowledged that these establishments were 'highly organized fronts for clandestine prostitution' where the waitresses sold sex as well as alcohol.[61] This was a particularly modern and daring choice of subject at a time when clandestine, or unregistered, prostitution was dramatically on the rise and when soliciting prostitutes had become a highly visible presence in the eating and drinking establishments (as evidenced by Bernard's *L'Heure de la viande*) as well as on the boulevards of Paris.[62] Lautrec's painting belonged to Bruant and hung at the Mirliton where the publisher Roques probably saw it. Its risqué theme was appropriate for the popular journals of the period, and in time Roques was to request an illustration from it, which he reproduced in *Le Courrier français* (no. 19) of 12 May 1889.

A Grenelle, l'attente might have been a later version in the series inspired by Bruant's song, 'A Grenelle', but even if this was not the case, it shared the themes and the melancholy of the Lautrec paintings that hung at the Mirliton: a solitary woman, probably a prostitute awaiting her client, leans on the café table in a disheartened attitude. Lautrec made *A Grenelle, l'attente* not from an actual scene in a café, but from a studio set-up, a fact that is obvious from the canvases leaning against the wall.[63] Studio backgrounds became prominent in a number of Lautrec's portraits from this point forward. In prefabricating genre scenes with posed models and studio props instead of working from life in the streets and night-time establishments of Paris, Lautrec used an approach similar to that of Degas in paintings such as *L'Absinthe*, which his own female drinkers recall in their dejection. Unlike Degas, however, he took little or no pains to recreate convincingly realistic settings. It is apparent that even

[59] Bruant, i. 123–7.

[60] Her attire is identical to that in Steinlen's illustrations of the same song in Bruant, i. 123–7.

[61] S. H. Clayson, 'Representations of Prostitution in Early Third Republic France', Ph.D. diss. (University of California, Los Angeles, 1984), 231–2. I am indebted to Clayson's entire discussion of the *brasseries à femmes*, 231–55. See also T. A.

Gronberg, 'Femmes de brasserie', *Art History*, 7 (Sept. 1984), 329–44.

[62] Clayson, 238.

[63] Gauzi, 45, affirms this, though he confuses the painting with Dortu's P308, *A Grenelle, buveuse d'absinthe*, and appears to conflate the descriptions of the two. Cf. Stuckey, 107, 117.

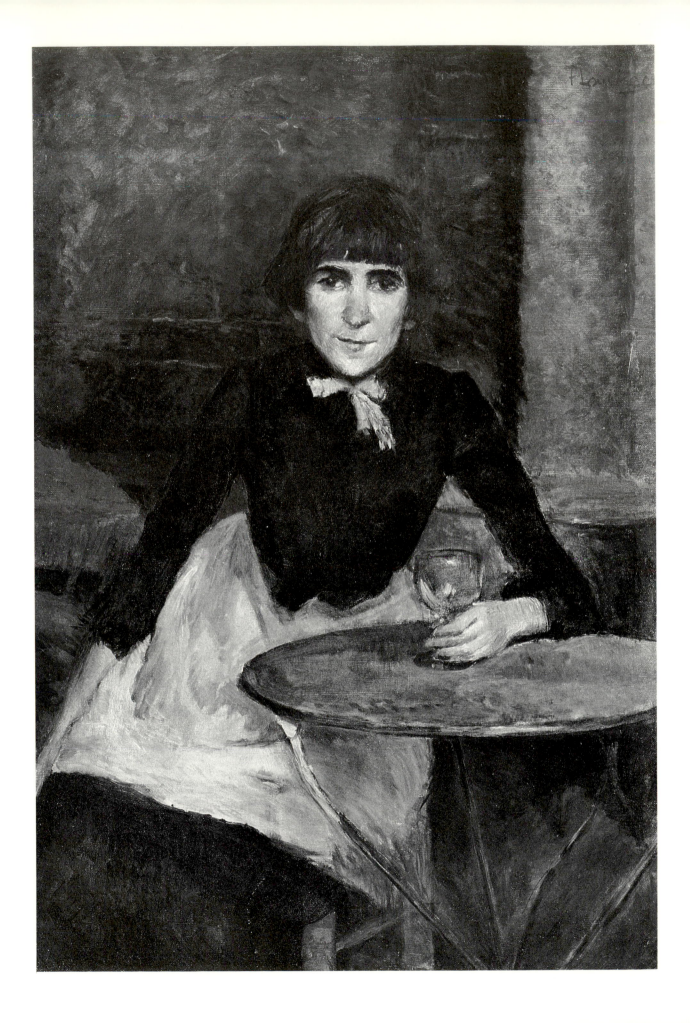

83. Facing: Henri de Toulouse-Lautrec, *A la Bastille, Jeanne Wenz*. Washington, D.C., National Gallery of Art, collection of Mr and Mrs Paul Mellon.

84. Right: Henri de Toulouse-Lautrec, *A Grenelle: l'attente*. Williamstown, Massachusetts, Sterling and Francine Clark Art Institute.

85. Below right: J. L. Forain, *L'Attente*. Watercolour. Cambridge, Massachusetts, Fogg Art Museum. (Photo, courtesy The Fogg Art Museum, Harvard University, Cambridge, Massachusetts, bequest of Grenville L. Winthrop.)

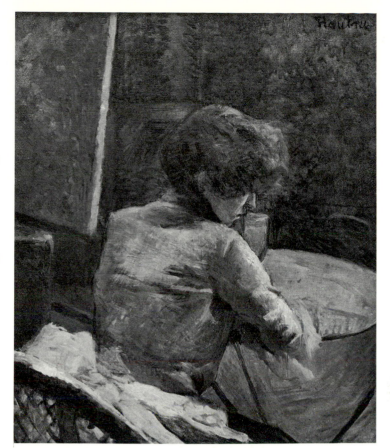

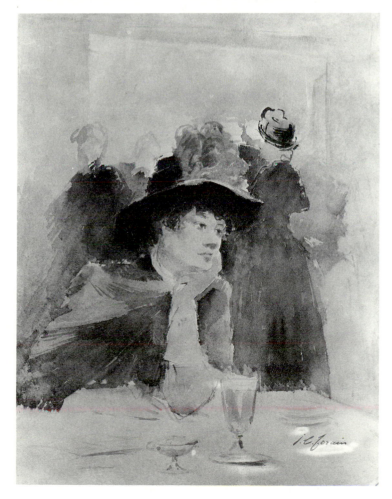

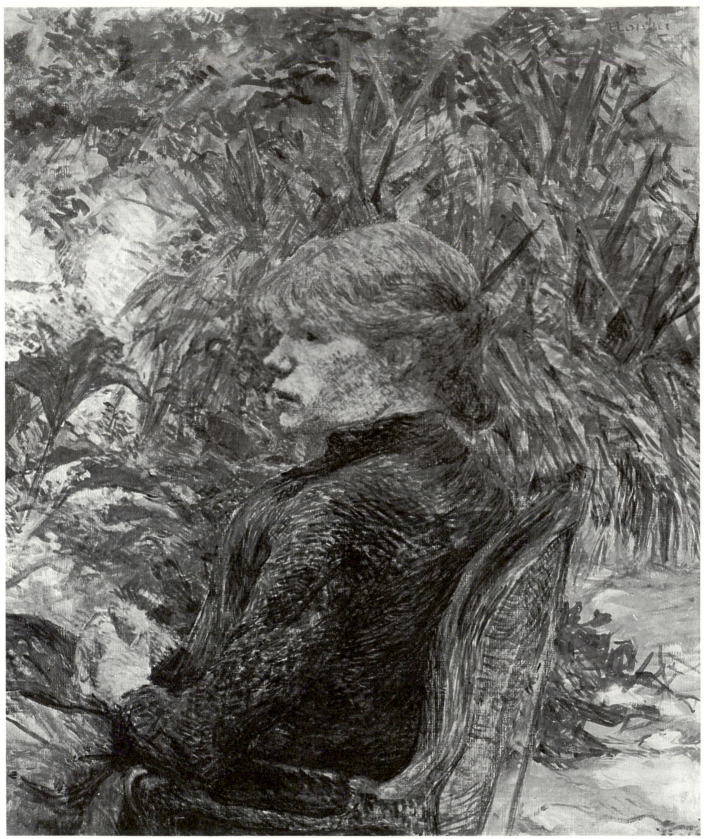

86. Henri de Toulouse-Lautrec, *Femme rousse assise dans le jardin de M. Forest*. USA, private collection. (Photo, courtesy of The Metropolitan Museum of Art.)

this early in his career, Lautrec felt more concern for the reality of his subjects and their emotional states than for the authenticity of their physical surroundings. And despite his kinship with Degas, he probably had more immediate precedents for his renditions of the theme among the followers of Degas. In the case of *A Grenelle, l'attente*, he came close in viewpoint and mood to a watercolour of *c.*1880 by Forain, also entitled *L'Attente* (Fig. 85)—a reminder that Lautrec experienced Degas's idiom principally through the work of an intervening generation.[64]

The portraits of women in the garden of M. Forest that Lautrec sent to Les Vingt, and a number of similar portrayals which should be placed with them, demonstrate his continuing interest in an Impressionist idiom of *plein-air* painting. The paintings might well have been the product of outdoor work that he mentioned in his letters from Paris of the spring and summer of 1887.[65] Lautrec apparently regarded such paintings as technical exercises or studies, rather than formal works;[66] but they also fit stylistically with the Impressionist-orientated portraits of early 1887 and maintain some of their conservative qualities. The same tight, comma-like strokes and strong modelling of the figure (e.g. Fig. 86) distinguish them; Lautrec seems to have largely abandoned the *naïveté* of the *plein-air* works of 1886 and returned to a more 'sophisticated' style of drawing. The figures also dominate these *plein-air* portraits of 1887, and in painting them Lautrec did not seek to capture the quality of outdoor light. Nevertheless the broken touch with its small crosshatchings, the coloured shadows, and the palette of predominantly blue, violet, and green pastel tones have the look of Impressionism. They are especially reminiscent of the late paintings that Manet did, which Lautrec could have seen, of figures set against lush green garden foliage.

Lautrec carried his touch closer to Neo-Impressionism in other paintings that he showed at Les Vingt in 1888, and possibly painted late in 1887, most notably *Poudre de riz* (Fig. 87), no. 9 in the exhibition catalogue, and *La Rousse au caraco blanc*, probably no. 3. In this his work was strongly analogous to much of van Gogh's of that period. Both artists used the pointillist stroke during 1887, sometimes freely but at other times in a relatively more uniform fashion, as in *Poudre de riz*. This painting and van Gogh's *Woman Sitting in the Café du Tambourin* (Fig. 88), for example, also painted in 1887, have stylistic similarities. In both paintings the artists were experimenting with a variation of the pointillist dot, creating a stippled effect. At times they varied their primary brush stroke of even-textured, short, straight bursts of colour with passages of much longer, sketchier strokes—as if neither had the patience for the painstaking, systematic application of Seurat's dot. The palette in *Poudre de riz*, consisting mostly of pastel shades of complementary colours, especially orange and blue, recalls the pale tones of Seurat's *Poseuses*, a study for which hung at the Salon des

[64] Moreover, Degas's *L'Absinthe* was not in Paris at this time. It had been purchased by a London collector shortly after being exhibited at the Impressionist exhibition of 1876. Cf. R. Pickvance, ' "L'Absinthe" in England', *Apollo*, 67 (May 1963), 395–8. The subject of the dejected prostitute leaning on the café table, awaiting a client, was also described by Huysmans: cf. T. Reff, *Manet and Modern Paris* (exh. cat., National Gallery of Art, Washington, DC, 1982), 76.

[65] H. Schimmel, no. 146, 115–16, redated to summer, 1887 in n. 40 above. He also mentions working outdoors in his letter of mid-June 1887, cited in n. 48 above and in a letter of summer 1887, no. 630, 376. In no. 165, 127, written in the autumn of 1888, Lautrec again alluded to *plein-air* painting.

[66] Sutton, *Lautrec*, 14, and Cooper, 78, state that Lautrec referred to his outdoor studies as 'impositions'.

Indépendants of 1887.[67] In subject and pose as well as touch, however, *Poudre de riz* more nearly resembles van Gogh's contemporary work. The solitary woman in *Poudre de riz*, probably a prostitute, is much like van Gogh's subject in *Woman Sitting in the Café du Tambourin*, and their poses as they sit with their arms crossed are almost identical. It can be no coincidence that Théo van Gogh owned *Poudre de riz*, which came so close to his brother's work of the period, and he may well have acquired it partly at Vincent's urging. Vincent himself referred to it admiringly in a letter to Théo in August 1888.[68]

Belgian avant-garde painters particularly identified Neo-Impressionism with what was most up to date in French art, and had invited Seurat and Pissarro to show their work at the Exposition des Vingt of 1887. They would have been keenly interested a year later in the two paintings in which Lautrec used his modified pointillist touch, *Poudre de riz* and *La Rousse au caraco blanc*, and also in his application of colour theory in the portraits of early 1887. *La Recherche de la lumière dans la peinture* (the study of light in painting) was the dominant theme of the 1888 exhibition as Octave Maus stated it in his preamble to the catalogue.[69] Max Sulzberger, the reviewer for the newspaper *L'Étoile belge*, clearly identified the evidence of Impressionism and Neo-Impressionism in the style of Lautrec and other exhibiting artists, though he was a harsh critic of the avant-garde, and heavily sarcastic in his commentary: 'The paintings and the pastels of Monsieurs Augustin, Caillebotte, de Toulouse, Lautrec [*sic*], A. Guillaumin, P. Signac, etc., are a veritable challenge to good sense. Under the pretext of studying light entire panels are covered with paint that looks like speckled wafers. Little dancing touches and impossible tones . . .'[70]

Lautrec's circus paintings evidence the continued influence of Degas and his followers, but they do not especially reflect the Neo-Impressionist experimentation of the portraits described above. A large group of studies of the Cirque Fernando, its clowns, acrobats, and equestriennes, can be dated to *c.*1887 in view of their relationship in style and subject to those shown at Les Vingt. Many are on-the-spot drawings, from which Lautrec assembled a repertoire of types that he subsequently incorporated into the paintings of the series. One is a rapidly brushed oil sketch on the leather skin of a tambourine, which Lautrec undoubtedly made as decor for the café Le Tambourin, a Montmartre haunt of the Petit Boulevardists.[71] These were Lautrec's only paintings of the year with multiple figures, and they employ the compositional techniques of cropping and asymmetry to convey the sense of a visual field casually glimpsed by the spectator. He had recently used these devices of Degas in the ballet paintings and Mirliton panels and once again he complemented them with a caricatural quality

[67] Société des Artistes Indépendants, *Catalogue des œuvres exposées*, 3e Exposition, Paris, 1887, *Poseuse de face*, no. 446. The exhibition was held 26 Mar.–3 May 1887. See also Rewald, *Post-Impressionism*, 102. Lautrec's painting is also close in style to van Gogh's *Lady Beside a Cradle* (de la Faille, F369).

[68] Van Gogh, iii. 6, no. 520.

[69] M. O. Maus, *Trente années de lutte pour l'art, 1884–1914* (Brussels, 1926), 61, 66. See also J. Block, *Les XX and Belgian Avant-Gardism, 1868–1894* (Ann Arbor, Mich., 1984), 63–9, on the group's interest in Neo-Impressionism.

[70] M. Sulzberger, 'Exposition des Vingt', *L'Étoile belge*, 5 (Feb. 1888), 2, col. 3.

[71] Pointed out by Welsh-Ovcharov, *Van Gogh and the Birth of Cloisonism*, 100; Lautrec's frequentation of Le Tambourin, along with Zandomeneghi, is mentioned by Coquiot, *Van Gogh*, 29, and cf. É. Bernard, 'Souvenirs sur van Gogh', 394, Lautrec made his pastel of van Gogh there. Tambourines decorated by the café's poet and artist patrons were displayed on its walls, cf. Grand-Carteret, *Raphael et Gambrinus*, 155–9, as cited by Welsh-Ovcharov, *Van Gogh and the Birth of Cloisonism*, 101 n. 4, and Coquiot, *Van Gogh*, 127.

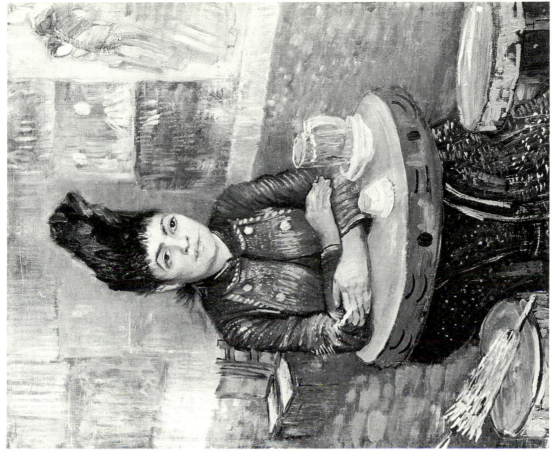

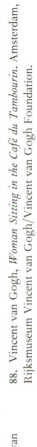

88. Vincent van Gogh, *Woman Sitting in the Café du Tambourin*. Amsterdam, Rijksmuseum Vincent van Gogh/Vincent van Gogh Foundation.

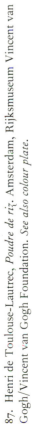

87. Henri de Toulouse-Lautrec, *Poudre de riz*. Amsterdam, Rijksmuseum Vincent van Gogh/Vincent van Gogh Foundation. *See also colour plate.*

derived from popular illustration. The circus paintings exhibit a crosshatched, Impressionist type of brush stroke. In *Au Cirque Fernando* (Fig. 89), Lautrec used sweeping diagonal strokes to impart the swift movement of the equestrienne past the viewers' stand, and these striations have some of the graphic quality of Degas's pastels. Such strokes were also a feature of the work of Degas's follower, Zandomeneghi, and it was under his influence, according to Gauzi, that Lautrec did his circus paintings.

The series of circus paintings that was later to culminate in one of Lautrec's masterpieces, *Au Cirque Fernando, l'écuyère* (Fig. 118, hereafter referred to as the 'Chicago *Écuyère*'), also represented one of his first attempts to incorporate his new, 'modern' subject-matter into multi-figured, narrative compositions that he intended as neither illustrations nor preparations for illustrations. These were among the earliest works in which he monumentalized commonplace, popular images and as such they were unique in his production of 1887. The circus as a subject for painting, like other popular or low-class themes, was already well established in Realist and Naturalist art and literature. Degas, Renoir, Tissot, and others had painted it; Edmond de Goncourt treated it in his 1879 novel, *Les Frères Zemganno*. Not surprisingly, however, 'high art' was not Lautrec's precedent for his studies of the circus. Degas and Goncourt had represented circus performers in terms of their acute skills and disciplined artistry. But to the Montmartre artists, including Lautrec, who haunted the Cirque Fernando in the 1880s, the noisy atmosphere and colourful, unrefined performance of the circus, with its animal smells and nonconformist cast of repulsive freaks, pathetic clowns, and breathtaking daredevils, epitomized the dual attraction and repulsion of popular culture. In Lautrec's renditions of the theme, this is evident from his use of caricature, particularly in the figures of the ringmaster, M. Loyal, and of the equestrienne, where the effect is to highlight the coarseness of their features. The equestrienne and her performance must have seemed to Lautrec a veritable inversion of his earlier sporting subjects, with their traditional snobbish aristocratic associations. The very lack of refinement in the circus and its popular appeal probably account for Lautrec's having come to the subject when he did.

In form, treatment, and choice of scenes, his depictions show the influence of the contemporary circus imagery in the popular press, the posters and handbills, programme covers, and current books on the subject, which often featured the equestrienne's act since it was the central attraction of the circus. For instance, every one of the elements in Lautrec's 'Chicago *Écuyère*', circus fan (Fig. 90), and the 'Missing *Écuyère*' is present in J. Faverot's *Au Cirque Fernando* (Fig. 91), which *Le Courrier français* published on 12 December 1886. In fact, an equestrienne, a ringmaster, and often a clown composed against the curving backdrop of the arena and the curving stands full of spectators had been typical of the engraved and lithographed popular images of the circus from the early nineteenth century onwards; it continued to be one of the most common (e.g. Fig. 92).[72] In his 'Chicago *Écuyère*' and 'Missing *Écuyère*',

[72] See e.g. the reproductions in H. Thétard, *La Merveilleuse histoire du cirque* (Paris, 1947), i. 66, *La Voltige équestre chez Franconi*, an engraving of *c*.1800; i. 233, *Le Cirque des Champs-Élysées en 1843*, a lithograph by Provost; and *Antoinette Cuzent Lejars*. See also D. Amiel (ed.), *Les Spectacles à travers les âges* (Paris, 1931), opp. p. 232, *Le Cirque*, colour engraving by C. Vernet, and opp. p. 229, programme cover from Cirque Rancy, *c*.1880–5; Baron de Vaux, *Écuyers et écuyères* (Paris, 1840), *Les Franconi*; and N. Wild, Bibliothèque Nationale, Département de la Musique, *Catalogues de la bibliothèque de l'opéra*, ii. *Les Arts du spectacle en France: affiches illustrées, 1850–1950*, no. 43, no. 46, posters for the Cirque d'Été, no. 59, no. 60, posters for the Cirque Fernando, and no. 70, a poster for the Nouveau Cirque.

Lautrec chose the elements most prevalent in the popular imagery—the clown, ringmaster, and equestrienne—then simply regrouped and enlarged them to occupy a monumental canvas. In the Chicago version, he also composed his figures daringly to convey the swift, dramatic passage of the performance before the eyes of the spectators. The paper-covered hoop through which the equestrienne jumped was another common image in circus illustration. Lautrec adapted it to present the list of his paintings in the Les Vingt catalogue of 1888 (Fig. 79). He treated the hoop in the way that handbills, books, and posters often did, putting it in the uplifted hand of a clown to frame a written announcement about the circus (e.g. Fig. 92).

No one popular image, however, was necessarily Lautrec's definitive source. His interest in the circus and his familiarity with popular illustration could have led him to any number of similar images. In addition, he was an enthusiastic firsthand observer and student of the circus itself. Immediate experience was always an important part of his preparation and it worked in conjunction with the vocabulary of popular imagery that he adopted and rephrased in order to formulate his own representations.

Maurice Vaucaire's poem of 1886, 'Au Cirque', was a literary demonstration of how writers as well as artists drew upon popular culture to promulgate the Naturalist outlook they shared. Vaucaire, an ardent champion of contemporary, low-brow entertainment, characterized the equestriennes, horses, and clowns as the inhabitants of 'une féerie / Ayant des odeurs d'écurie' ('a fairyland with the odours of the stable'), a comment whose counterpart might be Lautrec's use of caricature to delineate the coarseness beneath the glamorous spectacle of the equestrienne's stunt. Vaucaire's verses are contemporaneous with Lautrec's circus paintings, and narrate the same circus act with closely parallel imagery, highlighting the ironic counterpoint between the dazzling grace and erotic appeal of the equestrienne and the ridiculous awkwardness of the clowns: M. Loyal cracks his whip to summon the quivering horse, which whinnies and tosses its mane; the equestrienne jumps into the ring, smiles, throws 'twenty' kisses towards the stands, and mounts the horse, making little noises to excite it while the crowd laughs rapturously, 'amoureux de la gentille fille' ('infatuated with the obliging girl'); the orchestra plays a *quadrille*, the horse and rider circle the ring; then after a pause the clowns in their 'grotesque maillots . . . imprimées de lunes, de soleils et d'étoiles' ('ludicrous costumes . . . printed with moons, suns, and stars') arrive and the most comical of them all pretends to surprise the equestrienne with a kiss, which she spurns; at last the music rises, the clowns take up the hoops, and the equestrienne stands erect on her horse, hair flying and face radiant, preparing to burst through the painted paper on the hoops at full gallop. This was the moment that Lautrec painted in the 'Missing *Écuyère*':

> Sur la selle carrée et large de la bête,
> L'écuyère, debout, peut sauter et danser.
> Vite un coup de galop furieux, et la tête
> La première, affolée, elle va traverser
> Ces ronds de papier peint comme on crève un nuage.

> [On the broad square saddle of the beast,
> The equestrienne, standing, is able to jump and dance.
> Quickly thrusting into a furious gallop, and with her head first

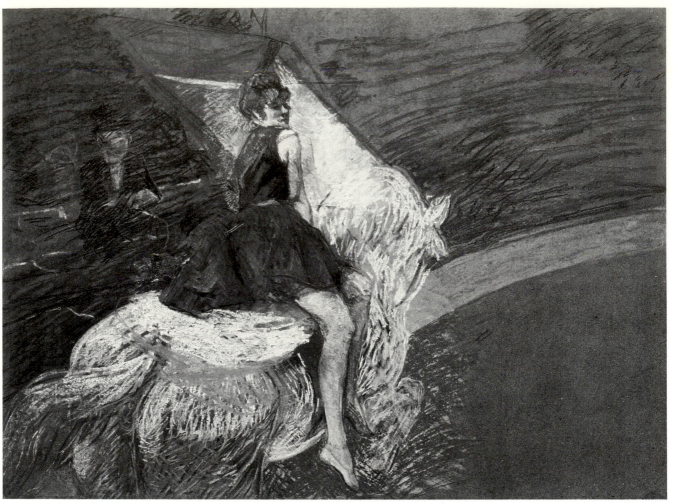

89. Henri de Toulouse-Lautrec, *Au Cirque Fernando*. Pasadena, Norton Simon Art Foundation.

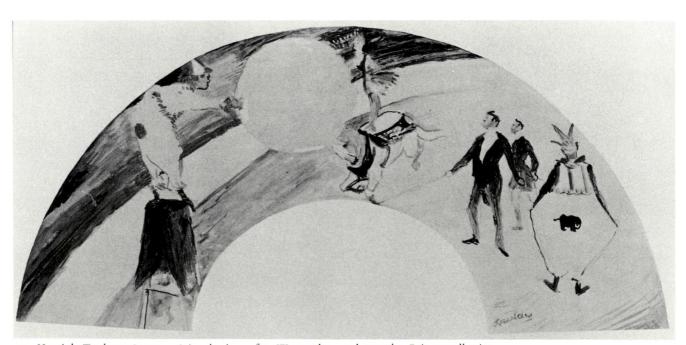

90. Henri de Toulouse-Lautrec, *Scène du cirque*, fan. Watercolour and gouache. Private collection.

AU CIRQUE FERNANDO

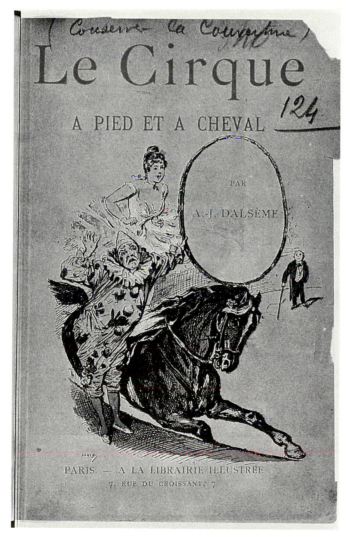

91. Above: J. Faverot, after, *Au Cirque Fernando*. Zinc engraving from *Le Courrier français* (12 Dec. 1886). Paris, Bibliothèque Nationale. (Photo, Bibliothèque Nationale.)

92. Left: Lithograph, frontispiece from A.-J. D'Alsème, *Le Cirque: à pied et à cheval* (Paris, *c*.1887). Paris, Bibliothèque Nationale. (Photo, Bibliothèque Nationale.)

Maddened, she is going to jump through
These hoops of painted paper, as if bursting a cloud.][73]

Vaucaire's poem recreated the mood of the scene, its 'Kitsch' quality, and traced its gradual build-up of dramatic tension to the breathless moment just before the equestrienne's leap through the hoop (the 'Chicago *Écuyère*' was later to depict the heightening speed and excitement of the rider circling the ring). 'Au Cirque' underscores the fact that Naturalist writers and artists worked in the same context, sharing its imagery and point of view. It was not a coincidence that Lautrec, like Vaucaire, chose to monumentalize the commonest elements of the equestrienne's performance in his major canvases. They were so frequently represented in the popular idiom, and so quickly and widely recognizable.

To produce monumental works was the goal of many painters of the post-Impressionist generation, and Lautrec, too, felt the ambition to create complex, large-scale compositions on themes from Parisian popular life: the huge 'Missing *Écuyère*' certainly was one result of it, as were Bernard's *L'Heure de la viande* and Anquetin's *Chez Bruant*. Zola's novel of 1886, *L'Œuvre*, treats the very subject of an artist, Claude Lantier, who longs to paint a series of murals representing modern life in Paris. Evidently Lantier's work was to be what Zola believed the Impressionists had failed to produce, monumental scenes of contemporary popular life. In the story, Lantier labours for years, but (like Anquetin and Bernard) never brings his masterpiece to fruition.[74] If any one of the Petit Boulevardists was to meet Zola's challenge to create monumental figure compositions describing contemporary Parisian life, it was Lautrec in his paintings of the Moulin de la Galette and the Moulin Rouge in the final years of the 1880s and the early 1890s.

The naturalistic orientation of many of Lautrec's subjects must also have made him an attractive prospect for Les Vingt at this time. Les Vingt and its literary organ, the journal *L'Art moderne*, held leftist political sympathies and endorsed art that was socially orientated or that had democratic themes, as opposed to art for art's sake, during the 1880s.[75] Nevertheless, it was in his illustrations and drawings of the period, rather than in his formal easel paintings destined for exhibition, that Lautrec explored most fully his new naturalistic themes.

'Sur le pavé': Illustrations and Drawings

Lautrec referred to his career as an illustrator in one of his letters of 1887: 'My illustrations are yet to be finished, thanks to the stereotyper who made them as black as my hat.'[76] *Le Mirliton* published four captioned illustrations by Lautrec during the year 1887: in January (no. 31), *Sur le pavé: la dernière goutte* (Fig. 93), the picture of a working man sprinkling holy water on a coffin while a bourgeois gentleman stands in the background, indifferently turned away from the scene; in February (no. 33), *Sur le pavé: le trottin* (Fig. 94), a drawing of a pavement flirtation between a young working girl and an elegantly attired, much older

[73] M. Vaucaire, *Effets de théâtre (la scène et la salle, le ballet, cafés chantants, à la foire)* (Paris, 1886), 115–17.

[74] On Zola's book as a reflection of the Parisian art scene in the 1880s see R. J. Neiss, *Zola, Cézanne and Manet* (Ann Arbor, Mich., 1968), 234–49. Zola's novel should be seen in conjunction with his 1880 *Le Naturalisme au salon* (see Hemmings and Neiss [eds.], 233–54), in which he reviews Impressionism.

[75] E. Herbert, 158.

[76] H. Schimmel, no. 136, 104, recently moved to autumn 1886 by him, but more likely belonging in the spring of 1887. See also no. 153, 120–1, recently redated by him to Nov. 1887.

man; in March (no. 34), *Le Dernier Salut*, another view of a working man at a funeral, this time watching the cortège pass by; and in August (no. 39), *A Saint-Lazare*, the only one of these four illustrations that pertained explicitly to a Bruant song. The others nevertheless treated favourite themes of the song-writer and were tinged with his social consciousness. Moreover, Lautrec took his titles in part from Bruant, who had realized his first great success with 'Sur le pavé',[77] a song that decried the miseries of the street people and the indifference of the *grande classe*. Without illustrating it literally, Lautrec clearly related his three Parisian street scenes to its sentiment and Bruant's spirit, which the song had come to symbolize.

The bourgeois gentleman in *Sur le pavé: la dernière goutte* is probably the undertaker or a professional mourner, but allegorically he may symbolize death. He now awaits the poor working man, who pays his final respects to the dead with his own 'last drop' of strength. Lautrec perhaps created a sequel to this incident in *Le Dernier Salut*, published two months later. Head bared, cap in hand, a working man in his smock pauses respectfully to watch a passing funeral procession. He is a figure similar to Steinlen's poor labourers, identified by their caps and smocks. Bruant both celebrated the poor and lamented their misery, and in many of his songs touched on how they died, either from lifelong, fruitless overwork, or by execution for petty crimes. Lautrec's tone recalls that of songs such as 'A Saint-Ouen', which projected this spirit:

> Enfin je n'sais pas comment
> On peut y vivre honnêt'ment,
> C'est un rêve;
> Mais on est récompensé,
> Car comme on est harassé,
> Quand on crève . . .
> Le'cim'tière est pas ben loin
> A St-Ouen.

> [After all, I don't know how
> One can live there honestly,
> It's a dream;
> But one is recompensed,
> For when one is too worn out to go on
> And one croaks . . .
> The cemetery ain't too far
> At St-Ouen.][78]

Borrowing the title of Bruant's famous song about life on the street for a second time, Lautrec gave his drawing of the encounter between the young, somewhat innocent looking errand-girl and the older, bourgeois man an ironically humorous caption of a kind that was to be rare in his work after this period:

[77] Zévaès, 27.

[78] Bruant, ii. 198–201. See also 'Fantaisie triste', Bruant, i. 81–3. In a preparatory version of this illustration (D3000), Lautrec visualized the man as a condemned figure on his way to execution, also a common theme in Bruant's songs. Cf. the song 'A la roquette' in Bruant, i. 68–9.

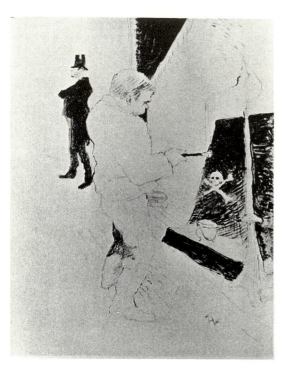

93. Henri de Toulouse-Lautrec, *Sur le pavé: la dernière goutte*. Pencil and wash. Hamburg, private collection.

94. Henri de Toulouse-Lautrec, *Sur le pavé: le trottin*. Pen drawing. Williamstown, Massachusetts, Sterling and Francine Clark Art Institute.

95. Facing: Henri de Toulouse-Lautrec, *Le Petit Trottin*. Lithograph. New York, Brooklyn Museum.

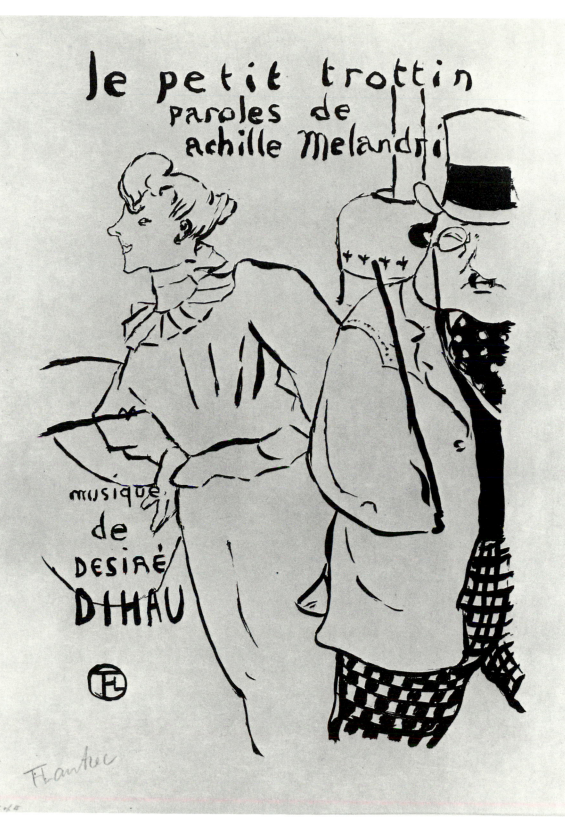

'Quel âge as-tu, petite?'
'Quinze ans, m'sieu . . .'
'Hum! déjà un peu vieillotte . . .'

['How old are you, little one?'
'Fifteen, sir . . .'
'Hmm! already a little oldish looking . . .']79

Sur le pavé: le trottin parallels in its theme many of Bruant's songs about young women of the street who grow old prematurely. Although Lautrec treats the young girl sympathetically, as the potential 'prey of indecent propositions',80 this illustration was somewhat more titillating and less humanitarian in tone than his others of this time.

By 1887, when Lautrec made his illustration, such encounters provided a stock subject for popular art, poetry, and songs, which alternately treated the girls as the men's victims or their victimizers. Indeed, in January 1887, in the same issue of *Le Mirliton* that featured *Sur le pavé: la dernière goutte* by Lautrec on its cover, a poem by Édouard Dubus entitled 'Les Trottins' dealt with the theme, but directed its satire at the girls rather than the men:

> Fillettes aux yeux polissons,
> Elles trottinent part les rues,
> Dévisageant les beaux garçons,
> Et les vieux chauves à verrues.
>
>
>
> Dans leur perversité précoce
> Elles ont des petits amants,
> Et lisent de mauvais romans,
> Pour se faire à la grande noce.
>
> [Lasses with lascivious eyes,
> They trot along the streets,
> Scrutinizing the handsome young men,
> And the old baldheads with warts.
>
>
>
> In their precocious perversity
> They have casual lovers,
> And read bad novels,
> In order to live it up.]81

Numerous popular songs of the period, in addition to those by Bruant, related stories about the exploits and petty sorrows of the young errand-girls, who had become erotic symbols,

79 Cf. Joyant, ii. 190; i. 98.

80 Adhémar, *Complete Lithographs and Drypoints*, nn. to lithograph no. 18, quoting a verse from a popular poem by Thomas Chesnois.

81 E. Dubus, 'Les Trottins', *Le Mirliton*, no. 31 (Jan. 1887).

because many of them took up clandestine prostitution in order to augment their meagre earnings.[82] The image of flirtation on the streets was also a favourite of Forain and Steinlen, whose illustrations were precedents for Lautrec's.

Lautrec's *Mirliton* covers of January, February, and March 1887 were hand-coloured with the aid of stencils. He coloured only small areas—the faces or isolated items of the clothing of his figures. In *Le Trottin*, for instance, the bright red scarf of the girl is the only touch of colour. This economic use of flat areas of colour, along with the relatively simplified compositions and concise use of line, as well as the silhouetting of black forms against light backgrounds in these illustrations, seems to be a harbinger of the bold abstract style of Lautrec's posters of the 1890s.[83] Yet compared with his mature graphic work, Lautrec's illustrations of this time still maintain a relatively conventional style of Realism. He treated his figures in a more straightforward, less caricatural manner than he later was to do, often modelling them in terms of light and dark and placing them in settings with receding orthogonals, to create a sense of depth.

In 1893 Lautrec returned to the subject of the errand-girl in his lithographic cover illustration for the sheet music to 'Le Petit Trottin' (Fig. 95), a song by Désiré Dihau. This later illustration on the theme of street encounters between young girls and old men presents a transformation of *Sur le pavé: le trottin* while it preserves all the original elements: the girl, wearing a little scarf around her neck and carrying a hatbox; the coquettish turn of her head; the well-dressed man, top-hatted, monocled, and wearing check trousers; his hands in his pockets and his walking stick jutting out from one of them; even the *pissoir* in the background with its pattern of air vents (at once an indication of the Paris street setting and a metaphor for the base physical nature of the encounter).[84] Lautrec must have had his 1887 version in mind when he did the later one, and in his repetition of both the subject and the imagery he not only inadvertently exposed a concise view of his stylistic development, but also demonstrated the enduring influence that the formative thematic sources of the 1880s exercised on his mature vision.

In his 1893 version Lautrec moved away from the relatively conservative Realism of his style of 1887. He simplified and abstracted the figures radically, to the point of distortion, and wittily intensified the quality of caricature and satire, accentuating the unappealing lasciviousness of the old man and making the girl less a victim than a victimizer who has rebuffed him. He enlarged the figures and reduced background detail, completely eliminating modelling and the receding orthogonals of the pavements so that volumes and space are flattened. He altered the attitudes and directions of the figures so that the man is no longer following the girl, rather she appears to have turned away from him; the two figures now form opposing diagonals that have met momentarily and then diverged. And he cropped the figure of the man severely at the edge of the composition to underscore further the ironically fleeting nature of the encounter. In effect, he manipulated the formal elements of the picture to complement the psychological quality of the experience, intensifying the sense of sly sexual

[82] Clayson, 210. See also E. Lipton, *Looking into Degas: Uneasy Images of Women and Modern Life* (Berkeley, 1986), 157–8. The trottin is described by G. Montorgueil, *La Parisienne peint par elle-même* (Paris, 1897), 95–104.

[83] Cate, 'The Popularization of Lautrec' in Wittrock and Castleman (eds.), 78–9.

[84] Thomson, 'Imagery of Lautrec's Prints', in Wittrock, i. 27.

innuendo and venality, and rendering the image more striking visually. The transformation from the realistic style of Lautrec's earlier career to the more abbreviated, abstract style of his mature graphic work was complete. Although the Realist and Naturalist theme remained the same, his stylistic shortcuts produced a more chic image, one eminently suited to selling the song for which Lautrec's cover was, in effect, an advertisement. His stylistic evolution had become largely a search for expressive means to convey the naturalistic content that he was first discovering in the latter 1880s—and to enhance, for publicity purposes, the element of titillation and delicious perversity in it.

Lautrec did a great number of drawings about this time depicting the popular types and common occupations observable in the Parisian streets and often intended them for publication. Many were never published but are datable to *c*.1887 because of their stylistic relationship to the illustrations published in *Le Mirliton* that year. In making such drawings, Lautrec was following the practice of Realist and Naturalist artists and writers from the 1840s onwards, who catalogued the customs, activities, occupations, and dress of modern life, especially of humble people.[85] This phenomenon persisted into the later part of the century and although it was widespread in the 1880s, it was particularly exemplified in art by the paintings and illustrations of Raffaëlli and in literature by J.-K. Huysmans in his *Croquis parisiens*.[86] At the popular level, journal illustrations and songs such as Bruant's further disseminated the ongoing Realist and Naturalist concern with typical features of contemporary urban life.

The *Croquis parisiens*, one of Huysmans's last Naturalist works, may have had their actual inspiration in part in Raffaëlli's and Forain's art; the writer's descriptions and the painters' images complement one another closely, and Huysmans was a long-time admirer of both artists.[87] The *croquis* were first published in 1880 with illustrations by Raffaëlli and Forain, and their work alone might have attracted Lautrec to the book. It was reissued in a new, expanded edition in March 1886,[88] just as Lautrec's interest in naturalistic subject-matter was emerging, and striking similarities exist between a number of his themes and those of Huysmans's prose sketches. Like Bruant and Lautrec, the author also treated the Grenelle quarter of Paris, which he made the setting for 'Le Bal de la Brasserie Européene à Grenelle', one of the new, naturalistic pieces that he added to the *Croquis parisiens* in its 1886 edition. This literary piece was an excerpt from his unfinished novel, *Gros-Caillou*, in which there was 'a dance hall full of tobacco girls, foot soldiers, whores and cuirassiers'.[89] More explicitly, Lautrec's drawing (Fig. 96) and painted sketch of a laundress on hands and knees parallel Huysmans's sketch about a crouching or squatting laundress in his group of sketches of 'Parisian Types':

Accroupies, là, depuis les rougeurs de l'aube jusqu'aux fumées du crépuscule, auprès de monstres, vêtues de guenilles, coiffées de marmottes et enterrées jusqu'aux aisselles dans des futailles, elles savonnent à tour des bras, frappent à tour de battoir le linge qui s'égoutte sur la planche.

[85] See A. C. Hanson, 'Popular Imagery and the Work of Edouard Manet', in U. Finke (ed.), *French 19th Century Painting and Literature* (Manchester, 1972); and T. Reff, 'Manet's Sources: A Critical Evaluation', *Artforum*, 8 (Sept. 1969), 40–8.

[86] See also F. Coppée's *Promenades et interieurs*, 1875, and the series of prose sketches, *Les Types de Paris*, published in 1889 by *Le Figaro* with illustrations by Raffaëlli, cf. L. J. Austin, 'Mallarmé and the Visual Arts', in Finke, 245.

[87] J.-K. Huysmans, *Parisian Sketches*, trans. R. Griffiths (London, 1960), introduction, 10–12. This translation is based on the 1886 edn.

[88] Id., *Croquis parisiens, nouvelle édition, augmentée d'un certain nombre de pièces et d'un portrait* (Paris, Léon Vanier, Éditeur des Modernes, 1886).

[89] Id., *Parisian Sketches*, Griffiths's introd., 10, quoting a letter from Huysmans to T. Hannon, dated 15 Feb. 1882.

Vues de dos, quand elles sont enfoncées dans des bouillons d'eau sale, leurs échines font saillie sous le canezou crasseux, des brindilles de tignasse courent à la débandade sur leur peau vernissée comme la pelure des oignons . . .

[Squatting there, like strange monsters, from the first flush of dawn until the mists of nightfall, wearing scarves over their heads, and plunging into the tubs up to their armpits, they soap and beat the linen with all their might, as it lies dripping on the planks.

Seen from behind, when they are deep in dirty foam, their backbones jut out beneath their filthy smocks and strands of tousled hair, like onion peel, run over their shiny skin . . .][90]

Lautrec's drawing, *Conducteur de tramway* (Fig. 97), recalls Huysmans's description of another Parisian type:

. . . fatigué de voir ces deux rangs de passagers qui se saluent à chaque secousse, il se détourne et contemple vaguement la rue.

A quoi peut-il songer alors que la carriole courre de guingois toujours dans les mêmes ruisseaux, toujours dans les mêmes routes?

[. . . tired of looking at these two rows of passengers bowing to each other at every jolt, he turns away and gazes vaguely at the road behind him.

What is he thinking about as the bus runs lopsidedly along, always through the same gutters and the same routes?][91]

Still another parallel exists between Huysmans's portrayal of a streetwalker and Lautrec's *A Montrouge—Rosa la Rouge* (Fig. 60) of 1886 (and Bruant's song as well). The woman stands 'aux aguets devant la porte d'un café, son oeil reculé par du bistre, tend des gluaux, mais le sourire impudent et douloureux de sa bouche épouvante le vulgaire chaland . . .' ('on the look-out in a café doorway, her sunken, black-ringed eyes set snares for the passers-by, but her impudent yet woe-begone smile scares the average customer . . .').[92] It is obvious not that Lautrec literally borrowed from Huysmans, but that he shared the same vision, which Raffaëlli, Forain, and Steinlen also shared, and the same interest in depicting popular types; he had entered into the Naturalist current of ideas and subject-matter of the 1880s.

Of all the influences on Lautrec's choice of naturalistic subject-matter, Raffaëlli was one of the most important. It is likely that Lautrec emulated him in his treatment of the *quadrille naturaliste* and in his taste for depicting popular Parisian types, and Raffaëlli was perhaps the best-known specialist on such themes during the 1880s. But even beyond the prestige that he commanded as an artist, he was an influential theorist. His ideas as well as his art were so familiar at this time that one contemporary writer discussed 'Le Raffaëllisme' as a veritable movement in the representation of street life, the poor quarters of Paris, the factories, the working people: all of them subjects previously considered vulgar.[93] Raffaëlli exhibited with

[90] Id., *Œuvres complètes*, viii, *Croquis parisiens* (Paris, 1928), 69 (*Parisian Sketches*, 42–3).

[91] Id., *Croquis parisiens*, 58 (*Parisian Sketches*, 38–9).

[92] Id., *Croquis parisiens*, 64 (*Parisian Sketches*, 40–1).

[93] D. Léon in *Les Maîtres artistes, numéro consacré à J.-F. Raffaëlli* (Paris, 10 Jan. 1903). Raffaëlli's reputation is also dis-

cussed by F. C. Legrand, *Le Groupe des XX et son temps* (exh. cat., Musées Royaux des Beaux-Arts de Belgique, Brussels, 1962), 89–90. His exhibitions in 1886 and 1887 at Petit's 5th and 6th Expositions Internationales had brought him to the height of his fame.

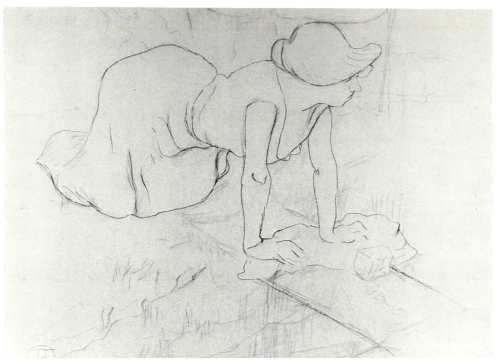

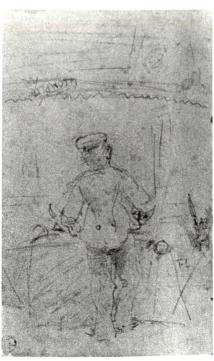

96. Henri de Toulouse-Lautrec, *Femme accroupie: blanchisseuse*. Pencil drawing on tracing paper. Albi, Musée Toulouse-Lautrec.

97. Henri de Toulouse-Lautrec, *Conducteur de tramway*. Pencil drawing. Private collection.

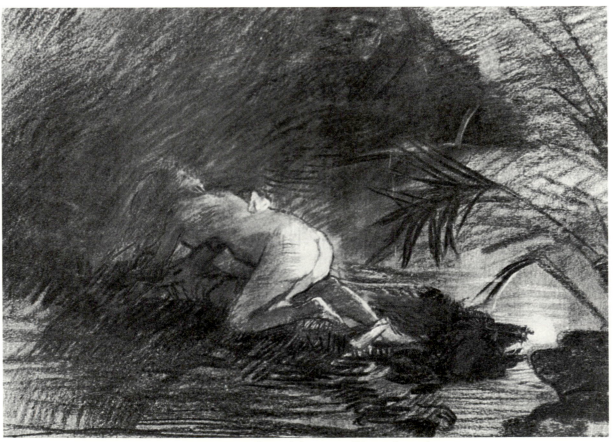

98. Henri de Toulouse-Lautrec, *La Curée: Renée*. Charcoal drawing. Albi, Musée Toulouse-Lautrec.

the Impressionists and shared their opposition to idealization and traditionalism; otherwise his socially conscious ideas had little to do with theirs. He labelled his own work *caractérisme*, a philosophy of art that advocated the portrayal of human types expressive of the moral complexion of modern life.[94] The premiss of *caractérisme* was that the egalitarian and democratic values of modern, scientific society required a new art. Raffaëlli recommended painting *le Beau* (the Beautiful), but not in the traditional sense. As a humanist, he found beauty in the inner character and moral spirit of ordinary, individual human beings, i.e. in expressiveness rather than in nature and idealized form, and for him the artist's task was to study and depict the psychological, moral, intellectual, and physiological character of individuals in contemporary society.[95] He recommended that modern artists turn to the previously neglected lower classes, 'the people', for subject-matter. Raffaëlli felt that art, through such ideas, could fulfil a social purpose as an agent of democratization. Secondarily, the artist ought to express the condition of his own spirit at the time he created each work, a necessity because in their emotions the agitated and unhappy artists of the Realist and Naturalist movement reflected the inquietudes and sorrows of society itself. For artists, Raffaëlli concluded, the concept of 'modern' lay not merely in their choice of subject-matter, but in their feelings toward it.

Raffaëlli's statements of his philosophy, which amounted to a manifesto of the social-realist or Naturalist movement of the 1880s, had an extraordinary reception, and obviously fulfilled a need.[96] His admirers included van Gogh, who interpreted his call for character in art as anti-academic,[97] and no doubt the other Petit Boulevardists were attracted to him as well. Gauzi noted Lautrec's high regard for Raffaëlli's painting in the mid-1880s,[98] and Joyant also called attention to the importance of Raffaëlli's ideas in Lautrec's milieu and noted that in his illustrations of the period Lautrec took Raffaëlli 'as a model'.[99] At a time of transition in his own development, Lautrec may have found a figure of particular appeal in Raffaëlli, who was not an out-and-out radical, notwithstanding his progressive social ideas.[100] He showed at the

[94] My text summarizes and paraphrases Raffaëlli's ideas as expressed in J.-f. Raffaëlli, 'Étude des mouvements de l'art moderne et du beau caractériste', *Catalogue illustré des œuvres de J.-F. Raffaëlli* (Paris, 1884); and J.-F. Raffaëlli, *Conférence faite par M. J.-F. Raffaëlli au Palais des Beaux-Arts de Bruxelles au Salon annuel des XX, le 7 février 1885: le laid, l'intimité, la sensation et la caractère dans l'art, une bibliothèque des dessins* (Brussels, 1885), 1–35. Transcript in Bibliothèque Nationale. Raffaëlli planned an entire book, 'Philosophie de l'art moderne', which, however, he never completed; cf. G. Coquiot, 'Jean-François Raffaëlli', *Gazette des beaux-arts*, 5 (1911), pt. 1, 53–68, pt. 2, 136–48.

[95] He drew these ideas largely from Taine whose socially conscious, positivistic philosophy valued science, reason, democracy, and individual worth. The concept of *caractère* probably derives directly from Taine's lectures on art of 1865 and 1867: cf. Fields, 110–13. He was also influenced by the ideas of the philosopher Charles Guillaume Humboldt and by Challemel-Lacour's study of Humboldt, *La Philosophie individualiste* (Paris, 1864). Raffaëlli's philosophy also echoed the ideas of earlier Realist artists, particularly Degas and his circle, and writers. E.g. Edmond and Jules de Goncourt, in the preface to *Germinie Lacerteux*, had recommended that modern artists turn to the lower classes for

subject-matter, as other writers on Realism had advised for some 30 years. Reff, *Degas*, 219, points out that already in 1866 the Goncourt brothers made a 'distinction' between expressiveness and conventional beauty, noting in their *Journal* that 'the beauty of the ancient face was the beauty of its lines' whereas 'the beauty of the modern face is the expression of its emotion'. For further discussion of Raffaëlli's ideas see J. Isaacson, *The Crisis of Impressionism, 1878–1882* (exh. cat., University of Michigan Museum of Art, Ann Arbor, 1979), 41–2, 161–2.

[96] See Coquiot, 'Raffaëlli'; also A. de Lostalot, 'Œuvres de J.-F. Raffaëlli', *Gazette des beaux-arts*, 29 (1884), 334–42; and Legrand, 89–90. NB In Mar. 1884, Roger-Marx stated in *Le Voltaire* that *caractère* ought to be the ideal of every artist.

[97] On van Gogh's admiration for Raffaëlli, see van Gogh, ii. 393, no. 414; ii. 394–6, no. 416; ii. 396–7, no. 417; ii. 451, 453, no. 436, no. 437; ii. 418, no. R57; ii. 555, no. 480; ii. 591, no. 501; and iii. 280, no. 640.

[98] Gauzi, 56–8.

[99] Joyant, i. 113–14; ii. 10–12.

[100] Rewald, *Impressionism*, 464–5, relates that Raffaëlli was considered a reactionary by many of the Impressionists.

Salons and enjoyed considerable official success, and he continued to paint portraits for wealthy patrons even while he was producing his scenes of the lower classes. At the same time his ideal of a socially progressive and humanistically orientated art coincided with the spirit of the artistic and intellectual circles of Montmartre, in which Lautrec then moved, and would have reinforced the influence of Bruant. Raffaëlli praised the socially conscious illustrators of the district, and they must have seen in him an articulate spokesman for their ideals. He declared the 'cancan' to be the only dance suitable to the agitation and freedom of modern society,[101] and advocated the illustrators' typical subject-matter—the café, the street, and the lower classes—as the most appropriate one for high art.[102] Moreover, Lautrec shared Raffaëlli's interest in expressing the emotions underlying reality. It was not fortuitous, therefore, that when Lautrec made his debut as an avant-garde artist at the fifth Exposition des Vingt in 1888, it was as a *caractériste* and *typiste*, terms by which van Rysselberghe was to refer to him as late as 1892.[103]

Like art and literature, the theatre of the 1880s also exhibited important manifestations of later Naturalism. Whereas the Naturalist novel was in decline during the decade, Naturalism in the theatre gained momentum after having lagged significantly behind.[104] It first made itself felt in the early 1880s, and advanced greatly with the establishment of Antoine's Théâtre Libre in 1887. There the notorious and provocative theatre of 'realism *rosse*'—sordid, brute, degraded realism—and the 'slice of life' play developed.[105] The Naturalist theatre of the late 1880s and 1890s stimulated a modest renaissance of interest in the Naturalist novel, and many theatrical adaptations of existing works were brought to the stage, especially those of Zola and the Goncourts.[106]

Lautrec, an avid theatre-goer, is likely to have acquired much of his familiarity with Naturalist novels from their stage adaptations. Zola's 1872 novel, *La Curée*, about greed and corruption in the Second Empire, was therefore a less probable source for Lautrec's drawing, *La Curée: Renée* (Fig. 98), than was its production as the play, *Renée*, at the Théâtre du Vaudeville in April 1887.[107] In this drama, Zola made one of his most forceful efforts to establish a Naturalist theatre. He intended the play to be a modern version of the story of Phèdre, recreated in Naturalist terms in which he supplanted the classical view of fate with contemporary ideas about heredity and environment, and devised sexual involvements that he dealt with in frank and brutal terms.[108] Lautrec's drawing depicts the final scene of act 3, the climactic episode of the play, when the incestuous love affair between Renée and her stepson, Maxime, nears its consummation in the sultry atmosphere of her hothouse, among the exotic flora. Zola's own stage directions specified that 'a ray of moonlight that enters through the glass panes, creates a bluish semi-darkness and causes the large plants to stand out as black silhouettes'.[109] Lautrec reproduced these lighting effects in his drawing, and

101 Raffaëlli, 'Étude des mouvements', 60.

102 Raffaëlli, 'Conférence faite par Raffaëlli', 22–3.

103 Chartrain-Hebbelinck (ed.), 65–7, no. 15, 76.

104 J. A. Henderson, *The First Avant-Garde, 1887–1894, Sources of the Modern French Theatre* (London, 1971), 27–30; L. A. Carter, *Zola and the Theater* (New Haven, Conn., 1963), 83–4.

105 S. M. Waxman, *Antoine and the Théâtre Libre* (New York, 1964), 17, 82, 90–1; Henderson, 81; and Carter, 98–9.

106 See C.-O. Gierow, 'Documentation-évocation. Le Climat littéraire et théâtral en France des années 1880 et "Mademoiselle Julie" de Strindberg', Ph.D. diss. (Uppsala, 1967), 33–62; and Carter, 215–18.

107 Carter, 50, gives the date of the performance. Joyant, ii. 194, suggested the connection to Zola's novel.

108 Carter, 50–5.

109 É. Zola, *Les Œuvres complètes. Théâtre II: Renée (pièce en 5 actes)* (Paris, 1924), 373.

poised the nude figure of Renée, on a bear skin rug, in a crouch like a cat's. Zola's play differs from his novel in its degree of explicitness. In the play, the scene simply fades; the author did not spell out the action. Presumably the poses and gestures of the players on the stage were to refer back to the novel, the original *La Curée*, which describes the scenes of seduction in detail, including Renée's animal-like crouch. In neither the novel nor the play, on the other hand, did Zola specify that Renée was nude. The nudity of Lautrec's female figure was his own interpolation. The drawing, in charcoal on blue paper, is traditionally placed in 1889. But the time of the play, 1887, and the careful rendering and deeply shadowed tonal quality of the drawing, all support an earlier date.

The Year 1888

Refinements in Painting

Throughout 1888, Lautrec continued to work with Impressionism and Neo-Impressionism as he had done in 1887, gradually developing a more distinctive brush stroke as he advanced towards a personal style. The stroke did not change so much, however, that the works of the two years became sharply distinguishable from each other, and 1888 was not a time of stylistic breakthrough for Lautrec. He concentrated on illustration and in painting he embarked on no new experiments, but refined old ones. This was not the year he reached maturity, as many writers have asserted, but a time of continued experimentation—yet with a slackened pace by comparison with 1887.

Two important and related events led to the widely held opinion that Lautrec emerged in 1888 as a mature artist. The first was his participation in the 1888 Exposition des Vingt in Brussels, which placed his work beside that of established, well-known artists in a major exhibition, and marked his first significant recognition as a progressive young painter. The second event was his presumed creation this year of his circus masterpiece, the large and ambitious 'Chicago *Écuyère*'. Joyant attributed it to 1888, perhaps because he believed it to have been one of the circus paintings that Lautrec showed at Les Vingt, or because he related it to them. However, the *écuyère* shown in Brussels probably was the 'Missing *Écuyère*' and evidence indicates that the group of related circus subjects largely belong to 1887 in the chronology.

The 'Chicago *Écuyère*', with its flatter and more boldly decorative qualities, perhaps influenced by Cloisonnism,[110] is completely anomalous in style to the paintings of 1887, despite its clear relationship to the circus subjects of that year in composition and individual elements. Dujardin identified the new Cloisonnist elements in Anquetin's works shown at Les Vingt, but not in Lautrec's. Moreover, the works that Lautrec sent to Les Vingt were not refined and mature (even though his exhibiting there was auspicious), but represented a series of experiments with progressive trends new to him. Neither does the 'Chicago *Écuyère*' share the stylistic qualities of Lautrec's work of 1888. This study withdraws a number of

110 Welsh-Ovcharov, *Van Gogh and the Birth of Cloisonism*, 40–1, 44.

works from 1888 in the traditional chronology. The paintings that correctly remain from Joyant's and Dortu's chronology, with others that logically belong to 1888, comprise, in style, a fairly homogeneous group. They indicate that Lautrec continued his explorations of 1887 of Impressionism and Neo-Impressionism, especially the divided brush stroke, and that he evidently did not yet feel prepared to follow the other painters of the Petit Boulevard in their dramatic advance into the more abstract style of Cloisonnism. He was not to begin to take up his friends' advances until at least 1889, and in 1888 the 'Chicago *Écuyère*' would have been too much of an isolated departure from the other work that Lautrec was doing. It represents a dramatic step towards the abstraction and stylization that were to characterize the artist's work of the 1890s. Its correct date is not likely to be 1888 or earlier, but later, with other works that share its stylistic qualities (see Chapter 5).

Bal masqué (Fig. 105), a grisaille study for an illustration, was the only work that Lautrec dated in 1888. In addition, his friend René Grenier inscribed '1888' on two Lautrec paintings that he owned, one of them his portrait, *Monsieur Grenier, artiste peintre*, and the other, *Étude de danseuse*. Three additional grisaille paintings on cardboard (e.g. Fig. 101), all of them preparatory studies for illustrations in *Paris illustré* of 7 July 1888 (e.g. Fig. 104), can likewise be dated 1888. These examples provide a stylistic reference for recognizing other, undated works of 1888. They follow logically from his work of 1887 in that all are impressionistic in nature. However, in most of them Lautrec applied the paint with a characteristic pronounced, short, crosshatched stroke alternating with occasional longer strokes, that seems to have been a new, personal variation of the Neo-Impressionist dot. Lautrec made only a small number of formal paintings this year; most are portraits and relatively few take up naturalistic genre subjects. The latter remain largely confined to his illustrative works and their painted preparations.

The abbreviated, regular stroke characterizes the outdoor study of a single female figure, *A Batignolles* (Fig. 99), and this, therefore, is Lautrec's one *plein-air* work that can be assigned to 1888 with any certainty. The distinctive brush stroke was not without precedent, however. It is apparent in the contemporary paintings of a number of Degas's followers, notably Zandomeneghi and Forain. But, in its overall articulation of the painting surface, it links Lautrec's work of 1888 more closely with Pissarro's of the early 1880s, the period when Pissarro was turning back towards tighter construction under the influence of Neo-Impressionism. Lautrec maintained a basic stylistic unity in his *plein-air* works throughout the later 1880s, especially in his light palette and conspicuous brush stroke. Developmental changes are evident in them nevertheless, even though the distinctions are not sharp. Those of 1886 (e.g. Fig. 61) are more awkward and naïve in their drawing and less firm in their modelling than the works of 1887 (e.g. Fig. 86) and 1888. By 1888, probably as a result of his assimilation of Neo-Impressionism, Lautrec moved to the uniform, evenly applied brush stroke of *A Batignolles*.

In *A Batignolles* Lautrec undertook another visual counterpart to a Bruant song, also entitled 'A Batignolles'. Again his theme was the streetwalker, in this case a young woman whose red hair framed her head like a halo. The painting and several preparatory drawings for it conform to Bruant's song, an elegiac ballad heavy with pathos, whose voice is that of the prostitute's pimp, mourning her death:

Alle avait des magnièr's très bien,
Alle était coiffée à la chien,
A chantait comme eun' petit'folle,
 A Batignolles.

Quand a s'balladait,[111] sous le ciel bleu,
Avec ses ch'veux couleur de feu
On croyait voir eune auréole,
 A Batignolles.

[She had good manners,
She had a 'doggie' hairdo (she had a fringe),
She used to sing like a little lunatic,
 At Batignolles.

When she strolled and sang ballads under the blue sky,
With her hair the colour of fire
One thought one saw a halo,
 At Batignolles.][112]

Bruant owned *A Batignolles*, and undoubtedly it, too, belonged to the gallery of portraits of streetwalkers that Lautrec painted to decorate the Mirliton.

Gueule de bois (Fig. 100) is another painting whose stylistic characteristics, especially the crosshatched brush stroke, clearly relate it to the work of 1888. But a drawing after it was reproduced in *Le Courrier français* of 21 April 1889 (no. 16), prompting Joyant to place both the finished painting and a pastel preparatory study in 1889. *Le Courrier français*, however, published other drawings by Lautrec in 1889 as reprises of paintings he had completed much earlier and *Gueule de bois* was undoubtedly a similar case. Moreover, other evidence indicates that Lautrec may have been at work on it early in 1888. Writing in the summer of 1888, van Gogh asked, 'Has de Lautrec finished his picture of the woman leaning on her elbows on a little table in a café?'[113] If he referred to *Gueule de bois*, which his description matches, Lautrec would have started the painting before van Gogh left Paris in February 1888. The parallels that existed between Lautrec's work and van Gogh's about this time support such a likelihood. The predominant blue with orange accents in *Gueule de bois* resembles the colour scheme of Lautrec's portrait of van Gogh and van Gogh's own works of his Paris period. It also indicates Lautrec's continued preoccupation with the colour theory of Neo-Impressionism and the use of complementary colours, even though he had by now rejected its strict pointillist dot, and adopted his own freer, crosshatched version of it.

[111] Either a misprint of *se balader* (to stroll), or an attempt by Bruant to coin a new verb from the substantive *ballade*, possibly with a double meaning intended.

[112] Bruant, i. 18.

[113] Van Gogh, ii. 544, no. 476. Sometimes thought to refer to *Poudre de riz*. See e.g. Stuckey, 121. However, *Poudre de riz* was sold to Théo by 12 Jan. 1888, and therefore completed prior to that date and to Vincent's late Feb. departure from Paris.

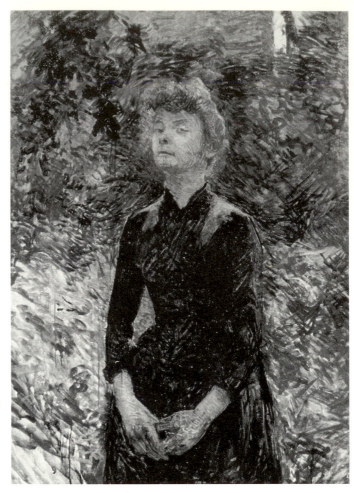

99. Henri de Toulouse-Lautrec, *A Batignolles*. Present location unknown. (Photo, Drouot.)

100. Below: Henri de Toulouse-Lautrec, *Gueule de bois*. Cambridge, Massachusetts, Fogg Art Museum. (Photo, courtesy of The Fogg Art Museum, Harvard University, Cambridge, Massachusetts, bequest—collection of Maurice Wertheim, Class of 1906.)

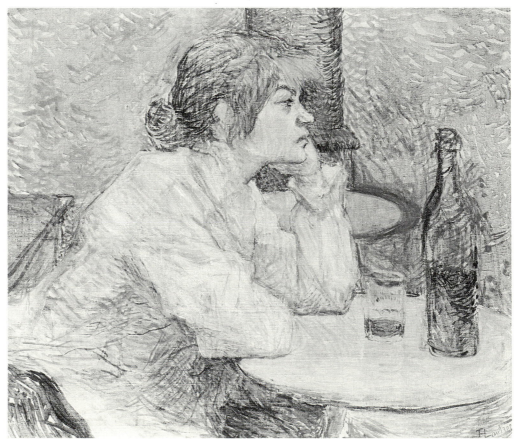

In *Gueule de bois*, or the 'hangover', Lautrec returned to the theme of the solitary woman drinker, this time in an authentic genre setting. The painting hung at the Mirliton,[114] and although it had no direct relationship to any of Bruant's lyrics, its picture of alcoholic dissipation and despondency corresponded to the song-writer's vocabulary. The spirit was also the same as that of van Gogh's *Woman Sitting in the Café du Tambourin* (Fig. 88). Degas had established the precedent for the depressed mood of such scenes in art in his *L'Absinthe* of c.1876, and Zola had done the same in literature with *L'Assommoir*, which Lautrec might have seen in its 1886 theatrical adaptation.[115]

Lautrec largely turned his attention to his popular illustration in 1888. It was not a year of venturesomeness in painting, but of gradual stylistic advancement. He produced no major, multi-figured compositions, only the small studies that he did as preparations for illustrations; the latter outnumber his formal paintings. And, significantly, illustration was the only aspect of his work of 1888 to which he referred directly in his few extant letters of that year.[116] For the time being, his focus seemed to change. He did not participate in any exhibitions after Les Vingt in February, or in Les Vingt of 1889 (where he should have shown his best works of 1888), though he was represented there regularly in succeeding years. He did not participate, either, in the showing in the spring of 1888 of the Indépendants, where Anquetin and van Gogh both exhibited.[117] Possibly the chilly reception that his work received in Toulouse in 1887 and Brussels in 1888 prompted him to question the viability of an avant-garde style, and even to hesitate temporarily in his commitment. On the other hand, Théo van Gogh sold a portrait of a woman by Lautrec to the collector Dupuis for 350 francs at the Goupil Gallery on 11 October 1888,[118] and the young artist could have had his confidence renewed.

Humanitarianism and Titillation: Illustrations

Lautrec heightened his career as a popular illustrator during 1888, but with no significant change from the spirit of the previous two years—he was still responding to the influence of Bruant, Raffaëlli, and the later Realist and Naturalist point of view, still representing characteristic Parisian types and scenes. The year 1888 was most important, perhaps, in terms of the continuing formative effects of the artistic, literary, and theatrical movement occurring around him. And these influences still made themselves felt mainly in his illustrations.

The illustrations that Lautrec executed in 1888 (and in fact for the entire period 1886–9) were not yet original graphic works. These would come in 1891 and thereafter, when he had resumed interest in the graphic arts following an interval of devoting himself exclusively to painting. The five published illustrations of 1888, like all those prior to 1891, were black and white photomechanical reproductions of his own preparations. One appeared in the *Paris illustré* (no. 10) of 10 March 1888, and depicted the masked ball at the opera. The other four

114 Joyant, i. 98.

115 At the Théâtre du Châtelet, cf. Gierow, 40, 52.

116 E.g. H. Schimmel, no. 164, 126–7.

117 Société des Artistes Indépendants, *Catalogue des œuvres exposées*, 4th exhibition (Paris, 1888), 12, 42. Anquetin exhibited 8 works (cat. nos. 22–9). Van Gogh showed 3 paintings (cat. nos. 658–60).

118 See J. Rewald, 'Théo van Gogh, Goupil, and the Impressionists', *Gazette des beaux-arts*, 81 (Feb. 1973), 75, 104. Théo's ledger lists this sale of a 'Tête d'étude' (65 cm. by 53 cm.) to Dupuis. It was later sold at auction (10 June 1891) as 'Portrait de femme' (63 cm. by 52 cm.), 'aquarelle gouachée', to 'Thomas' for 53 frs.

were published as a group in the *Paris illustré* (no. 27) of 7 July 1888, and represented characteristic Parisian types and street scenes. They had much the same spirit as Lautrec's earlier illustrations.

The surviving preparations for these published works, consisting of four grisaille paintings, one pen drawing, and several studies in charcoal, together with the reproductions themselves, confirm that Lautrec had alternative methods for rendering his finished illustration preparations. He began with preliminary charcoal sketches, then made either grisaille paintings or detailed drawings in ink or pencil based on them for reproduction by the printer.[119] The use of painted sketches as preparations reflected contemporary academic practice, though a photomechanical reproduction and not a painting became the final product, and Lautrec made many of his paintings of the later 1880s specifically as preparations for such works.

The four illustrations that Lautrec made as a group accompanied an article by Émile Michelet, 'L'Été à Paris', dedicated to 'the Parisians of the poorer class who never go on holiday'. Typically for this period, the author combined socially conscious descriptions of humble urban types with a series of more suggestive ones of the picturesque charm of Parisian working-class women, which he claimed was at its height in the summer. His travelogue account was directed at the upper-class male tourist. Three gouache paintings in black and white on cardboard and one pen drawing by Lautrec were photomechanically reproduced for this publication, and several rough preparatory sketches in charcoal survive as well. Lautrec must have been allowed a degree of freedom to invent his own visual counterparts to Michelet's text, because only two of his four images relate directly to it. The subject of one of his paintings, *Le Côtier de la compagnie des omnibus* (Fig. 101), does not appear in Michelet's article at all, although Michelet did mention in passing the 'functionaries of the street'. Lautrec's illustration, which none the less made an appropriate complement to the text, probably had its actual source in Bruant's song of social protest, 'Côtier', an ironic lyric in which the narrator is a poor working man guiding an old horse hitched to an omnibus. They are 'two pariahs: the old horse who is reluctant to climb the hill and the old man, who does not have security for his old age in spite of an entire life of work. And a poignant dialogue takes place between the man and the tired animal, who listens and with his poor hoary head seems to indicate approval of the discourse that the old worker addresses to him.'[120] Lautrec's depiction is one of the closest he made to a song by Bruant, and, significantly, the song-writer owned the painting. The song begins with the *côtier* (navigator, or conductor) hitching his horse to the omnibus and talking to him with affectionate sarcasm. Maybe he does not feel like hauling? Maybe he is tired of his job? But, like the conductor, he can no longer find another. Gently scolding the old animal and urging him on, the conductor continues:

> Viens, mon salaud, viens, guide à gauche,
> T'es trop vieux, va, pour dérailler,
> D'ailleurs, c'est pour ça qu'on t'embauche:
> Tu n'es pus bon qu'à travailler.

[119] Cate, 'The Popularization of Lautrec', in Wittrock and Castleman (eds.), 78, suggests that in 3 of the illustrations for the July *Paris illustré*, Lautrec used a *manière noire* approach, but the works in question do not bear this out. They are charcoal drawings heightened with paint, which were photomechanically reproduced through either a relief or lithographic process, but not gillotage.

[120] Zévaès, 52.

Ca t'étonn'? . . . ben vrai, tu m'épates:
C'est la vi' . . . faut porter l'licou
Tant qu'on tient un peu su'ses pattes
Et tant qu'on peut en foute un coup.
Et pis après, c'est la grand' sorgue,
Toi, tu t'en iras chez Maquart,
Moi, j'irai p't'êt' ben à la morgue,
Ou ben ailleurs . . . ou ben aut'part.

[Come on, my filthy beast, come on, turn to the left,
You're too old, go on, to run off the track,
Moreover, that's why they hire you:
You're no longer good for anything but work.

That surprises you? . . . truly, you flabbergast me:
That's life . . . one must carry the yoke
As long as one can stand up
And while one can still work non-stop.
And then after, is the big sleep,
You, you'll go to Maquart's (glue factory),
Me, I'll perhaps go soon to the morgue,
Or elsewhere . . . to some other place.][121]

Lautrec's painting closely resembles one of Steinlen's illustrations of the same song (Fig. 102). Steinlen's version was also published in 1888, in the first collection of Bruant's songs, *Dans la rue*, but Lautrec may have seen it earlier because many of the Steinlen illustrations in the collection had appeared previously on the sheet music for individual songs.

Lautrec's other illustrations in the series for Michelet's article are of the same genre as *Le Côtier de la compagnie des omnibus*. The preparation for *La Blanchisseuse* (Fig. 103), a laundress carrying her basket across a crowded Paris street, is a detailed ink drawing after a charcoal sketch, and is the one example among Lautrec's illustrations of 1888 for which he did not make a grisaille painting. Here Lautrec depicted another typical figure of the Parisian street scene, but this time he chose one also described by Michelet. The laundress was one of the working-class women who, according to the writer, were among the principal attractions of the Parisian streets in the summer:

C'est dans les coins populeux qu'il faut aller voir la fille du peuple, au cours de l'été. A Belleville ou à Ménilmontant. Là, nous rencontrerons à foison la blanchisseuse, la fillette pâle qui sillonne le trottoir, l'épine dorsale ployée pour faire contrepoids au grand panier de linge qu'elle porte au bras.

[It is to the populous quarters that one must go in order to see the daughter of the people, during the summer. To Belleville or Ménilmontant. There we'll encounter in abundance the laundress, the pale lass who makes her way through the street, her back bowed to counterbalance the large basket of laundry that she carries on her arm.][122]

[121] Bruant, i. 151–3.
[122] É. Michelet, 'L'Été à Paris', *Paris illustré*, no. 27 (7 July 1888), 426. Lautrec noted the publication of these illustrations in H. Schimmel, no. 164, 126, 13 July 1888.

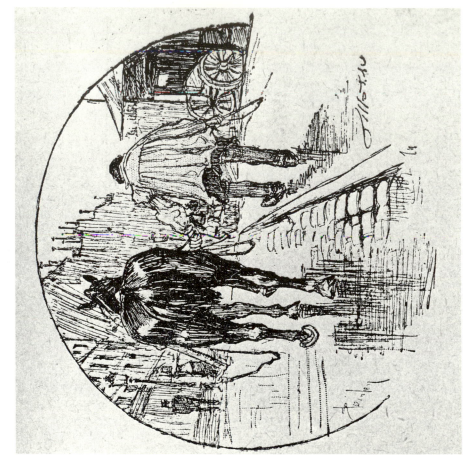

102. Above: Théophile Alexandre Steinlen, after, *Côtier*. Zinc engraving from Aristide Bruant, *Dans la rue* (Paris, n.d.). New York, collection of Mr and Mrs Herbert Schimmel.

101. Left: Henri de Toulouse-Lautrec, *Le Côtier de la compagnie des omnibus*. Grisaille painting. Paris, private collection.

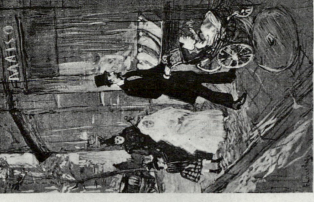
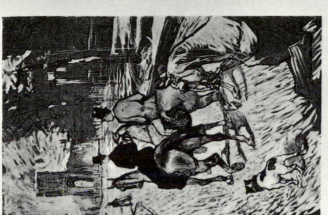

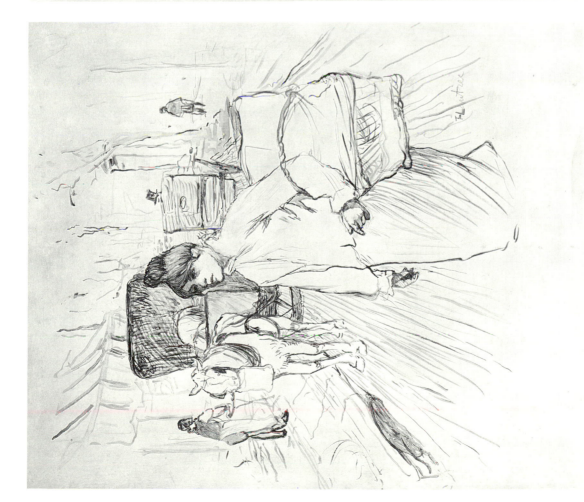

103. Above: Henri de Toulouse-Lautrec, *La Blanchisseuse*. Pen drawing. Cleveland, Museum of Art, gift of the Hanna Fund.

104. Right: Henri de Toulouse-Lautrec, after, *Cavaliers se rendant au bois de Boulogne* and *Un jour de première communion*. Two grisaille paintings photomechanically reproduced in *Paris illustré*, no. 27 (7 July 1888). Paris, Bibliothèque Nationale. (Photo, Bibliothèque Nationale.)

According to Michelet, work was plentiful in summer so that the laundress was particularly carefree, and therefore, he implies, sexually available. Although Lautrec's illustration does not stress, as does Michelet's text, the laundress's erotic allure, he was dealing with a theme that was 'freighted with a sexual meaning for middle class viewers', who assumed lower-class women in general, and laundresses in particular, to be sexually free and available.[123]

The laundress was a familiar figure throughout Realist literature and art and as a visual image Lautrec's representation undoubtedly derives from earlier, similar ones by Daumier, Degas, and Steinlen. Moreover, Zola in *L'Assommoir* and Huysmans in *Croquis parisiens* both described her, basket on hip. Huysmans wrote that laundresses swayed their hips 'à soutenir un panier énorme, marcher, courir, ne jamais se reposer' ('in order to support enormous baskets, walking, running, never resting').[124] Bruant also picked up the theme, possibly from Zola, because he entitled a song 'À la Goutte-d'or',[125] after the name of the street where the heroine of *L'Assommoir* operated her laundry shop. The song was published in 1886 as sheet music, with an illustration by Steinlen,[126] from which Lautrec might have taken ideas for his own treatment of the laundress.

The two remaining illustrations of the four that Lautrec executed for 'L'Été à Paris' also portray urban genre scenes and each has a surviving grisaille preparatory painting. Set directly alongside one another in the body of the text (Fig. 104), these illustrations provided an ironic counterpoint between the amusements of the Parisian upper and lower classes. *Un Jour de première communion* depicts a working-class family promenading on a Parisian street, including one small daughter in a white communion dress. Lautrec's scene relates to Michelet's description of a poor family on their way to a picnic in the bois de Boulogne. Despite the heat they are dressed in their Sunday best. The thin father, for whom Gauzi posed, pushes a baby carriage as he leads his family along the shop-lined pavements. The child in communion dress is not, however, mentioned by the writer. Lautrec must have added this figure in her frothy white dress to visually complement the dark shapes of the mother and father. *Cavaliers se rendant au bois de Boulogne*, by contrast, represents fashionable upper-class riders, Lautrec's earliest subject-matter. In this case Lautrec's illustration does not relate to Michelet's text and even seems to contradict it since the writer notes the contrast of the unusual 'solitude' of this park in summer to the 'elegant visions' that people it at other times of the year and advises his reader against going there.[127]

In each of these four illustrations, Lautrec employed Realist pictorial devices. The three grisailles are characterized by a painterly Realism and even his ink drawing abandons the more spare linear style of his *Mirliton* illustrations of the previous year. In each of the four images he set up the viewer's perspective on the scene as an illusionistic visual plunge into depth, reminding the viewer of Michelet's characterization of the Paris streets as 'inéluctable canaux de pierre . . . où s'écoule le flux de l'activité humaine' ('ineluctable canals of stone . . . through which streams a flood of human activity'). According to the writer, in this man-made environment, cut off from nature, the poorer Parisians see 'que des horizons de pierre, que des étendues de toitures où pointent des tuyaux de cheminées' ('only horizons of stone, only

[123] Lipton, 137; see also 133–4, 152.
[124] Huysmans, *Croquis parisiens*, 68 (*Parisian Sketches*, 42).
[125] Bruant, ii. 189–93.

[126] Cf. E. de Crauzat, *L'Œuvre gravé et lithographié de Steinlen* (Paris, 1913), 98, no. 312.
[127] Michelet, 426.

expanses of roofs, above which chimney pots soar skyward').[128] Each of Lautrec's pictures is like a window on to a Paris street, framing a setting in which figures emerge from a distance or proceed towards points where they will inevitably disappear from sight. Steinlen favoured this essentially realistic device almost as standard practice. Lautrec cleverly went beyond it in *Cavaliers se rendant au bois de Boulogne*, however, by using an elevated perspective, through which he implied that the scene was viewed from the eye level of an unseen rider, presumably on a horse to the left of the one just entering the picture in the lower right foreground. In effect, he put the viewer on horseback and on the verge of entering the scene. At the same time Lautrec used the startling entrance of the horse at the lower right, with only its head and neck, left shoulder, and foreleg yet visible, to return the viewer's eye from the deep background and leading figure to the surface of the painting. The strongly outlined silhouette of the forepart of the horse, cut off at the edge of the composition, suggests that a more radical style than Steinlen's influenced Lautrec. In addition, the stylized shadows on the ground appeared in Lautrec's work for the first time in this illustration; he was to employ them again in the 'Chicago *Écuyère*' and *Au Moulin Rouge, la danse*.

Lautrec's only other published illustration of 1888 was *Bal masqué*, a scene of Parisian night-life, published in conjunction with an article by Albert Guinon. Once again the published reproduction was made from a grisaille painting (Fig. 105) and several other painted and drawn preparations exist as well. The scene is the masked ball at the Opéra, and the principal subjects are the contrasting figures of ballerinas in their tutus and elegant gentlemen in formal attire. A group of revellers is seated at a table in the foreground and viewed against the milling crowd in the background. The theme, the Parisian masked ball of the late nineteenth century, was popular in the contemporary illustrated press and had been treated earlier by Manet.[129] The ball was a modern social institution notorious for what one contemporary observer called its 'freedom from embarrassment'. The masks, the jostling crowds, and the semi-darkness outside the ballroom 'authorized all kinds of audacious behaviour', according to another commentator, who noted that these occasions were especially perilous for women.[130] In fact, the masked balls were events of 'sexual commerce'.[131] Guinon's article, actually a brief one-act play, dealt precisely with the sexual permissiveness of the occasion. In Guinon's farce, a married woman whose husband has prudishly refused to escort her to the ball attends in disguise with another man. In the corridor the disguised woman is repeatedly pinched and finally grasped around the waist by a lecherous man whom she subsequently recognizes as her unwitting husband.[132] Although Lautrec's published illustration does not relate explicitly to Guinon's text, another work of this time, a painted sketch on cardboard of a scene at a masked ball, erroneously entitled *Au Moulin de la Galette* (Fig. 106), appears to correspond to it more closely and may have been Lautrec's originally projected illustration.

Lautrec did other representations of backstage flirtations and nocturnal masked balls at the

[128] Ibid. 425.

[129] See Manet's *The Ball at the Opera*, 1873, National Gallery of Art, Washington, DC.

[130] Montorgueil, *Paris dansant*, 98 (Montorgueil describes the masked balls of this period at length, 91–114), and H. le Roux, *L'Enfer parisien* (Paris, 1888), 9, respectively.

[131] L. Nochlin, 'A Thoroughly Modern Masked Ball', *Art in America*, 71, no. 10 (Nov. 1983), 188.

[132] A. Guinon, 'Bals masqués', *Paris illustré*, no. 10 (10 Mar. 1888), 149–51.

Opéra and the Élysée Montmartre about this time. Many are on cardboard and they are also likely to have been studies for prospective illustrations, possibly also alternatives for *Bal masqué*. These scenes, in style and tone, are all evidence of Lautrec's indebtedness to Forain. The short, crosshatched strokes and predatory mood are both reminiscent of Forain, who explored the atmosphere of vice and intrigue behind the spectacle of the masked ball in numerous works during the 1870s and 1880s (e.g. Fig. 107).

Forain unquestionably influenced Lautrec. In particular, Gauzi stated that the younger artist did his drawings for *Le Mirliton* and *Le Courrier français* under Forain's influence.[133] There were natural connections between them. Forain not only was the friend of Lautrec's earliest mentors, Princeteau and John-Lewis Brown, but of his father, the count, whose portrait he had painted about 1885.[134] He and Lautrec must also have been friends, because van Rysselberghe asked Lautrec to intercede to solicit Forain's participation in the 1888 Exposition des Vingt. Like Princeteau and Brown, Forain specialized in subjects related to the experiences of the worldly man-about-town, but whereas they concentrated on sporting scenes, he gravitated toward the city's night-life and treated it in a satirical, even caustic, vein. Though he took no particular political position at this time, he tended to satirize the conventions, corruptions, and pretensions of the bourgeoisie, in the prevailing spirit of Montmartre. Degas had influenced him profoundly, but ultimately he worked more anecdotally and had a greater interest in revealing social predicaments. Forain regularly contributed illustrations to *Le Courrier français* on the theme of prostitution and similar subject-matter and made a number of illustrations for Huysmans's naturalistic writings.[135]

About the time that Lautrec was producing *Bal masqué*, he returned to the subject of the *quadrille*, and, in much the same sketchy impressionistic style of *Bal masqué*, he painted *A l'Élysée Montmartre* (Fig. 108). This is another grisaille painting, and Lautrec probably made it in preparation for an illustration, but it was never published. In it he contrasted darkly shadowed male figures in formal wear with lighter, more freely painted areas, much as he had in *Bal masqué*, and set off the performers against the background of a crowd of onlookers as in the Mirliton panel, *Le Quadrille*. The pudgy figure of La Goulue dominates the scene. She prances brazenly into the circle of spectators and tosses her skirts high above her white underdrawers, their frothy lightness opposed to the black silhouette of her top-hatted partner, Valentin le Désossé. Huysmans's description of the dance at the Brasserie Européene in the 1886 edition of *Croquis parisiens* points up the similarity of the context in which both writer and artist worked:

Ce cri traversa les rafales de l'orchestre; dans un groupe de fantassins, un trou se creusa d'où jaillit une petite boulotte qui se rua en plein quadrille et, troussée jusqu'au ventre, gigota, montrant, sous le blanc madapolam de ses culottes, du nu de cuisses.

[The cry could be heard even above the blasts of the orchestra; a hole suddenly gaped in the middle of a group of infantrymen, and out of it there shot a plump little girl, who hurled herself right into

[133] Gauzi, 143.

[134] L. Browse, *Forain the Painter, 1852–1931* (London, 1978), 24–5.

[135] J.-K. Huysmans, *Œuvres complètes*, vi, *L'Art moderne* (Paris, 1928), 125, acclaimed Forain as the greatest contemporary painter of the prostitute. Forain etched the frontispiece used for the 1876 and 1879 editions of Huysmans's novel about prostitution, *Marthe histoire d'une fille*, and shared with Raffaëlli the illustration of the 1880 edition of *Croquis parisiens*.

the middle of the *quadrille* and, with her skirt up to her belly, started kicking up her legs, revealing beneath the fine white calico of her drawers, the naked flesh of her thighs.][136]

The dance-hall, one of Lautrec's favourite themes of the period, appeared not only in Naturalist illustration and literature, but also in the flourishing Naturalist theatre. In December 1888, Edmond de Goncourt revived *Germinie Lacerteux*, a novel he had written with his brother, Jules, as a play in ten tableaux. One of the tableaux, according to his directions, was a dance-hall scene to be enacted in front of a backdrop that depicted dancers and an orchestra in performance. Raffaëlli designed the sets,[137] and might have recast his *Quadrille naturaliste aux Ambassadeurs* in monumental scale for the dance-hall tableau. The audience at the Odéon theatre shouted down the play for its 'ultra-realism', and conservative critics and the public found the dance-hall episode in particular to be repugnant in its poor taste.[138]

By the close of 1888, Lautrec had moved definitively away from the academic atelier and into avant-garde circles. The move was gradual rather than abrupt and had occurred in a context of formative influences in both style and subject that he shared with the other young progressives who were then emerging from Cormon's. However, despite Lautrec's experimentation with progressive trends, a degree of conservatism remained in evidence in his easel paintings throughout 1886–8. Most of his work did not yet demonstrate the acute formal vision that later enabled him to capture the visual and psychological quality of his environment concisely through his manipulation of pictorial elements. Moreover, he confined his new genre subjects, and his more daring and unconventional stylistic essays to his popular illustrations and a limited number of paintings, many of them preparations for illustrations. Most of his formal easel paintings were more circumspect portraits and outdoor studies. Throughout his career he was to go on creating such relatively conservative works, even in juxtaposition with his most radical art. This was an extension of the conservatism that had already been apparent in both his extended allegiance to academic study and the prudence with which he advanced into avant-gardism. During the late 1880s, still at an immature stage of his development, he was assured of a degree of respectability by doing portraits, but could perhaps rationalize the more daring subject-matter of his multi-figured compositions as 'caricature', and as a sideline to his easel painting.

The more complete assimilation of the naturalistic themes into the realm of his formal paintings and the development of the formal devices that were finally to enhance this subject-matter and unite it with a more advanced style and aestheticism remained for the next phase. Evolving a novel style appropriate to his new subjects and creating works of a distinctive personal nature were to bring Lautrec to the first stage of his maturity in the next few years and complete the primarily Realist and Naturalist period of his development. The period 1886–8 remained formative, not definitive, and transitional, not conclusive, in his artistic evolution.

136 Id., *Croquis parisiens*, 35 (*Parisian Sketches*, 27).

137 Fields, 307. For the play see E. de Goncourt, *Germinie Lacerteux*, play in 10 tableaux (Paris, 1888), 3rd tableau, 39. First performed at the Théâtre National de l'Odéon, Paris, 18 Dec. 1888.

138 See Waxman, 102–3. For an example of the critical reaction, see 'Revue dramatique—Odéon, Germinie Lacerteux', *Revue des deux mondes*, 91 (1 Jan. 1889), 215–25.

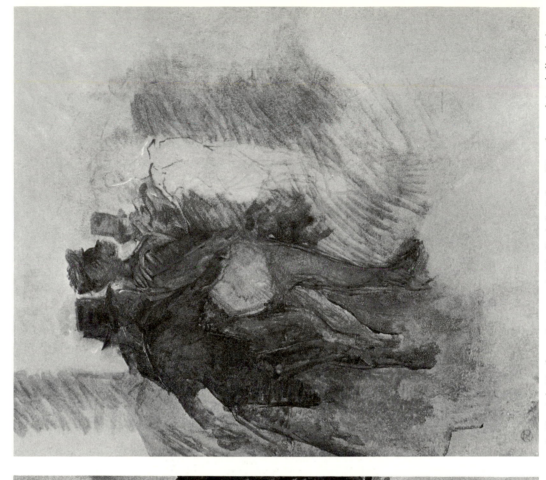

106. Henri de Toulouse-Lautrec, *Au Moulin de la Galette* (Dans les couloirs de l'opéra). San Diego, Museum of Art, Baldwin M. Baldwin Collection.

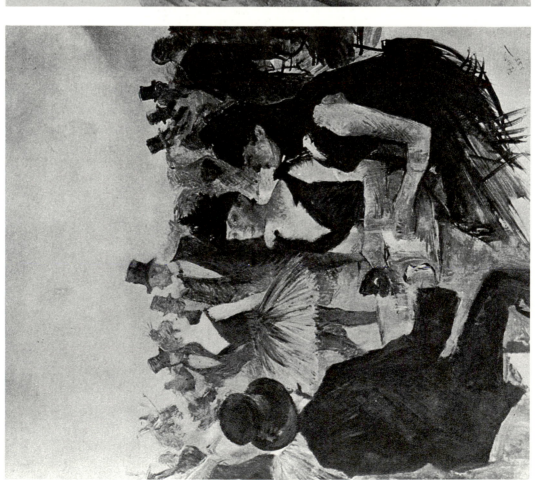

105. Henri de Toulouse-Lautrec, *Bal masqué*. Grisaille painting. Los Angeles, private collection.

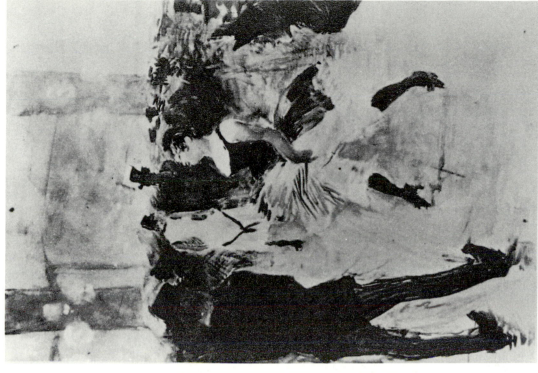

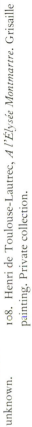

108. Henri de Toulouse-Lautrec, *A l'Élysée Montmartre*. Grisaille painting. Private collection.

107. Jean-Louis Forain, *Dans les couloirs de l'opéra*. Present location unknown. (Photo, Bibliothèque Nationale.)

5

The 'elixir of vulgarity' and the 'essence of the object'

Works of Early Maturity, 1889–1891

FROM his academic masters and the tradition of the Salon, Lautrec inherited the ideal of monumental history painting. His 'Missing *Écuyère*' represented an effort to reconcile this traditional ideal with a modern subject and style, but the attempt was immature. It remained for him to concentrate further on his search for an accommodation between the traditional and the modern, between the size and scope of history painting and the naturalistic subjects and avant-garde styles that captivated him. He did so from 1889 until late 1891, a period in which he turned his creative energies temporarily away from illustration to make painting his primary means of expression. It proved to be his heroic period as a painter. Not only did he produce the 'Chicago *Écuyère*' and so resolve the problem he had first posed in the 'Missing *Écuyère*'; he also created two other major compositions in which he elevated popular subject-matter to high art: *Au bal du Moulin de la Galette* in 1889 and *Au Moulin Rouge, la danse* in 1890. These achievements brought the Realist and Naturalist interests and orientation of his experimental years to a culmination, and comprised the first phase of his artistic maturity.

Lautrec was to retain permanently the Realist and Naturalist iconography that he developed during the 1880s, but in late 1891 his formal means advanced to a new stage. At the same time, the ideal of monumental history painting, which underlay his large works of the period, gave way to his renewed involvement with popular forms, smaller in format, and in many instances original prints. With his lithographic poster of late 1891, *La Goulue au Moulin Rouge*, Lautrec entered a period of concentration on abstraction, a heightened aestheticism and stylization, and a greater use of formal elements to enhance subjective expression. In effect this poster ushered in a second phase of maturity (beyond the scope of this study), in which he embraced a more advanced and daring style without altering his basic thematic commitment.

During the years 1889–91 Lautrec also completed his transition from apprentice to professional. This is evident not only from the maturity of his work, but from his regular exhibitions in the company of avant-garde artists, in particular at Les Vingt in Brussels and with the Indépendants in Paris. Lautrec dated only three paintings in 1889 and four in 1890, but ten in 1891. Otherwise, the records of the exhibitions he participated in constitute the most important aids to reconstructing this phase of his career. Throughout 1889–91, Lautrec continued to dwell on the themes of modern urban life and, although he no longer illustrated

the lyrics of Bruant, he still found immediate sources for his imagery in the popular illustrated press, whose everyday themes he now transformed into high art. In this lay his major contribution of the period. He fully embraced the subject-matter of contemporary journalistic illustration, and was no longer satisfied with reserving it for timid essays in a minor key. Having suspended his work as an illustrator *per se*, and having moved away from Bruant's direct influence, he produced the large-scale easel paintings that were climactic examples of the Naturalism to which illustration and Bruant had originally led him.

In the same period, Lautrec's formal sensibilities grew gradually more acute. However, prior to producing the Moulin Rouge poster, he did not become strikingly radical or innovative in style, nor did he entirely sever his allegiance to slightly conservative trends. He exhibited at the fashionable Cercle Volney, as well as in the major avant-garde shows; he made out-of-doors studies that were closest stylistically to orthodox Impressionism, and portraits that appear conservative in comparison with his large-scale genre paintings; and for the time being he remained content to consolidate his progress of the mid-1880s rather than embark on dramatically new directions. As a painter, however, he moved away from the varied experiments of the preceding period, and established a more consistent personal manner. In effect, he integrated the different threads, the formerly disparate elements, of the earlier art, uniting popular, naturalistic subjects with stylistic advancement, and made this union the basis of a mature art.

Lautrec was now evolving a distinctive way of applying paint thinly in long, striated brush strokes. He began also to layer his pigments, and whether he was painting on canvas primed with white ground or directly onto cardboard, he often left areas of the support exposed to function positively as 'colour'. By thinning his oil paints with turpentine (*peinture à l'essence*), he mixed a less viscous, more easily spread and absorbed medium that dried with a matt finish, giving an appearance more commonly associated with drawing or pastel than painting. He was, in effect, consolidating his personal variation of the Impressionist and Neo-Impressionist touch—his 'streak'—with his own adaptation in oil paints, first, of Degas's manner of applying pastel, and second, of the streaky drawing in illustrations by popular artists such as Steinlen, Forain, and Raffaëlli. At the same time Lautrec took up the advances of the Cloisonnists in a modified way, and heightened his exploitation of the abstract elements of colour, contour, and shape. With increased technical mastery, he took fuller advantage of the caricatural quality of popular illustration, and, without forgoing his Naturalist idiom, he progressed towards greater abstraction. In the course of these three years his stylization and manipulation of line became more noticeable. These developments prepared the way for the greater transformation in Lautrec's style that was to occur with the Moulin Rouge poster of 1891.

The Year 1889: 'Prepared to synthesize his observations'

Painting was Lautrec's primary interest in 1889. Although he published four illustrations in *Le Courrier français*, they were exclusively reprises of earlier paintings in the form of ink drawings photomechanically reproduced. And significantly, now that he had firmly established

his identification with the avant-garde, he no longer signed them with the pseudonym 'Tréclau'. The three dated paintings of 1889, Lautrec's portraits of Samary and Fourcade (Fig. 117) and the *Femme à la fenêtre* (Fig. 112), and others securely datable to this year, exhibit a remarkable consistency of style. The application of paint in long, dry streaks, often without regard for the surface texture of the objects depicted, characterizes all of them. Lautrec had occasionally used paint in this manner in his experiments with Neo-Impressionism, but never so uniformly throughout a composition. He was now overlapping his colours in repeated striations in large areas, applying them loosely and sketchily enough to leave the layers visible, and often directing his strokes vertically, horizontally, or diagonally to indicate depth or direction.

Lautrec usually worked from a palette of subdued, almost sombre colours, mainly the blues, browns, and dull greens characteristic of mid-century Realism, and reserved the pastel tones of Impressionism for his *plein-air* studies. His subdued palette was appropriate to his often pessimistic naturalistic subjects, but he introduced further disturbing notes by interspersing his predominantly autumnal tones with discordant touches of orange, yellow, and brighter greens. By means of this nascent exploitation of the expressive potential of colour, he was pushing his hybrid Impressionist–Naturalist style in a new direction.

In 1889 Lautrec began the year with an ambitious, multi-figured genre painting, *Au bal du Moulin de la Galette* (Fig. 109), a canvas of $35\frac{1}{2}$ by $39\frac{5}{8}$ inches. It depicted a popular lower-class dance hall, and in this case he concentrated on the spectators rather than the dancers. The painting revealed the artist's continuing interest in the vernacular imagery of Bruant, Raffaëlli, and others, and also in the thematic preoccupations of the illustrated press. This may explain why *Le Courrier français* reproduced it as an illustration, and why at least one contemporary reviewer noted that the painting fell within the category of illustration.[1] Popular periodical illustrations commonly depicted the activities of the seated and standing crowds of spectators at the Parisian *bals*, and did not concentrate exclusively on the dance. Such scenes exemplified modern mores. *Paris illustré* included a number of them with a series of articles on the *bals* and *carnavals* of Paris in 1888, and a drawing by Lunel, *La Salle de l'Élysée Montmartre* (Fig. 110), which appeared in *Le Courrier français* in late 1887, focused (like Lautrec's painting) on the milling onlookers at the *bal* and the interplay among them. The conversations and flirtations between men and women in the Lunel, and their gestures and poses, bear notable resemblances to those of some of Lautrec's background figures. It was not necessarily a direct source for Lautrec, but this and other such illustrations have a historical bearing on his choice of comparable subjects.

Nevertheless, in his sombre interpretation of the theme, Lautrec surpassed the anecdotal quality of the work of the illustrators. The oppressive mood of his painting of the Moulin de la Galette is contrary to their imagery, to the superficial lightheartedness of the Lunel. Similarly, it contrasted with the gay conviviality of Renoir's sunny, romanticized portrayal of the same dance-hall in his large canvas of 1876 (Fig. 111). Lautrec's more naturalistic work, which expanded on his earlier treatments of the dejected drinker, embodied a specifically modern feeling of disillusionment and sadness, and the irony of frustrated human contact in a supposedly sociable public setting. He went beyond his own and others' popular illustrations

[1] L. R. Milès, 'Beaux arts: cinquième exposition de la Société des Artistes Indépendants', *L'Événement* (4 Sept. 1889), 2.

of Montmartre dance-halls, and Renoir's idyll, in his psychological penetration of the patrons of the Moulin de la Galette, revealing more accurately the extent to which the pleasures of the era could be edged with melancholy and tension.[2] The sense that he captured of individual isolation in the modern environment bears far stronger comparison with the contemporary work of van Gogh, who explored the theme in *The Night Café at Arles*, and with the Naturalist novel.

Despite the differences between their paintings, Gauzi wrote that Renoir had been Lautrec's immediate source of inspiration: 'Renoir, who at that time had a very marked influence on Lautrec, had just exhibited, at Durand-Ruel's, his painting: *The Garden of the Moulin de la Galette* [*sic*]. Lautrec knew this painting and was impressed with it to such an extent that, wishing to treat the same subject, he dragged me along one Sunday afternoon to that dance-hall . . .'[3] Lautrec had viewed the Renoir during a major exhibition of works by Renoir, Pissarro, and Sisley at the Durand-Ruel Galleries in May and June of 1888. And although he transformed the older artist's amiable, prettified scene into a sordid and depressing one, he preserved enough of the essentials of Renoir's compositional scheme[4] to invite speculation that he intended his version as a deliberate critique. He seems to have selected an almost identical angle of vision, establishing the same strong diagonal in the right foreground and placing female figures to one side of it with their eyes directed at a man seated at a table opposite. In both the Renoir and the Lautrec, the nearest, most prominent figures form a triangle at the lower right of the canvas, and the crowd of dancers fills the background like a frieze. Several of Renoir's figures have almost exact counterparts in the Lautrec painting. Yet Renoir's is an outdoor painting of the Moulin garden in summer sunlight; Lautrec represented the dance-hall indoors at night, under artificial illumination, probably in winter. According to Gauzi and others, a respectable clientele of workers, artists, models, and people of the lower middle class in general frequented the Moulin de la Galette on Sunday afternoons, as they had in Renoir's day. That was the scene as Renoir chose to paint it. But, in the evenings, the dance-hall became the sinister and dangerous scene of rendezvous for pimps and prostitutes, and the dimly lit streets surrounding it were settings for violent brawls.[5] Lautrec elected to portray this sordid side, possibly in response to Renoir's lyrical representation of the congenial daytime patrons.

Lautrec accomplished his transformation of the Renoir by manipulating the formal means expressionistically to suggest the subjective psychological reality of this modern urban environment. Not only did he portray the tense, introverted facial expressions of the subjects of *Au bal du Moulin de la Galette* in his interpretation of their states of mind. He also organized

[2] See Rearick, 71–3, 199–201, on this aspect of *fin de siècle* entertainment, and K. Varnedoe, 'Gustave Caillebotte in Context', *Arts Magazine*, 50 (May 1976), 94–9, on other artists who shared a similar negative perception of the modern environment and the place of the individual in it.

[3] Gauzi, 84–6.

[4] My interpretation has been influenced by Theodore Reff's lecture on Toulouse-Lautrec in his course, 'Post-Impressionism', Columbia University, 1969.

[5] Cf. Gauzi, 84–9, who also notes that Lautrec avoided the Moulin de la Galette in the evenings; Darzens, 58; Bonnetain, 198–207; Bloch and Sagari, 87–8; and G. Renault and H. Chateau, *Montmartre* (Paris, 1897), 248–9. G. Coquiot, *Des peintres maudits* (Paris, 1924), 80–1, notes that Lautrec avoided the place because of its unsavoury character. On the Moulin de la Galette as Renoir knew it, see G. Rivière, *Renoir et ses amis* (Paris, 1921), 121–37. Francis Jourdain, who first met Lautrec in 1889, points out in Jourdain and Adhémar, 37, that even if the Moulin de la Galette was less middle class in Lautrec's day, it was not a malevolent place, and that Lautrec exaggerated 'le "côté mauvais lieu" du bal' in his painting.

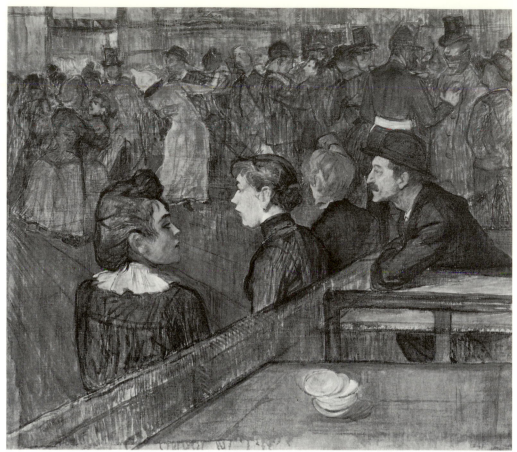

109. Henri de Toulouse-Lautrec, *Au bal du Moulin de la Galette*. Chicago, Art Institute, Mr and Mrs Lewis Larned Coburn Memorial Collection. (Photo, courtesy of The Art Institute of Chicago, © 1990. All rights reserved.) *See also colour plate*.

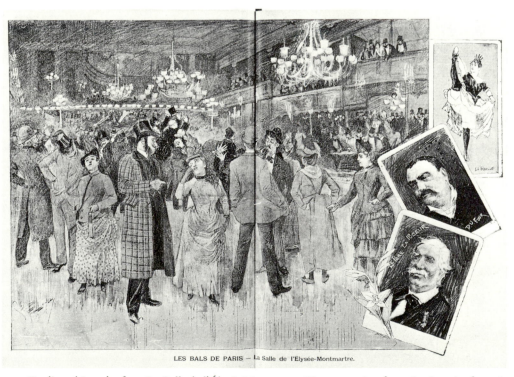

LES BALS DE PARIS — La Salle de l'Elysée-Montmartre.

110. Ferdinand Lunel, after, *La Salle de l'Élysée Montmartre*. Zinc engraving from *Le Courrier français* (30 Oct. 1887). Paris, Bibliothèque Nationale. (Photo, Bibliothèque Nationale.)

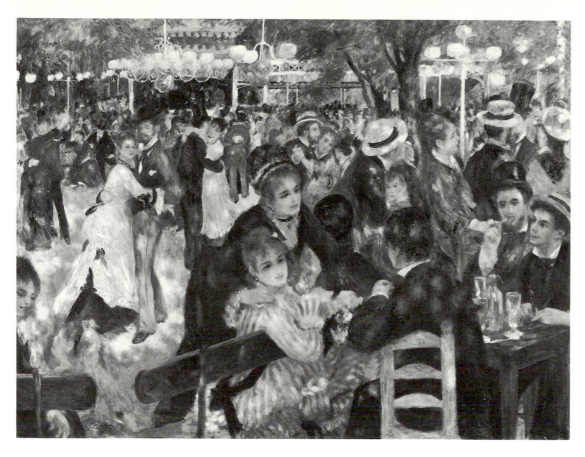

111. Above: Pierre Auguste Renoir, *Bal du Moulin de la Galette*. Paris, Musée d'Orsay. (Cliché des Musées Nationaux.)

112. Left: Henri de Toulouse-Lautrec, *Femme à la fenêtre*. Moscow, Pushkin Museum.

his composition masterfully into a series of interlocking surface and spatial triangles to hold it together and at the same time to contrast the physical and psychological involvement of the dancers with the isolation of the patrons who are mere observers and who remain separate from one another as well as from the dancers. Lautrec distorted perspective and scale to enhance the aura of psychological alienation. Strong diagonals criss-crossing one another in the painting heighten the disparities between the large figures of the sharply characterized, lonely spectators in the foreground and the small, less distinct forms of the dancing crowd beyond. The boards of the floor, by converging too acutely towards the left, exaggerate the illusion of distance between the near and the far groups of figures. Where Renoir had created an evenly flowing space in his painting by blurring the spatial divisions between the various groups of people, and introducing a dancing couple to mediate the distance between his foreground and background, Lautrec accentuated the gulf. In addition, the balustrade or back of the bench on which the three women in the foreground of Lautrec's painting sit recedes sharply toward the right, in opposition to the floorboards, and divides the women from the male figure at the table behind them. The psychological tensions between the figures complement the physical tensions inherent in the composition. The effect is especially pointed in the interaction between the male figure on the right and the foremost female figure at the left, who are the protagonists of the painting. Compositionally they balance one another, each as the principal form in its own triangle. Her eyes and the turn of her body direct the viewer towards the right as she glances over her shoulder, perhaps covertly at the man; and his posture, as he leans forward, returns the viewer toward the left. Their bodies are facing, yet, ironically, no social contact takes place between them, their eyes do not meet. They make a direct contrast to the comparable figures in Renoir's painting, who are relaxed and chat amicably. Similarly, while Renoir's dancers are mild and innocuous, some of Lautrec's seem frenzied and lustful.

In this painting, Lautrec made expressive use of colour, as well as composition, perhaps a result of his experiments as a Petit Boulevardist with dominant tones and their evocative potential. In contrast to Renoir's pastel palette, he set shrill, sour accents of orange and green against generally subdued, even drab tones of brown, creating visual breaks to complement the abruptness of his spaces. The accents of clashing colours jar, and add to the atmosphere of sleaziness. The green cast of the face of the woman at the left, and the unnaturally red hair of the woman in the foreground at the right realistically convey the unearthly effects of gas lighting, but they also contribute to the subjective expression of unpleasantness. At this time, Lautrec was just beginning to search out the unusual visual effects that were to be a major preoccupation of his art, one that he was often to exploit to the point of bizarre exaggeration during the following decade.

Lautrec's gloomy overtones had their closest parallels in Realist and Naturalist literary accounts of the Parisian *bals*. For instance, in the joyless scene at the Boule-Noire dance-hall in the stage version of Edmond de Goncourt's *Germinie Lacerteux*, Germinie and others watch the action on the drab, gaslit dance-floor from benches and tables flanking it. The play was first performed at the Théâtre National de l'Odéon on 18 December 1888, around the time Lautrec must have begun work on this painting.[6] In 'Le Bal de la Brasserie Européenne à

[6] E. de Goncourt in *Germinie Lacerteux*, play, 39–47.

Grenelle', from the 1886 edition of the *Croquis parisiens*, Huysmans also described the social life that transpired peripherally at the dance-halls, apart from the dancing. His literary imagery of the *bal*—illuminated dimly with red and green lights—bears a strong likeness to Lautrec's pictorial content:

Le bal de la brasserie Européenne était divisé en deux parties que coupait une balustrade: la première, formant un large couloir étayé par des colonnes de fonte, parquetée d'asphalte, garnie de tables et de chaises, plafonnée de toiles jadis vertes et maintenant pourries par les feux du gaz et les suintements de l'eau; la seconde, s'étendant, ainsi qu'une grande halle . . .

[The ball at the Brasserie Européenne was divided into two parts by a balustrade: one of them was in the form of a wide corridor supported by cast-iron pillars, floored with asphalt, furnished with tables and chairs, and roofed with a cloth that had once been green but which by now had become rotted by the gaslight and seeping water; the other stretched out, like a vast covered market . . .][7]

Huysmans sketched an immense, milling crowd and the wild dancing of the polka. Men, both soldier and civilian, 'paradaient, les mains dans les poches' ('strutted around with their hands in their pockets'), and girls were 'se poursuivant de même que des moutards' ('chasing each other around like little urchins'), while their relations were 'assis sur des bancs de bois, contre le mur' ('sitting on wooden benches against the wall').[8] Even more strikingly, Huysmans and Lautrec shared an awareness of the underlying sexuality of the dance, and the brutalization of the setting into a seedy, unhealthy, almost repulsive milieu. But Huysmans emphasized the crassness of the patrons of the dance-hall, whereas Lautrec treated them with a degree of compassion. The writer graphically described noises and smells to make his point, the painter used colour and composition to establish his.

Most contemporary critics emphasized the naturalistic rather than the synthetic qualities of *Au bal du Moulin de la Galette*, centring their remarks on Lautrec's observation of human types and their expression and gestures, and calling attention to the influences of Forain, Degas, and Raffaëlli in his work.[9] Just one discerning observer, Jacques Arnoux, who reviewed the 1890 Exposition des Vingt for the Belgian periodical *La Jeune Belgique*, recognized the exploitation of pictorial means for subjective purposes in Lautrec's painting. He observed that Lautrec was 'still a realist, to be sure, but already prepared to synthesize his observations. He analyses, without abandoning himself to pity, and with a sort of cruel joy, the lower depths of society, the scum swarming with brutish lust.'[10]

The naturalistic theme in combination with a subjective analysis of its mood was a component of much of the later Naturalism of the 1880s, the decade that bridged the Realist and Symbolist movements. Many of its literary practitioners, including Huysmans, intimated the emotional and psychological realities behind superficial physical appearances in order to capture a more complete reality.[11] Similarly, in the visual arts, Raffaëlli in the mid-1880s had advocated that artists go beyond literal depiction, and attempt to convey the essential

[7] Huysmans, *Croquis parisiens*, 32 (*Parisian Sketches*, 26).

[8] Ibid., 43, 34 (*Parisian Sketches*, 31–2, 27).

[9] See e.g. F. Fénéon's review of the Salon des Indépendants in *La Vogue* (Sept. 1889), cf. Fénéon, *Œuvres plus que complètes*, i. 169, and Daland, 'Le Salon des Vingt, Bruxelles', *Mercure de France*, 1, no. 3 (Mar. 1890), 89.

[10] J. Arnoux, 'Le Salon des XX de 1890', *La Jeune Belgique*, 9 (Feb. 1890), 124.

[11] See also G. de Maupassant, *Œuvres complètes illustrées*, *Pierre et Jean* (Paris, n.d.), 'Le Roman', preface, 1–25, in which he announced his new subjective orientation toward Naturalism and labelled his novel a psychological study.

inner character of modern reality. The Neo-Impressionists, in the duality of their scientific analysis of physical reality and their study of the emotional values inherent in colours, lines, and shapes, evidenced the same concern, and so did van Gogh and the Cloisonnists. Writing about Cloisonnism in 1888, the critic Edouard Dujardin had declared that art ought to express not the literal image, but 'the essence of the object', the character of things. The 'quasi-abstract' use of line and colour, handled in a summary fashion that seized 'the essential trait', Dujardin argued, would best convey the inner qualities of objects.[12]

By Gauzi's account, Lautrec began to think about his monumental dance-hall painting after he saw Renoir's treatment of the subject in the late spring of 1888. He published his illustration after it in *Le Courrier français* of 19 May 1889 and exhibited the painting in September 1889 at the Salon des Indépendants, where Théo van Gogh saw it and pronounced it 'very good'.[13] Probably Lautrec completed the large canvas early in 1889 after working on it through the winter, a likelihood that the winter clothing of his figures supports. In addition, however, he signed and dated a painted study on cardboard, *Femme à la fenêtre* (Fig. 112), that proves to have been a preparation for the female figure in the left foreground of *Au bal du Moulin de la Galette*. An undated portrait on cardboard, *La Fille du sergent de ville*, is another work that must have served as a study for *Au bal du Moulin de la Galette*; in profile and costume, the subject resembles the middle female figure in the foreground of the large painting and stylistically it is close to the works of 1889.

In a third study, Lautrec roughed out the light and dark areas of the entire composition much in the manner of an academic *ébauche*, though he did not include the male figure in the right foreground of the finished painting. These studies afford important clues to how Lautrec prepared his large-scale compositions. Unlike Renoir, he apparently did not take his canvas to the Moulin de la Galette and paint at the scene. Possibly he began with pencil or charcoal sketches that he made at the dance-hall, but thereafter he assembled the painting from compositional sketches and oil studies of individual models whom he posed at his studio.[14]

Often he composed his preparations on cardboard, apparently another common academic procedure; but he did not use cardboard for his preparatory renderings only. Like other progressive artists of the late nineteenth century, Lautrec adopted qualities of the academic sketch for his finished paintings. More and more of the small, formal works that he exhibited in 1889 and 1890 were on cardboard, usually in the sketchy technique of *peinture à l'essence*, which he had learned from Degas or Raffaëlli.[15] His conception of a finished painting did not require the high polish and elaborate detail of academic Realism. Although he made only small-scale finished works on cardboard, he recreated their sketch-like effect even in monu-

[12] Dujardin, 487–92. Émile Bernard also stated his interest in capturing the 'character' rather than the appearance of his subjects, cf. Welsh-Ovcharov, *Van Gogh and the Birth of Cloisonism*, 308.

[13] Van Gogh, iii. 551, no. T16, dated 5 Sept. 1889. Lautrec mentioned 'the great pleasure of exhibition opening day' in a letter of early Sept. 1889 in H. Schimmel, no. 170, 130. His participation in this exhibition, and the works he showed, were also noted by F. Javel in *L'Art français*, no. 126 (21 Sept. 1889).

[14] Joyant, i. 126, identifies Lautrec's friend Joseph Albert as the model for the principal male figure in the foreground. Cooper,

76, suggests a Degas monotype of the early 1880s as Lautrec's source for this figure. The compositional similarity of Lautrec's painting to the Degas (P.-A. Lemoisne, *Degas et son œuvre*, 4 vols. [Paris, 1946–9], cat. no. 688) additionally suggests Degas's influence.

[15] Cf. Joyant, ii. 66. Painting on cardboard had been Raffaëlli's hallmark since the early 1880s. Fénéon commented on this in 'Ve Exposition Internationale', *La Vogue* (28 June–5 July 1886), reprinted in *Œuvres plus que complètes*, i. 39. See also Joyant, i. 113.

mental paintings on canvas such as *Au bal du Moulin de la Galette*. Moreover, the use of this cheap, coarse proletarian material for formal works must have had democratic connotations. Lautrec probably chose it deliberately; he was not in a financial position that would have made the cost of canvas or paper prohibitive.

Lautrec now left the more painterly approach of his previous, Impressionist style behind him. His paintings at this point had the appearance of having been drawn with a brush. Their sketch-like qualities account in large part for the difficulty of distinguishing them from his preparatory studies. Often it requires a major, obviously completed work—such as *Au bal du Moulin de la Galette*—containing segments to which lesser works are clearly related, to determine with certainty that Lautrec originally intended particular smaller renditions of individual heads, figures, or small groups to be preparatory studies. His paintings of this time belong to one of three categories: studies of individual figures, compositional studies, and finished works. He did not necessarily have a specific formal work in mind when he initiated studies, but collected them as a repertoire of examples on which to draw for more complex compositions, whether large easel paintings or illustrations and graphic works. He also held to Cormon's precept of studying individual figures from life, while assembling major compositions in the studio rather than directly from the motif. Often he began with charcoal drawings on canvas—which is evident in many preparatory works—but now he customarily heightened them with colour. In effect, this practice further diffused the points of separation between his finished and his preparatory renderings, since scholarship has generally classified all such works as 'paintings'. The practice also explains the paucity of his drawings after 1888; with the addition of colour, he transposed them into the category of painting. Certain traits do help to identify his painted preparations of this period, as distinct from his finished paintings. The studies tend to be smaller and lacking in detail, and even more freely rendered, and their concentration is so focused on the figure, its head, and upper torso, that often the backgrounds are scarcely filled in.

Another portrait, *Fille à la fourrure* (Fig. 113), is stylistically similar to *Femme à la fenêtre* and probably also dates from 1889. It is on cardboard, its background is only partially filled in, and it appears to have been a study. Lautrec took an interest in female elegance at this time, and had a growing awareness of the abstract potential of line. Both are evident in the fashionable attire, refined silhouette, and upswept hair of his sitter, and the delicate interplay of line. His anonymous sitter may have been of lower social rank, but his treatment of the subject resembled the portraits of society women by James Tissot and Paul César Helleu. *Fille à la fourrure* bears Lautrec's inscription, 'Lautrec '91—to my friend Guibert', and Joyant, consequently, attributed the work to 1891; but it is likely that the artist was referring to the date when he presented the painting to his friend, not to when he painted it.[16]

Like the *Femme à la fenêtre*, the stylish *Fille à la fourrure* reappeared as the central figure in a larger, more finished painting of the crowd in the seedy environment of the Moulin de la Galette. This undated painting on cardboard is entitled *Au Moulin de la Galette* (Fig. 114). Recognizing its relation to *Femme à la fourrure*, Joyant also placed it in 1891. Lautrec, however, went to the Moulin de la Galette only rarely, and probably did not depict it again,

[16] Cf. J. Adhémar, 'Notices analytiques', in Jourdain and Adhémar, 116–17, cat. no. 35; Sugana, cat. no. 247.

after the Moulin Rouge opened in late 1889.[17] *Au Moulin de la Galette* resembles *Au bal du Moulin de la Galette*—the more important of the two works in style and mood as well as subject-matter—and may itself have been yet another preparation for it rather than a second, finished representation of the Moulin de la Galette. In either case, *Au Moulin de la Galette* probably also belongs in 1889.

This painting contains even more striking likenesses to Lunel's illustration of 1887 (Fig. 110) than does *Au bal du Moulin de la Galette*. Some of its figures have a marked similarity to those at the centre and right in the Lunel. But the Lunel remains quite composed, whereas Lautrec enhanced the realism of *Au Moulin de la Galette* by presenting simply a segment of a ceaselessly milling crowd, the figures moving in and out of the spectator's line of vision and turning and looking away from one another in a variety of directions, despite their close physical proximity. Stylistically, Lautrec was more advanced than his illustrator counterpart, especially in his attention to the abstract play of sinuous curves over the surface of his painting. Clearly it was the modernity of the subject-matter in such illustrations that now attracted him, not primarily their style or interpretation.

Lautrec took five paintings to the Exposition des Vingt that opened in mid-January 1890,[18] and, in so far as they are identifiable, all were productions of 1889. As listed in the exhibition catalogue, they were 'Au bal du Moulin de la Galette', 'La Liseuse', 'La Rousse', and two 'Études'.[19] No problems of identification surround *Au bal du Moulin de la Galette* or *La Liseuse* and, since Hélène Vary was Lautrec's model for the latter, the painting adds support to redating three other stylistically comparable portraits of her to *c*.1889. One of the 'Études', on the other hand, must remain unidentified because no known description of it exists. But informed speculation is possible about the other and about 'La Rousse'. Lautrec himself described them to his art dealer, in a letter of August 1890, and his remarks fit two extant paintings that he might well have done in 1889. Lautrec wrote: 'The other day I forgot two pictures, one showing a "seated woman in pink, full-face, leaning forward a little", the other "a red-haired woman seated on the floor, seen from the back, nude". These two pictures were shown this year in Brussels at the Vingtiste exhibit.'[20]

The signed but undated study, *Femme à l'ombrelle, dite 'Berthe la Sourde', assise dans la jardin de M. Forest* (Fig. 115), is the only existing work that matches the first part of Lautrec's description, and, since he regarded such *plein-air* works as studies, it could have been listed

[17] The only other work by Lautrec of post-1889 that might represent the Moulin de la Galette is P429 of *c*.1892. Entitled by Dortu *Un coin du Moulin de la Galette*, but also referred to as *L'Assommoir* or *Intérieur de cabaret*, it most likely belongs to a series of scenes of lesbians at the Moulin Rouge. Note the similarity of the narrow white table to that in *Au Moulin Rouge* (P427). *Au Moulin de la Galette* (P388) may, however, be the painting exhibited in June 1891 at the Salon des Arts Libéraux as *Un coin du Moulin de la Galette* and sold shortly thereafter through Joyant to the Boussod and Valadon Gallery and subsequently to a collector named Chavanne. Cf. Rewald, 'Van Gogh, Goupil, and the Impressionists', 104.

[18] Cf. H. Schimmel, no. 173, 132, 1 Jan. 1890, in which Lautrec announced his intention to leave 'at the end of January' for Belgium and take his paintings that were to be exhibited at Les Vingt. Actually, he must have left sometime earlier, as the 7th

Exposition des Vingt opened on 18 Jan. and a banquet, which he attended, was held on 16 Jan. by the Les Vingt group. See the exhibition review in *L'Art moderne*, 20 (26 Jan. 1890). Cf. Rewald, *Post-Impressionism*, 346–7.

[19] M. G. Dortu, M. Grillaert, and J. Adhémar, *Toulouse-Lautrec en Belgique* (Paris, 1955), 29, quoting from the exhibition catalogue. NB *La Liseuse* and one of the works entitled 'Étude' were sold during the Les Vingt exhibition. Cf. *L'Art moderne*, 20 (16 Feb. 1890), 59. In a letter of autumn 1889 Lautrec thanked Octave Maus for the invitation to exhibit at the 1890 showing and promised 'to send at least five canvases, which I shall select definitely by December 15'. On 11 Dec. 1889 he sent Maus the list of works that he planned to show. [H. Schimmel, no. 171, 131; no. 172, 131.]

[20] H. Schimmel, no. 177, 134. The recipient noted on the letter that he responded to Lautrec on 24 Aug. 1890.

114. Henri de Toulouse-Lautrec, *Au Moulin de la Galette*. Switzerland, private collection. (Photo, Christie's London.)

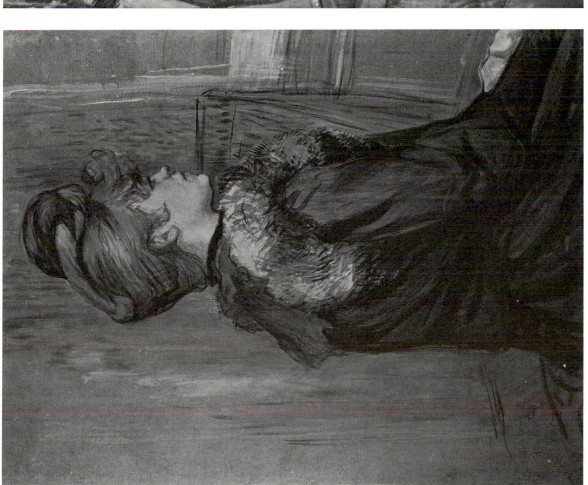

113. Henri de Toulouse-Lautrec, *Fille à la fourrure*. Formerly New York, Robert Lehman Collection. (Photo, courtesy of The Metropolitan Museum of Art.)

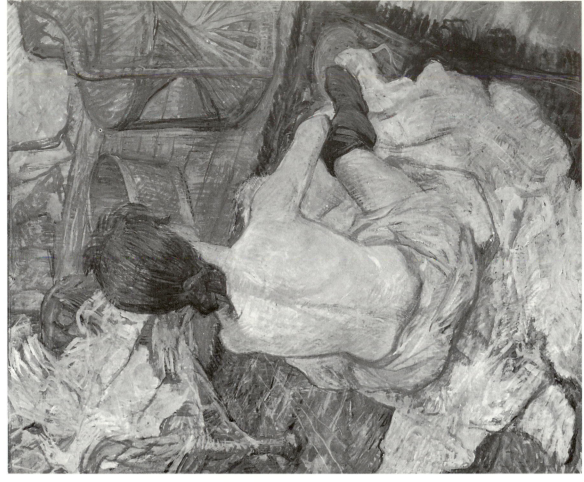

116. Henri de Toulouse-Lautrec, *La Toilette*. Paris, Musée d'Orsay. (Cliché des Musées Nationaux.)

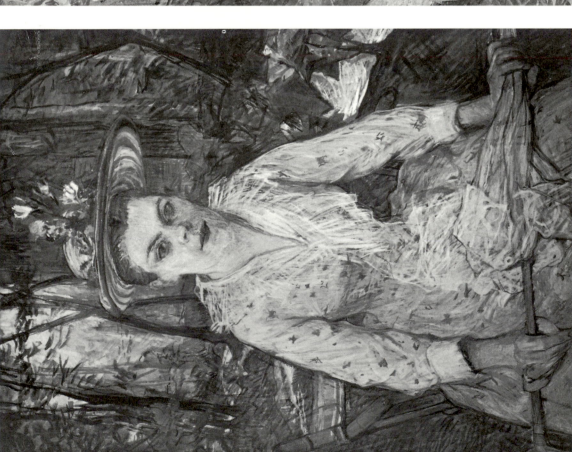

115. Henri de Toulouse-Lautrec, *Femme à l'ombrelle, dite 'Berthe la Sourde', assise dans le jardin de M. Forest*. Present location unknown. (Photo, courtesy Paul Rosenberg and Co., New York.)

as an 'Étude' in the 1890 Les Vingt catalogue. Lautrec's letters of the summer of 1889 confirm that he was working out of doors.[21] In contrast with the small, hatched strokes that texture the surfaces of Lautrec's earlier *plein-air* studies, the portrait of Berthe is a demonstration of the streaky application of paint, relatively smooth surfaces, and more elegant linear contours that had come to play a greater role than did tonal modelling in his work. Gauzi noted this transition in style from Lautrec's 'Impressionist period' and characterized it as a change from a preoccupation with colour to a concentration on drawing.[22]

Lautrec is not generally believed to have painted *toilette* scenes as early as 1889. Nevertheless, an undated oil on cardboard entitled *La Toilette* (Fig. 116) is the one painting in his known *œuvre* that fits the description in his letter of the painting of 'a red-haired woman', i.e. 'La Rousse', shown at the 1890 Exposition des Vingt. The subject of *La Toilette* is a nude with red hair. She is seated on the floor, and the angle of sight is from behind and above her. The painting is part of a group of related style and subject that Joyant set in 1896 because he related them to the cycle of preparatory paintings that Lautrec made for *Elles*, his album of lithographs of 1896, which included several scenes of women at their *toilettes*. But, in reality, none of the paintings of the group in question has an immediate connection to *Elles*, and they differ stylistically from Lautrec's work of 1896. In their relatively heavier application of paint and denser brush stroke, and in their layering of colours, they are in fact much closer to his paintings of 1889, and the exaggerated treatment of the diagonals of the floorboards to establish depth in *La Toilette* resembles that in one of the portraits of Hélène Vary and *Au bal du Moulin de la Galette*.

After Lautrec had ended his academic study, he represented the nude figure primarily in realistic scenes of contemporary women at their *toilettes*. This was Degas's practice also, and he was undoubtedly the direct inspiration for Lautrec. His pastels of the *toilette* in the mid-1880s have a layering of colours comparable with the style of Lautrec's paintings on the theme, and a similar stroke and high viewpoint. A number of his monotypes of the 1880s show the nude posed in much the same way—self-absorbed, wearing stockings, viewed from the back, and surrounded by the paraphernalia of her *toilette*.[23] Like Degas's figures, Lautrec's undoubtedly would have been recognized by his contemporaries as a prostitute preparing for her client by washing herself. Eunice Lipton has shown that bathing was 'unquestionably associated with prostitutes', as were the black stockings and removed clothing on the chair in conjunction with the woman's nakedness, and the suggestion of the bed in the background.[24] Although the client is present in a number of Degas's monotypes, making the meaning of such scenes explicit, he is discreetly omitted from Lautrec's painting, and from Degas's comparable pastels, which were more formal works, intended for public exhibition. None the less, the client's presence is implied by the high viewpoint, which identifies the viewer with him as he waits, presumably standing, and watches her perform her intimate and perhaps

[21] H. Schimmel, no. 169, 129–30, and Goldschmidt and Schimmel, no. 98, 112, n. 1, which mentions an unpublished letter (collection of Mme Privat) of this summer in which Lautrec is ' "dejected", because the rain prevents him from working'.

[22] Gauzi, 158.

[23] See e.g. nos. 190, 191, 192 in E. P. Janis, *Degas Monotypes* (exh. cat., Fogg Art Museum, Cambridge, Mass., 1968).

[24] Lipton, 169; see Lipton's entire discussion, 165–86. See also R. Thomson, 'Impressionism and Drawing in the 1880s', in C. Lloyd and R. Thomson, *Impressionist Drawings from British Public and Private Collections* (exh. cat., Arts Council of Great Britain, Oxford, 1986), 47, and R. Thomson, *The Private Degas* (exh. cat., Arts Council of Great Britain, 1987), 109.

titillating task, seated on towels with her thighs spread open, and modestly turned away from him. Some of Degas's pastels of *toilette* scenes had been exhibited at Théo van Gogh's gallery in January and February 1888,[25] and Lautrec might have seen them, but similar, though more anecdotal, images also appeared frequently in the popular illustrated press.[26]

Lautrec dated two male portraits, both executed on cardboard, in 1889. In *Monsieur Fourcade* (Fig. 117), he pictured a wealthy Parisian banker mingling with other patrons at the masked ball of the Opéra. It was exhibited at the Salon des Indépendants in September and October 1889. M. Fourcade, in his portrait, seems to step forward dramatically into the viewer's space. In *Monsieur Samary de la Comédie Française* Lautrec showed the actor alone on stage and seen from above, as if from a box at the theatre. Lautrec exploited the expressive potential of the silhouette in both paintings, imparting a caricatural quality that makes his subjects appear to combine worldly, gentlemanly elegance with a slight ridiculousness.[27] Degas used the same device, as well as the elevated vantage point of M. Samary's portrait— additional evidence, perhaps, of his influence on Lautrec. Lautrec, however, also utilized a familiar formula of the popular illustrators, especially Forain, by which an individual of otherwise dignified exterior took on a humorous aspect.[28]

Lautrec executed both of these portraits with his free, 'streaky' brush stroke, and in other characteristics, too, they were exemplary of his work of 1889. His style was far from abstract, but he was beginning to organize his paintings around distinctive shapes and large blocks of colour; and although his art remained less decorative and stylized than Cloisonnism, he paralleled it in his exploitation of form and colour to accentuate mood. In *Monsieur Fourcade*, Lautrec's treatment of the figure, his brush stroke, and his emphasis on silhouette bring this portrait exceptionally close to *Au Cirque Fernando, l'écuyère*, the 'Chicago *Écuyère*' (Fig. 118).

Comparisons between Lautrec's climactic circus painting and works attributable to 1889 indicate a close stylistic relationship between them. The streaky application of pigments, which gives the 1889 paintings the overall appearance of 'drawings' created with a brush, also characterizes the 'Chicago *Écuyère*'. It manifests the same strong contours and caricatural distortion as the portraits of Samary and Fourcade. Like *Au Moulin de la Galette* it combines a naturalistic subject with exaggeration of certain of the formal elements to convey the 'essential trait' or character of the scene. But in it Lautrec carried spatial flattening, the use of curving contours to create pronounced surface rhythms, exaggerated foreshortening, and simplification and stylization in general, even further than he did in any other work of 1889.

On the other hand, the 'Chicago *Écuyère*' has its radically asymmetrical composition and main figure in common with *Au Cirque Fernando* of *c*.1887 (Fig. 89); both paintings reveal just a corner of a large circular arena viewed from above at a steep angle and ringed by the cropped figures of spectators. Yet its conceptual rendering differs strikingly from the more

[25] M. Bodelsen, 'Gauguin, the Collector', *Burlington Magazine*, 112, pt. 3 (Sept. 1970), Appendix A, 612. Not all the works shown can be identified; however, the Lautrec calls to mind a number of Degas's pastels. See e.g. Lemoisne, no. 849, and paintings, e.g. Lemoisne, no. 642.

[26] See e.g. L. Legrand's *L'Influenza chez les artistes*, cover of *Le Courrier français*, no. 51 (22 Dec. 1889).

[27] Adhémar in Jourdain and Adhémar, 115, cat. no. 25.

[28] Theodore Reff suggested to me a parallel here to such works

by Degas as the *Portrait of Pellegrini*, *c*.1876, itself painted 'in an idiom clearly inspired by that of Pellegrini's political and social caricatures'. See Reff, *Degas*, 36. The vertical format and pose of Lautrec's figure with hand on hip were also typical of contemporary depictions of theatrical stars in posters, handbills, and the press. See e.g. *Paris illustré*, no. 116 (22 Mar. 1890), article on the Comédie-Française, accompanied by illustrations of its famous actors.

perceptual, vibrating surface of *Au Cirque Fernando* and the other circus paintings of its date, as well as from the works of 1888. It also seems close to the 'Missing *Écuyère*' in the individual elements of galloping horse, ringmaster, and two of the gentlemen in the audience, but has the appearance of a more masterly, more successful reworking of the same idea. It is as if the missing painting had been a prelude, a monstrously large sketch, for the more sophisticated work. The 'Chicago *Écuyère*' is horizontal instead of vertical, and smaller, $38\frac{3}{4}$ by $63\frac{1}{2}$ inches. Lautrec omitted the central clown that had dominated the missing work and enlarged the horse and equestrienne, but repeated the ringmaster as virtually the same figure; he left the floor of the circus ring unpainted, permitting the flat tone of his white ground to serve as the background of the composition. The 'Chicago *Écuyère*' represented an improved solution to a problem with which Lautrec had struggled in nearly all of his circus paintings of *c*.1887: to compose the elements of *écuyère*, ringmaster, clown, and audience. Late 1888 remains a plausible date for this definitive version, but the stylistic evidence points persuasively to the likelihood that it belongs with the works of 1889.

In addition, Lautrec's dramatically reductive and stylized treatment of this painting suggests a connection to the contemporary work of the Cloisonnists and to Gauguin's Synthetism, and here circumstances also point to 1889 as its likelier date. Recent works of Gauguin, Anquetin, Bernard, and others of the avant-garde were exhibited in June 1889 at the Café Volpini in the show of the Groupe Impressionniste et Synthétiste. The critic Fénéon took approving note of the daring new tendencies exemplified in these works, and pointed out that Gauguin had been influenced by Bernard and Anquetin, who, 'towards 1886', had renounced the optical Realism of the 'tachistes'—Impressionist and Neo-Impressionist 'spot' painters— in favour of a 'synthetic' and premeditated art, stressing contours and flat tones.[29] Friends of Gauguin had organized the exhibition as a manifestation of the new anti-naturalist and anti-pointillist direction of avant-garde art. Significantly, even at this late date, Lautrec was considered somewhat conservative by his peers. The Groupe Impressionniste et Synthétiste did not include him because he was exhibiting concurrently at the fashionable Cercle Volney, of which Gauguin disapproved,[30] but his style and subject-matter might have precipitated additional opposition to him. Stylistically he lagged behind the Cloisonnists and, whereas Gauguin and others had begun to embrace visionary content in their art, Lautrec persisted in his commitment to scenes from contemporary life.

Lautrec was none the less responding to and assimilating the most avant-garde stylistic developments of his milieu. The work that he viewed at the Café Volpini, coupled with his own rejection from the show, may have inspired him to return to his circus theme for one more revision, and to accomplish it with a monumental canvas that would equal the avant-garde at its most extreme in style. By means of *Au Cirque Fernando, l'écuyère*, Lautrec may have set out to prove himself an advanced painter despite his Realism and his association with the

[29] F. Fénéon, 'Autre groupe impressionniste', *La Cravache* (6 July 1889). Reprinted in Fénéon, *Œuvres plus que complètes*, 157–8.

[30] Van Gogh, iii. 544, no. T10, Théo van Gogh to his brother Vincent, 16 June 1889. See also D. Cooper (ed.), *Paul Gauguin: 45 lettres à Vincent, Théo et Jo van Gogh*, Collection Rijksmuseum Vincent van Gogh, Amsterdam (Staatsuitgeverij, 1983), no. 14, 103–5, written by Gauguin to Théo around 1 July 1889 and discussing Lautrec's exclusion from the Volpini show. Lautrec exhibited in June 1889 at the Cercle Artistique et Littéraire Volney, showing portraits in an impressionist style, cf. F. Javel, *L'Art français*, no. 113 (22 June 1889), and J. Antoine, 'Exposition supplémentaire du peinture du Cercle Volney', *Art et critique*, no. 3 (15 June 1889), 45.

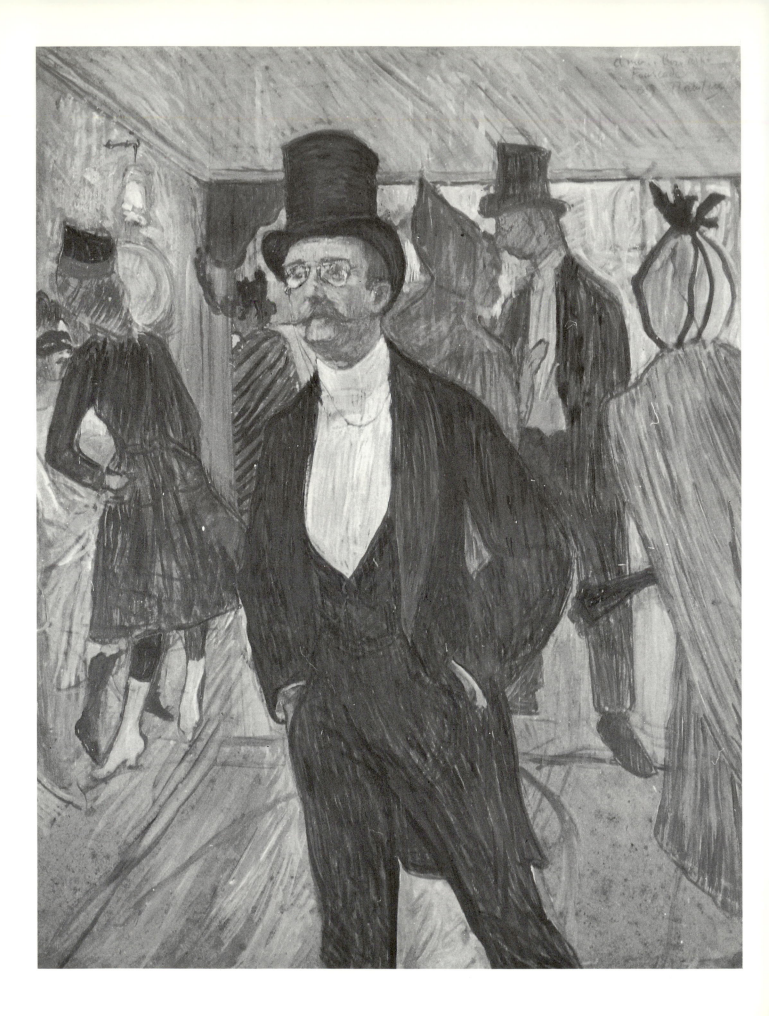

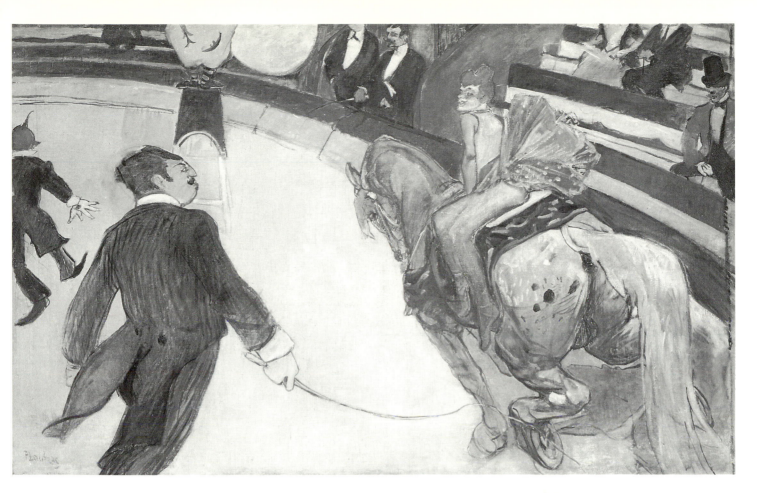

118. Above: Henri de Toulouse-Lautrec, *Au Cirque Fernando, l'écuyère*. Chicago, Art Institute, Joseph Winterbotham Collection. (Photo, courtesy of The Art Institute of Chicago, © 1990. All rights reserved.) *See also colour plate.*

119. Right: Henri de Toulouse-Lautrec, *Follette, chienne*. Philadelphia, Museum of Art, bequest of Lisa Norris Elkins.

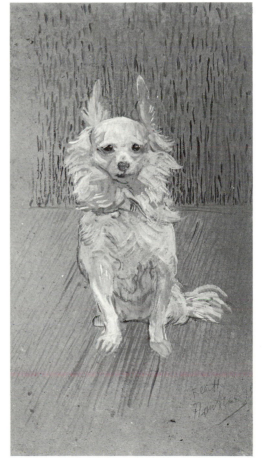

117. Facing: Henri de Toulouse-Lautrec, *Monsieur Fourcade*. São Paulo, Museum of Art.

élite Volney club. This would place the 'Chicago *Écuyère*' in the second half of 1889 and would also explain its character as Lautrec's most daring work of the year. Moreover, since the painting hung in the entry hall of the Moulin Rouge from its opening on 5 October 1889,[31] it is possible that Lautrec planned to complete the 'Chicago *Écuyère*' expressly for that event.

The Year 1890: Giving the Salon 'a slap in the face'

Lautrec published no illustrations in 1890. Like 1889, this was a year in which he concentrated intensively on painting. He continued to work out problems of Naturalist imagery in much the same more unified and individual style of the previous year, and only one different characteristic seems to distinguish his paintings of 1890. To his long, diluted streaks of paint, he added areas—often in the background—of short dashes or comma-like strokes reminiscent of pointillism. Of the four paintings that he dated in 1890, *Follette, chienne* (Fig. 119), the portrait of a dog, most graphically illustrates the technique, but it is also evident in his three other dated works of the year: *Au Moulin Rouge, la danse* (Fig. 120), *Mademoiselle Dihau au piano* (Fig. 123), and *Femme fumant une cigarette* (Fig. 126). The stylistic qualities of the dated works help to establish a chronology for 1890, and, in addition, there are numerous letters and the catalogues from two shows in which he exhibited works of this year, the sixth Salon des Indépendants of March–April 1890 and the Cercle Volney of January–February 1891.

Lautrec began 1890 as he had begun 1889, with an ambitious work, *Au Moulin Rouge, la danse*, 46 by 60 inches, a monumental restatement of the theme of the *quadrille*. Once again he pre-empted a subject from popular illustration and elevated it to high art. The painting was originally entitled *Dressage des nouvelles, par Valentin le Désossé (Moulin Rouge)* (Valentin le Désossé Breaking in the New Girls [Moulin Rouge]).[32] It depicts Valentin with a female dancer at the centre of a crowd of onlookers and indifferent passers-by. The dancer is not La Goulue, as general belief has it, but a 'new girl' attempting *la série*, one of the most daring movements of the *quadrille naturaliste*. In this provocative step, the dancer swung her leg high and in the same instant raised and agitated her skirt and petticoats.[33] Like *Au bal du Moulin de la Galette*, *Au Moulin Rouge, la danse* is a climactic work, both in subject and style, of the first, Realist–Naturalist phase of Lautrec's artistic maturity. It represented the summation of an idea traceable to his illustrative work of the mid-1880s.

Lautrec signed and dated *Au Moulin Rouge, la danse* 1890, but he probably began it late in 1889 because he went to Brussels for Les Vingt in January of 1890, travelled further in February, and still had the painting completed for installation at the Salon des Indépendants in mid-March. Jubilantly he reported its success in a letter to his mother shortly after the opening: 'I'm still reeling from the second exhibition opening. What a day!! But what a

[31] Cf. Cooper, *Lautrec*, 74. For the opening date of the Moulin Rouge see A. Georget, *L'Écho de Paris* (Oct. 1889), cited by P. Courthion, *Montmartre*, trans. S. Gilbert (Lausanne, 1956), 61.

[32] Cf. Société des Artistes Indépendants, *Catalogue des œuvres exposées*, 6th Exhibition, 20 Mar.–27 Apr. 1890 (Paris, 1890), 39,

no. 790. See also the reviews in *La Cravache parisienne*, no. 478 (19 Apr. 1890); *L'Art français*, no. 155 (12 Apr. 1890).

[33] On the 'figures' of the *quadrille naturaliste*, see Rodrigues [Ramiro], *Cours de danse*, 24–5, 42–54.

success. The Salon got a slap in the face from which it will recover perhaps, but which will give many people something to think about.'[34] Lautrec's painting complemented ten works by van Gogh and Seurat's *Chahut* at the exhibition. The Indépendants projected shocking unconventionality that year, and no doubt Lautrec accounted for it in part by monumentalizing a vulgar theme from popular life and illustration. This was the aspect of the painting on which Théo van Gogh commented when he described it to Vincent in a letter of 19 March 1890. Lautrec showed 'a large picture which is very striking', he wrote. 'Notwithstanding its scabrous theme it has great distinction.' Théo also remarked on the success of the exhibition and the growing public interest in the younger 'Impressionists'.[35]

As a scandalous subject, the *quadrille* had been the preserve of the popular press with its small-scale, cheaply produced art, and had not usually appeared in high art. Even in *Au bal du Moulin de la Galette* Lautrec kept the dance, with its implications of uninhibited sexuality, in the background. Therefore, by rendering the *quadrille* as the predominant theme of a large-scale formal picture, Lautrec created his most audacious major work to date. Not only did it go beyond *Au bal du Moulin de la Galette* and the theme of the *écuyère*, but it focused on a subject that much of the bourgeois and upper-class exhibition-going public regarded as anti-social and anti-establishment.[36] This public seems to have been simultaneously attracted to and threatened by the dance's lower-class vulgarity and challenge to propriety and morals, and at least one segment of it increasingly viewed the dance and representations of it as tantamount to pornography. The *quadrille naturaliste*, the places where it was performed, the dancers and onlookers who congregated in them, and the popular press that encouraged and even celebrated the new personal freedoms, came under hostile scrutiny as a threat to bourgeois morality. It was the attitude that André Chadourne had expressed emphatically in 1889, in a treatise in which he denounced such forms of popular entertainment and their 'lack of etiquette'. Aiming his diatribe at the dance and other 'naturalist entertainments', he declared that these 'degraded' and 'base' amusements not only lowered the moral and intellectual level of the entire nation, but 'debased the prestige of our country abroad'. Chadourne urged government censorship to correct the problem.[37] Senator René Bérenger was to bring the same opinion into sharper relief in 1891 when, as president of 'The League against Licence in the Streets', he campaigned against 'indecent' behaviour and outrages to the public morals. The popular illustrators and Valentin and La Goulue were among his favourite targets, with the result that numerous caricatures in the popular press depicted the two dancers in obscene confrontations with the senator.[38]

The illustrators themselves increasingly exploited the impropriety of the dance. Lunel's cover art (Fig. 121) for *Le Courrier français* on 12 May 1889 (no. 19)—the issue in which Lautrec's *A la Bastille* appeared—represented La Goulue directing her high kick brazenly into the faces of her well-dressed audience. The caption read, 'Greetings to the provinces and

[handwritten marginal note: against Bourgeoisie]

[34] H. Schimmel, no. 175, 132–3, datable to late Mar. or early Apr. 1890. The first opening was that of the Exposition des Vingt in Jan.

[35] Van Gogh, iii. 565–6, no. T29.

[36] See esp. Gauzi, 70, 78–80, who calls the dance 'canaille'; Jourdain in Jourdain and Adhémar, 34–5; and Natanson, *Toulouse-Lautrec*, 226–8.

[37] A. Chadourne, *Les Cafés-concerts* (Paris, 1889), 273–4, 310–11. This book was 'written to refute the false idea of the *café-concert* given by M. Vaucaire in *Paris illustré* of 1886'; cf. p. 10.

[38] On Bérenger, see Gauzi, 75; Jourdain and Adhémar, 85, who describe the caricatures of him that appeared in the press; and Perruchot, 211. See also *Dictionnaire de biographie française* (Paris, 1951), iv. 1498.

abroad!' It was the year of the Paris World's Fair, and Parisian illustrators took delight in shocking uninitiated visitors from the provinces and foreign countries. Lunel's visual analogy between the Eiffel Tower in the background and La Goulue's uplifted leg made the point that the latter as much as the former symbolized the modern city. Heidbrinck, in a caricature of the same vein for *Le Courrier français* of 29 June 1890, pictured a rear-end view of La Goulue bent over in an unceremonious display of her petticoats and underdrawers. She was accompanied by Valentin whose ironic reproach was the caption: 'Be careful, La Goulue, people will notice!' As a social phenomenon, the *quadrille naturaliste* seemed to epitomize the up-to-date, the shocking, the unconventional, and the anti-bourgeois in modern society, and the press celebrated it as such.

Au Moulin Rouge, la danse represented a 'scabrous theme' not only because it depicted the uninhibited *quadrille* with its actual and implied release from social restraints. Lautrec also included an obvious prostitute, easily recognizable to his contemporaries, as the painting's largest and most prominent figure. She is the woman in pink in the right foreground whose kind Huysmans described in 'Le Bal de la brasserie'. They arrived at the dance-halls late in the evening 'sous des buissons de panaches et des taillis de plumes, sous des feutres mousquetaire aux ailes extravagantes, des ronds de pâte rose se renversaient, creusés de trous bordés d'écarlate . . .' ('beneath extravagant plumed hats and masses of plumes and feathers, circles of pink face powder split by gaping scarlet-edged holes . . .').[39] It was bold of Lautrec to make this blasé creature a conspicuous figure in a formal work of art. A desire to shock, born of the defiantly rebellious Montmartre spirit, no doubt motivated him.

Lautrec's tendency to repeat his favourite themes, even after considerable lapses of time, was well in evidence by 1890, and of all of them he treated the *quadrille* most often. Now two general developments in his own art could have prompted him to return to it once more, in order to monumentalize what the public saw as a scandalous variety of popular entertainment. His confidence in the viability of a radical art must have grown and solidified with his expanding and increasingly successful participation in avant-garde exhibitions. He must have felt more daring, more prepared to integrate what he had absorbed as an illustrator into his formal essays. The financial independence guaranteed him by his monthly allowance,[40] and his consequent relative freedom from the pressure of making sales, no doubt reinforced this audacity. He had also moved forward stylistically, and undoubtedly was eager to apply his maturing creative powers to a favourite subject.

Several immediate influences may also have led Lautrec back to the subject of the *quadrille* in late 1889 and 1890. For instance, in November 1889, in his *Certains*, Huysmans published a lurid description of Raffaëlli's *Le Quadrille naturaliste aux Ambassadeurs* (Fig. 73) of 1886, the work that had influenced Lautrec earlier. Huysmans's commentary would certainly have caught his attention. The very terms in which Huysmans characterized the dance and his focus on its unsavoury qualities might have renewed and excited Lautrec's interest in the subject and perhaps also in the Raffaëlli. However, Huysmans went beyond Raffaëlli in projecting a disgusting, even putrid, mood into the scene. He described the dance more as he saw it through his own eyes than the way Raffaëlli had depicted it. With Lautrec he shared a

39 Huysmans, *Croquis parisiens*, 45 (*Parisian Sketches*, 33).
40 Frey, 'Biography of Lautrec' in Wittrock and Castleman (eds.), 27.

fascination with this new kind of entertainment spectacle—so far from the classical dance favoured by Degas—and this is as apparent in his written description as it is in Lautrec's visual portrayal:

deux blanchisseuses qui ont lâché le fer à repasser, le 'gendarme', deux lavasses roulées sur tous les canapés sans ressort des marchands de vins, secouent, les pieds au ciel, dans un furieux chahut, l'étal mouillé de leurs chairs; et il faut voir le sourire carnassier de ces bouches, la danse de ces fanons, le cancan de ces yeux de filles à trois francs, qui allument le fond des corridors ou attirent, pour de courtes besognes, dans la nuit des terrains vagues!

Les deux hommes qui leur servent de vis-à-vis sont encore plus turpides; l'un d'eux tord une gueule de garçon de cuvette et l'autre un mufle de camelot ou d'acteur; eux aussi se dégingandent, battent avec les moulinets de leurs bras une rémoulade de poussière dans les jets de gaz, font avec les manches de veste de leurs jambes les digue-digue-don d'une crampe atroce.

C'est de l'élixir de crapule, de l'extrait concentré d'urinoir transporté sur une scène, de la quint-essence de berge, de dessous de pont, enrobée dans une musique poivrée de cymbales et salée de cuivres.

[two laundresses who have thrown aside the iron, the termagants [*le 'gendarme'*], two tarts who have rolled around on all the sofas without springs of the wine merchants, thrusting their feet to the sky, in a furious high kick, showing off their damp naked flesh; and one must see the carnivorous smiles of those mouths, the dance of these little cattle, the cancan of these rounds of beef who cost three francs, who arouse you in dark corridors or lure you, for quick work in the night, to deserted lots!

Their two partners are even more torpid; one of them smirks, distorting his mug of a boy who cleans toilet bowls, and the other his snout of a peddler or performer; they contort their bodies, beating up a remoulade of dust into the gas jets with the little grinders of their arms, making with the jacket sleeves of their arms, the gestures caused by an atrocious cramp.

This is the elixir of vulgarity, of the concentrated extract of the urinal transported on stage, the quintessence of the ditch, of the muck below the bridge, robed in a music peppered with cymbals and salted with coarse, biting brass.][41]

Huysmans's writing, with its focus on the distorted and distasteful in the dance, emanated a sense of sordidness and decadence, as well as a combined attraction and repulsion, closer to Lautrec's work than to Raffaëlli's mood of mild glorification of the common people. But Lautrec's art usually conveyed less revulsion towards reality and greater compassion than Huysmans's.

Regardless of the difference in mood, *Au Moulin Rouge, la danse* bears comparison with the Raffaëlli in important visual respects. Lautrec composed his painting around a single dancing couple rather than a group of four dancers, but both works emphasize large, prominent forms against the backdrop of a distant crowd of spectators in black evening wear and top hats. Diagonal floorboards set off the figures of the dancers, which occupy a central space somewhat removed from the picture plane. The dark, wavy silhouette of Lautrec's male dancer and the arched arms and high kick of his female partner strongly recall the Raffaëlli. The visual impact of the composition is striking in each example.

41 Huysmans, *Œuvres complètes*, x, *Certains*, (Paris, 1928) 32–3. Excerpted from 'Note sur Raffaëlli', *La Cravache* (26 Jan. 1889), 1.

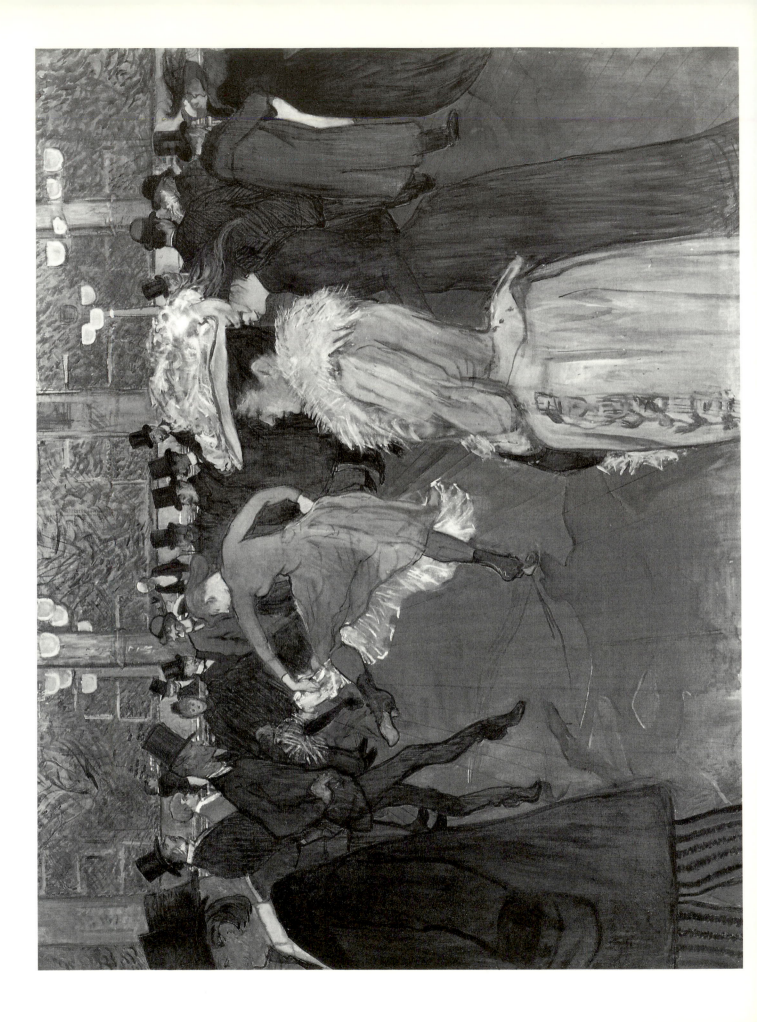

120. Above: Henri de Toulouse-Lautrec, *Au Moulin Rouge, la danse.* Philadelphia, Museum of Art, Henry P. McIlhenny Collection in Memory of Frances P. McIlhenny. *See also colour plate.*

121. Left: Ferdinand Lunel, after, *Salut à la province et à l'étranger!* Zinc engraving from cover of *Le Courrier français* (12 May 1889). Paris, Bibliothèque Nationale. (Photo, Bibliothèque Nationale.)

122. Below: Ferdinand Lunel, after, *Le Quadrille à l'Élysée Montmartre.* Zinc engraving from *Le Courrier français* (1 Dec. 1889). Paris, Bibliothèque Nationale. (Photo, Bibliothèque Nationale.)

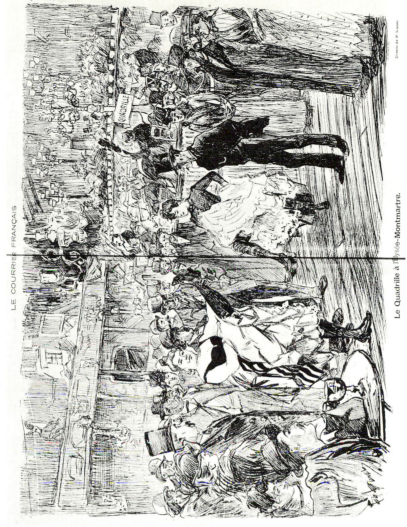

Le Quadrille à l'Élysée-Montmartre.

Salut à la Province et à l'Etranger!

By 1889–90, the exploitation of the *quadrille* was increasingly widespread in the illustrated press, and a number of examples more contemporary than the Raffaëlli may also have been among the immediate incentives that led Lautrec back to the theme. Most of the well-known illustrators, especially those of *Le Courrier français*, and in particular Uzès, Heidbrinck, Quinsac, Willette,[42] and Lunel (Fig. 122), had portrayed the *quadrille* at least once before Lautrec painted *Au Moulin Rouge, la danse*; it had become a banal subject. Though Lautrec is generally believed to have captured the distinctive shapes of Valentin le Désossé and his partner (not La Goulue) uniquely in his painting, the theme actually had its original expression in the popular press and by 1890 was undergoing repetition *ad nauseam*. Many of these later depictions imitated the Raffaëlli and a number had features that presaged aspects of Lautrec's painting.

The example by Lunel, however, provided a more direct source of inspiration for Lautrec's painting than any other illustration. *Le Courrier français* (no. 48) published his *Le Quadrille à l'Élysée Montmartre* as a two-page illustration on 1 December 1889, probably just at about the time Lautrec began work on his own major composition. The format of the Lunel, its frieze-like composition and diagonal floorboards, and especially the profile figures of Valentin and the foreground spectators—the latter cropped at the edges of the composition—bear a marked resemblance to *Au Moulin Rouge, la danse*. It is possible that Lautrec also began his painting in a competitive spirit with Lunel, who was rapidly becoming Paris's leading illustrator of the Montmartre night-life. And, while Lunel's illustration reflected the influence of Raffaëlli, certain of its features suggest that, in addition, he borrowed a number of ideas from Lautrec's Mirliton panel (Fig. 71): the large, cropped figures at the table in the left foreground, the crowd of spectators around the dancers, the angle from which the scene is viewed (permitting the inclusion of the balcony and band at the right).

Lautrec appears to have been the first artist to depict the *quadrille naturaliste* at the Moulin Rouge, which opened in early October 1889 and was quickly on its way to being the rage of Paris. The establishment's instant popular appeal may have been yet another motive for the artist to take up the *quadrille* as a theme once again. The Moulin Rouge acquired an early reputation for vulgarity, and the *quadrille* as it was performed there gained still further notoriety. No longer simply a participatory proletarian dance, it became a fully commercial entertainment spectacle, staged by a shrewd management with performers, now paid, to draw the patronage of a well-to-do class of gentlemen.[43] The Élysée Montmartre (which the Moulin Rouge displaced as the chief attraction of the district) and the Moulin de la Galette remained authentic lower-class dance-halls, squalid and gloomy places where the local populace danced for personal pleasure; but the more prosperous clientele (Lautrec included) of the Moulin Rouge came as spectators, primarily to see the provocative *quadrilles* and secondarily to observe the unconventional array of ostentatiously dressed prostitutes and pleasure-seeking

[42] See e.g. P. Quinsac, *La Revue de l'Alcazar d'été*, *Le Courrier français* (28 Aug. 1887), 6–7; O. Heidbrinck, *Bal masqué de l'Opéra*, *Le Courrier français* (26 Feb. 1888), 67, and *Au bal de l'Élysée Montmartre*, *Le Courrier français* (19 May 1889), 2; and A. Willette, *Le Quadrille naturaliste*, in Darzens, 59.

[43] *Le Courrier français*, no. 42 (19 Oct. 1890), reported that

Zidler, the owner of the Moulin Rouge, paid La Goulue, Mme Fromage, La Sauterelle, and La Macarona 300 frs. per month and forbade them to dance elsewhere. See also Montorgueil, *Paris dansant*, 175–6, 181–4. On the Moulin Rouge, see Jullian, 97–115, and Rearick, 183–6.

gentlemen who haunted the enormous, garishly decorated dance-hall and beer garden.[44] The Moulin Rouge capitalized on the salacious appeal of the *quadrille* and, in addition, its glittering environment offered an élite male clientele a place to rendezvous with prostitutes and to enjoy the excitement and risk of slumming, milling in a crowd of low-life performers and other characters who seemed unheedful of conventional social restraints—all this at a price and in the safety of a commercial establishment whose mirrored walls underlined the public and therefore daring display that was so essential to the experience.[45] In *Au Moulin Rouge, la danse*, Lautrec recreated the atmosphere of the place as well as the dance itself. And although his subject had no inherent originality, and his composition employed the commonplace ingredients of the theme (including the implication, in his original title, of an anecdotal content), his final achievement surpassed the works of all the illustrators who preceded him and his own Mirliton panel as well.

In *Au Moulin Rouge, la danse*, Lautrec departed from the busyness that made the Mirliton panel and Lunel's illustration confusing. He simplified and reduced the number of dancers, the number of auxiliary figures, and the anecdotal and descriptive details that tended to distract. He toned down the background elements to sharpen the impact of the main scene, and organized the space into three distinct, parallel planes to make it more legible. Taking his cues from the caricatural aspect of illustration, he also dramatically abstracted the shapes of his figures, making them read as a surface pattern of large, flat, outlined forms, echoed by the abstract pattern of their shadows on the floor. Through caricatural simplification and exaggeration, he parodied them, capturing their essential and typical qualities. The result is a more powerful design and more effective and concise rendition of the milieu than any other contemporary portrayal of the theme.

Raffaëlli had focused attention on his dancers by isolating them at the centre of a traditional composition. Both Lunel and Lautrec (in his Mirliton panel) had riveted their spectators' gaze on the action of the *quadrille*. In *Au Moulin Rouge, la danse*, Lautrec advanced beyond these conventional devices. By encircling his dancers with ample floor space within the ring of spectators, he enframed them on the picture plane as well as spatially, and consequently made them the most compelling figures in the painting without centring them as Raffaëlli had done with his dancers. Lautrec's distortion of the perspective in the orthogonals of the floorboards, which converge rapidly towards the performers, was a further means to draw the viewer's eye to the principal action in the painting. At the same time he set up a compositional drama by opposing the diagonal movement of the orthogonals with the recession of horizontal planes parallel to the picture plane—another contrast with Lunel and Raffaëlli, who had organized the floorboards in their illustrations as parallels to the dancers with far less dramatic effect. Lautrec's radical cropping and his off-centre composition more effectively set up the illusion that the scene extended indefinitely beyond the periphery of the painting; his placement of the dancers immediately within the crowd of spectators, some of them impassive passers-by who ignore the performance, created the impression of the dance-hall as the setting for many

[44] Cf. Gauzi, 69–70; Natanson, *Toulouse-Lautrec*, 226–7; Jourdain in Jourdain and Adhémar, 36–7.

[45] My analysis here is influenced by L. A. Erenberg, *Steppin' Out, New York Nightlife and the Transformation of American Culture, 1890–1930*, 133. NB The *Guide de plaisirs à Paris* (1898) describes the Moulin Rouge as a 'big marketplace of love'. Cf. Adriani (Tübingen), 307.

simultaneous, not necessarily related activities, and for boredom and ennui, as well as exhilaration.

The unnatural contortions of the dancers contribute to the aura of unhealthiness with which Lautrec infused *Au Moulin Rouge, la danse*, but as he had done previously in *Au bal du Moulin de la Galette*, he also used colour as a principal means to project the unpleasantness of the dance-hall milieu. The sickly green of the floor and background dominates the atmosphere in sour juxtaposition with touches of pink, red, and orange—acid hues produced by the scores of gas jets that lighted the Moulin Rouge. Lautrec amplified the grotesque qualities of the scene through the manipulation of colours. His dissonant palette created much the same effect as Huysmans's verbal metaphors.

After its exhibition at the Salon des Indépendants of 1890, *Au Moulin Rouge, la danse* was installed at the Moulin Rouge, where the 'Chicago *Écuyère*' had hung in the vestibule since the dance-hall's opening night. Possibly Lautrec had returned to the theme of the *quadrille* specifically to do a painting for the Moulin Rouge; conceivably he received a commission on the strength of the success of his earlier painting. Certain compositional elements of *Au Moulin Rouge, la danse* suggest this. Not only did Lautrec recreate the activities and atmosphere of the dance-hall, but he may have designed his painting as a kind of illusionistic mural that might appear as an extension of the actual interior of the Moulin Rouge. Its effect would have been that of a *trompe-l'œil*, playing on the sensation already produced by the mirrored walls at the rear of the dance-hall.

Across the foreground, the formal, frieze-like procession of large figures, nearly life-size and close to the surface, lends the picture the effect of a tableau not unlike some of the illusionistic wall paintings of the Renaissance. By proxy, viewers of the painting become part of it; the foreground figures are their counterparts. The line of spectators in the rear and the overall arrangement in planes parallel to the surface add to the illusion as does Lautrec's use of the floorboards as orthogonals receding into depth. As in the tableaux of, for example, Carpaccio, the large, unutilized space between the foreground and the background of *Au Moulin Rouge, la danse* suggests an expansive depth, while the exaggeration of abstract surface elements holds the design together. Outside viewers look down at the floor as if they were inside the painting, and their eye level determines the vanishing point of its perspective. Lautrec might have been inviting them to participate in this milieu together with his own friends Guibert, Sescau, Varney, and Jane Avril, whom he portrayed in the background.

Lautrec painted *Au Moulin Rouge, la danse* in his studio, as he had done *Au bal du Moulin de la Galette*, probably from sketches he had made at the scene and subsequent preparatory studies. Photographs of him at work (e.g. Fig. 80) show that he had masked off the bottom of his canvas, reducing what perhaps began as a 60 inch square by some 14 inches in height. He may have had to accommodate his format to the space requirements of the Moulin Rouge, where the wall panelling would have framed the painting; or, alternatively, he simply decided on different proportions after he had laid out his composition. In either case, he made the change early.

Just one contemporary critic, an anonymous reviewer, was discerning enough to note that in *Au Moulin Rouge, la danse* Lautrec combined realistic observation with 'expressive

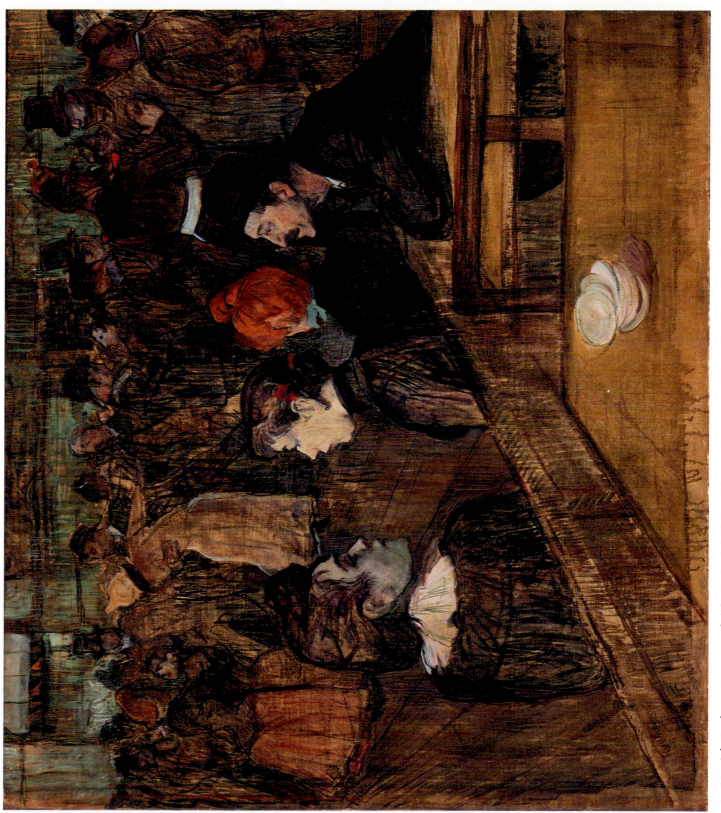

109. Henri de Toulouse-Lautrec, *Au bal du Moulin de la Galette*. Chicago, Art Institute, Mr and Mrs Lewis Larned Coburn Memorial Collection. (Photo, courtesy of The Art Institute of Chicago, © 1990. All rights reserved.)

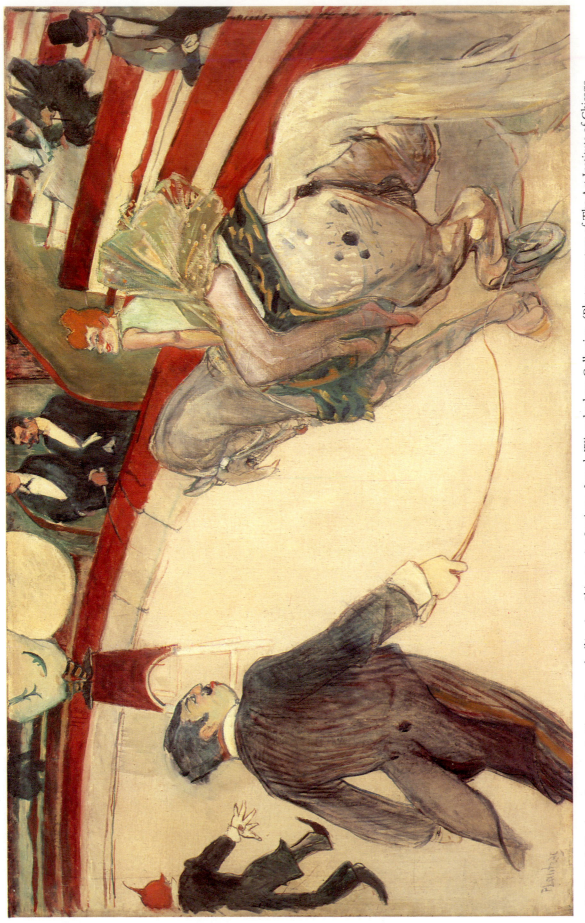

118. Henri de Toulouse-Lautrec, *Au Cirque Fernando, l'écuyère*. Chicago, Art Institute; Joseph Winterbotham Collection. (Photo, courtesy of The Art Institute of Chicago,)

qualities'.[46] Most of the reviews still treated Lautrec as a Naturalist artist and this major work of 1890 as a fundamentally naturalistic painting 'with a sarcastic vision', betraying the influence of Degas and Forain.[47] But in *Au Moulin Rouge, la danse* Lautrec also carried the play of large shapes and their silhouettes on the painting's surface further than he had ever done before. This incipient abstraction brought him still closer to the Cloisonnist work of his associates of the Petit Boulevard; in its caricatural qualities his painting particularly recalled Anquetin's work of *c*.1889–90.[48]

The year 1890 proved to be extremely productive for Lautrec. Besides *Au Moulin Rouge, la danse*, he produced three groups of small-scale portraits: straightforward likenesses, outdoor studies, and genre pieces of models posed in scenes with narrative implications. Significantly for Lautrec, the first of these groups probably led to his meeting Degas. It comprised a series of portraits of the brothers Désiré and Henri Dihau and their sister Marie, who were friends of Degas. All were musicians, Désiré and Henri players in the orchestra at the Opéra and Marie a music teacher. Degas had portrayed Désiré in his painting of *c*.1868–9, *L'Orchestre de l'opéra*. The family owned the painting; Lautrec greatly admired it,[49] and eventually the Dihaus introduced their young artist friend to the older one.[50] The meeting perhaps explains an increase in Degas's direct influence on Lautrec's work in the immediately ensuing period, particularly his *toilette* scenes, which became numerous in 1891 and beyond.

Lautrec painted his portrait, *Mademoiselle Dihau au piano* (Fig. 123), sometime before mid-March 1890. It might have had its inspiration from the painting that Degas made of Marie Dihau at the piano *c*.1872, which the family also owned and which Lautrec included on the wall in his background.[51] Théo van Gogh saw Lautrec's portrait at the preview of the Salon des Indépendants, and in his letter of 19 March he reported to Vincent that 'de Lautrec has an excellent portrait of a woman at the piano'.[52] Vincent, too, expressed keen interest in the portrait. Possibly he saw it during his brief stay in Paris late in May 1890, on his way to Auvers from the south. He mentioned it in a letter of July 1890, written to Théo shortly after his return to Auvers from an especially stressful second visit to Paris. In this letter Vincent recalled the 'agony' of his most recent visit to his brother; but in a postscript he seemed to reminisce about the happier occasion in May, which had followed his months of mental illness at Saint-Rémy: 'I retain many very pleasant memories of that journey to Paris, for several months I had hardly dared hope to see my friends again. . . . Lautrec's picture, portrait of a musician, is amazing, I saw it with emotion.'[53] The Dihau family owned the

[46] In *La Cravache parisienne*, no. 478 (19 Apr. 1890).

[47] G. Geffroy, *La Vie artistique* (Paris, 1892), i. 305, entry dated 22 Apr. 1890, and J.L., 'Aux indépendants', *Mercure de France*, i, no. 5 (May 1890), 176. See also *L'Art français*, no. 155 (12 Apr. 1890).

[48] See Welsh-Ovcharov, *Van Gogh and the Birth of Cloisonism*, 248–55, for reproductions.

[49] Cf. Rewald, *Impressionism*, 568, and Mack, 59–60. Both recount Mlle Dihau's reminiscence as related to Paul Sachs. Lautrec's lithograph of 1893, *Pour toi* (Adhémar, 90; Delteil, 19; Wittrock, 6) which illustrates the sheet music to a song by Désiré Dihau, and 2 related drawings (D3381 and D3383) derive immediately from Degas's likeness of Désiré playing the bassoon in the opera orchestra.

[50] Gauzi, 143.

[51] Cf. D. Cooper, *Lautrec*, 86, and M. Arnold, 'Toulouse-Lautrec and the Art of His Century', in Wittrock and Castleman (eds.), 47.

[52] Van Gogh, iii. 565, no. T29.

[53] Ibid. iii. 295–6, no. 649. Van Gogh refers to his months of mental illness at Saint-Rémy prior to his departure for Paris in May, during which he no doubt despaired of seeing his friends again, substantiating the notion that his remarks refer to his memories of the May visit to Paris when he stopped there on his way to Auvers from the South. See also the 1913 reminiscence of Théo's wife, Johanna van Gogh-Bonger, comparing the two visits (i, pp. l–lii). While she notes that Vincent lunched with Lautrec in July, it is possible that the two artists saw one another in May as well.

painting, and it is tempting to speculate that Lautrec took van Gogh to their home in May. In June, a month later, van Gogh, possibly inspired by Lautrec, painted his own, comparable portrait, *Marguerite Gachet at the Piano* (Fig. 124).[54]

The two likenesses, Lautrec's of Mademoiselle Dihau and van Gogh's of Mademoiselle Gachet, further document the rapport between these artists. Not only are the format, composition, and pose of the subject of van Gogh's painting close to Lautrec's, but it has a remarkably similar style. Like Lautrec—though in a more abstract and schematic fashion—van Gogh combined a background of pointillist-like dots with a figure that he defined in longer streaks of paint, both vertical and curved. Lautrec built his composition around the contrast between blue and orange; van Gogh also used complementary colours, though in greater variety. Even in its details, van Gogh's painting is close to Lautrec's, especially in the way he placed the sheet of music and the candle on the piano.

Lautrec also did three likenesses of Désiré and Henri Dihau this same year. They are comparable in style to one another and to the portrait of Marie. He probably painted them during the spring and early summer of 1890; all three picture an outdoor setting, as in spring or summer, but Lautrec left Paris in later summer and did not return until far into October.[55] One of them, *M. Henri Dihau* (Fig. 125) or '*M. Dihau saluant*', was exhibited at the Cercle Volney in January 1891 (and again that year at the Salon des Indépendants) and thus had to be a product of the previous year. Long streaks of paint for the figure and abbreviated strokes for the background characterize *M. Henri Dihau*, and the artist enhanced the good-natured air of his subject by concentrating on the silhouette and giving the painting the slightly caricatural title of 'Le Jovial M. Dihau' when he exhibited it in 1891.[56] In all three of his portraits of the Dihau brothers, the artist used an impressionistic colour scheme in purple and green. It recalls the portraits he had done in previous years in the garden of Père Forest. Lautrec also carried his *plein-air* studies into the new decade with a second series of portraits, all of female models posed in M. Forest's garden. These paintings, though they are undated, are attributable to 1890 by virtue of their strong stylistic similarity to *Au Moulin Rouge, la danse* and Lautrec's portraits of the Dihau family.

Lautrec did a third group of portraits *c.*1890–1, but they belong more to the category of genre painting than to the straightforward portraiture of the other two series because all of them have subtle narrative implications. In works such as these, in small formats, Lautrec made further explorations of contemporary urban subjects. Modern women gave him some of his favourite themes, in scenes of prostitutes and the *toilette*, and now he took up the everyday roles of the contemporary, 'liberated' woman—the latter a frequent subject of the illustrated press because she exemplified the changing morals and broadening freedoms it liked to celebrate. Here too, at a time of increasing difficulty in distinguishing 'between public prostitution and private sexual license',[57] it is likely that Lautrec's public would have perceived the unconventional women as clandestine prostitutes. Of this group of portraits, Lautrec

[54] Van Gogh, iii. 288–9, no. 645, June 1890, Vincent to Théo; and iii. 574–6, no. T39, 30 June 1890, Théo to Vincent in reply to no. 645. Both describe this painting. Cooper, *Lautrec*, 86, and de la Faille, F772, maintain that van Gogh did not see Lautrec's painting until July and therefore could not have been influenced by it. By contrast, Rewald, *Post-Impressionism*, 375, and Adriani (Tübingen), 104–6, theorize that van Gogh saw the Lautrec at the time of his visit to Paris in May.

[55] Cf. Goldschmidt and Schimmel, no. 103, 115–16. I disagree with Schimmel's removal of this letter to June 1887 (H. Schimmel, no. 143, 114). See also ibid. nos. 178, 179.

[56] Goldschmidt and Schimmel, no. 110, 122, n. 2.

[57] Clayson, 202.

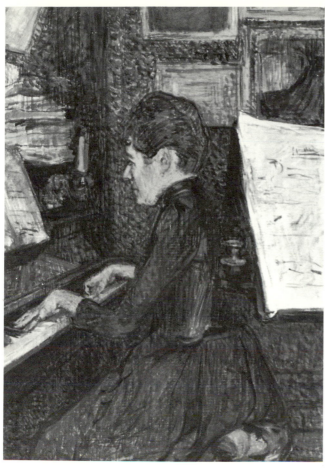

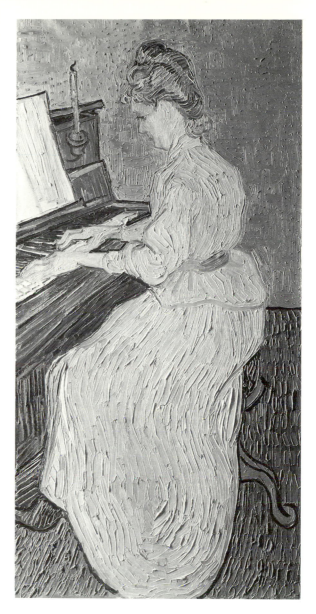

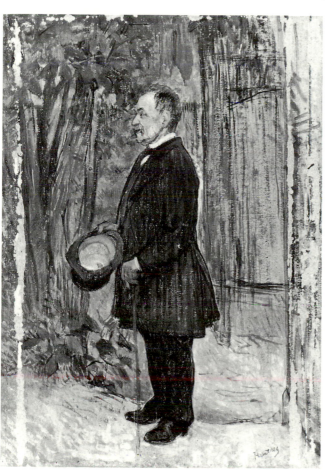

123. Above, left: Henri de Toulouse-Lautrec, *Mademoiselle Dihau au piano*. Albi, Musée Toulouse-Lautrec.

124. Above, right: Vincent van Gogh, *Marguerite Gachet at the Piano*. Oeffentliche Kunstsammlung Basel, Kunstmuseum.

125. Left: Henri de Toulouse-Lautrec, *M. Henri Dihau*. Albi, Musée Toulouse-Lautrec.

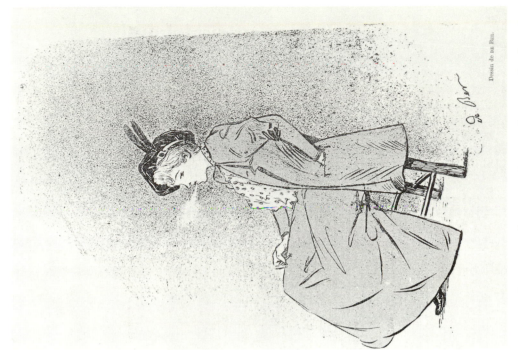

Dessin de ne Ban.

127. Ber, after, *Femme fumant une cigarette*. Zinc engraving from *Le Courrier français* (25 Dec. 1892). Paris, Bibliothèque Nationale. (Photo, Bibliothèque Nationale.)

126. Left: Henri de Toulouse-Lautrec, *Femme fumant une cigarette*. New York, Brooklyn Museum.

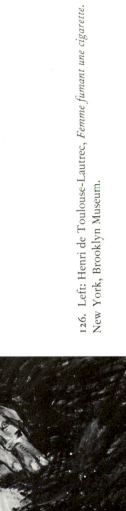

signed and dated *Femme fumant une cigarette* (Fig. 126), and the rest are datable to *c*.1890 in relation to it. *En meublé* or 'The Furnished Room' and *Femme assise de profil vers la gauche* (probably also titled 'En meublé' originally)[58] appear to be studies of the same model as in *Femme fumant une cigarette*, and they have a comparable subject-matter and style. All three paintings represent the independent woman who lived alone in furnished rooms, wore tailored, 'masculine' attire, and even smoked. The woman smoking, a modern phenomenon, and one associated with dubious morals, was common in the caricatures of the period, and an approximately contemporary example (Fig. 127) depicts a figure much like Lautrec's subject in her dress and self-assured posture: Lautrec was representing a popular stereotype. Yet his portrayal typically has a sympathetic quality and a sensitivity that surpass mere caricature.

Another painting that belongs to the group in style and subject-matter is *A la mie* (Fig. 128), which Lautrec exhibited with *En meublé* at the Salon des Indépendants in the spring of 1891. He probably painted it during late 1890 or early 1891. Like the other works in the group, it manifests the combination of streaks and hatchings common in Lautrec's painting of *c*.1890, and still evident in some works of 1891. In paintings such as *Femme fumant une cigarette*, Lautrec began to experiment with the off-centre placement of his figures, and he demonstrated his growing proficiency in the manipulation of line by giving a new linear elegance to the profiles of his models. In *A la mie*, he also concentrated on the manipulation of abstract elements, particularly contour. But here he exaggerated—almost to the point of parody—the dejected facial expressions and attitudes of his *déclassé* sitters and focused on the seediness both of the figures and their surroundings.

A la mie is a double portrait of Maurice Guibert, the artist's friend, with his mistress, Mariette Berthaud (Lautrec probably worked from a photograph),[59] but its narrative and anecdotal implications make it a genre scene. Here Lautrec returned to the Realist theme of the dissipated drinker, in a picture of the sordid, degraded side of modern life. His grim and uncommunicative alcoholic couple seated at a run-down café recalls many similar images in the illustrated press (e.g. Fig. 129)[60] and is also strongly reminiscent of Degas's *L'Absinthe* of *c*.1876 (Fig. 130). Both paintings parallel a scene in Zola's *L'Assommoir*, 'where Gervaise, having abandoned pride and hope, drinks herself into a stupor with Coupeau and his cronies'.[61] Degas had completed *L'Absinthe* before the publication of the novel; it could not have influenced him.[62] Lautrec, on the other hand, probably saw William Busnach's stage adaptation of Zola's novel, which was revived at the Théâtre des Menus-Plaisirs during the autumn of 1890.[63] In the play's seventh tableau, the reformed Coupeau has been enticed back into his old drinking habit. He spends all his pay in a bar, where Gervaise, his unhappy wife, finds him. He cannot get up; and she, also failing to resist the lure of drink, joins him.[64] The episode seems to seal their fate forever. Zola called this his favourite scene in his preface to

[58] Lautrec showed 2 paintings entitled 'En meublé' at the Indépendants in 1891 and at Les Vingt in 1892.

[59] The use of photographic documentation as an *aide-mémoire* was occasionally a part of Lautrec's procedure. Several such photographs are published in Dortu and Huisman. See also F. Daulte, 'Plus vrai que nature', *L'Œil*, 70 (Oct. 1960), 48–55.

[60] See also e.g. J. Faverot, *Deux heures du matin, la dernière cigarette*, cover of *Le Courrier français* (31 Oct. 1886).

[61] Reff, *Degas*, 170. An additional inspiration may have been Raffaëlli's *Les Buveurs d'absinthe*, shown at the Salon of 1889. See Thomson, 'The Drinkers', 29–33.

[62] Reff, *Degas*, 322 n. 95, 166.

[63] Cf. *La Revue théâtrale illustrée*, no. 16 (Nov. 1890).

[64] W. Busnach and O. Gastineau, *L'Assommoir* (Paris, 1880), 7th tableau, act 4, scene 7, pp. 150–2.

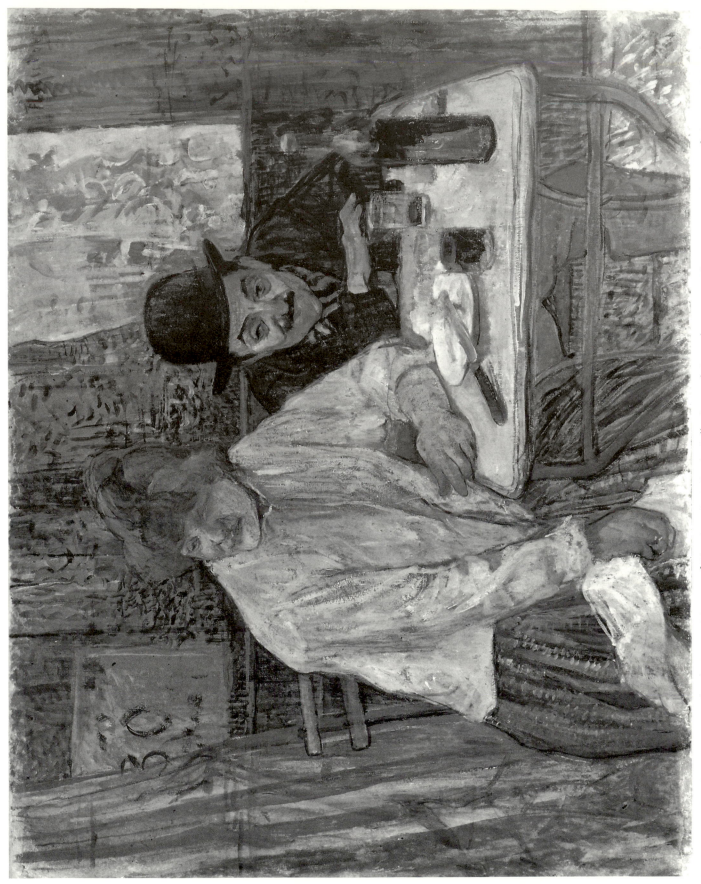

128. Henri de Toulouse-Lautrec, *A la mie*. Boston, Museum of Fine Arts, S. A. Denio Collection, and General Income. (Photo, courtesy Museum of Fine Arts, Boston.)

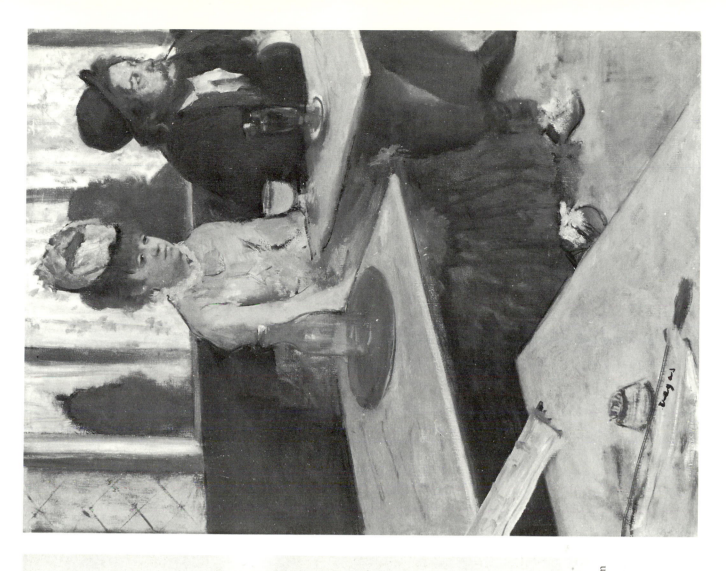

129. Théophile Alexandre Steinlen, after, *Dos et marmites*. Zinc engraving from cover of *Le Mirliton*, no. 57 (May 1889). New York, collection of Mr and Mrs Herbert Schimmel.

130. Right: Edgar Degas, *L'Absinthe*. Paris, Musée d'Orsay. (Cliché des Musées Nationaux.)

the play, a 'slice of life' in which the drama of alcoholism was staged with unprecedented rawness.[65] But even if the resemblance of Lautrec's painting to Zola's scene is coincidental, it demonstrates Lautrec's continued kinship with the milieu of Naturalism.

The Belgian critic Émile Verhaeren praised *En meublé* and *A la mie*, and referred to the artist as a *caractériste* in the manner of Raffaëlli and Forain because of his ironic vision and choice of subject—yet distinct from them in his use of colour and serpentine curves.[66] Gustave Geffroy also singled out *A la mie* in his comments about Lautrec's work at the Indépendants of 1891, and distinguished Lautrec from the Neo-Impressionists, in whose room his paintings had been hung: 'M. Toulouse-Lautrec jeeringly represents in grimy colours, suspicious milieux where hideous creatures appear, the larvae of vice and misery.'[67]

By 1890, Lautrec was gaining visibility for his art and a wider reputation. Not only did he participate in the official exhibitions, but the press also recognized him in critical reviews and dealers increasingly displayed his work informally in their galleries.[68] What critics and the public saw was a pictorial content still closely related to the outlook of the popular press, but on a vastly more imposing scale, and an artistic style that had stabilized into a distinctive personal mode. Although Lautrec's direction was towards the greater abstraction and more self-conscious stylization that was later to relate his art to the trends of the *fin de siècle*, he never abandoned his commitment to Realism and Naturalism. And when he manipulated the abstract means it was not only for their own sake, but also to augment subjective expression and realistic characterization. While he heightened the abstract and subjective elements of his art, therefore, he also enhanced its realism; his change was in emphasis only.

Postscript, 1891: Stripping 'to essentials'

The year 1891 was pivotal in Lautrec's career. In particular, towards its end he turned to lithography, which initiated the second phase of his maturity. During this stylistically innovative phase he found inspiration in the Japanese print, the work of Whistler, and the Art Nouveau and Symbolist tendencies of the 1890s. Presumably he also found excitement in his own experiments with graphic media. Yet in 1891 he continued to investigate some of his old themes in paintings whose style differed only subtly from that of the works of 1890. He still worked out of doors; the portrait remained his mainstay, he produced a series of male likenesses and another of genre studies of women at their *toilette*; and he did further investigations of the theme of the Moulin Rouge. In contrast to this continuity, however, Lautrec's major composition of this year was not a monumental painting, but the coloured lithographic poster *La Goulue au Moulin Rouge* (Fig. 137), his first original print. Its appearance established his reputation overnight, its creation began that part of his history beyond the

[65] W. Busnach and O. Gastineau, *L'Assommoir* (Paris, 1880), preface, 15.

[66] Émile Verhaeren, review of the Salon des Indépendants, *L'Art moderne*, 21 (5 Apr. 1891), 112.

[67] Geffroy, *La Vie artistique*, i. 309, Apr. 1891. See also J. Leclercq, 'Aux indépendants', *Mercure de France*, 2, no. 17 (May 1891), 299.

[68] From Aug. 1890 onwards, the 'Choses d'art' column in *Mercure de France* noted that works by Lautrec were on view at the Boussod and Valadon Gallery and at Chez Thomas, Boulevard Malesherbes (see vol. 1, 1890, and vols. 2 and 3, 1891; also vol. 4, Jan.–Apr. 1892).

scope of the present work. Though the poster's theme was familiar in Lautrec's work, its style constituted a dramatic advance and its medium was entirely new to the artist.

Exhibition catalogues greatly facilitate reconstruction of the chronology for 1891. In March, Lautrec showed a sizeable number of works (perhaps as many as ten) at the seventh Salon des Indépendants. In May, he showed two at the Salon des Arts Libéraux, and, in December, seven at Le Barc de Boutteville's gallery. Early in 1892, he took nine works to the Exposition des Vingt and showed several others at the Cercle Volney, all of them presumably belonging to the œuvre of 1891 at the latest. This was his final showing at the conservative Volney club, incidentally (he was rejected by the jury in January 1893),[69] an additional sign that 1891 was a pivotal year. Lautrec dated many of his 1891 works, wrote informative letters, and received a growing number of press notices—all further documentation of his development during this year.

Lautrec had first depicted the theme of the *toilette* in 1889. In 1891, he took it up again in a series of paintings that embodied a new emphasis on contour and abstract shapes and a freer, sketchier adaptation of his brush stroke of 1890 (e.g. Fig. 131). In style these works were frankly imitative of Degas, specifically of pastels that he did of similar subjects *c*.1887–90, some of which the Boussod and Valadon Gallery exhibited in late 1890.[70] (It was not a coincidence, therefore, that in September Lautrec wrote to his mother: 'Degas has encouraged me by saying that my work this summer wasn't too bad. I'd like to believe it.'[71] It is the earliest documentation that Degas reacted favourably to Lautrec's work.) But the Lautrec *toilette* scenes also had precedents in Legrand's illustrations in *Le Courrier français* of women combing their hair (e.g. Fig. 132).[72]

Of the *toilette* series, Lautrec signed and dated one of two related paintings titled *Femme se frisant* and one of three titled *Celle qui se peigne*. One of the undated paintings entitled *Celle qui se peigne* (Fig. 131), probably was one of two studies he exhibited early in 1892 at the Cercle Volney, and this also serves to verify its date.[73] Lautrec also made two portraits of a friend's wife, Madame Fabre, at her *toilette*, both undated (the works he may have referred to in his letter to his mother about Degas's encouraging remarks), with a strong stylistic similarity to the others from 1891 on this theme. Lautrec himself dated a third picture of Madame Fabre with her dog 1891.

Although some of the *toilette* scenes may be representations of prostitutes, observed in private moments, none of Lautrec's explicit brothel scenes has been placed as early as 1891

[69] In a letter of 19 Jan. 1893 to Roger-Marx, Lautrec reported his response to the rejection. Cf. H. Schimmel, no. 264, 195. NB His participation in the 1892 showing of Les Vingt is recorded in a series of 3 letters written to Maus in Nov. and Dec. 1891 and Jan. 1892 [H. Schimmel, no. 207, 153; no. 213, 158; no. 214, 167.] and in a letter written to his mother from Brussels on 6 Feb., the exhibition opening day. Published in Dortu, Grillaert, and Adhémar, 8–9, but erroneously dated 1890 by them. H. Schimmel, no. 216, 168.

[70] Cf. A. Aurier, 'Choses d'art', *Mercure de France*, no. 11 (Nov. 1890), 415, who cites in particular 'un merveilleux pastel de Degas: femme nue, assise parterre, se peignant'. (Esp. comparable to Lautrec's paintings are Lemoisne, nos. 930, 935, 976, 977, 978.)

[71] H. Schimmel, no. 205, 152. Contrary to most other sources, Rothenstein, 106, mentions in his memoirs of Paris in the late 1880s and early 1890s that Degas admired Lautrec's work as does J. E. S. Jeanès, *D'après nature* (Geneva, 1946), 36–7, in an undated recollection.

[72] See also e.g. Legrand's cover for *Le Courrier français* of 9 Mar. 1890 (no. 10), which is close to P347.

[73] The painting is mentioned by Geffroy, *La Vie artistique*, ii. 359 (5 Feb. 1892). Lautrec's exhibition of 'two studies' is also noted by C. Mauclair, 'Beaux arts: Cercle Volney', *La Revue indépendante*, 22 (Mar. 1892), 416. That the exhibition opened on 25 Jan. is revealed in H. Schimmel, no. 215, 167–8, which also notes the favourable review of Lautrec's work in the republican newspaper, *Le Paris*.

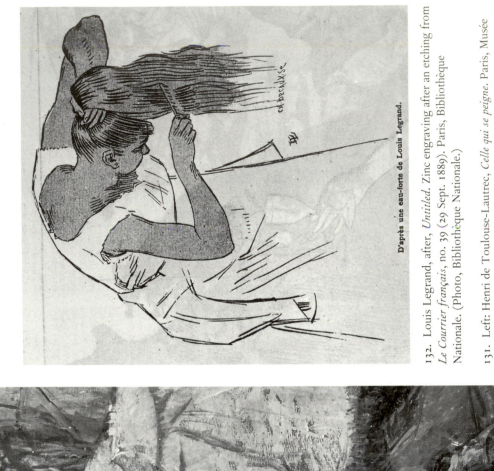

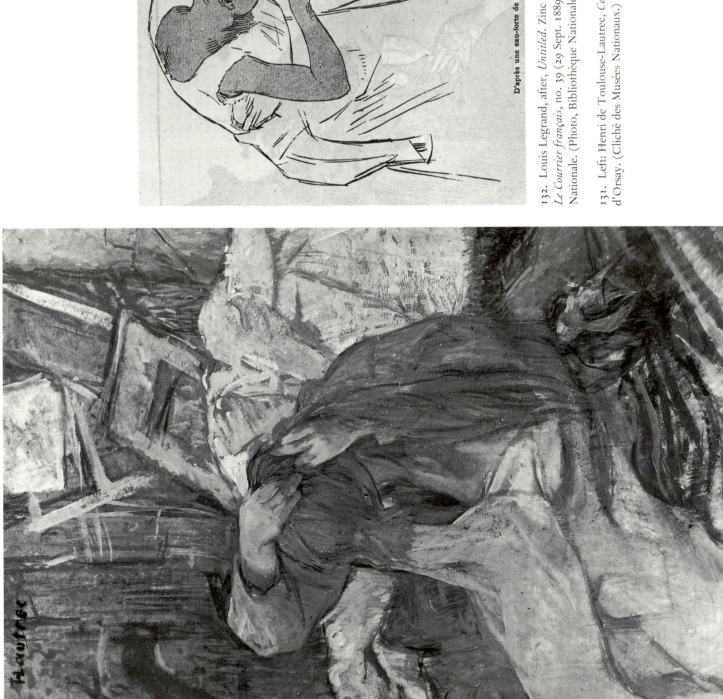

132. Louis Legrand, after, *Untitled*. Zinc engraving after an etching from *Le Courrier français*, no. 39 (29 Sept. 1889). Paris, Bibliothèque Nationale. (Photo, Bibliothèque Nationale.)

131. Left: Henri de Toulouse-Lautrec, *Celle qui se peigne*. Paris, Musée d'Orsay. (Cliché des Musées Nationaux.)

heretofore. None the less witness accounts exist that must refer to 1891 paintings of prostitutes in their salons. The first is a journalist's report of his interview with the painters taking part in a small exhibition, Impressionistes et Symbolistes, at Le Barc de Boutteville's gallery in December 1891. A group of Nabis had organized the show, which included works by Anquetin, Bernard, Maurice Denis, and Pierre Bonnard as well as Lautrec (who told the interviewer, J. Daurelle of *L'Écho de Paris*, about his preference for the art of Degas and Forain). Daurelle commented on the Lautrec paintings with a rhetorical question: 'Do not his women, dreaming in a melancholy mood on the sofas of "public convents", betray qualities of a truly cruel observation?'[74] Two paintings in the list of works by Lautrec in the exhibition catalogue fit Daurelle's observation: *Femme divan rouge* (no. 74) and possibly *Femme rousse assise* (no. 71).[75] A second observer, who viewed the ninth Exposition des Vingt in February 1892, referred similarly to the artist's brothel interiors with women on 'red sofas or settees'.[76] Probably some of Lautrec's paintings at Les Vingt had been among those he showed in December with the Impressionnistes et Symbolistes. On the basis of this evidence, and because of their stylistic resemblance to the *toilette* paintings of 1891, this study suggests the redating of certain of Lautrec's brothel scenes to 1891.

Lautrec probably painted the last of his outdoor studies in 1891. Perhaps as he focused increasingly on graphic art and incorporated artificiality into his work to a greater degree, his interest in *plein-air* studies, basically a manifestation of his Realist–Naturalist and Impressionist preoccupations, simply fell away. He dated just one *plein-air* painting in 1891, *Gabrielle la danseuse* (Fig. 133). In it, as is characteristic of his paintings of this year, he moved stylistically towards a stress on abstract elements. The contours of the figure are notable for their gracefulness, and the model's jacket and blouse, as well as the trees in the background, read as flat shapes on the painting's surface.

Lautrec's major effort of early 1891 was a group of straightforward male portraits, all Whistlerian in style, all of subjects who belonged to his own circle of friends. Each of these works was a variation on the theme of the elegant silhouette of a figure seated or standing in the painter's studio, set against a neutrally coloured background. Several show a Japanese scroll hanging on the wall. As a group they represented Lautrec's return to his earliest subject-matter, the worldly, aristocratic gentlemen whom he first portrayed in his studies of fashionable riders in the bois de Boulogne. He signed and dated his 1891 portraits of Dr Bourges, Georges-Henri Manuel, and Paul Sescau (see e.g. Fig. 134), and Dortu correctly assigned another, that of Gaston Bonnefoy, to 1891. A fifth, the portrait of Louis Pascal, is consistent in style and setting with the dated portraits in the series of 1891.

The evidence of exhibitions and letters corresponds to the stylistic evidence in the undated male portraits of 1891, and places at least four of them early in the year. In March, Lautrec showed his portraits of Bourges and Sescau at the Salon des Indépendants along with those

[74] J. Daurelle, 'Chez les jeunes peintres', *L'Écho de Paris* (28 Dec. 1891), quoted in trans. by Rewald, *Post-Impressionism*, 462. Lautrec mentions the exhibition and this article in a letter of 26 Dec. 1891; cf. H. Schimmel, no. 212, 157.

[75] *Peintres impressionnistes et symbolistes* (exh. cat., 1st Exhibition, Le Barc de Boutteville Gallery, Paris, 1891).

[76] E. Demolder, *L'Artiste* (Mar. 1892), 227. The catalogue of this exhibition also lists a work entitled 'Femme rousse assise' (no. 6), as well as a 'Femme brune' (no. 9), possibly the works to which Demolder refers. C. Mauclair, 'Beaux arts: Galerie de le Barc de Boutteville', *La Revue indépendante*, 22 (Jan. 1892), 143, also notes Lautrec's paintings of prostitutes at this showing. A. Alexandre, *L'Art du rire et de la caricature* (Paris, 1892), 346–7, likewise remarks on Lautrec's brothel subjects.

of Bonnefoy and Pascal. In May, he showed the portrait of Sescau at the Salon des Arts Libéraux. Three of his letters of 1891 contain references to the paintings of Pascal and Bonnefoy. In February, apparently in anticipation of the coming Salon des Indépendants, Lautrec reported, 'I'm busy with my exhibition, with three portraits in the works: Gaston [Bonnefoy], Louis [Pascal], and Bourges.'[77] Around this time he also wrote that Pascal was seeing him frequently, 'since I'm doing his portrait'.[78] Finally, in another letter of the same period, he told his mother, 'I've just finished the portrait of Gaston Bonnefoy and have begun one of Louis.'[79]

Lautrec's concentration on the silhouettes, the elegant contours, of the figures in these portraits of men spelled a new emphasis in his work. He paid close attention to their dandified attire and often depicted them wearing top hats and carrying walking sticks—provoking the reviewer Henry Gauthier-Villars to remark on the 'gaunt snobbism of parisian pseudo mashers "who grow pale in London" ' in his works at the Salon des Indépendants of 1891.[80] Lautrec's use of cardboard and his rough, sketchy application of paint in predominating long, vertical sweeps were his own artistic devices, but his paler, toned-down colours and his limited palette of tans, greyish blues, and greens were new. Whistler probably influenced both his new researches into subtle colour harmonies and his very resumption of the theme of the sophisticated gentleman boulevardier, the friend at ease in the artist's studio. Joyant himself noted a Whistlerian mood in Lautrec's work of this time.[81] Lautrec's representations of debonair sitters in simple compositions with muted tones were related to Whistler's portraits, especially the portrait of Théodore Duret (Fig. 135), which was in Paris in Duret's possession; Lautrec's seated figure of Georges-Henri Manuel recalls Whistler's portrait of his mother—which entered the collection of the Musée de Luxembourg in 1891—and that of Thomas Carlyle.[82] Whistler was tremendously popular with French artists during the early 1890s, and Lautrec's male portraits as a group are comparable not only to his works but to similar examples by other painters also in pursuit of the ideal of elegance à la Whistler. Seurat portrayed Signac in this manner, and Degas and his followers produced many such paintings. Incidentally, Lautrec exhibited a painting entitled 'Nocturne' among his works at the Exposition des Vingt of 1892, and, although it cannot be identified with any certainty,[83] the title further relates

[77] H. Schimmel, no. 186, 140–1; these 3 portraits were listed in the catalogue of the 7th Salon des Indépendants no. 386, no. 390, no. 389, respectively. Only the portrait of Sescau, perhaps due to late arrival, was not listed, but it was mentioned in exhibition reviews. See Société des Artistes Indépendants, *Catalogue des œuvres exposées*, 7th Exhibition, 20 Mar.–27 Apr. 1891, Paris, 1891, 23. See also H. Schimmel, no. 189, 142–3, of mid-Mar. 1891 in which Lautrec speaks of his rush to deliver 'les ouvrages' to the exhibition. The works were critized for their 'couleur lugubre' but praised for their line by Jules Antoine in his review of the Indépendants in *La Plume*, no. 49 (May 1891), 157, and the portrait of Sescau was mentioned by Octave Mirbeau in his review in *L'Écho de Paris* (31 Mar. 1891).

[78] Ibid, no. 188, 142. Recently moved from Jan. to Feb. by Schimmel.

[79] Dortu and Huisman, 71. [H. Schimmel, no. 187, 141.]

[80] H. Gauthier-Villars, 'Le Salon des Indépendants', *La Revue indépendante*, 19 (Apr. 1891), 112.

[81] Joyant, ii. 20.

[82] Whistler showed several portraits at the Salon of 1891, including that of Théodore Duret, according to Geffroy, *La Vie artistique*, i. 266–78.

[83] Dortu, Grillaert, and Adhémar, 30, identify it as *Au Moulin Rouge* (P427). In my dissertation ('Problems in the Chronology', 374–80), I concurred with them and speculated that the painting must have been completed in 1891 in order to have been exhibited at Les Vingt in 1892. I also noted that Lautrec appeared to have added an L-shaped piece of canvas at the bottom and right side of what I thought had been his original image of 1891, thereby enlarging it by some $6\frac{1}{2}$ ins. in width and $10\frac{3}{4}$ ins. in height. What I believed to be the original canvas was reproduced in A. Alexandre, 'Le Peintre Lautrec'. By identifying the startling, cropped, close-up likeness of the woman at the far right on the 'new' segment of canvas as May Milton I was able to date the 'addition' to 1895, the only year that Lautrec used her as a model. However, Reinhold Heller, working in conjunction with a

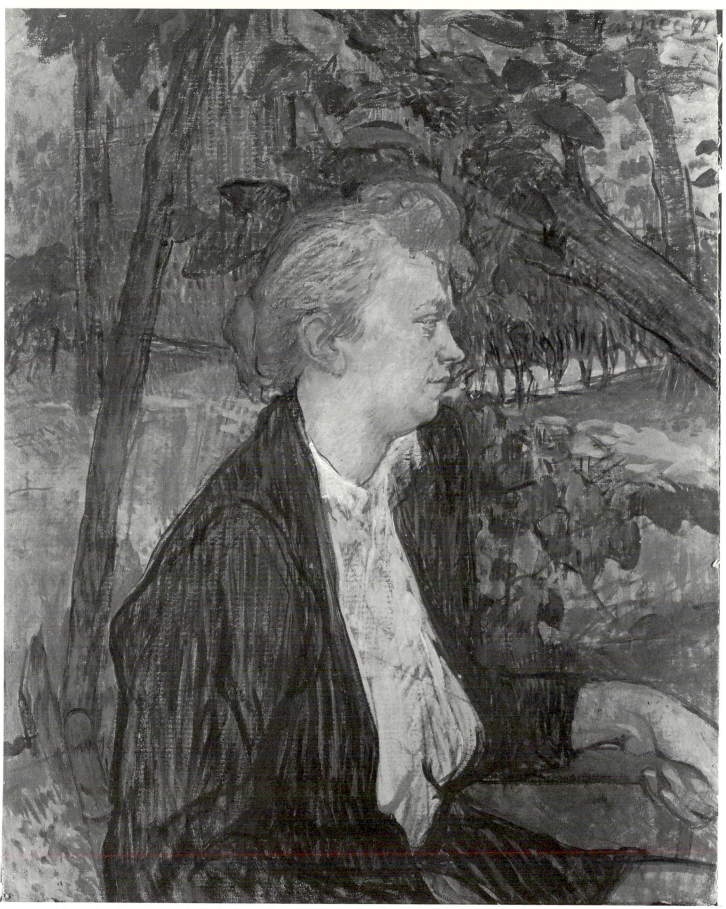

133. Henri de Toulouse-Lautrec, *Gabrielle la danseuse*. London, National Gallery. (Reproduced by courtesy of the Trustees, The National Gallery, London.)

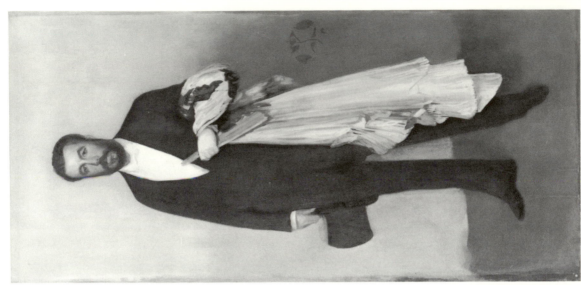

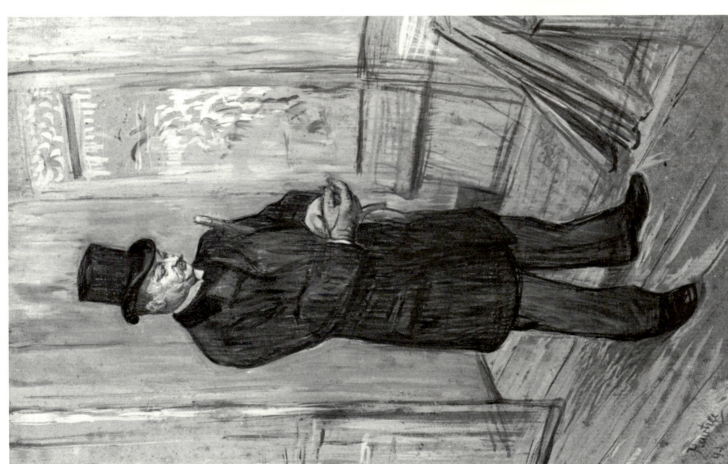

135. James McNeill Whistler, *Arrangement in Flesh Colour and Black: Portrait of Théodore Duret.* New York, Metropolitan Museum of Art, Wolfe Fund. All rights reserved.

134. Left: Henri de Toulouse-Lautrec, *M. le docteur Bourges.* Pittsburgh, Carnegie Museum of Art, acquired through the generosity of the Sarah Mellon Scaife family, 1966.

him, in 1891, to Whistler, who had shown several of his landscape 'Nocturnes' at the Salon of 1890,[84] and who had advocated the painting of night scenes in his 'Ten O'Clock' lecture, translated into French by Mallarmé in 1888.

The combination of a slightly heightened abstraction with a naturalistic subject typified much of Lautrec's work at this time. The perceptive Belgian critics noted the expressive use of colour in Lautrec's paintings at Les Vingt in 1892 as well as his ability to seize character through line, which they recognized as qualities that existed in his work in conjunction with his naturalistic interest in the *canaille*.[85] By 1891, his stylistic concentration was increasingly on the decorative, and he used flattened shapes and curving contours with growing self-consciousness to draw attention to the surfaces of his paintings. As his stylization became more pronounced, he also liked to juxtapose sketchily brushed areas with broad, smooth forms—devoid of modelling or the evidence of his stroke—that insistently contradicted perspective plunges into depth. He did at least three small representations on cardboard of the nocturnal activities of the Moulin Rouge in 1891, all undated and all sharing the integration of the naturalistic with the stylized and moderately abstract. Any of them might have been the 'Nocturne' exhibited at Les Vingt. They were part of a series of studies of the Moulin Rouge that he probably did in the autumn and winter of 1891–2 to celebrate the first season of the music hall under the new management of Joseph Oller. He exhibited some of these at the Salon des Indépendants in the spring of 1892 and yet others at the Boussod, Valadon et Cie Gallery in 1893.[86] The examples stylistically attributable to 1891 contrast the more consistently decorative and relatively more stylized representations of the Moulin Rouge that Lautrec must have made in 1892, following the Moulin Rouge poster of autumn 1891. In two of the 1891 portrayals, *Au Moulin Rouge* and *Au Moulin Rouge, le départ du quadrille*, Lautrec once again took up an old theme. His precedent was his grisaille of 1888, *A l'Élysée Montmartre* (Fig. 108), a depiction of a woman who raises her skirts as she steps onto the dance-floor. The third and most stylistically daring example, *Au Moulin Rouge ou La Promenade—La Goulue et Jane Avril au fond* (Fig. 136), focuses on the strollers at the periphery of the dance-hall rather than the dancers and includes the figure of La Goulue with her hands on her hips and that of Jane Avril dancing in the background. In *Au Moulin Rouge ou La Promenade*, Lautrec not only exploited contrasts between sketchily stroked and flatly painted areas, but carried further a device he had begun to use in 1890 in *Au Moulin Rouge, la danse*— that is, stylizing the trains of women's gowns into elongated, flat, curving shapes floating across the picture plane. His use of the dark, silhouetted figure to the extreme right as a *repoussoir* element is an even greater stylization.

The formal device of a figure that reads more as an abstract shape than as a recognizable person bridges the stylistic gap between relatively conservative works such as *Au Moulin*

(cont.) restorer at the Art Institute of Chicago, has recently proven conclusively that the 'added' segment with May Milton was part of the original canvas painted by Lautrec; it was cut off at some later date (presumably for exhibition in 1902) and subsequently reattached. The inevitable conclusion is that the canvas in its entirety is likely to have been painted in 1895. Cf. Heller, 114–35.

[84] Cf. Geffroy, *La Vie artistique*, i. 157. In addition, Théodore Duret's collection in Paris included at least 3 of Whistler's 'Nocturnes'. Cf. A. M. Young, M. Macdonald, and R. Spencer, *The Paintings of James McNeill Whistler* (New Haven, Conn., 1980), cat. nos. 156, 166, 173.

[85] See e.g. Demolder, 227.

[86] On this group of works see Joyant, i. 137–9, and Heller, 116.

Rouge ou La Promenade and Lautrec's most innovative production of 1891, his ground-breaking poster announcing the new season at the Moulin Rouge (Fig. 137). Furthermore, the profile of La Goulue's head in the poster is virtually identical to that in the painting and the two heads seem to share the same preparatory sketches. The poster belongs with Lautrec's other portrayals of the Moulin Rouge in 1891 even as it opened the way to his stylistic maturity. As a colour lithograph, it was his first original print, and in that respect has no precedent among his works—his earlier graphic art consisted merely of photomechanical reproductions of his drawings. The poster, entitled *La Goulue au Moulin Rouge*, depicts La Goulue and Valentin le Désossé, and constitutes Lautrec's definitive statement on the theme of the *quadrille naturaliste*.[87] It was a commissioned work for the Moulin Rouge, and Lautrec established its date precisely in two letters. 'My poster is pasted today on the walls of Paris', he wrote some time in December 1891, and on 26 December he reported its success.[88]

The Parisian craze for the *quadrille* had reached frenzied heights in 1891. Beginning late in October 1890 and continuing into the new year, the dramatic actress Réjane created a nightly sensation with her performance of the *quadrille* on stage in her role as the star of Henri Meilhac's popular comedy, *Ma Cousine*, at the Théâtres de Varietés. When it was publicized that she had taken lessons from Grille d'Égout, the dance won the enthusiastic favour of respectable women of fashion, who flocked to classes where they could learn it from another star of the Moulin Rouge, Nini-patte-en-l'air.[89] In imitation of the dancers at the Moulin Rouge, these same fashionable women also adopted *la mode canaille* in their dress.[90] The journal *Gil Blas* inaugurated an illustrated supplement with two highly successful issues on the subject of the *quadrille naturaliste* in May 1891.[91] They described in detail the history of the dance, the stars who performed it, and even the proper attire for it, in addition to the steps or 'figures' that comprised it. Numerous illustrations in colour by Louis Legrand accompanied the subject-matter, and his *chahuteuses* in their red stockings and frothy drawers and petticoats (e.g. Fig. 138) foretold Lautrec's figure of La Goulue on the poster proclaiming the Moulin Rouge's entertainments of the autumn and winter. These special issues of the *Gil Blas* supplement were sold out immediately. Certainly Lautrec's poster appeared at exactly the moment to capitalize on this fad for the *quadrille*, and indeed to crystallize in a dynamic visual form the excitement that all Paris felt about it.

The genesis of the poster of 1891 lay in Lautrec's earlier renderings of the same theme, and their origins in popular imagery. All the basic elements, in fact, had already appeared in

[87] He was to represent the *quadrille* once more, in a large canvas for La Goulue's booth at the Foire du Trône in 1895 (P592), but it was merely a nostalgic reprise of the theme as a sentimental favour for an old friend, cf. Gauzi, 80.

[88] H. Schimmel, no. 211, 156, recently redated Dec. 1891 by him, and no. 212, 157. See also a letter of autumn 1891 in Dortu and Huisman, 90–1, in which Lautrec mentions the 'printing delays' that were holding up the publication of his poster. [H. Schimmel, no. 209, 154–5.]

[89] H. Meilhac, *Ma Cousine, comédie en trois actes* (Paris, 1897), première, 27 Oct. 1890. Her dance occurred during the pantomime in the second act. Cf. the numerous rave reviews: M. Savigny in *L'Illustration*, 96 (1 Nov. 1890); *La Revue théâtrale illustré*, no. 17 (Dec. 1890); H. Baur, *L'Écho de Paris* (29 Oct. 1890); *La Vie parisienne* (1 Nov. 1890); *Le Courrier français*, no. 49 (7 Dec. 1890); as well as Rodrigues [Ramiro], *Cours de danse*, 7–9, 13–17, and Montorgueil, *Paris dansant*, 176–8. See also the cover illustration by Legrand, *Une Élève de Mlle Réjane*, for *Le Courrier français* of 7 Dec. 1890.

[90] O. Uzanne, *La Française du siècle: la femme et la mode de 1792 à 1892* (Paris, 1893), 231–3.

[91] E. Rodrigues [E. Ramiro], *Les Excentricités de la danse, Gil Blas illustré*, pt. 1 supplement (10 May 1891); pt. 2 supplement (23 May 1891). Over 60,000 copies were printed to meet the popular demand. Cf. E. Rodrigues [E. Ramiro], *Louis Legrand, Peintre-graveur* (Paris, 1896), pp. iii–iv. A revised version was printed in book form the following year: see Rodrigues [Ramiro], *Cours de danse*.

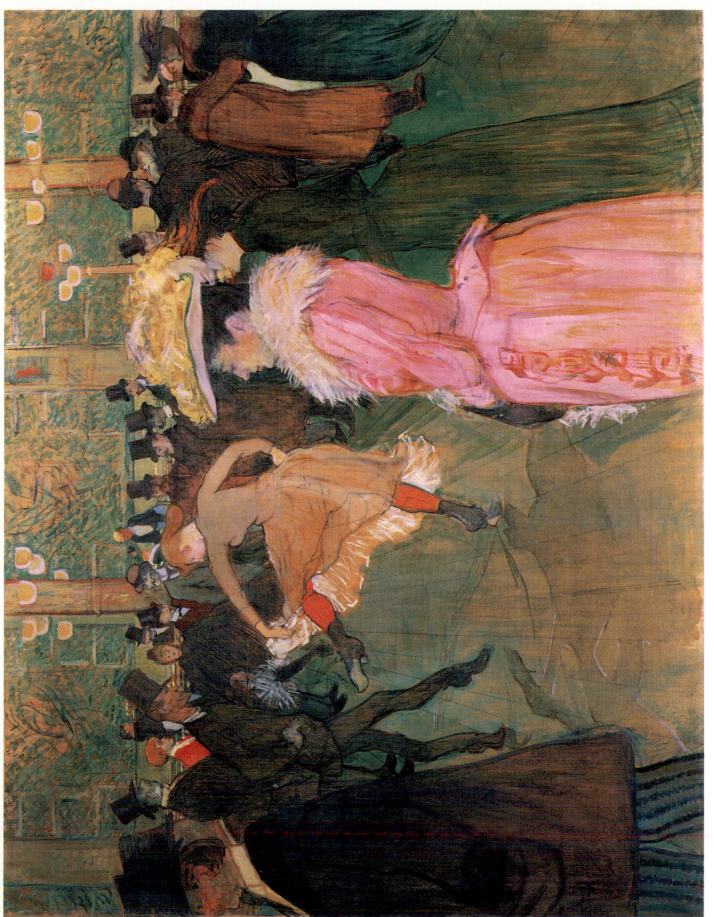

120. Henri de Toulouse-Lautrec, *Au Moulin Rouge, la danse*. Philadelphia, Museum of Art, Henry P. McIlhenny Collection in Memory of Frances P. McIlhenny.

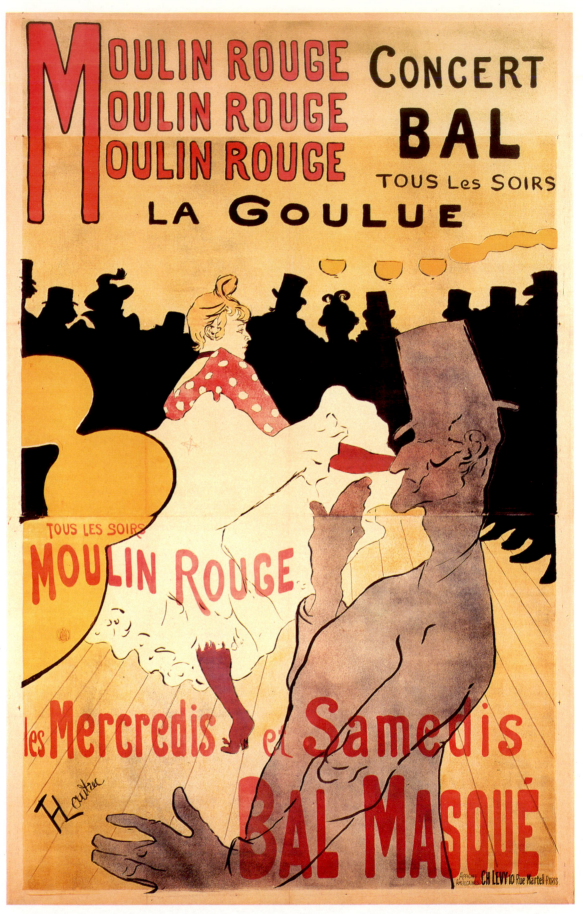

137. Henri de Toulouse-Lautrec, *La Goulue au Moulin Rouge*. Poster. Colour lithograph. Chicago, Art Institute, Mr and Mrs Carter H. Harrison Collection. (Photo, courtesy of The Art Institute of Chicago, © 1990. All rights reserved.)

Au Moulin Rouge, la danse, his masterpiece of 1890: the background frieze of top-hatted bystanders, the female dancer—now transformed into La Goulue—doing her insolent high kick, the wavy silhouette of Valentin le Désossé with his hat tipped rakishly forward, the receding orthogonals of the floorboards, the spatial organization in three parallel planes, the brilliant yellow lights encircling the background columns. In fact, the poster more or less repeats, in mirror image and more highly caricatured form, the format of the central section of the painting. These same elements had still earlier sources in Raffaëlli, Lunel, and other illustrators, and Lautrec repeated the predominantly red, yellow and black colour scheme of Raffaëlli.

In the poster, Lautrec achieved a union of Naturalism and abstraction in which he radically simplified space, eliminated modelling, and used colour arbitrarily. He carried the abstraction and the reductive tendency of his painting of 1890 to the extreme. Not only did he rearrange individual elements, but he translated the entire Naturalist scene into an idiom of exaggeration, abstract simplification, and extreme stylization. The figures, which he daringly reduced to silhouettes, became flat shapes against a flat surface, entirely negating the formerly illusionistic space despite the receding floorboards. In the foreground, Lautrec placed the greyish shape of Valentin, in the middle distance the white shape of La Goulue's petticoats and underdrawers, and in the background the sharply outlined row of spectators melded into a solid black silhouette. He set a single circle of yellow lights peculiarly afloat as a *repoussoir* in the left foreground. By means of these arbitrary forms, he jumbled the normal cues of aerial perspective, in which objects naturally blur and colour intensity fades in the distance. He also amplified his use of caricatural exaggeration and distortion to accentuate the salient and even the absurd features of his subjects, heightening the ironic humour of his presentation.

Lautrec's long-standing interest in Naturalism culminated in the Moulin Rouge poster, and at the same time newer directions in his style also crystallized. He magnified the shock value of his favourite subject-matter with the boldness of his abstraction and the originality of his presentation. Clearly a number of sources inspired his unprecedented emphasis on simplification, some possibly specific and immediate, others more or less indirect. Not all of them were necessarily new influences on his thinking or his art, but in the poster he brought them to mature realization. The Chat Noir cabaret might have been such a source. It offered nightly performances of the Montmartre shadow theatre, which could have suggested to Lautrec his backdrop of solid black figures in the poster.[92] He had never before exploited caricature so boldly—the element that lent the poster its expressiveness and the figures their character— and it had a general source in the tradition of popular illustration. The Japanese woodcut may also have directly influenced his caricatural distortion and other stylistic traits as well: his uptilted perspective; his juxtaposing of flat, clearly outlined areas of bright colour with no transitional modelling; his abbreviated forms; and the self-consciousness of his decorative effects and design.[93] Many of the stylistic qualities of Japanese art, especially the tilted ground

[92] The theory is advanced by W. Rubin, *Shadow and Substance: The Shadow Theater of Montmartre and Contemporary Art* (exh. cat., Houston Contemporary Arts Museum, 1956); also in 'Shadow, Pantomimes and the Art of the Fin de Siècle', *Magazine of Art*, 46 (Mar. 1953), 114–22. Gauzi, 96–9, recalls attending the Chat Noir shadow theatre with Lautrec.

[93] See T. Reff, 'Degas, Lautrec, and Japanese Art', in *Japonisme in Art, An International Symposium* (Tokyo, 1980), 206–7, on specific stylistic features in Lautrec influenced by the Japanese woodcut. General discussions of Lautrec and Japanese art can be found in the exh. cat., *Japonisme: Japanese Influence on French Art, 1854–1910* (Cleveland Museum of Art, Cleveland, Ohio, 1975),

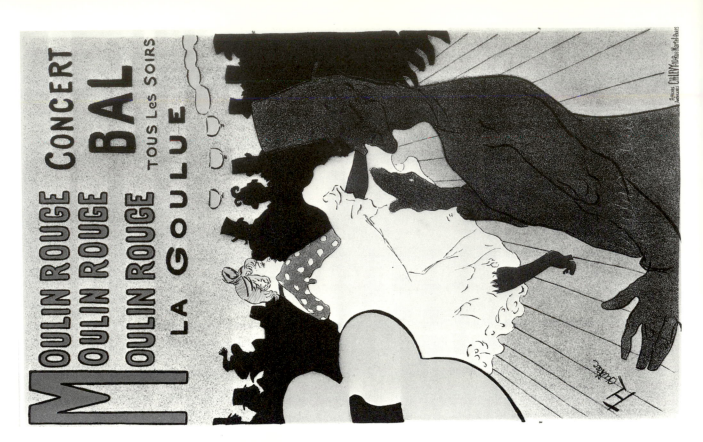

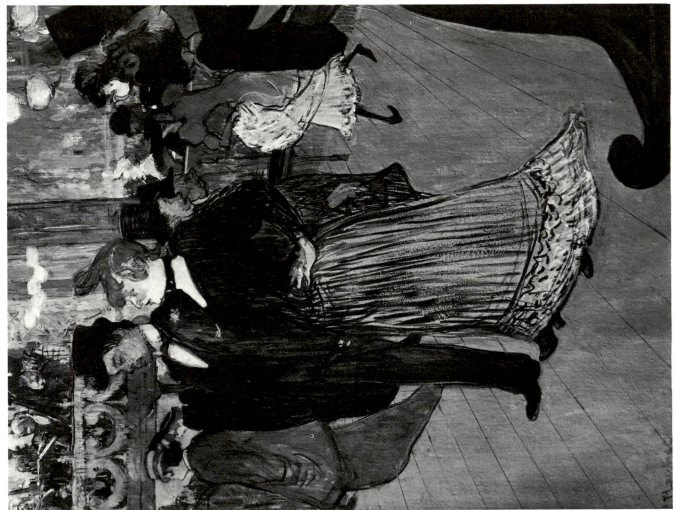

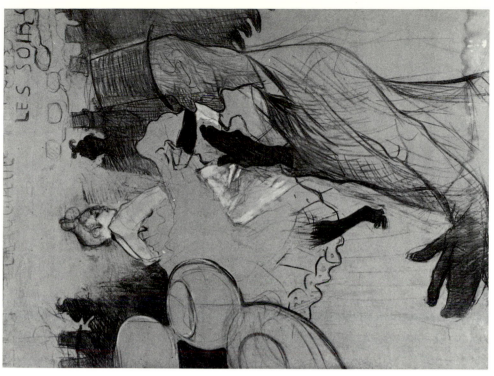

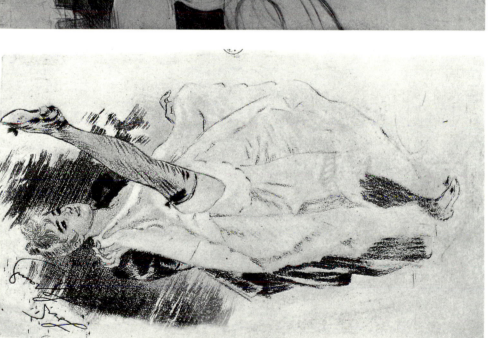

136. Above, left: Henri de Toulouse-Lautrec, *Au Moulin Rouge ou La Promenade—La Goulue et Jane Avril au fond*. Josse Bernheim-Jeune Collection, stolen by German troops in 1944. (Photo, Bernheim-Jeune, Paris.)

137. Above, right: Henri de Toulouse-Lautrec, *La Goulue au Moulin Rouge*. Poster. Colour lithograph. Chicago, Art Institute, Mr and Mrs Carter H. Harrison Collection. (Photo, courtesy of The Art Institute of Chicago, © 1990. All rights reserved.) *See also colour plate.*

138. Right: Louis Legrand, *La Série*. Etching from Eugène Rodrigues [Erastène Ramiro], *Cours de danse, fin de siècle* (Paris, 1892) (originally published as a zinc engraving after a watercolour by Legrand in *Gil Blas illustré*, May 1891). Paris, Bibliothèque Nationale. (Photo, Bibliothèque Nationale.)

139. Far right: Henri de Toulouse-Lautrec, *La Goulue et Valentin le Désossé*. Charcoal drawing on canvas, heightened with colour. Albi, Musée Toulouse-Lautrec.

planes and cropped figures, had reached Lautrec indirectly in the 1880s through Degas and others to whose artistic vocabularies these devices were integral.[94] But Lautrec manifested his own interest in Japanese art during that earlier period mainly by incorporating isolated objects into his paintings—a mask (Fig. 58), a kimono—or in two instances by using a fan-shaped format (e.g. Fig. 90). From 1891 on, the direct influence of Japanese stylistic devices became accentuated in Lautrec's work.

The art of his more avant-garde contemporaries may also have influenced Lautrec's rendering of the Moulin Rouge poster. It had precedents in the work of the Cloisonnists and Synthetists, particularly in Bernard's and Gauguin's zinc plate lithographs of 1889: in their simplified, stylized drawing, their emphatic, curving contours and decorative flat shapes, and their use of dark silhouettes against light grounds.[95] By this time, Lautrec also had a professional association with the Nabis. He had exhibited with some of them at the Salon des Indépendants in the spring of 1891, and in the autumn, while he was working on the poster, he must already have been making his plans to exhibit with them again at Le Barc de Boutteville's gallery in December. Their early prints could have added stylistic ideas to his own, in particular the lithographed programmes that Vuillard and Bonnard had designed for the Théâtre Libre in 1890;[96] but Bonnard's poster, *France champagne*, created in 1890 and exhibited for the first time in 1891, was a more important precedent for Lautrec and may have influenced him directly.[97]

André Mellerio, an early admirer of Lautrec, referred to posters as the 'frescoes of the crowd', and stressed the democratizing quality of this new art-form.[98] This concept, by coincidence, related back to the Petit Boulevard and its Naturalist commitment to a popular audience. Yet the utilitarian and commercial purpose of the poster is equally noteworthy as one of the factors that determined its style and approach to subject. In making it, Lautrec assumed the obligation to present an abbreviated, legible message with bold visual impact and maximum public appeal. He fulfilled his purpose with a stark, succinct statement. As Adhémar commented, the scene was 'stripped to essentials'.[99] For the publicity purposes of the poster, Lautrec also made an altogether racier and more sexually suggestive image than he had in his earlier renditions of the theme. Much of the erotic appeal of the *quadrille* centred on the possibility of glimpsing bits of female flesh, exposed amidst layers of lace petticoats and underdrawers during the high kick, and the women were known to have occasionally heightened this thrill by dancing without their knickers. Richard Thomson has noted that Lautrec made witty and knowing reference to the display of the female sexual organ as the

cat. nos. 162–70, and in S. Wichman, *Japonisme, the Japanese Influence on Western Art in the 19th and 20th Centuries* (New York, 1981), 62–9 and *passim*. More particularized investigations have also been made by T. Charpentier in 'Un Aspect peu connu de l'activité de Lautrec: sa collaboration à la reliure d'art', *Gazette des beaux-arts*, 56 (Sept. 1960), 165–78; and M. Melot, 'Questions au japonisme', *International Symposium*, 239–60. A major exhibition of Japanese woodcuts was held in the spring of 1890 in Paris: see *Exposition de la gravure japonais* (exh. cat., École des Beaux-Arts, Paris, 1890).

[94] Cf. Reff, 'Degas, Lautrec and Japanese Art', 192–3, 195, 202.

[95] For reproductions, see C. Boyle-Turner, *The Prints of the*

Pont-Aven School, Gauguin and His Circle in Brittany (exh. cat., Smithsonian Institution Traveling Exhibition Service, Washington, D.C., 1986), 38–9, 48, 57–64, all shown at Volpini's.

[96] See G. L. Mauner, *The Nabis: Their History and Their Art, 1888–1896* (New York, 1978), figs. 4–6.

[97] R. Goldwater, ' "L'Affiche moderne", a Revival of Poster Art after 1880', *Gazette des beaux-arts*, 22 (Dec. 1942), 181; and A. Vaillant, *Bonnard* (Greenwich, Conn., 1965), 44. On the date of the poster, see Mauner, 221–2.

[98] Mellerio, *La Lithographie originale en couleurs*, trans. M. Needham, in Cate and Hitchings, 95–7.

[99] Adhémar, *Complete Lithographs and Drypoints*, p. xii.

'quintessence' of the dance by making it 'the pivot' of La Goulue's 'propellor-like pose',[100] and indeed it is the focal point of the poster as a whole, in sly juxtaposition with the phallic, erect shape of Valentin's hand. Through this kind of sexual innuendo, Lautrec underscored and even celebrated the fact that sexual thrill was the product being sold *tous les soirs* (every night) by the Moulin Rouge to its bourgeois clientele, of which the viewer by implication is a part, as he presumably stands on the near side of the circle of onlookers. Clearly he structured his poster to lure, at least subliminally, a public in search of liberation and novelty.

In his poster, Lautrec exploited not only modernistic style and the risqué and coarse aspects of Naturalism for commercial ends, but also the appeal of decadence. His new stylized and abstract pictorial techniques and slyly obscene imagery conveyed the new mood of artifice that was transforming the dance itself. As the *quadrille* had become *à la mode* with high society, and so found itself welcome in the new decade with an altered cultural status, it lost its original character as a 'naturalistic', proletarian expression. What the naturalists formerly appreciated as its plebeian, down-to-earth vulgarity now enjoyed the approbation of an effete and jaded clientele with a taste for titillation, hedonism, a delicious perversity. In the sensibilities of the 1890s, 'modernity' attained a new identification with 'artificiality'. The one-time embodiment of Naturalism was changing into a decadent, *fin de siècle* fashion. As early as 1888, the 'Decadent' novelist Felicien Champsaur had foreshadowed this development in *L'Amant des danseuses*. He based his character, Marie Cloporte, on La Goulue, and cast her as the epitome of depravity, a figure as contradictory as Salomé in her combined repulsiveness and allure. In her crude language and 'obscene' charm, she was the 'icon' of 'materialist excess' and 'grossness'.[101] (In 1890, albeit tongue in cheek, the *Revue indépendante* went even further in describing the erstwhile symbol of Naturalism, La Goulue, in completely new terms as 'La Goulue, symbolic and synthetic'.)[102] Huysmans, too, in his description of the dance in *Certains* in 1889, already had projected the overtones of decadence that were subduing the original meaning of the *quadrille naturaliste*. And in Huysmans as in Lautrec (and others), the emerging new manifestations seemed like the direct outgrowth of their earlier naturalistic investigations of the corruption and decay on the underside of modern urban life.

Lautrec's Moulin Rouge poster of 1891 prefigured a large part of his production of the 1890s, that is, graphic works and preparatory paintings for them, in which he was to employ the same advanced stylistic devices. Somewhat incongruously he adhered to conventional methods of preparation, learned in the academic atelier, for this, his most radical work to date. He made a number of preliminary drawings and painted sketches for it on cardboard or canvas (e.g. Fig. 139). Several examples demonstrate that he even used a tonal modelling entirely contrary to the flattened shapes of the poster. He was to remain cautious about introducing the distinctive stylistic devices of the poster into his more formal paintings, and to experiment with greater freedom—just as he had earlier—in the presumably lesser medium

[100] Thomson, 'Imagery of Lautrec's Prints', in Wittrock, i. 20. The following interpretation has been influenced by Thomson's discussion, 19–21; and by L. Nochlin, 'Lautrec, the Performer and the Prostitute: Advertising and the Representation of Marginality', unpublished typescript of a lecture given at the Museum of Modern Art, New York, 1985.

[101] F. Champsaur, *L'Amant des danseuses* (Paris, 1888); see esp. pp. 92–6.

[102] 'J', 'Calendrier des théâtres', *La Revue indépendante*, 15 (May–June 1890), 341.

of popular art. Transferring a style ordinarily used for popular and commercial purposes to 'high' art still appeared radical in the 1890s. The inference persisted that art of this character must be intended for the rapid glance of the undiscriminating ordinary passer-by, not the delectation of the thoughtful, élite connoisseur.[103] Consequently, in such work also, Lautrec did not seek so much to express a concern for and sensitivity to the inner life as he did in many of his paintings, but rather to convey sensational and momentarily alluring superficialities. The irony of the Moulin Rouge poster was that it brought Lautrec full circle. He had borrowed a theme and an abbreviated and caricatural style from popular imagery, elevated both to the realm of high art in his monumental paintings, and finally with one definitive, climactic statement returned them to the world of popular imagery in a poster for display throughout the streets of Paris.

[103] Hence, writing to Octave Maus about his showing at Les Vingt in 1892, Lautrec worried that the organization might be 'afraid' to exhibit his recently published poster. Cf. a letter of 27 Dec. 1891 (H. Schimmel, no. 213, 158).

Conclusion

This work has attempted to define and describe the phases of Lautrec's early development and to establish the factors contributing to the genesis of his distinctive style and subject-matter. A number of its conclusions differ in substance and emphasis from those of much of the previous Lautrec literature, beginning with the rejection of the traditional idea that Lautrec's work is not amenable to chronological study.

The chronology set forth here differs radically in only a few instances from the standard Joyant chronology. The most extreme adjustment extends Lautrec's academic career to 1887, and consequently redistributes his academic works over a longer period. Otherwise, the most important changes have been to rearrange works in relation to one another, but within the same general chronological periods in which Joyant originally placed them. Lautrec's artistic evolution, as a result, emerges in a more or less continuous, logical unfolding.

The notion that reactionary teaching stifled Lautrec's youthful talent and that he assumed a radical independent stance early in his career in opposition to it proves to be an exaggeration. In actuality he advanced only gradually away from a conservative background towards his ultimate progressive position; and conservative influences played a significant role in the evolution of his art. Through his earliest work as an *animalier* and *peintre sportif*, Lautrec developed an appreciation of elegance and style. Through long academic training he learned draughtsmanship, formal perspective, and practical techniques of preparation to which he adhered throughout his career. He also acquired under Bonnat and Cormon a respect for realistic study of the model, and for the tradition of monumental 'high' art.

In the present work, the influence of the milieu in which Lautrec worked outweighs that of his physical and mental afflictions overwhelmingly. There is some merit in the conventional point of view that Lautrec's physical deformity and consequent personal suffering motivated him to associate with social outcasts whom he felt to be his fellows, and to make them the principal subjects of his art. On the other hand, his sources did not lie exclusively in his own eccentric psyche. His very life-style reflected contemporary socialy
on Montmartre, with their impetus towards liberation, both on the personal and socio-political level. He shared with many of his contemporaries the resulting and seemingly contradictory combination of social consciousness and focus on the pursuit of hedonistic pleasures. Moreover, the type of imagery that he chose was not peculiarly his, but constituted a crucial part of his artistic, intellectual, and social environment.

His definitive subject-matter, with its stress on the socially marginal low-life and non-conformist characters of the modern urban scene, originated in the progressive later Realist and Naturalist movement. In the 1880s it saturated the illustrated press and the lyrics of the popular song-writers, and gave birth to the Naturalist theatre. From the same sources Lautrec took an approach to art that emphasized portraying the modern character. And from popular

illustration he learned to employ caricatural exaggeration and abbreviation towards this end. His own early career as a popular caricaturist had a crucial role as a catalyst in his formation.

In one sense, Lautrec's choice of subjects was consistent from the beginning. Like Guys, Baudelaire, Huysmans, Manet, Degas, Forain, and Lunel, to name a few, he represented the haunts of pleasure-seeking gentlemen—worldly men of his own social status frequenting the same places that he did: the bois de Boulogne, the race-track, the dance-hall, the opera, the theatre, the cabaret, the brothel. Eventually, however, his understanding and penetration of the seamier aspects of these milieux divided him in attitude from his aristocratic peers. His earliest representations of such subjects, the equestrian paintings, lacked the irony, the shrewd caricature, and the psychological perception of later works, and were quite ordinary examples of this genre of painting.

Lautrec's progressive style, just as tangibly as his subjects, was related to a contemporary context. From the stylistically advanced artists of his day, he learned the heightened colour and divided stroke of Impressionism and the colour theory of Neo-Impressionism; he gained a new conception of preserving the immediacy and surface appearance of the sketch in the finished work; he learned also to create less 'composed', more informal compositions, and ultimately to manipulate formal elements more abstractly for expressive purposes. Previous scholarship has often treated Degas as practically the only influence acceptable to Lautrec. Certainly the younger artist knew Degas, admired his art, and emulated him in subject-matter and style. Degas's influence on Lautrec cannot be discounted. Yet several artists of the later Realist and Naturalist 'movement' also shared Degas's vision and emulated him, and they were intermediary figures, some of whom had more direct impact on Lautrec's work than Degas.

Lautrec's art was clearly the product of his constant awareness of the world around him, and his response to it, even as his rendering of that world grew more stylized and abstract. And contrary to the 'formalist' point of view, depicting the world around him was not just a pretext for exploring abstract formal arrangements. In fact, Lautrec finally was to employ the abstracted formal means of the Symbolists in conjunction with the stylistic exaggeration of caricature to enhance the expressiveness and psychological penetration of his Naturalism. The subjective emotional tensions, evocativeness, and aestheticism of Symbolism and the urban themes of Realism and Naturalism ultimately fused in his mature work, nullifying any question of whether history ought to identify him as a Symbolist or as a Realist. Lautrec attained maturity as a master of naturalistic subjects while his style continued to evolve. His thematic maturity coincided for the first time with a radically more innovative and less realistic style in late 1891 with the poster for the Moulin Rouge, and its appearance foretold the next stage of his artistic production. In this second phase of maturity, a considerable portion of his graphic output was to utilize modernist style and Naturalist subjects for commercial ends, while his formal paintings used some of the same elements to probe more deeply into the psychological realities of the modern environment.

APPENDIX A

Checklist of Revised Dates

Note: These charts have been revised since publication in *Gazette des beaux-arts* (G. B. Murray, 'Henri de Toulouse-Lautrec, A Checklist of Revised Dates, 1878–1891', 95 [Feb. 1980], 77–90). Further, works with dates that are more precise than those published by Joyant and Dortu, even if the year remains the same, as well as those with dates that are more approximate, are included. Occasionally a work is listed if new information is provided, even if its traditional date is maintained. When Dortu's title is incorrect, my revised title follows it in parentheses.

Title or Description	Dortu Number	Dortu Date	Joyant Date	Comments
ANIMAL AND SPORTING SUBJECTS				
1877–8				
La Calèche	——	——	——	All relate to Grandjean's *L'Avenue du bois
Related drawings	D595	*c.*1876–81	?[1]	de Boulogne*, exhibited at the Salon of
	D695	*c.*1876–80	?	1877
1878				
Deux chevaux et groom	P43	1880	——	All derive from Goubie's painting, *Retour
Drawings after Goubie	D566	*c.*1876–80	?	d'une chasse aux oiseaux de mer*, as do two
	D543	*c.*1876–80	?	other Lautrec paintings of 1878: *Attelage
	D1492	*c.*1879–81	——	en tandem* (P1) and *Monsieur* (P3). All
				relate stylistically to the dated works of
				1878 (P4, P5, A58, A60, A61)
1878				
Cavalier du XVIII *siècle*	P40	1880	1880	All copy motifs from Goubie's *Le Vol de
Related drawings	D475	*c.*1876–80	?	la corneille*
	D2081	1881	?	
	D2703	*c.*1882	——	
1878				Military subjects
Drawing, *Cavalier*	D499	*c.*1876–80	?	Both are preparatory drawings for *Les
Drawing, *Cavalier avec lance*	D1238	*c.*1879–81	?	Hussards* (P4), dated 1878

1 Joyant's listing of drawings is too imprecise to permit the specific identification of individual drawings, in most cases. Data from Joyant regarding drawings are provided here only in those few cases where identification is absolutely clear.

Title or Description	Dortu Number	Dortu Date	Joyant Date	Comments
[1878]				Scenes of military manœuvres of 1878
Cuirassiers à cheval—grandes manœuvres à Bosc	P12	1879	1879	
Artilleur sellant son cheval	P13	1879	1879	
Related drawings	D746	1879	——	
	D1530	c.1879–81	?	
	D462	c.1876–80	?	(NB *Cavalier de chasse ressanglant son cheval* [P9] shares D462, a tracing, as a preparatory stage)
L'Artillerie en service de campagne	P14	1879	1879	
Le Bosc. Batterie d'artillerie	P19	1879	1879	
Artilleur à cheval	P27	1879	——	
Related watercolour, *Chasse à courre*	A80	c.1879–80	——	Uses same horse and figure as P27
Deux chevaux avec ordonnance	P75	1880	1880	
Related drawing (p. 64 of a notebook)	D212	c.1875–80	1875–80	Entire notebook, D189–D235, probably datable to 1878
Watercolour, *Le Général Séré de Rivières*	A193	c.1881–2	——	Related in style and subject to 1878 military scenes. (Possibly an imitation of Detaille's *Artilleur à cheval* [Chicago Art Institute], exhibited at Salon of 1877)
Watercolour, *Artilleur*	A154	1880	?	
Watercolour, *Manœuvre de cavalerie*	A184	c.1881	——	
Drawings of the military manœvres	D1779	c.1880	——	
	D743	1879	1879	
Pages from a notebook	D207	c.1875–80	1875–80	From the same notebook as D212 above
	D209			
	D210			
	D211			
Pages from a notebook	D983	c.1879–80	1879–80	Entire notebook, D927–D987, probably datable to 1878
	D946			
	D950			
	D957			
	D1215	c.1879–91	?	
	D506	c.1876–80	?	
	D2250	c.1881	——	

Title or Description	Dortu Number	Dortu Date	Joyant Date	Comments
[1878]				
Watercolour, *Cheval roux*	A3	c.1873–5	1873–5	Reprise of *Niniche* (P2), datable to 1878. Both paraphrase the horse in Princeteau's *Chevaux et lapins* (Libourne, Musée)
1878				
Cavalier de chasse à courre ressanglant son cheval	P9	1879	1879	Shares preparatory tracing (D462) with *Artilleur sellant son cheval* (P13), redated to 1878 above; stylistically similar to works of 1878
Related drawing (tracing)	D1489	c.1879–81	——	
Related drawing	D1498	c.1879–81	——	
Related drawing (tracing)	D2650	1882	1882	
1879				
Watercolour, *Le Fauconnier*	A164	1881	——	Nearly identical to another watercolour of the same title (A78), signed and dated 1879 by Lautrec
Comte Alphonse de Toulouse-Lautrec en fauconnier	P91	1881	1881	A variation of the above watercolours; related to bronzes exhibited at the Exposition Universelle, 1878; stylistically similar to works of late 1879 (e.g. *Charrette attelée* [P25], inscribed 'novembre 79')
Related watercolour, *Chasse au faucon*	A137	c.1879	?	
Related watercolour	A138	c.1879–81	?	
Buggy au bord dela mer	P92	1881	1881	Verso of P91; stylistically similar to it
1879, winter				Works done in Nice
Marin assis	P37	1880	1880	(See Goldschmidt and Schimmel, nos. 22, 23, 24, and Princeteau's account in Martrinchard, 63–4. He notes Lautrec's paintings of 'boats, sea, sunsets, horsewomen' done in Nice, winter 1879)
Barque de pêche	P80	1880	——	
Tête de matelot Américain, cover of an album of related drawings	P82	1880	1879–81	
	D900–D926	c.1879–80	1879–81	
and watercolours	A81–A97	c.1879–80	1879–81	All related stylistically to one another in static and awkwardly drawn figures; muddy subdued tones; and loose, sketchy application of paint
Tête de chien Gordon, verso of album cover	P81	1880	1879–81	
Flotte	P88	c.1880	——	
Watercolour, *Matelot du Trentham*	A151	1880	——	
c.1878–early 1879				
Cavalier de chasse à courre	P7	1879	1879	All stylistically similar to dated and
Cavalier de chasse à courre	P8	1879	1879	datable works of 1878–early 1879 and to

Title or Description	Dortu Number	Dortu Date	Joyant Date	Comments
[c.1878–early 1879]				
Watercolour, *Réunion de cavaliers de chasse à courre*	A4	c.1873–5	1873–5	Princeteau's works of this period (P7 and A4 paraphrase Princeteau's *Deux cavaliers de chasse à courre*)
Related drawings	D543	c.1876–80	?	
	D361	c.1876	——	
Watercolour, *Piqueur à cheval*	A7	c.1873–81	1873–81	
Valet des chiens	P39	1880	1880	
Close variant, *Valet des chiens*,	P87	1880	——	
and related drawing	D2345	c.1881	——	
c.1878–9				
Drawings after bronzes of	D2231	c.1881	——	Related works are placed in this period
hunting and racing scenes	D2235	c.1881	——	(see text)
	D2238	c.1881	——	
	D2239	c.1881	——	
	D2241–	c.1881	——	
	D2244			
c.late 1879				
Aux Courses de Chantilly	P10	1879	1879	Signed and dated 1879; stylistically attributable to later in year because of new animation
Watercolour, *Deux chevaux effrayés par une locomotive*	A195	1883	——	Based on an experience of this time described by Princeteau. Related stylistically to works dated or attributable to late 1879, e.g. P25
Related drawings	D2400	c.1881–2	?	
	D2401	c.1881–2	?	
	D2136	1881	?	
	D2152	1881	?	
1881				
Drawing, *Equipage*	D1599	c.1879–82	?	All are related to *Mail-Coach, a Four-in-Hand* (P94), signed and dated 1881
Untitled drawings	D1867	c.1880–1	1880–1	
	D1855	c.1880–1	1880–1	
Drawing, *A Four-in-Hand*	D2240	c.1881	——	
Watercolour, *Mail Coach*	A158	c.1880	——	
Drawing, *Amazones et chien*	D1251	c.1879–81	1879–81	Both relate to the painting *Amazone* (P112), datable stylistically to 1881
Drawing, *Amazone et cavalier*	D2701	c.1882	——	

Title or Description	Dortu Number	Dortu Date	Joyant Date	Comments
Spring 1881				
Princeteau dans son atelier	P130	1881	——	The drawing is found in a letter (Maison
Related drawing	D2077	1881	——	Natale de Toulouse-Lautrec Collection)
				datable to spring 1881, when Lautrec
				worked at Princeteau's studio
Princeteau dans son atelier	P131	1881	——	These relate in style and subject to the
Related drawing	D2082	1881	——	above
*c.*1878–81?				
Cuirassier	P100	1881	1881	Signed 'H.T.-L., d'après Princeteau
Related drawing	D743	1879	1879	1881', but possibly incorrectly labelled at
				a later date, because Princeteau's account
				(Martrinchard, 63–4) places it
				unequivocally in 1878–9. Both Joyant (i.
				254) and Princeteau identify it as having
				hung at the chateau of Lautrec's mother
				at Malromé. Stylistically consistent with
				works of 1878–9
*c.*1879–82				
Drawings				All close to Princeteau's drawings and
Chasse à courre	D1197	*c.*1879–81	?	paintings of this period
Cavaliers sautant	D1226,	*c.*1879–81	?	
(2)	D1229	*c.*1879–81	?	
Le Galop	D1357	*c.*1879–81	?	
Cavalier	D1366	*c.*1879–81	?	
Cavalier à galop et chien	D1420,	*c.*1879–81	?	
(2)	D1424			
Cavaliers	D1774	*c.*1880	——	
Cavalier	D1785	*c.*1880	——	
Le Saut	D1788	*c.*1880	——	A variation of one of Princeteau's
				recurrent figures; see e.g. Princeteau's
				Chasse (France, d'Amade Collection)
Untitled drawing	D1851	*c.*1880–1	——	All related to Princeteau's works of this
Drawing, *Cheval au galop*	D2149	1881	?	period (specifically to far left-hand rider
Related watercolour, *Chevaux au*	A139	*c.*1879–81	——	in *Le Saut de la rivière*, Musée, Libourne)
galop				
*c.*late 1879–82				
Au Bosc	P11	1879	1879	Related stylistically to works of this
				period, in lively motion and brush stroke

Title or Description	Dortu Number	Dortu Date	Joyant Date	Comments
1882				
Voiture attelée d'un cheval et mulet	P98	1881	1881	All this group are related stylistically to
Cheval de trait à Céleyran	P101	1881	1881	works dated 1882 by Lautrec (e.g.
Cheval blanc	P104	1881	1881	*Céleyran, un tombereau* [P181] and *Deux*
Cheval de trait à Céleyran	P144	c.1881	——	*chevaux menés en main* [P158]). Broader,
Cheval attaché	P145	c.1881	——	flatter strokes, more light areas, bolder
				contrasts between light and dark, more
				abbreviated forms. (NB P101 and P144
				are close variants)
Un petit chat	P156	1882	1882	Inscribed 1882; copy from the *animalier*
				L.-E. Lambert's *Envoi* (1875)
1882				
Charrette embourbée	P140	c.1881	——	Cf. preparatory study on verso (D2668),
				inscribed 'février 1882' by Lautrec

<div align="center">LAUTREC'S ACADEMIC CAREER</div>

Title or Description	Dortu Number	Dortu Date	Joyant Date	Comments
1882				Bonnat period: copies after reproductions
				of old masters
Tête de femme, after Leonardo's drawing of Leda (Windsor Castle)	D1792	c.1880	——	
Drawings after Leonardo's 'Étude des proportions de la tête de cheval'	D2889 D2863 D2864 D2884	1885	1885	The entire album in which these drawings are located should be redated 1882 (D2851–D2889)
	D1859	c.1880–1	1880–1	
Sheet of studies of head, one after Rembrandt	D1102	c.1879–81	1879–81	
1882				Bonnat period: further drawings
Académie d'homme nu (after Michelangelo's *David*)	D1982	1881	?	
Drawing, '*Bonnat! Monfa!*'	D1978	1881	?	
'Lot' of drawings, including the above two; sketches of horses; a sheet of rudimentary line drawings of nudes (D1969) which are	D1948, D1951– D1999	1881	?	The undated drawings in this 'lot' are all on the same kind of paper and of the same size (except for the centre sheet, which is double the size of the others). The 'lot' belonged to Lautrec's mother. It probably was originally a notebook. The

Title or Description	Dortu Number	Dortu Date	Joyant Date	Comments
preparatory studies for D2427 and D2458; two preparatory drawings for the painting *Jeanne* (D1980, D1983); and a sheet of studies of human hands (D1986)				combination of equestrian subjects with works related to Lautrec's early academic study supports a date of 1882 for the 'lot'
1882				Bonnat period: Lautrec's less skilled academic drawings
Rough sketches:				
Nude figures	D763–D764	1879	1879	
	D754	1879	1879	
	D759	1879	1879	
Contour drawings of nudes and plaster casts:				
Méphisto	D1650	1880	?	
Silhouettes, sheet of studies of nudes	D1651	1880	?	
Tête de profil et croquis, sheet of studies of nudes	D1655	1880	?	
Sheet of studies of a nude, including a portrait sketch of Bonnat	D1679	1880	?	
Deux mains, sheet of studies of hands and heads	D1681	1880	?	
Cinq personnages, sheet of studies of nudes	D1709	1880	——	
Croquis, studies of a male nude	D2326	c.1881	——	
	D2329	c.1881	——	
True *académies* of Bonnat period (all *dessins ombrés*):				
Homme tenant un baton	D2428	c.1881–3	1881–3	
Femme debout, bras levé and	D2429	c.1881–3	1881–3	
Nu de femme, bras levé, both of the identically posed female model	D2488	c.1881–3	1881–3	
Femme assise and	D2427	c.1881–3	1881–3	
Homme, main sur la hanche (Preliminary line drawings for both of these are on the same sheet, D1969)	D2458			
Further drawings after the nude model	D2430	c.1881–3	1881–3	
	D2434	c.1881–3	1881–3	

Title or Description	Dortu Number	Dortu Date	Joyant Date	Comments
[1882]				
	D2442	c.1881–3	1881–3	
	D2444	c.1881–3	1881–3	
	D2448	c.1881–3	1881–3	
	D2451	c.1881–3	1881–3	
	D2517	c.1881–3	1881–3	
	D2520	c.1881–3	1881–3	
	D2524	c.1881–3	1881–3	
	D2569	c.1881–3	1881–3	
Head studies done under Bonnat:				
Tête de femme	D1062	c.1879–81	1879–81	
Études de têtes	D1075	c.1879–81	1879–81	
1882				Bonnat period: studies after plaster casts
Belvedere torso:				
Line drawing	D2618	c.1881–3	1881–3	D2755 bears the 'Monfa' signature, used
Shaded drawings	D2609			consistently for signed and dated works
	D2612			of 1882 and rarely thereafter
	D2755	1883	1883	
Torse, painting	P161	1882	1882	Reprises D2755
1882, summer				Studies related to dated portrait drawings Lautrec made of family members. (In many cases, sitters left unidentified by Joyant and Dortu)
Drawings of Charles de Toulouse-Lautrec	D718	c.1878–80	?	All relate to signed and dated drawings such as D2621, D2658, D2659. (The entire notebook [D668–D741] in which D718, D722, and D740 are located should be redated to 1882).
	D722			
	D740			
	D1654	1880	?	
	D1673	1880	?	
	D1682	1880	?	
	D1689	1880	?	
	D1698	1880	?	
	D1907	c.1880–2	?	D1907 is actually dated 1882 by Lautrec
	D2126	1881	1881–2	
	D2137	1881	?	
	D2157	1881	?	
	D2339	c.1881	——	
	D2340	c.1881		
	D2349	c.1881	——	
	D2366	c.1881	——	
	D2373	c.1881	——	

Title or Description	Dortu Number	Dortu Date	Joyant Date	Comments
Tête penchée en avant, drawing of Lautrec's maternal grandmother, Louis Imbert du Bosc	D1656	1880	?	Preparatory study for D2637; also related to D2636, both signed and dated. See also D2638, a preparatory drawing for D2636, plotted with vertical reference line (correctly placed in 1882 by Dortu and Joyant)
Drawings of Amédée Tapié de Céleyran	D1657 D1908	1880 *c.*1880–2	? *c.*1880–2	Cf. D2633, signed and dated
Drawing of Raoul Tapié de Céleyran	D1911	*c.*1880–2	?	Cf. D2660, signed and dated
Drawing of Adèle de Toulouse-Lautrec (Lautrec's mother)	D2131	1881	1881	Cf. D2635, datable with certainty to 1882
Drawing of Beatrix Tapié de Céleyran	D2306	*c.*1881	——	Cf. D2631, datable with certainty to 1882
Unidentified man	D2635	*c.*1881	——	Cf. D2661, signed and dated 1882

(Other signed and dated portrait drawings of summer 1882: D2632, D2634, D2655, D2662–D2666, and *Comtesse Émilie de Toulouse-Lautrec* [Munich, Staatliche Graphische Sammlung], not catalogued by Dortu or Joyant; cf. Adriani [Tübingen], 36–7)

1882				*Ébauches* done while at Bonnat's
Jeanne, half-length nude	P231	1884	1884	Subdued tones, tentative modelling, unfinished appearance (preparatory drawings D1980, D1983, from above 'lot', datable to 1882)
Étude de jeune fille nue, partial figure of a nude	P325	*c.*1888	——	Related in style to *Jeanne*
Buste d'homme	P234	*c.*1884	——	These heads are similar in style to P176
Le Joueur de flûte	P237	*c.*1884	——	(correctly placed in 1882 by Dortu and
Étude de tête et de torse	P203	*c.*1884	——	Joyant)
1882				Bonnat period
Drawings related to P174, *La Vieille des écrevisses* (correctly placed in 1882 by Joyant and Dortu)	D1910 D1906	*c.*1880–2 *c.*1880–2	? ?	Datable to 1882 by virtue of relationship to dated preparatory drawing (D2639) for P174
1882, summer				Paintings done on vacation
La Comtesse A. de Toulouse-Lautrec lisant un journal	P125	1881	1881	All related to portrait drawings of same time; also related stylistically to two signed and dated portraits of 1882, *Le Buveur* (P146) and *Mlle Tapié de Céleyran*
Related drawing	D2794	1883	——	

Title or Description	Dortu Number	Dortu Date	Joyant Date	Comments
[1882]				
G. Tapié de Céleyran, enfant	P127	1881	——	(P183), in their dark earth tones, intense chiaroscuro, and heavily laid on paint
Charles de Toulouse-Lautrec	P192	c.1882	——	Possibly inspired by Bonnat's portrait of Victor Hugo, Salon of 1880
1883				Equestrian subjects
Piqueur et bûcheron	P194	c.1882	——	Close in style to La Croisée des chemins
Related drawing	D2128	1881	?	(P217), dated 1883 by Lautrec, and the
Le Fiacre	P142	c.1881	——	closely related Retour du chasse (P219). All show the influence of John-Lewis Brown
1883–7				Académies done at Cormon's: Lautrec's more proficient academic drawings
Académies of nude models	D2431	c.1881–3	1881–3	Total of 169 drawings of the nude model redated here
	D2433	c.1881–3	1881–3	
	D2435–D2441	c.1881–3	1881–3	
	D2443	c.1881–3	1881–3	
	D2445–D2447	c.1881–3	1881–3	
	D2449	c.1881–3	1881–3	
	D2450	c.1881–3	1881–3	
	D2452–D2457	c.1881–3	1881–3	
	D2459–D2487	c.1881–3	1881–3	
	D2489–D2516	c.1881–3	1881–3	
	D2518	c.1881–3	1881–3	
	D2519	c.1881–3	1881–3	
	D2521–D2523	c.1881–3	1881–3	
	D2526–D2529	c.1881–3	1881–3	
	D2531–D2568	c.1881–3	1881–3	
	D2570–D2602	c.1881–3	1881–3	D2578 is datable specifically to 1885–6 because of relationship to drawing by
	D2613–D2617	c.1881–3	1881–3	Émile Bernard (Clément Altarriba Collection, published in Cate and Boyer,
	D2619	c.1881–3	1881–3	The Circle of Toulouse-Lautrec, 11) of the same nude couple, identically posed D2752 may be datable to 1885–6 because it depicts the same model as La Grosse Maria, P229

Title or Description	Dortu Number	Dortu Date	Joyant Date	Comments
	D2752–D2754	1883	1883	
	D2756	1883	1883	
	D2783			Related to D2592
Head study	D2757	1883	1883	
Académies of clothed models	D1626	1880	1880	D1912 is related to D1626 (NB One *académie* of a clothed model [D2764] is inscribed '19 juin 1883' and related drawings of the same model and drawings on their versos [D2759–D2763 and D2765–D2766] have been placed correctly with it by Joyant and Dortu)
	D1912	c.1880–2	?	
Étude de modèle: moine assise de face en prière	D2749	1883	1883	
Drawings of Bedouins	D2778	1883	——	Comparable to *académies* of Cormon period in style and proficiency (possibly copies of figures from paintings of oriental subjects by Fromentin [Cormon's teacher], Horace Vernet or Gérôme, or costumed figures posed in the studio)
	D2781	1883	——	
	D2782	1883	——	
	D2785	1883	——	
1883–7				Academic drawings of plaster casts done at Cormon's
After Pollaiuolo's	D2605	c.1881–3	1881–3	
Bust of a Warrior	D2610	c.1881–3	1881–3	
in the Bargello	D2055	1881	1881	
After Aphrodite removing her sandal	D2603	c.1881–3	1881–3	
After a torso of Aphrodite	D2611	c.1881–3	1881–3	
After a bust of Charles IX (Louvre) from the School of Pilon	D2606	c.1881–3	1881–3	
After a fragment of an antique head	D2608	c.1881–3	1881–3	
After a head of a pope	D2604	c.1881–3	1881–3	
After Ilyssos from the Parthenon	D2751	1883	1883	
c.late 1883–4				*Ébauches* done under Cormon
After the nude model, oil on tracing paper (preparatory charcoal drawings: D2514, D2547, D2583, D2452)	P197–P200	c.1882–3	1881–3	P197–P200 and P207 exemplify Lautrec's progress to painted studies of the full figure during his early phase at Cormon's
Académie d'homme nu	P207	1883	1883	

Title or Description	Dortu Number	Dortu Date	Joyant Date	Comments
[1883–4]				
Étude d'homme, tête	P175	1882	1882	More powerful modelling of facial planes
Drawing of same model, *Tête d'homme*	D2784	1883	——	and more effective use of chiaroscuro than in comparable studies done under Bonnat (e.g. P176)
Étude d'après le plâtre	P216	1883	1883	After a Renaissance bust
c.1884–5				Painted sketches done at Cormon's of mythological and historical subjects; some may be inspired by Victor Hugo
Au harem	P167	1882	1882	Lautrec probably reached this
Étude de nu	P168	1882	1882	intermediate level of academic training
Étude pour la bordure d'un panneau de tapisserie (possibly Daphnis and Chloë)	P173	1882	1882	late in 1884; by autumn 1885 when Gauzi entered Cormon's atelier, Lautrec had abandoned such subjects; these
Sujet mythologique: Icare	P201	1883	1883	paintings coincide in time with Cormon's
Allégorie: le printemps de la vie	P204	1883	1883	project to make illustrations for Hugo's
Allégorie: le printemps de la vie (Bacchus and Ariadne)	P205	1883	1883	poetry
Related drawing, *Tigres*	D2687	c.1882	——	
Esquisse allégorique	P211	1883	1883	Based on Hugo's 'L'Aigle du casque' from *La Légende des siècles*
Esquisse allégorique: dauphin	P212	1883	1883	
Allégorie, enlèvement	P213	1883	1883	
Scène mérovingienne	P214	1883	1883	
Peuplade primitive	P215	1883	1883	
Preparatory drawing, *Sujet de composition*	D2773	1883	1883	
Spartiate montrant à son fils un ilote ivre	P222	c.1883	——	
1884				Victor Hugo project
Ink drawings:				
Oceano nox	D2006	1881	1881	Based on Hugo's poem 'Oceano nox'
Ancre	D2011	1881	——	from *Les Rayons et les ombres* (D2006
Ancre	D2012	1881	——	inscribed by Lautrec 'Rayons et ombres—Océano nox')
Group of ink and pencil drawings:				
Laboureur menant deux bœufs	D2005	1881	1881	After Hugo's poem 'A M. le Duc de ***'
Un Laboureur menant deux bœufs	D2008	1881	——	from *Les Rayons et les ombres* (D2009 inscribed by Lautrec 'Rayons et

Title or Description	Dortu Number	Dortu Date	Joyant Date	Comments
Laboureur menant deux bœufs	D2009	1881	——	ombres—A M. le Duc de ***'; D2005
Le Labour	D2010	1881	——	inscribed 'pour les valeurs')
Ink drawing, *Cavalier arabe au grande galop*	D2007	1881	1881	Probably after Hugo's poem 'Sultan Mourad' from *La Légende des siècles*
Charcoal drawing on canvas, *Chevalier*	D2000	1881	1881	Possibly related to Victor Hugo project: D2000
	D2758	1883	1883	
Charcoal drawing, *Composition: chevalier avec trois nymphes sortant des eaux*				Possibly illustrating Hugo's poem 'Les Chevaliers errants' and D2758 possibly illustrating 'Moschus', both from *La Légende des siècles*
1883				Portraits, first phase at Cormon's
Monsieur Dennery	P223	c.1883	——	Letter no. 49 (Goldschmidt and Schimmel) dates it spring 1883; Lautrec also posed for Rachou on this divan in a portrait of 1883 (see Goldschmidt and Schimmel, fig. 20)
Related drawing of Dennery, *Monsieur en chapeau melon*	D1625	1880	1880	Related to two other dated drawn portraits of Dennery (D2746, inscribed 'novembre 1883', and D2795)
Étude du nu	P170	1882	1882	Related in style and circumstance to portrait of Dennery: the figure is seated on same divan as Dennery, in a comparable attitude of informality; same sombre palette (D2747, on verso of dated drawing of Dennery [D2746] may be related to this painting)
1884–5				Other portraits done while at Cormon's (first phase)
Portraits of Carmen	P243–P246	1885	1885	Possibly mentioned by Lautrec in a letter of spring 1884 (see text). Overall dark, gloomy colouring, brown- and green-tinged shadows, strong modelling in light and dark in both drawings and paintings
Related preparatory drawings	D2966–D2967	1886	1886	
Tête d'homme	P202	1883	1883	P202 and P124 represent the same studio model, a mature, full-bearded man, unlikely to have been Lautrec's friend Devismes, a boy of no more than 16 in 1881; these two portraits similar in their cautious realism to one another and to the Carmen portraits above (same model
Related drawing, *Tête d'homme à barbe*	D2777	1883	——	
Tête d'homme, M. Étienne Devismes (Tête d'homme)	P124	1881	1881	

Title or Description	Dortu Number	Dortu Date	Joyant Date	Comments
[1884–5]				used for P208, painted in later phase at Cormon's)
1883, summer				Peasant subjects done at Céleyran during vacation while at Cormon's (first phase)
Le Jeune Routy à Céleyran (head)	P150	1882	1882	Influenced in their solid draughtsmanship
Related drawings	D2646	1882	1882	and lack of *fini* by *juste milieu* peasant
	D2643	1882	1882	subjects Lautrec saw at Salon of 1883
Le Jeune Routy à Céleyran (seated)	P149	1882	1882	
Painted sketch	P177	1882	1882	
Related drawings:				
Line drawing on tracing paper	D2644	1882	1882	
Charcoal drawing	D2645	1882	1882	
Other drawings of Routy	D2647	1882	1882	
	D2648	1882	1882	
	D2649	1882	1882	
	D1909	c.1880–2	?	
Un travailleur à Céleyran	P147	1882	———	The worn figure pausing in his work as well as the lack of *fini*, and the freely brushed, diagonal strokes of the background, resemble Lhermitte's *La Moisson* shown at 1883 Salon
Vieille femme assise sur un banc à Céleyran	P148	1882	1882	
Vieillard à Céleyran	P151	1882	1882	
Painted sketches of same sitter	P265	1886	1886	
	P266	1886	1886	
	P273	1886	———	
Céleyran, un vieux (head)	P74	1880	1880	
Preparatory charcoal drawing	D2769	1883	1883	
Preparatory line drawing on tracing paper	D2770	1883	1883	
Same model (full length), *Halte dans le désert*	P48	1880	1880	
Un travailleur à Céleyran	P152	1882	1882	
Preparatory drawing	D2640	1882	1882	
Charcoal drawing on canvas, *Une vendangeuse* (*Vieille femme filant*)	D1637	1880	1880	
Preparatory line tracing, *Vieille femme filant*	D2652	1882	1882	

Title or Description	Dortu Number	Dortu Date	Joyant Date	Comments
*c.*1883				Drawings of peasant subjects (related to work of summer 1883)
Femme donnant du grain	D1658	1880	?	D1658, D1660, and D1707 close to
Femme donnant du grain	D1660	1880	?	drawings by Millet of women feeding
Coqs et poules	D1659	1880	?	chickens and doing farm chores
Coqs et poules	D1661	1880	?	
Deux ménagères	D1707	1880	?	
Tête d'un vieil homme	D1628	1880	1880	
Tête d'homme âgé, coiffé d'un chapeau de paille	D1629	1880	1880	
Paysan assis	D2354	*c.*1881	——	
Auguste Besset, mécanicien à	D2641	1882	1882	
Sainte-Rose près Céleyran	D2642	1882	1882	
*c.*1883				Outdoor subjects
Madame la Comtesse A. de Toulouse-Lautrec (at breakfast)	P90	1881	1881	Stylistically related to *plein-air* peasant paintings of 1883
*c.*1883–4				*Plein-air* landscape studies done while at Cormon's
Landscapes:				Those done at Céleyran probably date
La Viaduc de Castelvieil à Albi	P32	1880	1880	from summer 1883 (see Goldschmidt and
Preparatory drawing (*Pont*)	D2134	1881	1881	Schimmel, no. 50); letter of Nov. 1884
Landscapes done at Céleyran	P49–P58	1880	1880	(no. 63) also refers to landscapes done on
Bosc, la terrasse	P61	1880	——	summer vacation that year. All are
Au Bord de la rivière	P68	1880	1880	probably influenced by 1883 exhibition of
Au Bord de l'eau	P71	1880	1880	Barbizon School Painting at Georges
Rivière	P135	1881	——	Petit Gallery
Allée	P136	1881	——	
Landscape drawings	D1675	1880	1880–2	
	D1685	1880	1880–2	
	D1686	1880	1880–2	
	D2348	*c.*1881	——	
	D2350	*c.*1881	——	
	D2352	*c.*1881	——	
	D2353	*c.*1881	——	
*c.*1883–4				Outdoor subjects, cattle
Deux bœufs sous le joug	P79	1880	1880	Related to one another in style and
Deux bœufs sous le joug	P128	1881	——	subject; related to peasant and outdoor
Bœufs attelées à un tombereau, Céleyran	P154	1882	1882	subjects of 1883–4 in style. Possibly these are the paintings of 'cattle' Lautrec

Title or Description	Dortu Number	Dortu Date	Joyant Date	Comments
[*c*.1883–4]				
Deux bœufs	P235	*c*.1884	——	mentioned showing to Cormon in letter of Nov. 1884 (Goldschmidt and Schimmel, no. 63). (NB P235 is a study for P128; P154 is inscribed 'Routy')
1884				
Le Labour dans les vignes	P209	1883	1883	Its direct source is Princeteau's painting of 1884, *Bœuf labourant*, which won a medal at the Salon of 1884 (Princeteau's interest also shifted markedly *c*.1883–4 from upper-class to peasant subjects, cf. Martrinchard, 51)
1884–5				
Madame la Comtesse A. de Toulouse-Lautrec (at Malromé)	P190	1882	?	Malromé not purchased until spring of 1883 and Lautrec did not visit there until late summer or early autumn 1884. In an undated letter from Malromé of the period 1884–5, his mother reported, 'Henri paints me every morning surrounded by my beautiful hortensias' (Attems, 199)
late 1885–7				Painted *académies*: final years at Cormon's
Académie d'homme nu (demi-figure peinte)	P206	1883	1883	All may have been made for competitions of 1886; they exhibit Lautrec's technical progress in their strong modelling, mastery of chiaroscuro, and anatomy. The model in P206 is shown identically posed in a photo of Cormon's studio of 1886
Académie d'homme nu: buste (demi-figure peinte)	P208	1883	1883	
Le Polisseur de marbre (full figure in crouching position)	P184	1882	——	
late 1885				Portraits: late years at Cormon's
La Femme au noeud rose (Jeanne Wenz) (tête d'expression?)	P264	1886	1886	Lautrec mentioned working on it in a letter of autumn 1885; dark toned palette, brownish shadows, relatively sketchy surfaces
late 1885–late 1886				
Émile Bernard (tête d'expression?)	P258	1885	——	Datable according to Bernard's stay in Paris and his own memoirs; comparable .in style to portrait of Jeanne Wenz

Title or Description	Dortu Number	Dortu Date	Joyant Date	Comments

<div align="center">FIRST FORAYS INTO THE AVANT-GARDE</div>

Title or Description	Dortu Number	Dortu Date	Joyant Date	Comments
c.late 1885–early 1886				Cautious experiments
La Grosse Maria	P229	1884	1884	'Dark Realist' style, use of pastel tones in shadows
La Blanchisseuse (Carmen Gaudin)	P346	1889	1889	
A Montrouge—Rosa la Rouge (Carmen Gaudin),	P305	1888	1888	These relate to a Bruant song of early 1886. Painting is in 'dark Realist' style, but Joyant gave it a later date, possibly in relation to the drawing after it (D3090), reproduced in *Le Courrier français*, 2 June 1889. D2899 is a variation on the theme of *À Montrouge*, probably intended for publication
Related drawings, both signed 'Tréclau':				
ink and blue pencil	D2899	1885	——	
tracing of D2899	D2898	1885	——	
Pierreuse (Carmen Gaudin)	P352	1889	——	
Toulouse-Lautrec par lui-même, de dos	P238	c.1884	——	'Dark Realist' style; use of argot on canvas here also indicates influence of Bruant
Tête de femme rousse en caraco blanc	P345	1889	1889	Two outdoor studies of Carmen Gaudin in 'dark Realist' style
Femme rousse	P353	c.1889	——	
late 1886				Outdoor studies in Impressionist style, with awkward, simplified drawing
Mme Suzanne Valadon	P249	1885	1885	
Mme Suzanne Valadon	P250	1885	1885	
Femme assise de face et tenant une ombrelle	P341	1889	1889	
1885–6 (probably late 1886)				Bolder ventures: paintings and related works
Mirliton panels:				
Le Refrain	P260	1886	1886	P260 and P261 stylistically related; P261 is a grisaille made in preparation for illustration published in *Le Mirliton* of 29 Dec. 1886 (Mirliton opened during summer of 1885)
Le Quadrille	P261			
Related drawings	D2950	1886	1886	D2973, an ink and charcoal drawing on Gillot paper, is an alternative version of *Le Quadrille* in vertical format, surrounded by portraits in vignette of the familiar personalities of the Élysée Montmartre
	D2973	1886	1886	
	D2974	1886	1886	
	D2976	1886	1886	
	D3018	c.1887	——	
	D3019	c.1887	——	
	D3021	c.1887	——	
	D2977	1886	1886	

Title or Description	Dortu Number	Dortu Date	Joyant Date	Comments
[c.1885–6 (probably late 1886)]				
	D2843	1885	1885	
Related painting, *Au bal de l'Élysée Montmartre*	P286	1887	1887	Comparable in style to P260
Ancelin Inn paintings	P239–P242	1885	1885	Stylistic parallels to securely datable Mirliton panels
Profil de jeune fille	A196	1885	——	Mentioned by Lautrec in a letter of autumn 1886 (Dortu and Huisman, 240) as the 'small head of a boarder at the inn where I've done some panels'
Ballet scenes, *Danseuses*	P257	1886	1886	Stylistic parallels to Mirliton panels and Ancelin Inn paintings
	P262	1886	1886	
	P263	1886	1886	
1886, autumn				Bolder ventures: illustrations and related works
Jeune fille tenant une bouteille de vin, blue pencil drawing	D2928	c.1885–6	1885–6	D2925, D2926, D2928 intended for publication in issue of *Le Courrier français*
Related drawing	D2993	c.1886	——	of late Sept. or early Oct. 1886 devoted
Les Vendanges, pencil and blue chalk on Gillot paper	D2925	c.1885–6	1885–6	to the *vendanges*. (*Gin-cocktail* [D2965] was the only drawing by Lautrec actually
Related drawings	D1630	1880	1880	published by the *Courrier*. It appeared in
	D1632	1880	1880	the issue of 26 Sept. 1886)
Sortie du pressoir, pencil drawing on Gillot paper	D2926	c.1885–6	1885–6	
Related drawings	D2992	c.1886	——	
	D1631	1880	1880	
	D1633	1880	1880	
Bar du café de la rue du Rome, charcoal drawing, use of *estompe*	SD14	1886	——	Preparatory drawings for *Gin-cocktail* (D2965); here dated more specifically to late 1886
Au bar, conté crayon drawing	D2982	1886	1886	Preparation for SD14
Gin-cocktail, charcoal drawing	D2964	1886	1886	Shows transformation of SD14 to D2965 by addition of figures and changes in hats and glasses
Bataille de fleurs: mail-coach à Nice, ink and charcoal drawing on Gillot paper	D2844	1885	1885	Related stylistically to this group. D2927 part of group owned by *Le Courrier français* and auctioned in 1891 together
Jeune fille lisant	D2927	c.1885–6	1885–6	with *Vendanges* series
c.1886				Bolder ventures: subjects of prostitution
A Saint-Lazare, ink and pencil drawing on Gillot paper	D2842	1885	1885	Illustrates Bruant's song of same name, not written until mid-1886. Signature 'Tréclau' not used before 1886.

Title or Description	Dortu Number	Dortu Date	Joyant Date	Comments
				Preparation for an illustration first reproduced as cover of *Le Mirliton*, no. 39 (Aug. 1887). Preparatory oil sketch (P275) is dated 1886–9 and inscribed 'to the author of Saint-Lazare' by Lautrec; it was probably painted in 1886 and given to Bruant in 1889
1886				Bolder ventures: subjects of prostitution
A Grenelle, buveuse d'absinthe	P308	1888	1888	Illustrates Bruant's song 'A Grenelle' of May 1886. Preparatory drawing, D2947, *A Grenelle: buveuse pour le Mirliton*, is dated 1886 by Lautrec. Also related to series of *Artilleur et femme* (D2963 and P268–P272) (correctly set in 1886 by Joyant). (NB Figure of artilleryman first appeared on verso of D2947 [i.e. D2948])
Related blue pencil drawing, *Deux pierreuses*	D2897	1885	——	Signed 'Tréclau' and possibly intended for publication
Intérieur	SP6	no date given	——	Painting of identical subject (street walkers in a café) to D2897, and possibly a preparatory sketch for it. (NB SP6 and D2897 use same model as *A Grenelle* and *Artilleur et femme*)

<div align="center">CONTINUED EXPERIMENTATION</div>

Title or Description	Dortu Number	Dortu Date	Joyant Date	Comments
early 1887				Paintings
Madame la Comtesse A. de Toulouse-Lautrec, mère de l'artiste	P277	1887	1887	Shown in Toulouse in spring 1887
Preparatory drawing	D2849	1885	1885	
Related drawing	D1627	1880	1880	
Madame Juliette Pascal	P279	1887	1887	Six paintings, all stylistically related to P277
Madame Aline Gibert	P280	1887	1887	
Monsieur François Gauzi	P276	1887	1887	
A la Bastille, Jeanne Wenz	P307	1888	1888	(NB A drawing [D3089] after P307 was later reproduced in *Le Courrier français* of 12 May 1889)
A Grenelle, l'attente	P328	c.1888	——	
Vincent van Gogh, pastel	P278	1887	1887	Date of early 1887 supported by Hartrick
1887				Paintings: all probably shown at Les Vingt in Feb. 1888 (along with P276–P279)

Title or Description	Dortu Number	Dortu Date	Joyant Date	Comments
[1887]				
Femme rousse assise dans le jardin de M. Forest	P343	1889	1889	Close in style to P277 (impressionistic pastel palette, tight comma-like strokes,
Femme rousse en mauve, plein-air	P342	1889	1889	yet strong modelling)
Femme assise dans le jardin de M. Forest: Justine Dieuhl, de face	P394	1891	1891	Same qualities as above, plus naïve simplification in frontal pose and perspective. (Parallels van Gogh's work of this period, e.g. *Portrait of Père Tanguy* [de la Faille, F363])
La Rousse au caraco blanc	P317	1888	1888	Modified Neo-Impressionist touch (again
Poudre de riz	P348	1889	1889	close to van Gogh's work of this period, e.g. *Lady Beside a Cradle* [de la Faille, F369])
(*c.*1886–8)				Circus subjects: multiple figures; impressionistic brush stroke; cropped, asymmetrical compositions
Missing *Écuyère* (begun *c.*1886)	——	——	——	May have been cut down to *Au Cirque Fernando: 'clown'*, no. 130 at Manzi–Joyant Retrospective Exhibition of 1914 (also missing)
Scène du cirque, fan, watercolour	A197	*c.*1888	——	
Illustration for Les Vingt catalogue, 1888	D3034	1888	1888	
*c.*1886–8				Drawings and paintings of circus subjects: same stylistic features as above
Au cirque (ringmaster)	D3057	1888	——	
Au Cirque Fernando	P315	1888	1888	
Écuyère	P322	1888	——	
Au Cirque Fernando: 'clown'	P313	1888	——	
Au Cirque Fernando: 'clown'	P314	1888	1888	P314 close in composition and format to
Clown	D3054	1888	——	J. Faverot, *Au cirque: les chapeaux*, published in *Le Courrier français* (26 Sept. 1886), 9
Au cirque: écuyère, painting on a leather tambourine	P316	1888	1888	Probably done for the Café le Tambourin (the circular form of the tambourine serves as the hoop through which the *écuyère* jumps)
Related drawing, *Scène du cirque*, and its verso,	D2109	1881	?	
Femme à l'éventail	D2108	1881	?	
Au cirque: dans les coulisses	P321	1888	——	

Title or Description	Dortu Number	Dortu Date	Joyant Date	Comments
Related drawings	D3056	1888	——	
	D3011	1887	1887	
	D3012	1887	1887	
	D2330	1881	——	
Related painting	P290	1887	1887	
Le Pitre	P327	c.1888	——	
Au Cirque Médrano: Boum-Boum (Clown)	P488	1893	1893	Misdated by Joyant, who related it in date to the portrait of Mme Gortzikoff (P487), to whom this painting was later given. The Cirque Médrano, where Boum-Boum became the most celebrated clown, was not established until 1898. (NB Contrast between clown in striped costume and figure silhouetted in black parallels Faverot's illustrations, e.g. *Le Bilboquet* [*Le Courrier français* (5 Sept. 1886), 6])
La Trapéziste	P489	1893	1893	Misdated in relation to above
Related drawing	D3035	1888	1888	
Other circus drawings	D3055	1888	——	D3055 in fan-shaped format
	D2673	c.1882	——	
1887				
Au café	P274	1886	——	Related stylistically to works of 1887
c.1887				Drawings of Parisian types: related stylistically to drawings published in *Le Mirliton* of 1887 (*Sur le pavé: le trottin* [D3001], *Le Dernier Salut* [D3004], *Sur le pavé: la dernière goutte* [D3005])
Homme à la casquette	D2961	1886	1886	D2961 and D2962 probably also intended
Related drawings	D2988	1886	——	as illustrations—both ink on bristol
	D1944	1881	1881	paper
Le Fiacre	D2962	1886	1886	
Femme accroupie (squatting laundress)	P490	1893	1893	Further urban types; some may have been preparations for illustrations
Preparatory tracing	D2971	1886	1886	
Conducteur de tramway	D3045	1888	1888	
Related drawings:				
Dans le tramway	D2921	c.1885	——	
Conducteur	D2284	c.1881	——	
Jeune couple sur une voie de chemin de fer	D3080	c.1888	——	

Title or Description	Dortu Number	Dortu Date	Joyant Date	Comments
[c.1887]				
Monsieur debout, allumant son cigare	D2891	1885	1885	
Tracing of D2891, heightened with colour	P254	1885	1885	
Related drawings	D1939	1881	1881	
	D1937	1881	1881	
	D1940	1881	1881	
Prisonnier	D2979	1886	1886	
Dans les prisons	D3050	1888	1888	
1887				
La Curée: Renée	D3096	1889	1889	Both probably relate to Apr. 1887
Femme accroupie	D3286	c.1892	———	theatrical production of Zola's play *Renée*
1888				Paintings
Monsieur Louis Pascal	P291	1887	———	Both related in style to *A Batignolles*
Tête de femme, de profil vers la gauche	P289	1887	1887	(P306)
Femme assise de face, drawing	D3088	1889	1889	Both of same model as in *A Batignolles*
Femme assise	SD72	no date given	———	
Gueule de bois	P340	1889	1889	(NB Joyant misled by drawing after P340 [D3092] published in *Le Courrier français* of 21 Apr. 1889) Stylistically close to datable works of this year, e.g. *Monsieur Grenier* (P304), *Étude de danseuse* (P309), *Madame Lili Grenier* (P302, P303), and *A Batignolles* (P306). Mentioned by van Gogh in letter of 1888
Preparatory pastel	P339	1889	1889	
early 1888				Illustrations and related paintings
Bal masqué	P284	1887	1887	Study for the grisaille *Bal masqué*, P301, signed and dated by Lautrec and reproduced in *Paris illustré*, no. 10 (10 Mar. 1888)
Preparatory drawings	D2969	1886	1886	
	D2970	1886	1886	
	D3083	1889	1889	
Au bal masqué de l'Élysée Montmartre	P285	1887	1887	Related stylistically to *Bal masqué* and to *A l'Élysée Montmartre* (P311), possibly alternative preparations for *Bal masqué*
Souper	P287	1887	1887	
Au Moulin de la Galette (*Dans les couloirs de l'opéra*)	P283	1887	1887	
Related drawing	D2960	1886	1886	

Title or Description	Dortu Number	Dortu Date	Joyant Date	Comments
1888, summer				Illustrations and related paintings
Un jour de première communion, grisaille on cardboard	P298	1888	1888	Illustrations for Émile Michelet's 'L'Été à Paris', *Paris illustré* no. 27 (7 July 1888)
Preparatory charcoal drawing	D3033	1888	1888	
Cavaliers se rendant au bois de Boulogne, grisaille on cardboard	P299	1888	1888	
Le Côtier de la compagnie des omnibus, grisaille on cardboard	P300	1888	1888	
La Blanchisseuse, ink drawing	D3029	1888	1888	
Preparatory charcoal drawing	D3028	1888	1888	

WORKS OF EARLY MATURITY

*c.*1888–9 (possibly late 1889)				
Au Cirque Fernando, l'écuyère (Chicago)	P312	1888	1888	Related stylistically to works of 1889, especially to portraits of Fourcade (P331) and Samary (P330) and to avant-garde work exhibited at Café Volpini in June 1889. Hung at the Moulin Rouge from its opening in Oct. 1889
late 1888–early 1889				Cycle of paintings related to the Moulin de la Galette
Au bal du Moulin de la Galette	P335	1889	1889	P335 begun after Lautrec saw Renoir's
Femme à la fenêtre	P351	1889	——	*Bal du Moulin de la Galette* in spring
Au bal du Moulin de la Galette	P334	1889	1889	1888, finished prior to publication of drawing after it (D3091) on 19 May 1889. (NB P351, which Lautrec signed and dated 1889, and P334, a compositional sketch, are preparatory studies for P335)
La Fille du sergent de ville	P368	1890	1890	May be a study for P335, can be seen finished in photo (Ic159) of Lautrec working on *Au Moulin Rouge, la danse* in late 1889 or early 1890; stylistically close to the works of 1889 (e.g. *Fille à l'accroche-coeur* [P336], another portrait that probably belongs within the cycle of preparations for P335)
(*c.*1889)				
Femme en buste, Augusta	P367	1890	1890	Related in style to P368
Fille à la fourrure	P387	1891	1891	Related stylistically to studies for P335; is

Title or Description	Dortu Number	Dortu Date	Joyant Date	Comments
[*c*.1889]				itself a study for the main figure in P388; its inscription, 'Lautrec '91—à mon ami Guibert', probably refers to the date when Lautrec presented it to his friend
Au Moulin de la Galette	P388	1891	1891	See above. (NB Lautrec later adapted elements of this composition for *Alfred la Guigne* [P516] of *c*.1893–4)
1889				Illustrations
Au café, pencil and ink	D2968	1886	1886	Reproduces P274, redated to 1887 above. Though never published, it is stylistically close to the illustrations published by *Le Courrier français* in 1889 (D3089–D3092); probably it too was intended for publication
c.1889–90				Portraits
Hélène Vary	P318	1888	1888	Related stylistically to works of 1889;
Hélène Vary (a study)	P319	1888	1888	especially close to P336, P351, and P387
Hélène Vary	P320	1888	1888	in consistent application of colours over the surface in long strokes and in neutral palette; same sitter and comparable style to *La Liseuse* (P349), exhibited at Les Vingt in Jan. 1890; P320, the most finished of the three, shown at Volney in Jan. 1891 (cf. J. Antoine, *La Plume*, 2 [15 Feb. 1891], 78) and subsequently sold for 300 francs (cf. Goldschmidt and Schimmel, nos. 125, 127, 129)
1889				Studies of Berthe
Femme à l'ombrelle, dite 'Berthe la Sourde', assise dans le jardin de M. Forest	P360	1890	1890	Probably the 'Étude' shown at Les Vingt in 1890 and later described by Lautrec
La Femme au chapeau noir, Berthe la Sourde	P373	1890	——	Related stylistically to P360. Its inscription, 'Lautrec '90—à mon ami Durand', is likely to refer to the date when the artist made a gift of it to a friend, but it led Joyant to place both paintings in 1890

Title or Description	Dortu Number	Dortu Date	Joyant Date	Comments
1889				*Toilette* scenes
La Toilette	P610	1896	1896	Probably the 'Rousse' shown at Les Vingt in 1890 and later described by Lautrec
Femme à sa fenêtre	P507	1893	1893	All related in style to P610
La Toilette	P609	1896	1896	
La Toilette: le repose du modèle	P611	1896	1896	
Femme rousse assise sur un divan	P650	1897	1897	
late 1889–early 1890				
Au Moulin Rouge, la danse	P361	1890	1890	Signed and dated 1890 and completed by mid-Mar. 1890 opening of Salon des Indépendants, but possibly begun in 1889 since Lautrec was abroad in Jan. and Feb. 1890 and its large scale probably required work over an extended period of time. (NB Combination of long streaks and short dashes exemplifies style of this year, seen also in other dated paintings, e.g. *Follette, chienne* [P357], *Femme fumant une cigarette* [P362], and *Mlle Dihau au piano* [P358])
Au promenoir, la convoitise	P337	1889	1889	Stylistically close, especially in caricatural qualities, to P361. Shows an encounter between a prostitute and a gentleman at the Moulin Rouge
Femme en toilette de bal à l'entrée d'une loge de théâtre	P523	1894	1894	Can be seen completed in a photograph (Ic158) taken *c.* late 1889–early 1890 of Lautrec at work on *Au Moulin Rouge, la danse.* Stylistically close to P330 and P331 in streaky application of paint and caricatural quality
early 1890				Portraits
Mlle Dihau au piano	P358	1890	1890	Signed and dated 1890 by Lautrec; completed by mid-Mar. 1890 opening of Salon des Indépendants
M. Henri Dihau	P381	1891	1891	Probably done in spring or early summer 1890; exhibited at Cercle Volney in 1891. Stylistically close to P358
Désiré Dihau	P380	1891	1891	Both close in style to P381; P379 also
Désiré Dihau	P379	1891	1891	shown at Cercle Volney in Jan. 1891

Title or Description	Dortu Number	Dortu Date	Joyant Date	Comments
[early 1890]				
Au piano: *Juliette Pascal dans le salon du* *Château de Malromé*	P630	1896	1896	In Goldschmidt and Schimmel, no. 103 (June 1890), Lautrec mentioned his plans to paint Mme Pascal that summer at Malromé; close in pose and format to P358
*c.*1890				*Plein-air* studies
Femme aux gants assise	P396	1891	1891	Close in style to dated works of 1890 (as
Femme aux gants debout	P397	1891	1891	is *Femme rousse assise dans le jardin de M.*
Femme dans le jardin de M. Forest	P398	1891	1891	*Forest* [P366], correctly placed by Joyant)
*c.*1890–early 1891				Genre 'portraits' and *plein-air* studies. (NB This group includes the dated *Femme fumant une cigarette* [P362], *Femme assise de profil vers la gauche* [P364], and *En meublé* [P365], correctly placed by Joyant)
A la mie	P386	1891	1891	Stylistically closer to works of 1890 than
Casque d'or	P407	1891	1891	1891. P386 shown at Salon des Indépendants (together with P364 and P365) in spring 1891. P407 is the portrait of a notorious prostitute who danced at the Moulin de la Galette; comparable to P379–P381 in loosely brushed purple and green background against which more densely painted figure is set (cf. Stuckey, 167)
Sous la verdure	P409	1891	——	Close in style to P407
*c.*1891				*Toilette* scenes (this group includes *Femme se frisant* [P375] and *Celle qui se peigne* [P389], both signed and dated, and the related, undated *Femme se frisant* [P374], *Celle qui se peigne* [P390], and *Celle qui se peigne* [P391], correctly placed by Dortu and Joyant; all show a new emphasis on contour and abstract shapes plus a freer brush stroke)
Femme à sa toilette, Mme Fabre	P347	1889	1889	Belongs with *toilette* scenes and the series of portraits of Mme Fabre of summer 1891, i.e. the dated *La Femme au chien* (P395) and *La Toilette: Madame Fabre* (P392)

Title or Description	Dortu Number	Dortu Date	Joyant Date	Comments
*c.*1891?				Brothel scenes
Femme de maison	P509	1893	1893	Possibly among those shown in Dec.
Femme de maison	P539	1894	1894	1891 at le Barc de Boutteville Gallery and
Femme de maison	P540	1894	1894	at Les Vingt in 1892
early 1891				Male portraits (all this group definitely datable to early 1891 by Lautrec's letters of Feb. 1891)
M. le Docteur Bourges	P376	1891	1891	P376, P383 signed and dated 1891; P376,
M. Paul Sescau, photographe	P383	1891	1891	P383, P410, P467 all completed in time
Gaston Bonnefoy	P410	1891	——	for Mar. and Apr. showing of Salon des
Monsieur Louis Pascal, study	P466	1893	1893	Indépendants. (P377, dated 1891, and
Monsieur Louis Pascal, final version	P467	1893	1893	P378, both portraits of Georges-Henri Manuel, also belong to this group.) All stress elegant contours and silhouettes as does *Gabrielle la danseuse* (P393), Lautrec's only dated *plein-air* portrait of 1891
*c.*late 1891				Moulin Rouge scenes
Au Moulin Rouge ou la promenade	P399	1891	1891	Part of series of works Lautrec made in
Jane Avril, la Mélinite	P415	1892	1892	late 1891 and early 1892 to celebrate the
Au Moulin Rouge	P421	1892	1892	new season at the Moulin Rouge under
Au Moulin Rouge: le départ du quadrille	P424	1892	1892	Oller's management; close in style to other paintings of 1891 in moderately stylized forms, but less decorative than 1892 representations of Moulin Rouge. (NB P415 is a preparatory sketch for background figure in P399.) P399, P421, or P424 might have been the 'Nocturne' exhibited at Les Vingt in Jan. 1892
(1891, autumn)				
La Goulue au Moulin Rouge, poster	——	——	1891	Lautrec's letters date its completion to Dec. 1891
La Goulue	D3219	1892	1892	Studies for poster of 1891 (other studies
	D3478	1894	1894	are D3202 and P400–P402). (NB Lautrec also may have used D3219, D3478, and P400 as preparations for P399)

Title or Description	Dortu Number	Dortu Date	Joyant Date	Comments

<div style="text-align:center">WORKS DATED BEYOND THE SCOPE OF THIS STUDY</div>

Title or Description	Dortu Number	Dortu Date	Joyant Date	Comments
early 1892				Moulin Rouge scenes
Au Moulin Rouge	P422	1892	1892	Shown at Indépendants (19 Mar.–27 Apr.
La Goulue entrant au Moulin Rouge	P423	1892	1892	1892); more decorative style—must follow Moulin Rouge poster (P422 related to a lithograph [Delteil, no. 11]); part of group of works of autumn 1891– winter 1892 celebrating new season at the Moulin Rouge
1892				Studies of the surgeon, Dr Péan
Une opération de trachéotomie	P384	1891	1891	Lautrec's cousin, Gabriel Tapié de
Une opération par le docteur Péan à l'Hôpital Internationale	P385	1891	1891	Céleyran, began his study of medicine with Dr Péan in late 1891 (see
Drawings of Dr Péan and related subjects	D3154– D3198	1891	1891	Goldschmidt and Schimmel, no. 125) and introduced Lautrec to Péan sometime
	SD16– SD20	1891	——	after that. The paintings and drawings of Péan probably date from 1892 and later; they are more abstract and abbreviated than the works of 1891
1892				
Portrait de femme	P296	1888	1888	Belongs with series of portrait medallions made to decorate the brothel on the rue d'Amboise (P440–P457)
1895				
Au Moulin de la Galette (La Goulue et Valentin le Désossé)	P281	1887	1887	Both are preparatory studies for one of Lautrec's canvas decorations for La
Au Moulin de la Galette: La Goulue et Valentin le Désossé (La Goulue et Valentin le Désossé)	P282	1887	1887	Goulue's booth at the Foire du Trône (P592) made in 1895
Related drawing	D3476	c.1893	——	
1895?				
Au Moulin Rouge	P427	1892	1892	Reinhold Heller showed that P427 was cut down at a later date and subsequently put back together. Its original state must date from 1895 since it includes the figure of May Milton, treated by Lautrec only in

Title or Description	Dortu Number	Dortu Date	Joyant Date	Comments
				1895 (P572, portrait sketch of May Milton, may be a preparatory study)
1891–5?				
Femme de dos	P458	1892	1892	Studies for figure with her back to us
Femme assise vue de dos	P403	1891	1891	(Jane Avril) in P427. Alternatively these
Femme rousse	P404	1891	1891	may have been made at an earlier date and utilized later
c.late 1897–early 1898				
Toulouse-Lautrec par lui-même, ink drawing	D4020	*c.*1895	——	Reproduced in *Hommes d'aujourd'hui*, issue devoted to Lautrec and datable to this time

APPENDIX B

Lautrec's Commentaries on the Exhibitions of 1883[1]

The Salon and Petit's International Exhibition[2]

Democracy is at the Salon. Equality, congestion. Nothing is lacking. Universal suffrage has even invaded the sublunary spheres where Cabanel reigns, and the medal of honour reverts to the choice of the majority.[3] Reaction! Reaction! cried the art dandies [*gommeux*] and they opened on the rue de Sèze, at M. Petit's gallery, a little church where one goes, in the peaceful meditation of the daytime and in the suffocation of the carpets, to worship distinction in painting.[4]

Last year Monsieurs Gérôme,[5] Baudry,[6] Dupré[7] and others gathered together the pick of the crop and, appealing to the élite of foreign artists, opened an International Exhibition.[8] It was a real treat because of its exiguity.

Was it really worth it to open the Salle Petit again and to hang there the lucubrations of several young men, the majority of whom had nothing in their favour other than being as international as their predecessors?[9]

Alongside of works of real value, such as *The Forge* by M. Bastien-Lepage,[10] the portrait and the

[1] Originally published in Joyant, i. 62–74.

[2] Although Joyant labels this section 'Le Salon', Lautrec here describes Petit's Exposition Internationale as well.

[3] Lautrec refers to the democratizing reforms of the Salon of 1883 (see text). See also C. Bigot, 'Le Salon de 1883', *Gazette des beaux-arts*, 27 (1883), 459–60. Alexandre Cabanel (1823–89), a strict academician, had previously virtually controlled jury selections and hence the coveted awards, which now reverted to the choice of the majority of the membership of the newly founded Société des Artistes Français.

[4] Georges Petit's Première exposition de la Société Internationale de Peintres et Sculpteurs. Yet another Exposition Internationale de la Peinture was held at Petit's later that spring. The latter is generally referred to as Petit's second Exposition Internationale, held at his gallery at 8, rue de Sèze. The sumptuous rooms were a meeting-place in the afternoons for elegant crowds of art fanciers. From this point in his review, Lautrec goes on to discuss the show at Petit's and not the Salon, to which he returns only in his last paragraph.

[5] Jean Léon Gérôme (1824–1904), one of the most successful academic painters of his time, professor at the École des Beaux-Arts, member of the Institut. He specialized in oriental subjects, tinged with eroticism and rendered with an archaeological precision of detail.

[6] Paul Jacques Aimé Baudry (1828–86), a successful academic painter, Prix-de-Rome winner, and member of the academy.

[7] Jules Dupré (1811–89), painted lyrical landscapes in the Barbizon mood.

[8] Petit's first Exposition Internationale, founded in 1882. 'The by-laws of the society specified that the members would invite twelve artists each year, three of them to be French'; cf. Rewald, *Impressionism*, 519 n. 1. The exclusiveness of Petit's exhibitions must have made them particularly appealing in 1883 to conservative artists and public alike, threatened by the democratization of the Salon. See A. Baignères, 'Première exposition de la Société Internationale de Peintres et Sculpteurs', *Gazette des beaux-arts*, 27 (1883), 187–92, who complained that there was no longer an élite.

[9] Baignères also complained that this exhibition was unnecessary, given that the last international exhibition had just been held the past spring and that there were too many exhibitions being held anyway.

[10] Jules Bastien-Lepage (1848–84), was popular with conservative critics for his combination of solid academic draughtsmanship with *plein-air* qualities and 'democratic' subjects of labour. His was the kind of 'modernism' with which Lautrec was beginning to identify. The painting referred to here is his *Intérieur de forge à Damvillers*, also praised by Baignères as Lepage's best work in this show, and later shown at the Salon of 1884. Lepage also showed portraits and landscapes at Petit's in 1883.

study by M. Boldini,[11] and two sculptures by M. de Saint-Marceaux,[12] we had to put up with the morbid fantasies of a Béraud[13] and the fashion plates of a Toffano.[14]

Do you wish to sell, M. Sargent? Certainly the manner in which you 'wipe' your brush is marvellous, but, really, international art will hardly regenerate itself at the enthusiastic contact of your brush.[15]

M. Duez amuses me, especially when he starts to play it big.[16] Does he believe himself to have accomplished very much by dishing out again the portrait of our friend and master Butin?[17] Any common art dealer could have done this as well. In fact, there's quite a good one at the corner of the rue Neuve-des-Capucines.

M. Gemito is charming, as are his busts![18] They are old acquaintances.

In sum, is it the jealousy of youth, or is it only an insignificant little international storefront that has been presented to us here? My tendency is toward the latter.

But, good God, Monsieurs Dagnan,[19] Edelfeld [*sic*],[20] Sargent,[21] and Bastien-Lepage[22] have yet to expect more from the Salon than mere feminine approval, which the chilly ladies stifle behind their sumptuous catalogues.

Leave Béraud to them. Such an unencumbering man!

The Clubs

Fiddledeedee to the Saint-Arnaud and the Mirliton, the clubs have given their little annual show.

The Volney (formerly Saint-Arnaud) included among its members several painters of distinction.[23]

[11] Giovanni Boldini (1842–1931), a portrait painter extraordinarily popular with fashionable Parisian society at this time. He painted in a bold, sketchy style. Since he was Italian born, he counted among the foreign artists at the International Exhibition.

[12] René de Saint-Marceaux (1845–1915), a fashionable sculptor of the day, exhibited regularly at the Salons. He showed several portrait busts at this show, including a *Basquaise*. Cf. Baignères.

[13] Jean Béraud (1849–1936), a successful Salon painter, specializing in anecdotal genre scenes of modish Parisian life. He showed the paintings *Boulevard, le soir* and *Sortie de l'opéra*, and another representing spectators in the orchestra of a theatre during intermission. Cf. Baignères.

[14] Édouard Toffano (1838–1920), an Italian-born portraitist. He showed several 'fashion pieces' at this exhibition. Cf. Baignères.

[15] John Singer Sargent (1856–1925), an American painter rapidly achieving a reputation as a portraitist of fashionable society. Lautrec here refers sarcastically to his famous bravura brush stroke, implying that such flamboyance is hardly the way to true quality, even if it sells. He showed his portrait of *The Boit Children* (Boston, Museum of Fine Arts) under the title *Portraits d'enfants*, along with several views of Venice, including *A Street in Venice* (Washington, DC, National Gallery of Art), and his portraits of *Vernon Lee* and *Mrs Daniel Curtis*. Cf. Baignères; and R. Ormond, *John Singer Sargent* (London, 1970).

[16] Ernest Duez (1843–96), a painter of portraits, landscapes, and genre scenes, and winner of many medals at the Salon. His style was a modified *juste milieu* Impressionism. He was criticized

by Baignères as well as by Lautrec for showing a portrait of Butin and a *Coucher du soleil* which had been shown at the Salon of 1882.

[17] Ulysse-Louis-Auguste Butin (1837–83), a *juste milieu* portrait and genre painter who had recently died. Best known for his seascapes and scenes of the life of fishermen.

[18] Vincenzo Gemito (b. 1852), an Italian sculptor specializing in portrait busts who enjoyed considerable success at the Paris Salons. He represented foreign sculpture at this show. He exhibited a *Neopolitan Fisherman* and a *Marchand d'eau*. Cf. Baignères.

[19] Pascal Adolphe Jean Dagnan-Bouveret (1852–1929), a Prix-de-Rome winner who was very successful at the Salons. He painted anecdotal genre scenes and portraits and was considered to be a follower of Bastien-Lepage. At this exhibition he showed the painting *La Vaccination*.

[20] Albert Gustaf Aristides Edelfeldt (1854–1905), a Finnish painter, trained in Paris under Gérôme and specializing in genre scenes and portraits. He had been a great success at the Salon of 1882. At the Salon of 1883 he showed a portrait of *Mme de B. . .* (no. 880) and a *Vieille paysanne finlandaise* (no. 881). Lautrec, like Baignères, preferred his simple realism and humble subjects to the prettified paintings of Toffano.

[21] Showed *Portraits d'enfants* at the Salon of 1883 (no. 2166).

[22] Showed *L'Amour au village* at the Salon of 1883 (no. 731).

[23] From 1889 until the early 1890s Lautrec himself showed frequently at the Cercle Volney, which like the other he mentions was a fashionable society club.

M. Carolus-Duran[24] and M. Delaunay[25] offer quite a fascinating contrast, the one with his masterly suppleness, the other with his tight and implacable drawing.

But, M. Delaunay, why the green leaves that make the reds of your general stand out so disagreeably? Too many 'laurels', M. Delaunay!

M. Henner has the 'palm' with his head of a young girl; one could not be more mysterious without being slack.[26]

M. Princeteau made me appreciate the exhibits of the clubs at their true value. He submits the first rough sketch that hits his eye and that never fails to be included in the first class and with honours.

Who is this bilious gallic master M. Luminais?[27]

M. Maignan has quite a pretty little canvas, what sentiment—perhaps it's sentimentality.[28]

M. Montenard, bravo, your sunlit seascape is very slipshod—go right ahead—but don't wait for the Impressionists.[29] All this, is it sufficient for the multitude of crummy connoisseurs!

Place Vendôme, opposite the column, the Mirlitons!

What a mob! Lots of people, lots of women; lots of nonsense! It's a jostling done with gloved hands, wielding tortoise-shell or gold pince-nez; but it's a jostling none the less.[30]

Here are the observations that I have collected in the midst of so many elbows.

First, an exquisite study by Jacquet and also a well-powdered portrait by him. You are well set off, M. Jacquet,[31] against an old man by M. Cabanel and another old man by M. Cormon, whose slightly problematic pose is redeemed by the perfection of his hands. A portrait of a young girl, by the same painter, is the last word in the comprehension of anaemia, the bloodshot eyes, the pasty skin; all is rendered with a sincerity which should serve as a lesson to many and to our best painters. It is for you that I say this, M. Carolus-Duran. In spite of all the love that I have for your rich temperament, I cannot compliment you for your head of a child.[32] M. Rochefort, who is at my side, shares my opinion, I'm glad to say.[33]

Are you satisfied, M. Carolus? and Velasquez too?[34]

Oh! M. Gérôme, what a lovely 'sauce' for your *Eunuque*, and a white eunuch, if you please. Why didn't you put some of the same energy you used in the modelling of this impotent orang-utan into the portrait of Mme X?

M. Cabanel has recovered the distinction of his best days in the portrait of a blond woman.

[24] Émile-Auguste Carolus-Duran (1838–1917), one of the most popular official painters of the day, specializing in society portraits. He pleased the public with a *juste milieu* style which reconciled precise underdrawing with a more spontaneous application of colour.

[25] Jules-Élie Delaunay (1828–91), an academic painter, teacher at the École des Beaux-Arts, and member of the Institut. He practised a classical, Ingresque style.

[26] Jean-Jacques Henner (1829–1905), an extremely successful and honoured academic painter. His paintings of this period display soft modelling, blurred contours, and mysterious shadowy effects, influenced by Correggio.

[27] Évariste-Vital Luminais (1822–96), painted history, genre, and hunt scenes in a painterly style.

[28] Albert Maignan (1845–1908), a Salon artist and a pupil of Luminais. He painted portraits, history, and genre scenes.

[29] Frédéric Montenard (1849–1926), showed regularly at the Salon where he was a great success at this time. His genre, landscape, and marine paintings were in a *juste milieu*, modified Impressionist style.

[30] The exhibitions were great worldly events, where high society gathered to see and be seen, attired in their fashionable best; cf. J.-P. Crespelle, *Les Maîtres de la belle époque* (Paris, 1966), 21.

[31] Gustave-Jean Jacquet (1846–1909) painted portraits in a nostalgic rococo manner, exhibiting regularly at the Salons. Apparently one of Lautrec's favourites, he was also mentioned in a letter of the previous year. See Joyant, i. 57.

[32] Despite his sarcasm, Lautrec seems to be praising Cormon's realism, which he contrasts to Carolus-Duran's fashionable prettification.

[33] Possibly Henri Rochefort (1831–1913), a political journalist famous for his nationalist and republican views and for his virulence.

[34] Carolus-Duran was famous for his copies of the paintings of Velasquez, which had a permanent influence on his style.

M. Detaille, I like your panoramas very much, but your two small canvases are really superior: not so many panoramas![35] Look at M. Dupray[36] . . . there's a young man who is moving forward, look out, M. Detaille!

You have studied English pictures, M. Gervex; what charm in the big blue eyes of your little child! *A merry Christmas and a happy New Year!* What I like about you is the diversity of your talent. Where are your stevedores for the public to compare and praise?[37]

M. Chartran, beware of dryness and you will go far.[38] Ah! M. Lefebvre, what softness![39] It's quite suitable, but quite boring. M. Jalabert merits the same reproaches.[40]

Let us salute M. Machard.[41] I have never seen a woman's hand so charming, fine, faded, ornamented with a sombre sapphire and drowned in black fur, with a simple gesture, without affectation: this hand is the best of what there is at the show.

The sculptors, as always, do well. M. Franceschi[42] and M. d'Épinay[43] are marvellous, the one with the bust of Mlle Bartet, the other with two heads of young shepherds.

Conclusion: many pretty things, but only pretty; the average note is seductive, but then, how could one bear a grudge against people who simply want to make one pass an afternoon?

The Watercolourists

The watercolour is dead, the gouache reigns alone. The Society of Watercolourists which has maintained itself brilliantly up to the present is rapidly tumbling into the abyss of commercialism. I congratulate M. Bastien-Lepage, who does watercolours for the first time and who, by his simplicity, surpasses all the others.

M. Duez follows him closely with his *Flood*, but what is the meaning of those large encumbering flowers? Are you ambitious for the title of screen painter, M. Duez?

Bravo, Madame Lemaire, your peaches are the most frank strokes of the brush of the lot.[44] But, good God! where do you find the models who display your costumes? Ah! M. Vibert, how ugly to

[35] Édouard Detaille (1848–1912), one of the most popular painters of the period. His specialty was military scenes painted with a detailed realism. In 1883 he exhibited vast panoramas of the battles at Champigny and Rezonville, made together with Alphonse de Neuville in 1882–3. Also praised by Lautrec in a letter of the previous year. See H. Schimmel, no. 71, p. 61.

[36] Henri Louis Dupray (1841–1909), a painter of military subjects.

[37] Henri Gervex (1852–1929), a fashionable *juste milieu* painter, producing at this time portraits of society women in a modified Impressionist style. He had earlier gained attention for his audacious realism in paintings shown at the Salons of 1881 and 1882 and designed to decorate the *Mairie* of the 19th Arrondissement in Paris. In these he represented a civil marriage in the *Mairie*'s marriage chamber, stevedores from the docks, and butchers from the slaughterhouses of the Villette district: 1881, *Le Mariage civil*; 1882, *Les Bouchers de la villette* and *Quai de la villette à Paris*. Because the public criticized him for taking realism too far, he turned more and more to society portraiture. Lautrec implies here that he prefers Gervex's realism to his prettified portraits.

[38] Théobald Chartran (1849–1907), a distinguished academic painter of religious and historical subjects and fashionable portraits. He was a Prix-de-Rome winner.

[39] Jules-Joseph Lefebvre (1836–1911), a conservative, academic painter of mythological and historical subjects in a style of meticulous realism and smooth finish. He had a brilliant official career. At this time he produced dreamy portraits of women.

[40] Charles-François Jalabert (1819–1901), a portrait and genre painter.

[41] Jules Louis Machard (1839–1900), a history and portrait painter, a Prix-de-Rome winner.

[42] Jules Franceschi (1825–93), a portrait sculptor who showed regularly at the Salon. He sculpted a bust of the critic Albert Wolff.

[43] Prosper d'Épinay (b. 1836), a popular sculptor whose work had also been included in the above exhibition at Petit's. Cf. Baignères.

[44] Madeleine Lemaire (1845–1928), a fashionable society painter, one of the most well-known women artists of her day. She specialized in still lifes of flowers and fruits, but also painted portraits and genre scenes. She has been called the 'Berthe Morisot des pompiers'. Cf. Crespelle, 87.

make caricatures as insipid as yours! You dish out again the eunuch of M. Gérôme, and, I must say, by comparison, he loses.[45]

Should I mention Monsieurs Leloir,[46] Detaille, and de Neuville[47] with their panoramas; M. de Beaumont[48] and M. Jourdain?[49]

I bow down before the coffin of Gustave Doré[50] and end up crying before that of the watercolour.

Boudin Exhibition

I have been to see the Exhibition of Boudin, who is indulged with one all to himself.[51]

I don't have to spell out here Boudin's background, son of a sailor, seaman, helmsman, or caulker. What does it matter to us? I have only found in him a painter not at all banal, who, but for his grey and often monotone touch, remains an enchanter.

The impressions of the beach are also very pleasing. I'll cite his *Porte du Havre During a Storm*, the white sails sharp against the violet sky, and which stands out amongst hundreds of studies which fill five or six rooms.[52] He's an earnest [artist] . . .

The Women Artists

Rudely ignored in the masculine exhibits, the women artists staged last year a little *coup d'état* and gallantly opened an exhibition to which the public responded more gallantly yet.[53]

As a journalist, or rather as a gallant idler [*flaneur*], I visited their show to which an invitation card gained me entry; like a fashionable lady on a Thursday afternoon: astonishingly, there was no turnstile. Among the thousand and one more or less fatiguing exhibitions, which, to use the accurate term of my sympathetic colleague, A. Wolf [*sic*],[54] are 'rampant' at this moment in Paris, it is the only one which, in a public locale, has not set up a humiliating commercial standard, as another no less sympathetic colleague put it.

I looked around for the mistress of the house and only saw lots of still lifes. The forsaken ones are, in effect, fond of these unintimidating subjects in which their qualities of perfection, which make

[45] Jean-Georges Vibert (1840–1902), a founder of the Société des Aquarellistes Français and a popular painter of anecdotal scenes, often satirizing the life of the clergy. He painted with a highly finished, photographic realism learned from his teacher, Meissonier.

[46] Alexandre-Louis Leloir (1843–84), a noted watercolourist and one of the founders of the Société des Aquarellistes in 1879. He was famous for his costume pieces of historical and genre subjects and for his fans, painted with 18th-cent. subjects.

[47] Marie-Adolphe Alphonse de Neuville (1835–85), a painter of military subjects, especially episodes of the war of 1870. Presumably watercolour versions of the panoramas done in conjunction with Detaille and shown at the Mirliton were exhibited at the Watercolourists' Salon.

[48] Charles Édouard de Beaumont (1812–88), a watercolourist and also a founder of the Société des Aquarellistes of which he eventually became president.

[49] Roger Joseph Jourdain (1845–1918), a fashionable genre painter who enjoyed considerable success at the Salons of the late 1870s and early 1880s.

[50] Paul-Gustave Doré (1832–83), who died on 23 Jan. 1883.

[51] Eugène-Louis Boudin (1824–98); a major one-man show of his work was held in Feb. 1883 at the Durand-Ruel Gallery.

[52] Possibly the painting *Le Havre*, *Storm*, signed and dated 1883 (Washington, DC, Corcoran Gallery). Boudin's favourable reception by collectors and the press at this time made him an established success in Paris, where he had already enjoyed a degree of official success since 1881 when he won his first medal at the Salon. See G. Jean-Aubrey, *Eugène Boudin* (Greenwich, Conn., 1969), 100.

[53] Probably the Society of Women Painters and Sculptors, which had its first annual exhibition in 1882.

[54] Albert Wolff (1835–91), the art critic for *Le Figaro*, who was extremely influential in the art world. A conservative and an opponent of the Impressionists, he was known for his wit and virulence and for his ambiguously worded reviews.

living nature dull by comparison, find a free field. I congratulate Madame Muraton.[55] Moreover, she is a talent who can't complain about the annual Salon, where her brilliant and sincere colour and her masculine valour have been for . . . (I was going to say for a long time, but I decline, out of gallantry), have been, I say, not only pointed out, but rewarded. Her peaches and her apricots are plump, and I don't know what strong odour of vigorous sap emanates from her still lifes, which cease to be still and become alive.

By contrast, her little white donkey, standing beside grapes (the sketch of her painting *The Grape Harvest*) has a slight air of a stuffed animal. I have tried to sweeten my critique by saving my nasty words for this little donkey; Madame Muraton will not thank me for it, I will submit to her anger without complaining, out of gallantry.

Let's finish up with the still lifes. Madame Hamon,[56] who employs vigorous and precise impastos on very studied underdrawings, occupies a high rank with her *Chinese Porcelain*, her *Herrings*, which are well smoked and salted. Madames Ayrton,[57] Peters,[58] and Madame Villebessen also deserve credit for their efforts to 'virilify' their brush, if I may say it this way. The curious thing is that all of these women seldom do well without exaggerating the energy of their technique. I have not seen any canvas here that is truly feminine. Will you leave to men alone the understanding of women? They'll accept, the monsters, out of gallantry.

Madame de Goussaincourt is afraid of being soft and so she makes wooden geraniums; the background partially makes up for this grave fault by its *brio*.[59] I prefer that to the insipidness of Madame Coeffier who serves us *Martha and the Magdalene* (?) in a gooey syrup.[60] Ah! the beautiful white robes and the beautiful rose ribbons!

Madame D. de Cool, whose painting *At the Sorceress'* is dear to her, finds it necessary to dish it up to us again.[61] At the Salon, it was hardly noticed, but here it looks more important and, in sum, it's the only slightly complicated painting. Then she rushes into faceted sculpture, for which she also has a weakness, in her *Venganza*. A Spaniard, with a knife in his hand, looks around him to see who he can stab. The wretch doesn't see that his dagger will roll inoffensively to the ground, his fingers being made of soap. Madame de Cool, who is a powerful woman, loves to impasto, but she impastos everything with the same square brush. And, none the less, it is one of the strongest here, I admit it, out of gallantry.

I absolutely bow before Mlle Robiquet.[62] She knows how to be energetic without harshness and to be mysterious without insipidity. Her little canvas, *Miss Louisa*, a head study, is without doubt the best head here. The somewhat indistinct profile is drawn in a charming fashion while abundant hair overflows the frame, resplendent. Here gallantry is no longer necessary, but adoration.

Madame Salles-Wagner is lightly inspired by Henner in the head of her little child on a blue background.[63] The flesh is a bit greenish, but the ensemble is appealing. This green is, none the less,

[55] Euphémie Muraton (b. 1840), a still-life, animal, and genre painter, who showed frequently at the Salon, where she won a medal in 1880.

[56] Adrienne Hamon, an official painter who showed at the Salon.

[57] Annie Ayrton (d. 1920), a flower and still-life painter.

[58] Madame Peters (1843–1926), a German flower painter who showed in Paris.

[59] Louise de Goussaincourt de Gavain, a still-life painter who showed at the annual Salons.

[60] Marie-Pauline-Adrienne Coeffier (1814–1900), who specialized in religious subjects and pastel portraits, showed at the annual Salons until 1868.

[61] Delphine Arnould de Cool (b. 1830), a painter and sculptor, who showed at the annual Salons.

[62] Marie-Anne Robiquet, a painter of religious subjects, who made her debut at the Salon of 1879.

[63] Adélaïde Salles-Wagner (1825–90), a successful history, genre, and portrait painter.

nothing next to Madame Pillaut-Reisener's, non-catalogued, who is inspired by Manet and who surely gives the strange note in this exhibition.[64] The pastels are still more impressive. A violet cat permits itself to be caressed by a bile yellow young girl.

Mlle Keyser tries less to astonish the public and is perhaps the most successful.[65] Her *First Communion* and her portrait of Madame S. . ., although bordering on the chic, are of a very pleasing and rather personal note. Mlle Pichon gives us a portrait of her grandfather. This good old man, his eyes behind enormous round glasses, is portrayed with a certain *naïveté*, occasionally clumsy, but which demands indulgence and even praise.[66]

The above-mentioned very Parisian journalist doesn't shun the sharp word in his profound coolly considered, and sweetly philosophical accounts. I can, however, affirm that he has rarely been as biting as when he affirmed to us that the portrait of M. Ignotus, by Mlle Porte, was a good likeness.[67] In spite of all the jealousy that the handsome moustaches of your colleague might inspire in you, you will never agree that he has come to that point of putrefaction, will you, M. Wolf [*sic*]? No, it's not the reddish background that mars this portrait, it's the portrait that mars the background. Mlle Koch is jealous of Carolus: she gives us a little red on red girl, in which the end is not justified by the means.[68]

Mlle Peyrol-Bonheur, faithful to the traditions of her family, perpetuates cows and bulls into which she has unfortunately forgotten to put a skeleton.[69] From there, collapse.

Madame Jobard tries to be witty.[70] She paints a nude woman with a background that smacks of the style of Henner's studio (the door facing), and entitles it *The Woman with Doves*. No more doves than I have on my hand. I searched in vain for three-quarters of an hour to find them. I gave up, out of frustration, and perhaps out of gallantry.

The landscapists throw themselves into force tardily.

Madame de la Villette has good strong seascapes,[71] upon my word, and Madame Bruneau turns out landscapes with so few details as to seem rudimentary.

Among the drawings and watercolours, I note some sketches by Mlle Formstecher[72] and Madame Chatillon,[73] some landscapes by Madame Ericson,[74] better than her paintings, and boldly painted flowers by Madame de Cool, which I approve without reserve, especially in her enamels, which are perfections. As for the rest, mere imitations . . .

The sculpture astonished me. These women have not only consented to handle heavy clay and the chisel, but they have distinguished themselves at it. Madame Bertaux, president of the Society of the Abandoned, has a bronze medallion of an unprecedented vigour, a very good fragment of a statue,

[64] Rosalie Pillaut-Reisener, a pastelist who showed in Paris from 1877 until the early 1880s.

[65] Hilda-Elisabeth Keyser (1851–98), a painter who showed at the Salons of the 1880s.

[66] Marie-Pauline Pichon, a painter. She studied at the École des Beaux-Arts and showed at the Salons. Again Lautrec opts in favour of a work in a realist vein.

[67] Adèle Porte, a painter. Ignotus was another writer and critic for *Le Figaro*.

[68] Elisa Koch, who showed portraits and genre pieces in oils and pastel.

[69] Juliette Peyrol-Bonheur (1830–91), a sister of Rosa Bonheur and, likewise, a specialist in animal subjects.

[70] Clémence-Jeanne Jobard, who specialized in portraits on porcelain and miniatures.

[71] Élodie de la Villette (b. 1848), a landscape and marine painter who showed regularly at the Salons.

[72] Anna Formstecher (b. 1848), a painter who showed at the Salons.

[73] Zoë-Laure de Chatillon (1826–1908), a painter who showed at the Salons.

[74] Anna Maria Ericson (b. 1853), a watercolour and landscape painter.

and a bust of 'Spring', the head ornamented with butterfly wings and coquettishly leaning toward the shoulder; it has an exquisite sentiment.[75]

My compliments to Madame Buttet for her *Beppo*, to Madame Crozier for her *Emma*.[76] And Madame Legendre for her watchdog with muff and slippers! . . .

Madame Delattre distinguishes herself with her bust of Madame G. . ., which is really very out of the ordinary.[77] Is that all?

Alas! yes. But why do Madames Madeleine Lemaire, Louise Abbema, and Sarah Bernhardt shine by their absence?[78]

Probably they are no longer women, but legends.

But what, dear madame, were you saying?

H. de Toulouse-Lautrec

[75] Hélène Hebert Bertaux (1825–1909), a sculptor, known especially for her medals.

[76] Anne-Jane Crozier, an English genre painter.

[77] Thérèse Delattre, a sculptor and medallist, a pupil of Mme Bertaux. She won an honourable mention at the Salon of 1883.

[78] Louise Abbema (1858–1927), an extremely famous woman artist of the period, known for her painting, engraving, and sculpture. By pointing out her absence as well as that of Madeleine Lemaire and the actress Sarah Bernhardt, who was also a sculptor and who had shown her work at previous Salons—three of the most talented women artists in Paris—Lautrec ironically comments on what he sees as a lack of such quality in this show.

Checklist of Exhibitions and Attempted Identification of Works Exhibited: 1886–Early 1892

Data have been assembled from exhibition catalogues, references in Lautrec's letters, and primary sources such as witness accounts and exhibition reviews, wherever possible.

Dortu's catalogue numbers are given in parentheses.

Joyant/Dortu titles are italicized; titles listed in exhibition catalogues or in reviews are in quotation marks.

1886–?　On permanent exhibition at Le Mirliton
Works entered this collection 1886–9
1. *A Montrouge—Rosa la Rouge* (P305)
2. *A Grenelle* (P308)
3. *A Saint-Lazare* (P275)
4. *Le Refrain de la chaise Louis XIII, au cabaret d'Aristide Bruant* (P260)
5. *Le Quadrille de la chaise Louis XIII, a l'Élysée Montmartre* (P261)
6. *A la Bastille* (P307)
7. *A Grenelle, l'attente* (P328)
8. *A Batignolles* (P306)
9. *Gueule de bois* (P340)
10. *Le Côtier de la compagnie des omnibus* (P300)

1866　Salon des Arts Incohérents
(As Tolau-Segroeg, Hongrois de Montmartre)
Opening 19 Dec. 1886
1. 'Les Batignolles—trois ans et demi avant Jésus Christ', no. 332

1887　Exhibition at a Montmartre restaurant (probably Grand-Bouillon-Restaurant du Chalet, 43 avenue de Clichy)
Nov., Dec. 1887 (organized by Vincent van Gogh)
According to Bernard, Lautrec exhibited paintings of 'prostitute types'. Not possible to determine precisely which works were shown.

1887　Exhibition at Toulouse, precise location unknown
Month of June 1887
1. Portrait of *Madame la Comtesse A. de Toulouse-Lautrec, mère de l'artiste* (P277)

1888　5ᵉ Exposition des Vingt
Opening 2 Feb. 1888
1. 'Rousse (plein-air)', probably *Femme rousse assise dans le jardin de M. Forest* (P343), no. 1

2. 'Rousse (plein-air)', probably *Femme rousse en mauve* (P342), no. 2
3. 'Rousse étude appartient à M. Leclanché', probably *La Rousse au caraco blanc* (P317), no. 3
4. 'Portrait de Mme A. de T. L.', *Madame la Comtesse A. de Toulouse-Lautrec, mère de l'artiste* (P277), no. 4
5. 'Portrait de Mme J. Pascal', *Madame Juliette Pascal* (P279), no. 5
6. 'Portrait d'homme', possibly *Monsieur François Gauzi* (P276), no. 6
7. 'Étude de face', possibly *Femme assise dans le jardin de M. Forest, Justine Dieuhl, de face* (P394), no. 7
8. 'Étude de profile', possibly the portrait of *Vincent van Gogh* (P278), no. 8
9. 'Poudre de riz, à M. van Gogh', *Poudre de riz* (P348), no. 9
10. 'Écuyère', probably the 'Missing *Écuyère*', no. 10
11. 'Eventail du cirque', *Scène de cirque*, fan (A197), no. 11
12. Drawing for the catalogue illustration, after the clown in the 'Missing *Écuyère*', *Clown* (D3034)

1889 Exposition de la Société des Amis des Arts de Pau
1. 'Femme rousse assise (plein air)', probably *Femme rousse assise dans le jardin de M. Forest* (P343), no. 436

1889 Salon des Arts Incohérents
1. 'Portraits d'une malheureuse famille atteinte de la petite grêlure'

1889 Exposition du Cercle Artistique et Littéraire Volney
Month of June 1889
1. 'Portrait', not possible to identify more precisely
2. Another portrait or portraits

1889 5ᵉ Salon des Indépendants (3 Sept.–4 Oct. 1889)
Opening 3 Sept. 1889
1. 'Bal du Moulin de la Galette', *Au bal du Moulin de la Galette* (P335), no. 257
2. 'Portrait de M. Fourcade', *Monsieur Fourcade* (P331), no. 258
3. 'Étude de femme', not identifiable, no. 259 (possibly one of Lautrec's studies for *Au bal du Moulin de la Galette*)

1889–? On permanent exhibition at Le Moulin Rouge
1. *Au Cirque Fernando, l'écuyère* ('Chicago *Écuyère*') (P312)

1890–? On permanent exhibition at Le Moulin Rouge
1. *Au Moulin Rouge, la danse* (P361)

1890 7ᵉ Exposition des Vingt
Opening 18 Jan. 1890; banquet, 16 Jan. 1890
1. 'Le Bal du Moulin de la Galette', *Au bal du Moulin de la Galette* (P335), no. 1
2. 'Rousse', *La Toilette* (P610), no. 2
3. 'Liseuse', *La Liseuse* (P349), no. 3
4. 'Étude', *Femme à l'ombrelle, dite 'Berthe la Sourde', assise dans le jardin de M. Forest* (P360), no. 4
5. 'Étude', not identifiable, no. 5

1890 6ᵉ Salon des Indépendants
 20 Mar.–27 Apr. 1890
 1. 'Dressage des nouvelles, par Valentin le Désossé (Moulin Rouge)', *Au Moulin Rouge, la danse* (P361), no. 790
 2. 'Portrait de Mlle Dihau', *Mademoiselle Dihau au piano* (P358), no. 791

1891 Cercle Volney
 Opening 26 Jan. 1891
 1. 'Étude de jeune fille', *Hélène Vary* (P320) (Gauzi, 41, identifies P320 as the painting shown, although he mistakenly gives 1890 as the date of the exhibition)
 2. 'Le Jovial M. Dihau', *M. Henri Dihau* (P381), no. 208
 3. 'Désiré Dihau', *M. Désiré Dihau, basson de l'opéra* (P379), no. 187

1891 7ᵉ Salon des Indépendants
 20 Mar.–27 Apr. 1891
 Lautrec's works not all listed in the Indépendants catalogue this year; Lautrec listed under *De* Toulouse-Lautrec, p. 23
 1. 'A la mie', *A la mie* (P386), no. 383
 2. 'Portrait du jovial M. Dihau', *M. Henri Dihau* (P381), no. 384
 3. 'En meublé', *En meublé* (P365), no. 385
 4. 'Portrait de M.G.B.', *Gaston Bonnefoy* (P410), no. 386
 5. 'Étude', not identifiable, no. 387
 6. 'En meublé', probably *Femme assise de profile vers la gauche* (P364), no. 388
 7. 'Portrait du docteur B.', *M. le docteur Bourges* (P376), no. 389
 8. 'Portrait de M.L.P.', *Monsieur Louis Pascal* (P467), no. 390
 9. 'Truc for live', not identifiable, no. 391
 10. *M. Paul Sescau, photographe* (P383), not listed in catalogue (Lautrec probably delivered it to the exhibition too late), but mentioned in exhibition reviews

1891 Salon des Arts Libéraux
 Opening 28 May 1891
 1. 'M. Sescau', *M. Paul Sescau, photographe* (P383)
 2. 'Un coin du Moulin de la Galette', possibly *Au Moulin de la Galette* (P388)

1891 Peintres Impressionistes et Symbolistes, 1ᵉ Exposition, Gallery of le Barc de Boutteville
 Dec. 1891
 1. 'Femme cigarette', *Femme fumant une cigarette* (P362), no. 68
 2. 'Sortie de bain', not identifiable, no. 69
 3. 'Femme canotier', not identifiable, no. 70
 4. 'Femme rousse assise', not identifiable, no. 71 (also shown at Les Vingt in 1892)
 5. 'Femme rousse jardin', possibly *Femme rousse assise dans le jardin de M. Forest* (P366), no. 72
 6. 'En meublé', either *En meublé* (P365) or *Femme assise de profil vers la gauche* (P364), no. 73
 7. 'Femme divan rouge', not identifiable, no. 74

1892 Cercle Volney
 Opening 25 Jan. 1892

1. *Celle qui se peigne* (P390)
2. 'Étude', not identifiable

1892 9ᵉ Exposition des Vingt
Opening 6 Feb. 1892
During the following spring, some of the same works were shown in Antwerp at the Première Exposition de l'Association pour l'Art (cf. E. Verlant, 'Chronique artistique', *Le Jeune Belgique*, 2 [1892], 318)

1. 'La Goulue (Moulin Rouge), affiche, 2ᵉ état', i.e. second state of the poster *Moulin Rouge*, no. 1
2. 'La Goulue (Moulin Rouge), affiche, état définitif', i.e. the poster *Moulin Rouge* (Delteil, no. 339), no. 2
3. 'Jeune fille', possibly *Mademoiselle Dihau au piano* (P358) or *Hélène Vary* (P320), no. 3
4. 'En meublé', *En meublé* (P365), no. 4
5. 'En meublé', *Femme assise de profil vers la gauche* (P364), no. 5
6. 'Femme rousse assise', not identifiable, no. 6
7. 'Nocturne', possibly *Au Moulin Rouge ou la promenade* (P399), *Au Moulin Rouge* (P421), or *Au Moulin Rouge, le départ du quadrille* (P424), no. 7
8. 'Portrait d'homme', probably one of 1891 series, no. 8
9. 'Femme brune', not identifiable, no. 9

1892 8ᵉ Salon des Indépendants
19 Mar.–27 Apr. 1892

1. 'La Goulue et sa soeur (Moulin Rouge)', *Au Moulin Rouge* (P422), no. 1167
2. 'La Goulue: repos entre deux tours de valse (Moulin Rouge)', *Au Moulin Rouge ou la promenade* (P399), no. 1168
3. 'La Goulue entrant au Moulin Rouge', *La Goulue entrant au Moulin Rouge* (P423), no. 1169
4. 'Celle qui se peigne' (no. 1), *Celle qui se peigne* (P390 or P391), no. 1170
5. 'Celle qui se peigne' (no. 2), *Celle qui se peigne* (P390 or P391), no. 1171
6. 'Femme brune', not identifiable, no. 1172
7. 'Affiche pour le Moulin Rouge (2ᵉ)', i.e. second state of the poster, *Moulin Rouge*, no. 1173

Select Bibliography

ADHÉMAR, J., *Toulouse-Lautrec, His Complete Lithographs and Drypoints* (New York, 1965).

—— et al., *Toulouse-Lautrec, collection génies et réalités* (Paris, 1962).

ADRIANI, G., *Toulouse-Lautrec: das gesamte graphische Werk* (Cologne, 1976).

—— *Toulouse-Lautrec und das Paris um 1900* (Cologne, 1978).

—— *Toulouse-Lautrec, Gemälde und Bildstudien* (exh. cat., Kunsthalle Tübingen, Cologne, 1986).

—— *Toulouse-Lautrec, das gesamte graphische Werk. Sammlung Gerstenberg* (Cologne, 1986).

Albi, Musée Toulouse-Lautrec, *Catalogues* (Albi, 1924, 1952, 1963, 1967, 1973, 1985).

ALEXANDRE, A., 'Le Peintre Toulouse-Lautrec', *Le Figaro illustré*, special issue, no. 20 (Apr. 1902), 1–24.

—— *Jean-François Raffaëlli: peintre, graveur et sculpteur* (Paris, 1909).

D'ARGENCOURT, L., and DRUICK, D., *The Other Nineteenth Century* (exh. cat., National Gallery of Canada, Ottawa, 1978).

—— et al., *Puvis de Chavannes, 1824–1898* (exh. cat., National Gallery of Canada, Ottawa, 1977).

ARNOLD, M., *Henri de Toulouse-Lautrec* (Hamburg, 1982).

—— 'Das Theater des Lebens', *Weltkunst*, 52 (Feb. 1982), 302–6.

ARWAS, V., *Belle Époque, Posters and Graphics* (London, 1978).

ASTRÉ, A., *H. de Toulouse-Lautrec* (Paris, 1926).

Countess ATTEMS, née Mary Tapié de Céleyran, *Notre oncle Lautrec*, 3rd rev. edn. (Geneva, 1963).

BEAUTÉ, G., Countess ATTEMS, née Mary Tapié de Céleyran, and MONTCABRIER, R. de, *Il y a cent ans: Henri de Toulouse-Lautrec* (Geneva, 1964).

DE BERCY, L., *Montmartre et ses chansons, poètes et chansonniers* (Paris, 1902).

BERNARD, É., 'Les Ateliers', *Mercure de France*, 13 (Feb. 1895), 194–205.

—— 'Notes sur l'école dite de "Pont-Aven"', *Mercure de France*, 12 (Dec. 1903), 675–82.

—— 'Souvenirs sur van Gogh', *L'Amour de l'art*, 5 (1924), 393–400.

—— 'Louis Anquetin, artiste peintre', *Mercure de France*, 239 (1 Nov. 1932), 590–607.

—— 'Louis Anquetin', *Gazette des beaux-arts*, 11 (1934), 108–21.

—— 'Affaire Vincent', *Cahiers d'art documents*, no. 16 (Geneva, Jan. 1952).

—— 'Émile Bernard et Vincent van Gogh', *Cahiers d'art documents*, no. 17 (Geneva, Feb. 1952), 12–14.

—— 'Des relations d'Émile Bernard avec Toulouse-Lautrec', *Cahiers d'art documents*, no. 18 (Geneva, Mar. 1952), 13–14.

—— 'L'Aventure de ma vie', in *Lettres de Paul Gauguin à Émile Bernard* (Geneva, 1954).

BERNARD, T., 'Toulouse-Lautrec sportsman', *L'Amour de l'art*, 12 (Apr. 1931), 135.

BLOCH, L., and SAGARI, *Paris qui danse* (Paris, n.d.).

BLOCK, J., *Les XX and Belgian Avant Gardism, 1868–1894* (Ann Arbor, Mich., 1984).

BODELSEN, M., *Toulouse-Lautrec's Posters, Catalogue and Comments* (exh. cat., Museum of Decorative Arts, Copenhagen, 1964).

BOIME, A., *The Academy and French Painting in the Nineteenth Century* (New York, 1971).

—— *Art Pompier: Anti-Impressionism* (exh. cat., Emily Lowe Gallery, Hofstra University, New York, 1974).

BOIME, A., *Strictly Academic, Life Drawing in the Nineteenth Century* (exh. cat., University Art Gallery, State University of New York, Binghamton, 1974).

BONNETAIN, É., *Mon petit homme* (Brussels, 1885).

BOURET, J., *Court Painter to the Wicked: The Life and Work of Toulouse-Lautrec*, trans. D. Woodward (New York, 1966).

BOYLE-TURNER, C., *The Prints of the Pont-Aven School, Gauguin and His Circle in Brittany* (exh. cat., Smithsonian Institution Traveling Exhibition Service, Washington, DC, 1986).

BROOK, A., 'Henri de Toulouse-Lautrec', *The Arts*, 4 (1923), 125–65.

BROWSE, L., *Forain the Painter, 1852–1931* (London, 1978).

BRUANT, A., *Dans la rue*, 2 vols. (Paris, 1895).

—— *L'Argot au XXᵉ siècle*, 2nd edn. (Paris, 1905).

BUCHLOH, B. H. D., GUILBAUT, S., and SLOTKIN, D. (eds.), *Modernism and Modernity*, Vancouver Conference Papers (Nova Scotia, 1983).

CARCO, F., *La Belle Époque au temps de Bruant* (Paris, 1946).

CARTER, L. A., *Zola and the Theater* (New Haven, Conn., 1963).

CATE, P. D., and HITCHINGS, S. H., *The Color Revolution: Color Lithography in France, 1890–1900* (exh. cat., Jane Vorhees Zimmerli Art Museum, Rutgers University, New Brunswick, NJ, 1978).

—— and GILL, S., *Théophile-Alexandre Steinlen* (Salt Lake City, Utah, 1982).

—— and BOYER, P. E., *The Circle of Toulouse-Lautrec* (exh. cat., Jane Vorhees Zimmerli Art Museum, Rutgers University, New Brunswick, NJ, 1986).

Centenaire de Toulouse-Lautrec (exh. cat., Musée du Petit Palais, Paris, 1964).

Center Ring, the Artist: Two Centuries of Circus Art (exh. cat., Milwaukee Art Museum, Milwaukee, Wis., 1981).

CHAMPSAUR, F., *L'Amant des danseuses* (Paris, 1888).

CHARPENTIER, T., 'Un Aspect peu connu de l'activité de Lautrec: sa collaboration à la reliure d'art', *Gazette des beaux-arts*, 56 (Sept. 1960), 165–78.

Chevaux et cavaliers, René Princeteau, 1843–1914 (exh. cat., Gallerie Schmit, Paris, 1965).

CLARK, T. J., *The Painting of Modern Life: Paris in the Art of Manet and His Followers* (New York, 1985).

CLAYSON, S. H., 'Representations of Prostitution in Early Third Republic France', Ph.D. diss. (University of California, Los Angeles, 1984), 231–2.

COGNIAT, R., *Lautrec* (Paris, 1966).

COOLUS, R., 'Souvenirs sur Toulouse-Lautrec', *L'Amour de l'art*, 12 (Apr. 1931), 134.

COOPER, D., *Henri de Toulouse-Lautrec* (New York, 1966).

COOPER, J., *Nineteenth-Century Romantic Bronzes* (Boston, 1975).

COQUIOT, G., *Les Bals publics* (Paris, 1896).

—— *Les Cafés-concerts* (Paris, 1896).

—— 'Jean-François Raffaëlli', *Gazette des beaux-arts*, 5 (1911), pt. 1, 53–68, pt. 2, 136–48.

—— *Henri de Toulouse-Lautrec* (Paris, 1913).

—— *Lautrec, ou quinze ans de moeurs parisiennes: 1885–1900* (Paris, 1921).

—— *Des peintres maudits* (Paris, 1924).

DE CRAUZAT, E., *L'Œuvre gravé et lithographié de Steinlen* (Paris, 1913).

CRESPELLE, J.-P., *Les Maîtres de la belle époque* (Paris, 1966).

Les Dames de Montmartre (exh. cat., Musée de Montmartre, Paris, 1966).

DARZENS, R., *Nuits à Paris* (Paris, 1889).

DAULTE, F., 'Plus vrai que nature', *L'Œil*, no. 70 (Oct. 1960), 48–55.

—— *Toulouse-Lautrec, chefs-d'œuvre du Musée d'Albi* (exh. cat., Musée Marmottan, Paris, 1976).

DELTEIL, L., *Le Peintre-graveur illustré (XIXᵉ et XXᵉ siècles). Tome dixième et tome onzième, H. de Toulouse-Lautrec* (Paris, 1920).

DEVOISINS, J., 'Toulouse-Lautrec d'Albi', *La Revue française*, no. 250 (Feb. 1972), 5–16.

DORRA, H., 'Émile Bernard et Paul Gauguin', *Gazette des beaux-arts*, 45 (1955), 227–46, 255–60.

DORTU, M. G., *Toulouse-Lautrec* (Paris, 1952).

—— *Toulouse-Lautrec et son œuvre. Les Artistes et leurs œuvres: études et documents mis en œuvre par Paul Brame et C. M. de Hauke*, 6 vols. (New York, 1971).

—— GRILLAERT, M., and ADHÉMAR, J., *Toulouse-Lautrec en Belgique* (Paris, 1955).

—— and HUISMAN, P., *Lautrec par Lautrec* (Lausanne, 1964).

—— and —— *Toulouse-Lautrec* (Garden City, NY, 1971).

—— and MÉRIC, J. A., *Toulouse-Lautrec: le jeune Routy à Céleyran. Suite complète de huit dessins et trois peintures, 1882* (Paris, 1975).

—— and —— *Tout Toulouse-Lautrec: la peinture* (Paris, 1981).

DUMESNIL, R., *L'Époque réaliste et naturaliste* (Paris, 1945).

DURET, T., *Lautrec* (Paris, 1920).

EGBERT, D. D., *Social Radicalism and the Arts, Western Europe: A Cultural History from the French Revolution to 1968* (New York, 1970).

ESSWEIN, H., *Henri de Toulouse-Lautrec* (Munich, 1912).

D'EUGNY, A., 'Toulouse-Lautrec et ses modèles', *L'Amour de l'art*, 26 (1946), 189–95.

Exposition H. de Toulouse-Lautrec (exh. cat., Musée des Arts Decoratifs, Paris, 1931).

Exposition Henri de Toulouse-Lautrec, introd. by A. Alexandre (exh. cat., Galeries Durand-Ruel, Paris, 1902).

Exposition des œuvres de Henri de Toulouse-Lautrec du 20 avril au 3 mai 1903 (exh. cat., Galerie Barthélemy, Paris, 1903).

Exposition retrospective de l'œuvre de H. de Toulouse-Lautrec, introd. by A. Alexandre (exh. cat., Galerie Manzi-Joyant, Paris, 1914).

Exposition Toulouse-Lautrec (exh. cat., Galeries Bernheim jeunes et cie, Paris, 1908).

Exposition Toulouse-Lautrec (exh. cat., Orangerie des Tuileries, Paris, 1951).

DE LA FAILLE, J.-B., *The Works of Vincent van Gogh, His Paintings and Drawings*, rev. and annot. by A. M. Hammacher (Amsterdam, 1970).

FEINBLATT, E., and DAVIS, B., *Toulouse-Lautrec and His Contemporaries: Posters of the Belle Époque* (exh. cat., Los Angeles County Museum, Los Angeles, 1985).

FELDMAN, W. S., 'His Work and Influence', *Jules Bastien-Lepage* (exh. cat., Les Musées de la Meuse, Verdun and Montmedy, 1984), 116.

FÉNÉON, F., *Œuvres plus que complètes*, ed. J. U. Halperin, 2 vols. (Geneva, 1970).

FERMIGIER, A., *Toulouse-Lautrec*, trans. P. Stevenson (New York, 1969).

FIELDS, B. S., 'Jean-François Raffaëlli (1850–1924): The Naturalist Artist', Ph.D. diss. (Columbia University, 1979).

FINKE, U. (ed.), *French 19th Century Painting and Literature* (Manchester, 1972).

FOCILLON, H., 'Lautrec', *Gazette des beaux-arts*, 5 (1931), 366–82.

FORBES, C., and KELLY, M., *War à la Mode* (exh. cat., Walters Art Gallery, Baltimore, Md., 1977).

FRANKFURTER, A. M., 'Toulouse-Lautrec: The Artist', *Art News Annual*, 20 (1951), 87–126.

GANS, L., 'Vincent van Gogh en de Schilders van de "Petit Boulevard"', *Museumjournaal*, 4 (Dec. 1958), 85–93.

GAUZI, F., *Lautrec et son temps* (Paris, 1954).

GAVIN, W., *The Elegant Academics, Chroniclers of Nineteenth-Century Parisian Life* (exh. cat., Sterling and Francine Clark Art Institute, Williamstown, Mass., 1974).

GEFFROY, G., *La Vie artistique*, 1st ser., vol. 1, 1892, vol. 2, 1893. Preface by E. de Goncourt.

—— 'Henri de Toulouse-Lautrec', *Gazette des beaux-arts*, 12 (1914), 89–104.

—— 'Forain', *L'Art et les artistes*, special issue, no. 21 (Nov. 1921), 49–78.

GEORGES-MICHEL, M., 'Lautrec et ses modèles', *Gazette des beaux-arts*, 79 (1972), 241–50.

VAN GOGH, V., *The Complete Letters of Vincent van Gogh*, 2nd edn., 3 vols. (Boston, 1978).

GOLDMAN, B., 'Realist Iconography: Intent and Criticism', *Journal of Aesthetics and Art Criticism*, 18 (1959–60), 183–92.

GOLDSCHMIDT, L., and SCHIMMEL, H. (eds.), *Unpublished Correspondence of Henri de Toulouse-Lautrec*, introd. and notes by J. Adhémar and T. Reff (New York, 1969).

—— and —— *Toulouse-Lautrec lettres: 1871–1901*, introd. and notes by J. Adhémar and T. Reff (Paris, 1972).

GOLDWATER, R., ' "L'Affiche moderne", A Revival of Poster Art after 1880', *Gazette des beaux-arts*, 22 (Dec. 1942), 173–82.

—— 'Puvis de Chavannes, Some Reasons for a Reputation', *The Art Bulletin*, 28 (Mar. 1946), 33–43.

GONCOURT, E. DE, and GONCOURT, J. de, *Germinie Lacerteux* (Paris, 1921).

—— *Journal de sa vie littéraire*, 22 vols. (Monaco, 1957).

GOWANS, A., *The Unchanging Arts: New Forms for the Traditional Functions of Art in Society* (New York, 1971).

GRONBERG, T. A., 'Femmes de brasserie', *Art History*, 7 (Sept. 1984), 329–44.

HANSON, L., and HANSON, E., *The Tragic Life of Toulouse-Lautrec* (New York, 1956).

HARASZTI-TAKACS, M., 'Études sur Toulouse-Lautrec', *Bulletin du Musée Hongrois des Beaux-Arts*, no. 26 (1965).

HARTRICK, A. S., *A Painter's Pilgrimage through Fifty Years* (Cambridge, 1939).

HEILMANN, C., *Henri de Toulouse-Lautrec* (exh. cat., Bayerische Staatsgemäldesammlungen, Munich, 1985).

HELLER, R., 'Rediscovering Henri de Toulouse-Lautrec's "At the Moulin Rouge" ', *Museum Studies*, 12, no. 2 (1986), 114–35.

HEMMINGS, F. W. J., *Culture and Society in France, 1848–1898, Dissidents and Philistines* (New York, 1971).

HENDERSON, J. A., *The First Avant-Garde, 1887–1894, Sources of Modern French Theatre* (London, 1971).

HERBERT, E. W., *The Artist and Social Reform: France and Belgium, 1885–1898* (New Haven, Conn., 1961).

HERBERT, M., *La Chanson à Montmartre* (Paris, 1967).

HERBERT, R., *Neo-Impressionism* (exh. cat., Solomon R. Guggenheim Museum, New York, 1968).

—— 'City vs. Country: The Rural Image in French Painting from Millet to Gauguin', *Artforum*, 8 (Feb. 1970), 44–55.

—— *Jean-François Millet* (exh. cat., Arts Council of Great Britain, London, 1976).

—— and HERBERT, E., 'Artists and Anarchism', *Burlington Magazine*, 102 (1960), 472–82, 517–22.

HOFMANN, W., and HOPP, G., *Pariser leben: Toulouse-Lautrec und seine Welt* (exh. cat., Kunsthalle, Hamburg, 1986).

HOLT, R., *Sport and Society in Modern France* (Hamden, Conn., 1981).

HUGO, V., Édition Nationale, 43 vols. (Paris, J. Lemonnyer and G. Richard, and cont. by É. Testard, 1885–).

HUYGHE, R., 'Aspects de Toulouse-Lautrec', *L'Amour de l'art*, 12 (Apr. 1931), 142–58.

HUYSMANS, J.-K., *Œuvres complètes*, ed. L. Descaves, 20 vols. (Paris, 1928).

The Impressionists and the Salon (1874–1886) (exh. cat., Los Angeles County Museum of Art, University of California, Riverside, 1974).

ISAACSON, J., *The Crisis of Impressionism, 1878–1882* (exh. cat., University of Michigan Museum of Art, Ann Arbor, 1979).

—— 'Impressionism and Journalistic Illustration', *Arts Magazine*, 56, no. 10 (June 1982), 95–115.

JAWORSKA, W., *Gauguin and the Pont Aven School*, trans. P. Evans (New York, 1972).

Jean-Louis Forain (exh. cat., Musée Marmottan, Paris, 1978).

JEDLICKA, G., *Henri de Toulouse-Lautrec* (Berlin, 1929).

—— *Henri de Toulouse-Lautrec*, trans. J. Erskine (New York, 1962).

John-Lewis Brown, 1829–1890 (exh. cat., Galerie des Beaux-Arts, Bordeaux, 1953).

JOHNSON, L. F. Jun., 'The Light and Shape of Loie Fuller', *Baltimore Museum of Art News*, 20 (1956), 9–16.

—— 'Toulouse-Lautrec, the Symbolists and Symbolism', Ph.D. diss. (Harvard University, 1956).

—— 'Time and Motion in Toulouse-Lautrec', *College Art Journal*, 16 (1956–7), 13–22.

JOOSTEN, E., 'De Verzemelung van Théo van Gogh', *Museumjournaal*, 5 (Mar. 1960), 155–7, 190–1.

JOURDAIN, F., *Toulouse-Lautrec* (Paris, 1954).

—— and ADHÉMAR, J., *T-Lautrec* (Paris, 1955).

JOYANT, M., *Henri de Toulouse-Lautrec*, 2 vols. (Paris, 1926–7).

—— 'Toulouse-Lautrec', *L'Art et les artistes*, no. 74 (Feb. 1927).

JULIEN, E., *The Posters of Toulouse-Lautrec*, trans. D. Woodward (Monte Carlo, 1951).

—— *Pour connaître Toulouse-Lautrec* (Albi, 1953).

—— *Toulouse-Lautrec: au cirque* (Paris, 1956).

JULLIAN, P., *Montmartre*, trans. A. Carter (New York, 1977).

KAHN, A., *J.-K. Huysmans: Novelist, Poet and Art Critic* (Ann Arbor, Mich., 1987).

KELLER, H., *Toulouse-Lautrec: Painter of Paris*, trans. E. Bizzari (New York, 1969).

KNAPP, B. L., *Le Mirliton: A Novel Based on the Life of Aristide Bruant* (Paris, 1968).

LACHENAL, F., *et al.*, *Henri de Toulouse-Lautrec* (exh. cat., Ingelheim am Rhein, 1968).

LaMURE, P., *Moulin Rouge, a Novel Based on the Life of Henri de Toulouse-Lautrec* (New York, 1950).

LANDRÉ, J., *Aristide Bruant* (Paris, 1930).

LAPPARENT, P. DE, *Toulouse-Lautrec*, trans. W. F. H. Whitmarsh (London, 1928).

LASSAIGNE, J., *Toulouse-Lautrec*, trans. M. Chamot (Paris, 1946).

—— *Henri de Toulouse-Lautrec*, trans. S. Gilbert (Lausanne, 1953).

'Lautrec et les autres', *L'Amour de l'art*, 12 (Apr. 1931), 159–64.

LAVER, J., *English Sporting Prints* (London, 1970).

LECLERCQ, P., *Autour de Toulouse-Lautrec* (Geneva, 1954).

LEGRAND, F. C., *Le Groupe des XX et son temps* (exh. cat., Musées Royaux des Beaux-Arts de Belgique, Brussels, 1962).

LEMOISNE, P.-A., *Degas et son œuvre*, 4 vols. (Paris, 1946–9).

LETHÈVE, J., *La Caricature et la presse sous la III͏ᵉ République* (Paris, 1961).

LIPTON, E., *Looking into Degas: Uneasy Images of Women and Modern Life* (Berkeley, Calif., 1986).

LÖVGREN, S. *The Genesis of Modernism: Seurat, Gauguin, van Gogh and French Symbolism in the 1880s*, rev. edn. (Bloomington, Ind., 1971).

LUCIE-SMITH, E., *Toulouse-Lautrec* (Oxford, 1983).

—— and DARS, C., *Work and Struggle: The Painter as Witness, 1870–1914* (New York, 1977).

MACK, G., *Toulouse-Lautrec* (New York, 1938).

MacORLAN, P., *Lautrec, peintre de la lumière froide* (Paris, 1934).

MAGNE, J., 'Forain témoin de son temps: la satire sociale et morale', *Gazette des beaux-arts*, 81 (1973), 241–51.

MAINDRON, E., *Les Affiches illustrées: 1886–1895* (Paris, 1896).

—— *Les Programmes illustrées des théâtres et des cafés-concerts, menus, cartes d'invitation, petites estampes, etc.* (Paris, n.d.).

MARTINO, P., *Le Naturalisme français, 1870–1895* (Paris, 1923).

MARTRINCHARD, R., *Princeteau, 1843–1914, professor et ami de Toulouse-Lautrec, sa vie, son œuvre* (Bordeaux, 1956).

MAUNER, G. L., *The Nabis: Their History and Their Art, 1888–1896* (New York, 1978).

MAUS, M. O., *Trente années de lutte pour l'art, 1884–1914* (Brussels, 1926).

MELOT, M., 'Questions au japonisme', *Japonisme in Art, An International Symposium* (Tokyo, 1980), 239–60.

—— *Les Femmes de Toulouse-Lautrec, les albums du Cabinet des Estampes de la Bibliothèque Nationale* (Paris, 1985).

MÉTÉNIER, O., *Le Chansonnier populaire Aristide Bruant* (Paris, 1893).

MONTORGUEIL, G., *La Parisienne peint par elle-même* (Paris, 1897).

—— *Paris dansant* (Paris, 1898).

—— *Old Montmartre* (Paris, 1924).

MOULOUDJI, M., *Aristide Bruant* (Paris, 1972).

MÜNTZ, E., *Guide de l'École Nationale des Beaux-Arts* (Paris, 1889).

MURRAY, G. B., 'Problems in the Chronology and Evolution of Style and Subject Matter in the Art of Henri de Toulouse-Lautrec, 1878–1891', Ph.D. diss. (Columbia University, 1978).

—— Review of M. G. Dortu, *Toulouse-Lautrec et son œuvre*, *The Art Bulletin* (Mar. 1978), 179–82.

—— 'Henri de Toulouse-Lautrec, A Checklist of Revised Dates, 1878–1891', *Gazette des beaux-arts*, 95 (Feb. 1980), 77–90.

—— 'The Theme of the Naturalist Quadrille in the Art of Toulouse-Lautrec', *Arts Magazine*, 55 (Dec. 1980), 68–75.

MUSCULUS, Pastor P. R., 'L'Ascendance royale de Toulouse-Lautrec', *Gazette des beaux-arts*, 74 (1969), 179–80.

NATANSON, T., *Un Henri de Toulouse-Lautrec* (Geneva, 1951).

—— 'Toulouse-Lautrec: The Man', *Art News Annual*, 20 (1951), 77–87.

NICOLSON, B., 'Notes on Henri de Toulouse-Lautrec', *Burlington Magazine*, 93 (1951), 299–300.

NOCHLIN, L., *Realism* (Baltimore, 1971).

—— 'Lautrec, the Performer and the Prostitute: Advertising and the Representation of Marginality' (unpublished typescript of a lecture given at the Museum of Modern Art, New York, 1985).

—— (ed.), *Sources and Documents in the History of Art: Impressionism and Post-Impressionism, 1874–1904* (Englewood Cliffs, NJ, 1966).

NOVOTNY, F., *Toulouse-Lautrec*, trans. M. Glenney (London, 1969).

OBERTHUR, M., *Cafés and Cabarets of the Montmartre* (Salt Lake City, Utah, 1984).

OURSEL, H., 'Musée des Beaux-Arts de Lille: un tableau de Toulouse-Lautrec', *Revue du Louvre et des musées de France*, 25 (1975), 275–7.

Paintings, Drawings, Prints and Posters by Toulouse-Lautrec (exh. cat., Art Institute of Chicago, 1930).

PERRUCHOT, H., *La Vie de Toulouse-Lautrec* (Paris, 1958).

PEVSNER, N., *Academies of Art, Past and Present* (London, 1940).

PICENI, E., *Zandomeneghi, catologo generale dell'opera* (Milan, 1967).

POLÁŠEK, J., *Toulouse-Lautrec Drawings* (New York, 1976).

Post-Impressionism: Cross-Currents in European Painting (exh. cat., Royal Academy of Arts, London, 1979).

REARICK, C., *Pleasures of the Belle Époque: Entertainment and Festivity in Turn-of-the-Century France* (New Haven, Conn., 1985).

REBELL, H., *La Câlineuse* (Paris, 1900).

REFF, T., *Degas: The Artist's Mind* (New York, 1976).

—— 'Degas, Lautrec, and Japanese Art', *Japonisme in Art, An International Symposium* (Tokyo, 1980), 189–213.

RENAULT, G., and CHATEAU, H., *Montmartre* (Paris, 1897).

REWALD, J., *Georges Seurat* (New York, 1946).

—— *The History of Impressionism*, 4th rev. edn. (New York, 1973).

—— *Post-Impressionism from van Gogh to Gauguin*, 3rd rev. edn. (New York, 1978).

RICH, D. C., 'Where Shall We Put Lautrec?', *The Arts*, 17 (Feb. 1931).

—— *Toulouse-Lautrec au Moulin Rouge* (London, 1949).

RICHARDSON, J., *The Bohemians: La Vie de Bohème in Paris, 1830–1914* (New York, 1971).

ROBERTS-JONES, P., *La Presse satirique illustrée entre 1860 et 1890* (Paris, 1956).

—— *De Daumier à Lautrec: essai sur l'histoire de la caricature française entre 1860 et 1890* (Paris, 1960).

—— *La Caricature du second empire à la belle époque* (Paris, 1963).

RODRIGUÈS, E. [Erastène Ramiro], *Cours de danse, fin de siècle* (Paris, 1892).

—— *Louis Legrand, peintre-graveur* (Paris, 1896).

ROGER-MARX, C., 'Toulouse-Lautrec, graveur', *L'Amour de l'art*, 12 (Apr. 1931), 165–71.

ROSEN, C., and ZERNER, H., *Romanticism and Realism, the Mythology of Nineteenth-Century Art* (New York, 1984).

ROSKILL, M., *Van Gogh, Gauguin and the Impressionist Circle* (Greenwich, Conn., 1970).

ROTHENSTEIN, W., *Men and Memories* (New York, 1935).

RUBIN, W., *Shadow and Substance: The Shadow Theater of Montmartre and Contemporary Art* (exh. cat., Contemporary Arts Museum, Houston, Tex., 1956).

RUDORFF, R., *The Belle Époque: Paris in the Nineties* (London, 1972).

SCHAPIRO, M., *et al.*, 'The Reaction against Impressionism in the 1880s: Its Nature and Causes', *Problems of the 19th and 20th Centuries: Studies in Western Art*, Acts of the Twentieth International Congress of the History of Art, 4 (Princeton, NJ, 1963).

SCHAUB-KOCH, É., *Psychanalyse d'un peintre moderne, Henri de Toulouse-Lautrec* (Paris, 1935).

SCHIMMEL, H. D., (ed.), *The Letters of Henri de Toulouse-Lautrec*, trans. Divers Hands; Introd., Gale B. Murray (Oxford, 1991).

—— and CATE, P. D. (eds.), *The Henri de Toulouse-Lautrec W. H. B. Sands Correspondence* (New York, 1983).

SCHMIDT, V. MD, 'The Malady of Toulouse-Lautrec: Case Report and Diagnosis', *Papers Dedicated to Torben* (Copenhagen, 1966).

SCHNIEWIND, C., *The Art Institute Presents Toulouse- Lautrec* (Chicago, 1949).

SCHNIEWIND, C., *A Sketchbook by Toulouse-Lautrec Owned by The Art Institute of Chicago* (New York, 1952).

SEGEL, H. B., *Turn-of-the-Century Cabaret* (New York, 1987).

SEIGEL, J., *Bohemian Paris: Culture, Politics and the Boundaries of Bourgeois Life, 1830–1930* (New York, 1986).

SHATTUCK, R., *The Banquet Years: The Origins of the Avant-Garde in France, 1885 to World War I*, rev. edn. (New York, 1968).

SHIFF, R. *Cézanne and the End of Impressionism* (Chicago, 1984).

SHONE, R., *Toulouse-Lautrec* (London, 1977).

STALEY, A., *et al.*, *From Realism to Symbolism: Whistler and His World* (exh. cat., Wildenstein Galleries, New York, 1971).

STROMBERG, R. M. (ed.), *Realism, Naturalism, and Symbolism: Modes of Thought and Expression in Europe, 1848–1914* (New York, 1968).

STUCKEY, C. F., *Toulouse-Lautrec: Paintings* (exh. cat., Art Institute of Chicago, 1979).

STURGES, H., *Jules Breton and the French Rural Tradition* (exh. cat., Joslyn Art Museum, Omaha, Neb., 1982).

SUGANA, G. M., *The Complete Paintings of Toulouse-Lautrec* (New York, 1969).

SUTTON, D., 'Some Aspects of Toulouse-Lautrec', *The Connoisseur Yearbook* (1956), 71–8.

—— *Lautrec* (New York, 1962).

SWART, K. W., *The Sense of Decadence in Nineteenth-Century France* (The Hague, 1964).

SYMONS, A., *From Toulouse-Lautrec to Rodin* (London, 1929).

Tenth Loan Exhibition: Lautrec, Redon (exh. cat., Museum of Modern Art, New York, 1931).

Théophile Alexandre Steinlen, 1859–1923 (exh. cat., Bibliothèque Nationale, Paris, 1953).

THÉVOZ, M., *Retrospective Théophile Alexandre Steinlen* (exh. cat., Charleroi, 1970).

THOMPSON, J., *The Peasant in French 19th Century Art* (exh. cat., Douglas Hyde Gallery, Trinity College, Dublin, 1980).

THOMSON, R., *Toulouse-Lautrec* (London, 1977).

—— 'The Drinkers of Daumier, Raffaëlli and Toulouse-Lautrec', *Oxford Art Journal*, 2 (Apr. 1979), 29–33.

—— 'Henri de Toulouse-Lautrec, Drawings from 7 to 18 Years', in S. Paine (ed.), *Six Children Draw* (London, 1981), 46–7.

—— 'Toulouse-Lautrec and Sculpture', *Gazette des beaux-arts*, 102 (Feb. 1984), 80–4.

Toulouse-Lautrec (exh. cat., Art Institute of Chicago and the Philadelphia Museum of Art, 1955).

Toulouse-Lautrec, 1864–1901 (exh. cat., Arts Council of Great Britain, Tate Gallery, London, 1961).

Toulouse-Lautrec, Book Covers and Brochures (exh. cat., Harvard College Library, Department of Printing and Graphic Arts, Cambridge, Mass., 1972).

Toulouse-Lautrec, Paintings, Drawings, Posters (exh. cat., M. Knoedler and Co., New York, 1937).

Toulouse-Lautrec, Paintings, Drawings, Posters, Lithographs (exh. cat., Museum of Modern Art, New York, 1956).

Toulouse-Lautrec, Portraits and Figure Studies, the Early Years (exh. cat., Fogg Art Museum, Cambridge, Mass., 1965).

Toulouse-Lautrec et son milieu familial (exh. cat., Musée, Rennes, 1963).

UZANNE, O., *The Modern Parisienne* (New York, 1912).

VALBEL, H., *Les Chansonniers et les cabarets artistiques* (Paris, 1895).

VARNEDOE, K., 'Revisionism Revisited', *Art Journal*, 40 (Fall-Winter 1980), 348–52.

VAUCAIRE, M., *Effets de théâtre (la scène et la salle, le ballet, cafés chantants, à la foire)* (Paris, 1886).

VERONESI, G., 'Toulouse-Lautrec', *Emporium*, 113, (1957), 243–8.

DU VIGNAUD, B., and DU VIGNAUD, A., *Drawings and Watercolors by Toulouse-Lautrec* (exh. cat., Gallery of the French Embassy, New York, 1985).

VISANI, M. C., *Toulouse-Lautrec*, trans. D. Fort (Paris, 1970).

VUILLARD, E., 'Lautrec raconté par Vuillard', as told to Germain Bazin, *L'Amour de l'art*, 12 (Apr. 1931), 141–2.

WARD-JACKSON, P., 'Art Historians and Art Critics VIII: Huysmans', *Burlington Magazine*, 109 (Nov. 1967), 617–22.

WARNOD, A., *Bals, cafés et cabarets*, 5th edn. (Paris, 1913).

—— *Le Vieux Montmartre* (Paris, 1913).

—— *Les Bals de Paris* (Paris, 1922).

WATTENMAKER, R., *Puvis de Chavannes and the Modern Tradition* (exh. cat., Art Gallery of Ontario, Toronto, 1975).

WEBER, E., *France, Fin de Siècle* (Cambridge, Mass., 1986).

WEISBERG, G. P., *Social Concern and the Worker: French Prints from 1830–1910* (exh. cat., Utah Museum of Fine Arts, University of Utah, Salt Lake City, 1974).

—— *The Realist Tradition: French Painting and Drawing, 1830–1900* (exh. cat., Cleveland Museum of Art, Cleveland, Ohio, 1980).

—— 'Jules Breton, Jules Bastien-Lepage, and Camille Pissarro in the Context of Nineteenth-Century Peasant Painting and the Salon', *Arts Magazine*, 56 (Feb. 1982), 115–19.

—— 'P. A. J. Dagnan-Bouveret, Jules Bastien-Lepage and the Naturalist Instinct', *Arts Magazine*, 56 (Apr. 1982), 70–6.

—— (ed.), *The European Realist Tradition* (Bloomington, Ind., 1982).

—— et al., *Japonisme: Japanese Influence on French Art, 1854–1910* (exh. cat., Cleveland Museum of Art, Cleveland, Ohio, 1975).

WELSH-OVCHAROV, B., *Vincent van Gogh, His Paris Period, 1886–1888* (The Hague, 1976).

—— *Vincent van Gogh and the Birth of Cloisonism* (exh. cat., Art Gallery of Ontario, Toronto, 1981).

WILDER, F. L., *Sporting Prints* (New York, 1974).

WITTROCK, W., *Toulouse-Lautrec, The Complete Prints*, trans. C. E. Kuehn, 2 vols. (London, 1985).

—— and CASTLEMAN, R. (eds.), *Henri de Toulouse-Lautrec, Images of the 1890s* (exh. cat., Museum of Modern Art, New York, 1985).

WOODCOCK, G., *Anarchism, A History of Libertarian Ideas and Movements* (New York, 1962).

YOUNG, A. McL., MacDONALD, M., and SPENCER, R., *The Paintings of James McNeill Whistler*, 2 vols. (New Haven, Conn., 1980).

ZELDIN, T., *France: 1848–1945*, i, *Ambition, Love and Politics*; ii, *Intellect, Taste and Anxiety* (Oxford, 1973; 1977).

ZÉVAÈS, A., *Aristide Bruant* (Paris, 1943).

ZOLA, É., *Les Œuvres complètes*, with notes and commentary by M. Le Blond, Eugene Fasquelle edn., 50 vols. (Paris, 1927–9).

Index

Figures in italic refer to illustrations on that page